Michael Snodin & Maurice Howard

rnament *A Social History Since 1450*

YALE UNIVERSITY PRESS
NEW HAVEN AND LONDON
in association with THE VICTORIA AND ALBERT MUSEUM

Designed by Derek Birdsall
Set in Walbaum by Omnific
Printed and bound in Hong Kong

Library of Congress Cataloging-in-Publication Data

Snodin, Michael.
 Ornament: a social history since 1450/Michael Snodin and
Maurice Howard.
 Includes bibliographical references and index.
 ISBN 0–300–06455–1 (cloth)
 1. Decoration and ornament—Europe. I. Howard, Maurice.
II. Title.
NK 1442.S62 1996
745.4'494 — dc20 95–39597
 CIP

A catalogue record for this book is available
from the British Library.

Contents

For
Patricia and Oliver
and for
Mary Eminson and Margaret Williamson

Preface

The opportunity to write this book was created by the European Ornament Gallery, opened at the Victoria and Albert Museum in 1992 with the aid of a grant from the Wolfson Foundation. It was curated by the two authors, together with Hilary Young and Clare Graham. The gallery summarizes the major themes of European ornament since the mid-fifteenth century, working very much like a three-dimensional encyclopedia of ornament in which objects of different date and status are juxtaposed, thus drawing out their common inheritance of motifs. While such an arrangement is able to illuminate many issues of design and ornament it is by its very nature unable to demonstrate a social history of the development of these objects and their relationship to each other. It is to fill that gap that this book has been written, adding, so to speak, the 'How?' and the 'Why?' to the gallery's 'What?'. There are many ways to write a book together; in this case the joint experience of the gallery allowed the authors to develop ideas in common while writing individual chapters; thus Maurice Howard was largely responsible for those on architecture, the human figure and public and popular culture, Michael Snodin for those on the printed image, the domestic interior and exoticism.

At the Victoria and Albert Museum we have been particularly indebted to the Director, Elizabeth Esteve-Coll, and to John Murdoch, Charles Saumarez Smith and Susan Lambert for their unstinting support for the gallery and the writing of this book. Maurice Howard's contribution to both projects was carried out under the staff exchange scheme between the Museum and the University of Sussex. For ideas and advice we have been especially grateful to the following friends and colleagues at the Victoria and Albert Museum: Stephen Astley, Tim Barringer, Stephen Calloway, Rosemary Crill, Paul Greenhalgh, John Guy, Wendy Hefford, Anna Jackson, Charles Newton, Clive Wainwright, Rowan Watson and Christopher Wilk. At the University of Sussex we have been especially indebted to Craig Clunas, Dorothy Scruton and Margit Thøfner. Outside our two institutions we have been given much help by Stella Beddoe of the Royal Pavilion Art Gallery and Museums, Brighton, Catherine Bindman at the Metropolitan Museum of Art, Matteo Ceriana of the Pinacoteca di Brera, Milan, Anna Contadini at Trinity College, Dublin, Antony Griffiths of the British Museum, Carolyn Hammond of the London Borough of Hounslow Public Libraries, Elisabet Hidemark of the Nordic Museum, Stockholm, Hanspeter Lanz of the Schweizerisches Landesmuseum, Zurich, Fred Redding, archivist at Selfridges, London, Molly Seiler of the Brooklyn Museum, Colin Stockhall of Gallagher Ltd and Mark Turner of Middlesex University, as well as Michael A. Brown, Peter Fuhring, Claire and Richard Gapper, Eloy Koldeweij and Anna Brita Snodin. Numerous requests for photographs have been ably tackled by James Stevenson and the Museum photographers and other technical matters handled by the Media Services Unit of the University of Sussex. At Yale University Press John Nicoll and Candida Brazil have been both supportive and creative in bringing the book into its final shape.

Michael Snodin
Maurice Howard

September 1995

Introduction

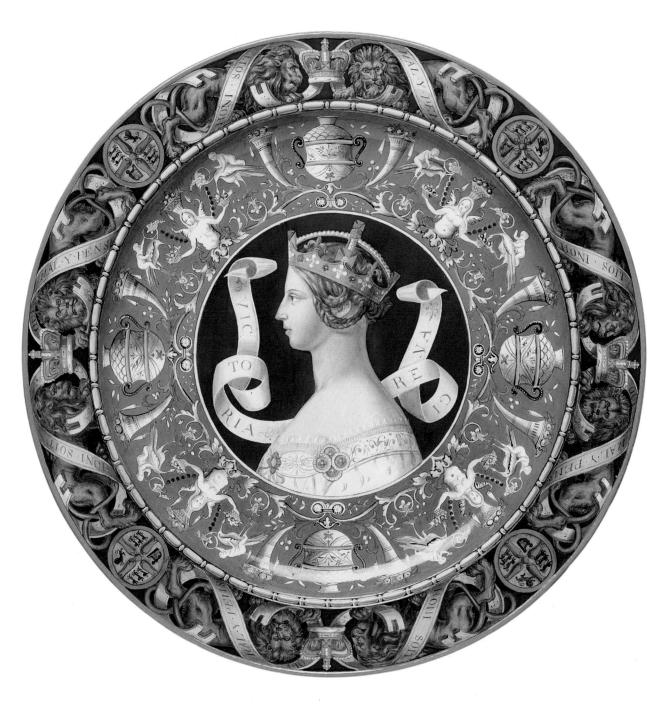

The word 'ornament' is most generally used today to refer to objects of no particular use that give pleasure simply by their presence as an addition to their surroundings. If we had to think of the most likely places we would expect to see ornaments we might at first think of the domestic environment: mantelpieces, window ledges, open spaces in gardens – in fact any surfaces or areas that are not somehow in constant use but are looked at and therefore need objects on or in them to act as the focus of attention. If a surface or area is in occasional use, we might move ornaments, the use-less, to make way for things of a more practical nature as we do when putting aside a vase of flowers to lay a table for a meal. Equally domestic perhaps are the ornaments human beings place upon themselves, such as jewellery and badges, of which some are worn every day, and others only on special occasions. The highly personalized statement of the choice of an item of dress, however, reminds us that ornaments, even if they are totally superfluous, are far from meaningless; they reveal a great deal of the character of the wearer or the owner of the house and we know that we judge, and are judged by, such things.

The definition of all the objects around us as either useful or 'ornamental' (and therefore by implication useless) is not, however, as straightforward as it might first seem. Often ornaments which can have no practical use have their origin in the shapes of everyday objects. So, the great dish shown in plate 1, made in 1855, is recognizably shaped like a plate but its size and, more importantly, the amount of information and decoration placed upon it which demands to be seen makes it into something purely 'ornamental'. Its proper place is not the dining table but the shelf of a great cabinet where it can be viewed and admired. Similarly, the great urns made by the Minton factory and shown at the Paris Exhibition in 1867 (plate 2) are heavily decorated with both ornament and figurative work; they cannot even be picked up in a conventional way by the handle or even by one person.

Not all ornaments therefore are portable objects or necessarily small. They are often made in shapes that relate back to their practical origins. Our definition widens further if we consider ornament that is attached to something else; if asked to define the purpose of the braid around the edge of a coat or the wallpaper of a room we might say it provides the 'ornament' of the item of dress or the space it decorates. We have thus shifted our notion of ornament from referring to a particular, perhaps trivial, object towards a sense of it as the necessary completion of something to which it belongs. This could be purely practical; the braid might be covering the stitching, and therefore the construction, of the coat,

1. Dish, English, c.1855. Earthenware painted by Thomas Kirkby in enamel colours, made by Minton and Co. The dish, which is 25 inches (63.5 cm) in diameter, shows the head of Queen Victoria surrounded by grotesque ornament in the style of Italian Renaissance maiolica. London, Victoria and Albert Museum

2. Vase, English, c.1867. Enamelled earthenware, painted by Thomas Allen and modelled by Victor Simyan. Made by Minton and Co. The vase stands 4 feet (121.9 cm) high. The body depicts a boar hunt after Rubens and the cover, the myth of Prometheus. London, Victoria and Albert Museum.

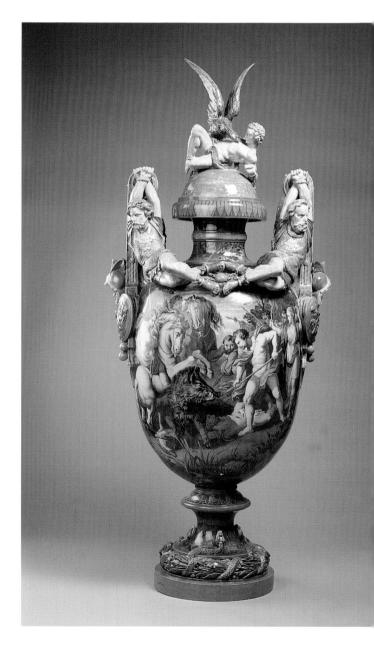

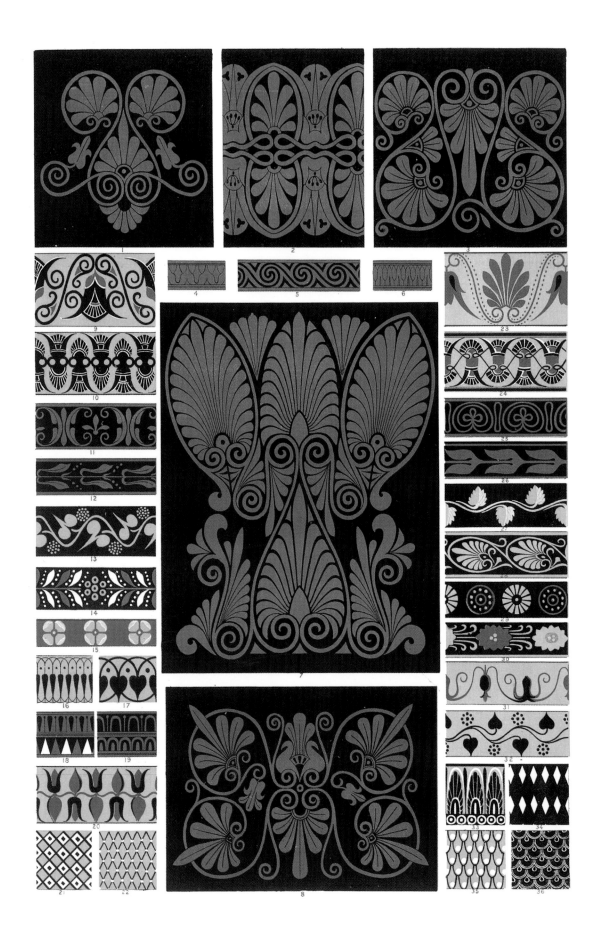

and wallpaper may be used to give the room extra height or disguise uneven surfaces. It could also be serving a purpose that is, in the broadest sense, aesthetic; the colours or shapes may echo those of other things around it. Ornament is both functional and contextual; it serves to relate one thing to another.

The idea that ornament has meaning and purpose much exercised the minds of nineteenth- and early twentieth-century writers on the subject. They lived in a society where the sheer volume of objects carrying ornament had increased dramatically. This was due mainly to the spending power of a new urban middle and working class with lean but sufficient means to buy decorated objects, the greater supply of which had come about through faster means of mechanical production. From the middle of the nineteenth century, and greatly influenced by the series of international exhibitions, beginning with the Great Exhibition in London in 1851, large handbooks or 'grammars' of ornament were published which sought to tell the history of ornament and categorize historical styles. This of course set an even faster pace to the already growing interest in the revival of styles of the past. Laid out on the page were a range of designs for borders, framing elements and individual motifs which could be used singly, or multiplied at will, to give fabrics, wallpapers, in fact any surface to which ornament could be applied, the essential look of 'Greek', 'Roman', 'Gothic' or, in the case of the British market, 'Elizabethan' (plate 3). The compilers of the grammars of ornament did not mean their work to be indiscriminately or randomly applied. When these great books formed the foundations of the teaching of ornament in art schools, it was not simply a choice of designs they sought to offer but rather the principles on which particular configurations of ornament had come into being. Seeking out the fundamental rules of ornament from past styles was the object of the work of the doyen of all historians of ornament, Owen Jones, who published his *Grammar of Ornament* in 1856. He commented: 'The principles discoverable in the works of the past belong to us; not so the results. It is taking the end for the means.'[1]

3. Greek ornament, from Owen Jones,
The Grammar of Ornament, 1856. London,
Victoria and Albert Museum.

4. Detail of the decoration of Raphael's loggias.
Hand-coloured etching by Giovanni Ottaviani
after Pietro Camporesi and G. Savorelli. Italian
1772–7. The decoration of the Vatican loggias
firmly established the grotesque as an ornamental
form in Renaissance Europe. London, Victoria and
Albert Museum.

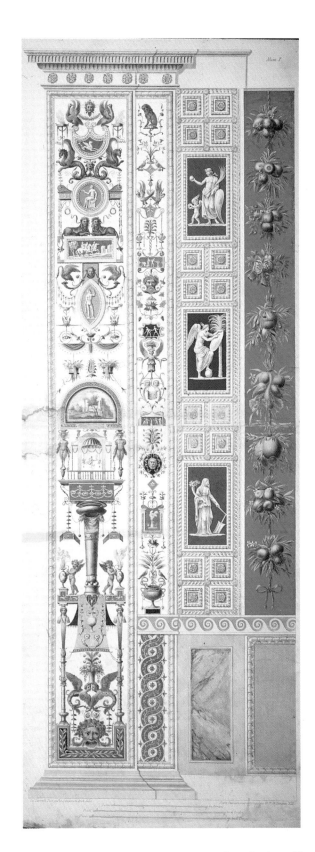

From this command of the vocabulary of past styles of ornament, nineteenth-century critics felt empowered to make value judgements on the merits of particular styles relative to each other. In doing so, they were reviving the notion, first expressed in ancient times, that there was a moral dimension to the use of ornament. In imperial Rome of the first century BC, the architect Vitruvius criticized the highly decorative wall-painting of his day as containing 'monstrosities, rather than truthful representations of definite things'. What he saw around him was illogical and unnatural: 'reeds are put in the place of columns, fluted appendages with curly leaves and volutes, instead of pediments, and on top of their pediments numerous tender stalks and volutes growing up from the roots and having human figures senselessly seated upon them' (plate 4).[2] It was a similiar, high-minded antipathy to illogical representation that caused Pugin in the nineteenth century to champion ornament that was flat and made up of areas of saturated colour. Three-dimensional pattern was bad and showed poor judgement because it used ornament inappropriately; since a floor is flat, the carpet covering it cannot be patterned as if walking across the room simulated the experience of walking across a bed of flowers (plate 5).

5. Section of encaustic floor made for the Palace of Westminster, designed by A.W. N. Pugin, c.1850. London, Victoria and Albert Museum.

The art critic and social commentator John Ruskin took this argument a stage further in his belief that the moral condition of a society could be understood by the character of its ornament and the means by which it was carried out. For Ruskin, gothic ornament of the medieval period possessed true moral fibre or integrity because it flourished as the expression of a true Christian religion and was produced by craftsmen who remained close to the direct inspiration of their sources in nature. They were free to experiment, even be self-expressive, with those sources. Hence Ruskin's opposition to what he called the 'wearisome exhibition of well-educated imbecility' of Renaissance ornament which depended for its effect on the repetition of motifs and appealed to the intellect rather than emotions of the beholder (plate 6).

Much 'deception' was indeed going on. Man-made materials could now fake the old and the rare. In the eyes of some writers there was a premium on goods still made of natural materials, such as wood. As the architect Le Corbusier was to summarize it in 1925: 'Previously, decorative objects were rare and costly. Today they are commonplace and cheap. Previously, plain objects were commonplace and cheap; today they are rare and expensive.'[3] Some people recognized that new materials should create their own vocabulary of style, indeed they often did so by their very use in the new objects of an industrialized society. As the painter Paul Gauguin observed in 1889: 'To the architect-engineer belongs a new decorative art, such as ornamental bolts, iron corners extending beyond the main line, a sort of gothic lacework of iron. We find this to some extent in the Eiffel Tower' (plate 7).[4] When, however, industrial products followed the tradition of earlier objects in having decorative surfaces and thus disguised their method of construction many critics were scornful of such practice. Already, a generation before the quotation from Le Corbusier cited above, architects such as Louis Sullivan in America and Adolf Loos in Austria were advocating the banishment of ornament altogether. They believed that the wide choice of revived styles had led to an application of them that was excessive and misunderstood; the only way to purge this was to refrain altogether. This position was supported by the new intellectual fashion for the human science of psychology which suggested that the human being's urge to ornament the body and the things around it was a primitive, irrational and indulgent desire that needed to be resisted.

The grammars of ornament of the nineteenth century have their counterpart in the many useful dictionaries of ornament published in more recent times. Equally, interest in the psychological interpretation of ornament has continued in an attempt to explain the

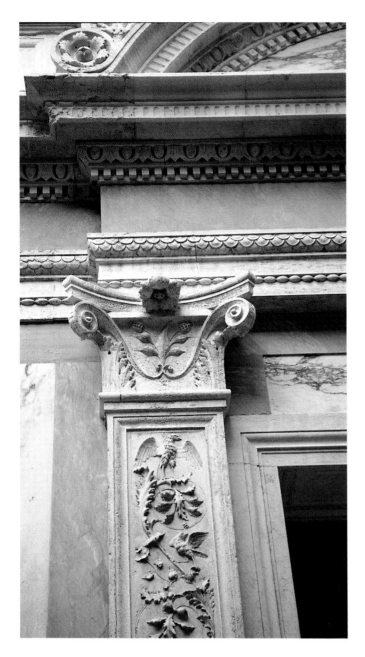

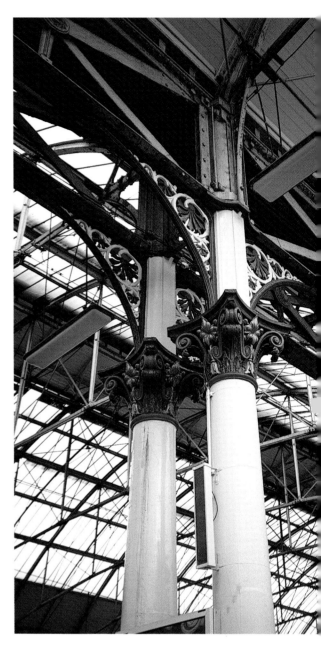

6. Detail of the south side of S. Maria dei Miracoli, Venice, by Pietro Lombardo, 1480s. An example of classical running ornament on a Renaissance frieze and entablature.

7. Detail of ironwork, Piccadilly Railway Station, Manchester, 1862.

seemingly irresistible urge of human beings to decorate the objects around them. This has led to many cross-cultural studies, equipped as we now are with greater knowledge of non-European civilizations, to ascertain in what ways the desire for ornament is common across the world and how it is determined by social and environmental conditions. The aim of the present book is somewhat different and, measured against the dictionaries which give comprehensive coverage and the books which offer psychological insight into the will to decorate, is more focused. It seeks to open up discussion of ornament in the area of what might loosely be defined as its social history in Europe since the mid-fifteenth century, explored through a series of thematic chapters. We can codify ornament on the one hand, listing and classifying its various motifs, and on the other we can attempt to explain the complex and abstract ways it reflects the workings of the brain. Somewhere between is the history of the use of ornament and of the contexts it inhabits and complements. Central to each of the themes of this book is the idea that there are known rules of what is and what is not appropriate or decorous in any given context. If rules are broken, then people choose to do that consciously; the very process of breaking rules emphasizes the fact that normally they are there.

The idea of rules, of the appropriateness of chosen forms of ornament to their context, is bound up with the legacy of the classical tradition in European art. This set the dominant standards of what was perceived to be correct forms of ornament through the wide availability of prints, both in illustrated books and in loose sheets, often sold in sets. Hence the book begins its discussion at a point in the middle of the fifteenth century when it became the self-appointed task of writers on art, at first from Italy and later from other parts of Europe, to stress the significance of the classical tradition as a way of raising the status of the visual arts in the context of wider intellectual debate. It was also the point at which the first printed books were about to change the reading culture of Europe. These events also explain why the book begins with debates about architecture and printed images. In architecture, classicism was felt to have its true roots not only because all the major characteristics of the classical style were first worked out in ancient times through buildings, but also because the surviving buildings of antiquity could be measured, drawn and lessons learned; the rules of the art of the classical past were felt to be inherent within them. Then through the wide dissemination of printed images of classical forms, a Europe-wide demand for certain kinds of ornament came into being.

From that basic starting-point there follow two chapters that explore ornament in the personal and domestic context through dress and the interiors of houses. In these two spheres, the personal interpretation of the rules of ornament in relation to prevailing social proprieties are constantly examined. Equally manifest in dress and interiors are the distinctions of class and gender that characterize society in both the European and the American tradition. Lastly, two chapters look at two further contexts for ornament that widen the debate in completely different ways. In Chapter 5, as opposed to the personal choice of clothes and the things we choose to create our home environment, we discuss how ornament has been used in the public world we are exposed to beyond our doors, in the world of religious ceremonial, of popular culture and corporate imagery. That is to say, we ask what is the nature of the ornament we share and understand in groups or which powerful institutional forces such as the Church, the state or multinational corporations, insist we share? In Chapter 6 we ask, how has the Eurocentric culture which forms the core of this book been changed by the impact of the ornament of non-European cultures? Has the reaction to these cultures simply been that of absorbing the ornament which is similar to European, or do these cultures always remain as a convenient contrast, a strange 'other' which underpins the notion that Europe is somehow 'normal' and 'modern'? Certainly in the great nineteenth-century grammars of ornament the desire to systematize the exotic in a way familiar to Western eyes is seen (plate 8). The ornament of India and China is illustrated in terms of phases of development (and, by implication, increasing sophistication) that parallel those of European ornament during the Renaissance. Grammars of ornament have also recognized that Europe has had its own distinctively 'other' culture, one of great visual richness, by their inclusion of the 'Alhambresque', a style which emerged in the Iberian peninsula during the Moorish occupation and took its name from the famous building in Granada.

8. Hindoo ornament, from Owen Jones, *The Grammar of Ornament*, 1856. London, Victoria and Albert Museum.

The systematization of styles that went on in printed sources extended to the ultimate source of ornament, nature itself. Plants and patterns found in all forms of natural vegetation were always a rich source of ideas. They had been used extensively in medieval decoration to celebrate, through the splendour of the natural world, the power of the divine, as in the famous leaves of Southwell that form the capitals to the colonettes in the chapter house of the Minster there (plate 9). Yet once again it was the coming of the printed book which extended the use of nature more widely; from about 1480, illustrated herbals, both drawing on and encouraging an interest in herbal remedies and gardens, offered a rich source of inspiration for decoration. Nature, however, was perceived more as the starting-point for ideas than simply a source to be used in its raw, unmediated state. Owen Jones wrote that 'flowers or other natural objects should not be used as ornaments, but conventional representations founded upon them sufficiently suggestive to convey the intended images to the mind, without destroying the unity of the object they are employed to decorate'.[5] We do indeed find that the great majority of natural patterns, such as sprigs or flowers decorating fabrics, are stylized by making the individual motif symmetrical or relating a series of identical motifs one to another in a way quite unlike their natural growth on bushes or trees (see plate 10).

The idea that human skill needs to adapt nature for the purposes of art ensured that ornament has had only a secondary place among the visual arts. Crucial to the development of painting, as propagated by writers and then by academies from the Renaissance to the nineteenth century, was that the judicious selection of the best in nature, beginning with the human body itself, was the path to perfection and the ultimate test of a great artist. Great history paintings recorded the highest human ideals and served as exemplars of human behaviour; they consequently dominated the intellectual high ground of the visual arts. By comparison, the decorative arts were secondary, at best only supportive, sometimes even superfluous; in an essay of 1892, the British illustrator, painter and designer Walter Crane complained about the assumption that decorative art 'belonged distinctly to a lower category, that its demands upon the mind, both of the artist and the spectator, were much less and … required less skill and power to produce than what is called pictorial art'.[6] In the late twentieth century, we have less faith in concepts of universal standards and qualities in art than a century ago. We are much more aware of the social contexts in which art is produced. The ornament of the public and private surroundings of people's lives is a key factor in our understanding of that social history.

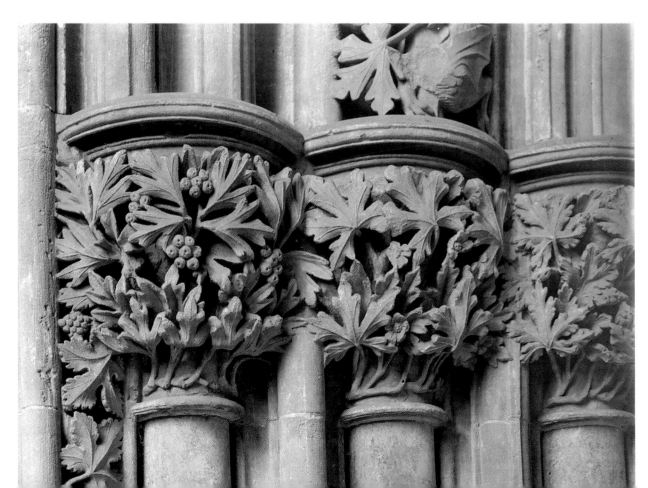

10. Coverlet with stylized lily, tulip and pineapple design. American (Pennsylvania) nineteenth-century. The pineapple was a symbol of hospitality. The American Museum, Claverton Manor, Bath.

9. Detail of capitals from the vestibule to the Chapter House, Southwell Minster, Nottinghamshire, *c.*1290.

1

Ornament and the Printed Image

Long before the invention of printed images, ornamental ideas were able to travel from medium to medium, across and between countries and continents and through time.[1] They were carried in the heads of architects and craftsmen, in drawings, especially those in craftsmen's modelbooks, and on artefacts.[2] The advent, in late medieval Europe, of prints on paper revolutionized this traditional process; henceforth printed images were to be the main channel for the motifs, ornamental compositions and design ideas that are put into their social context elsewhere in this book.

Printed images have the power to be both restricting and releasing. In some circumstances they can encourage uniformity, as is made clear in an Italian engraving warning against the dangers of independent invention (plate 11), yet on other occasions their potential as an unrestricted source makes them a natural and indeed the principal springboard for the development of design ideas. In tracking this process here, it will become clear that the places from which new design ideas first emerge are not necessarily those in which they receive their full development or widest distribution. Before 1800 the story is often the progress of a style from the closed world of the courts, with their exclusive artist or architect designers, to that of the great mercantile cities, with their craftsmen and prolific print publishing houses. The evidence and chief agent of this process was the type of print now known as engraved ornament, or the ornament print.[3]

The ornament print

Today, thousands of ornament prints lie carefully preserved as single sheets, in sets and in bound volumes in the print rooms and libraries of the world.[4] Although many are now admired as works of art in their own right, their original function as design resources in craftsmen's

11. Title page to a set of Italian jewellery design prints, c.1750. Anonymous engraving after a drawing by GC and an idea by DMT. The text reads: 'anyone who believes he can invent is certain to make a mistake, but he who studies does not labour in vain'. London, Victoria and Albert Museum.

workshops have made many far rarer than most fine art prints. By the time Adam Bartsch compiled his great catalogue of European (excluding French) prints, published between 1803 and 1821,[5] certain older examples of engraved ornament, for reasons described below, had a firmly established place in the history of European printmaking. A more design-based approach was taken by the new museums of the decorative arts, beginning with the Museum of Manufactures, the ancestor of the Victoria and Albert Museum, founded in 1852. Their comprehensive collections, often kept in libraries together with printed books, were valued both as histories of style and as exemplars for modern craftsmen and designers (plate 12). In organizing and cataloguing these collections the full range of ornament prints was revealed. The standard catalogue, that of the Kunstbibliothek in Berlin,[6] makes a fundamental distinction between ornament prints for general use and more or less specialized prints intended for particular trades and professions (although, as we shall see, this distinction was often ignored by the users of such prints). In the latter, which are more numerous than pure ornament prints, lie the origins of engraved ornament and indeed of engraved prints in general.

12. Plaque after an engraving by Lucas van Leyden dated 1528. Porcelain, painted by Alexander Fisher of Stoke on Trent, 1865. Made for a Society of Arts competition, in which craftsmen were set to reproducing the Lucas print (or a photograph of it) in a variety of media. London, Victoria and Albert Museum.

109

Kelly
on Spoons &c
June 4. 1836

R Bynold Esq
on Fish Knife
June 2. 1836

L. Lonsdale
on Dining S Handles

Alexander
on 2 Chamb: Candles
1 June 1836

on Waiter
Their Majesties
May 30. 1836

on Soup Tureen
Lord Lonsdale
May 31. 1836

on Cover &c

Barrow
on Sugar Tongs
June 1. 1836

Ornament and the first European prints

Although paper was being made in Europe by the late thirteenth century it was probably not until the 1380s that it was used for prints. These employed the woodcut technique, which had been used for centuries for printing patterns on to textiles.[7] Interestingly, in spite of technical precedents in the decorative arts, these early woodcuts largely ignored ornament, being chiefly restricted to inexpensive images for religious devotion. This was perhaps because they were originally made by wood carvers, who would have had no use for such textile patterns in their own workshops. In goldsmiths' workshops, however, it is probable that the technique of taking impressions on paper from the incised decoration on metal, well attested later (plate 13), had early been recognized as a means by which ornament could be recorded and passed on.

Whatever the initial trigger may have been, it is certain that the first prints taken from inked engraved metal plates emerged from German goldsmiths' workshops in the 1430s, rapidly followed by similar prints made in the Netherlands.[8] Most of these early northern engravings consisted, like the woodcuts, of religious scenes, the figures often almost embedded in minutely delineated decorative settings of architecture and plants which betray their origins in the goldsmith's workshop. They also included playing cards, animals and birds, and the first ornament prints. Among the earliest is a set of panels by the goldsmith Israhel van Meckenem the Elder, and a circular print dated 1466, probably a design for a metal paten for the mass, by the Master ES, a goldsmith of Swiss origin who introduced printmaking on a large scale to northern Europe (plate 14).

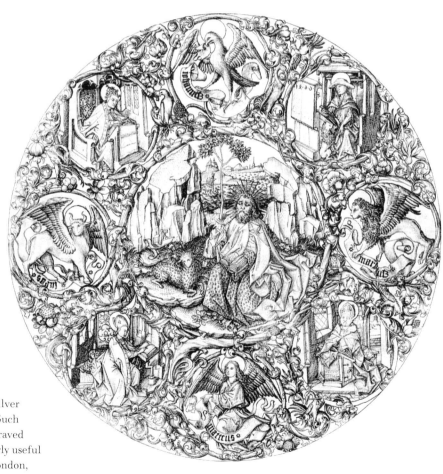

13. Page from the pattern book of the silver engraver Samuel Jackson, dated 1836. Such pattern books of inked 'pulls' from engraved crests and coats of arms were particularly useful as a record of work for repeat orders. London, Victoria and Albert Museum.

14. St John the Baptist, the Church fathers and symbols of the Evangelists, probably a design for a paten, 1466. Engraving by the Master ES. London, British Museum.

A design revolution

These images of Gothic figures and foliage were, in the words of William Ivins, 'the first exactly repeatable pictorial statements that were to intended to provide ideas or information that could be put to work',[9] and as such are of the profoundest significance for the development of Western science and culture. Before the coming of prints design ideas could only be recorded and transmitted through carefully executed drawings (sometimes collected together in the form of pattern or model books),[10] by copying actual objects, or through such direct methods as templates and casting models. By the middle of the sixteenth century printed images had become the key to the rapid dissemination of ornamental styles and the standardization of styles within certain trades. While the ornament prints of the early northern goldsmith-engravers may originally have been intended for their own trade, they were mostly generalized enough to be rapidly adopted as models for ornament on other types of object; Israhel van Meckenem the Elder's panels were, for instance, copied both on stoves and on carved panelling.[11]

Far more influential, however, perhaps because of their much greater numbers, were the prints of figure scenes and animals. The flowers, wild men, birds and animals on the cards of about 1440 by the Master of the Playing Cards were repeated on illuminated manuscripts (by about 1454),[12] bookbindings and stained glass, no doubt assisted by the fact that in about 1450 the printing plates were cut up and reassembled in a manner more useful to those looking for models.[13] Master ES's very large output of figure scenes and playing cards was also used for bookbindings, as well as by painters, embroiderers, carvers and metalworkers all over Europe. The demand for these images is attested by the wholesale copying of prints by other engravers; 90 per cent of the over 620 engravings made by Israhel van Meckenem the Younger between the 1460s and about 1500 were copied from those of others. Such plundering became characteristic of the print trade and of the use of printed images of all types in architecture and the applied arts, blurring in practice the Berlin catalogue's distinction between specialized images and those intended for more general application.

15. A reliquary, *c*.1484. Engraving by Alart Duhameel. Paris, Musée du Louvre.

Only the most apparently trade-specific prints, such as the impressive later fifteenth-century images of church silver, would seem to have been immune from this cross-fertilization of ideas, but even these present problems of use and interpretation. An engraving by Netherlandish architect and sculptor Alart Duhameel (c.1449–1509) (plate 15) shows a reliquary at full size (1,097 millimetres high) together with a detailed partial plan at a smaller, indicated, scale, closely resembling the handling and layout of contemporary silver designs and architectural drawings. The lettering suggests that the print records a design for a reliquary made in 1484 for the church of Saint John at Hertogenbosch,[14] but given the dominating architectural style in this period such a print could have been used for details of woodwork and architecture as well as by goldsmiths.

More difficult questions arise over such images as the prints of a censer (c.1475–80) (plate 16) and a crozier (c.1480–90) by Martin Schongauer, the first northern European engraver to approach printmaking in painterly terms. Their illusionism and dense shadows, Schongauer's key technical innovation, separate them from other prints of church silver and make them look like representations of existing objects rather than designs. They seem not to have been used directly by craftsmen, unlike Schongauer's figure scenes, which were not only very widely copied by other printmakers but resurfaced on silver, textiles, sculpture, Italian maiolica and Limoges enamels, or his foliage prints, used by contemporary wood carvers, nor do they appear, as might have been expected, in the work of contemporary painters. Although the workshop of the Basel goldsmith family of Schweiger contained impressions of the crozier and censer, it was the Schongauer prints of the Agony in the Garden and the Christ taken prisoner which were used to decorate a pax.[15] On the other hand, the suggestion that they were made by Schongauer to develop his own artistic ideas does not easily fit with the economic realities of the engraving trade.

Early ornament prints in Italy

In Italy the earliest surviving engravings were made in Florence, probably towards the end of the 1440s. As in northern Europe, figurative subjects predominated, except that in Italy they were largely secular. This humanist emphasis was also reflected in Italian printed ornament, which from the beginning employed the antique motifs that had become firmly established in Florentine architecture and ornament by the 1450s. As ambassadors of Renaissance decoration, Italian ornament prints of the next hundred years or so were to have an influence out of all proportion to their small number

relative to those made north of the Alps. The first surviving prints, made in the 1470s, are also the earliest certain examples of printed ornament designed to be cut out and pasted to objects as decoration. One group of Florentine engravings, attributed to Baccio Baldini, was for pasting to circular boxes,[16] while another, by Francesco Rosselli, consists of candelabra and borders, often found hand-coloured, for framing figurative prints, including a cycle of the Life of the Virgin and of Christ.[17] Baldini was a goldsmith but Rosselli was a miniature painter, whose decorations on illuminated manuscripts were in the same antique style as his printed borders.

16. A censer. Engraving by Martin Schongauer, c.1475–80. London, British Museum.

Book decoration and antique ornament

In northern Europe the ornamented letters, decorations and illustrations of illuminated manuscripts had been reproduced in printed form almost as soon as metal type was introduced in the 1450s. From that date, the woodcut illustrations and decorations of books, which until the middle of the sixteenth century probably had longer print runs and better distribution systems than those for separate prints,[18] became a major conduit for the transmission of design ideas. Only with the emergence of the first big print publishers and the abandoning by book publishers of cheap woodcuts in favour of expensive engravings did the balance in printed images pass from the book to the print trade.

The first firmly dated print of antique ornament is a decorated woodcut title page of 1476, designed and cut by immigrant Germans working in Venice (plate 17). Its rising candelabrum ornaments imitate the borders of Italian illuminated manuscripts, in turn derived from the decorations of architectural pilasters. By the 1490s the idea had been elaborated by Venetian publishers into a type of decorated page border which helped to export north Italian Renaissance ornament to the rest of Europe and was copied for what can be claimed to be the first dated northern print in the new style, a German book decoration of 1508.[19] Probably of about the same date is a set of pilaster candelabrum ornaments designed and partly engraved by Giovanni Pietro da Birago, who had been decorating illuminated manuscripts with similar architectural motifs since the 1470s (plate 18). Birago's prints may have reached Nuremberg by 1508; they were certainly in France by about 1510 when they were copied in woodwork in the Château de Gaillon, a pioneering building in the new style partly executed by Italians, who may have brought such prints with them.[20]

An explosion in print production

The introduction of the antique style to the north in about 1500 coincided with the start of an explosion in the production of ornament prints, which in the next fifty years saw the emergence of all the main types of print as well as the systems to market them. One of the reasons for such an explosion must lie in the nature of antique decoration. Unlike the organic late Gothic style which it gradually supplanted, classical ornament was part of a formal system which could easily be broken down into standard components and motifs, ready for reassembly. Not only did they include the parts of the classical orders, but also elements separated out from architectural decoration, including 'pure' ornament such as candelabrum pilaster panels, palmette, acanthus, Greek key, and Vitruvian scroll borders and ornament derived from figures and actual objects such as masks, rosettes, paterae, festoons, trophies and vases. Also included were motifs of modern invention but incorporated into the classical system, such as cartouches and balusters. The isolation of these elements, handily framed in printed and drawn images, not only encouraged their separate development, often leading them far away from their classical origins, but also greatly facilitated their use on objects other than architecture. Both tendencies greatly encouraged and were encouraged by the production of orna- ment prints.

Another likely factor in the increase in ornament prints in about 1500 was the changing nature of patronage. The great courts were the centres for crucial developments in design and ornament, which less innovative establishments were able to keep up with by employing (or poaching) peripatetic artists, architects and craftsmen. At the top end of the scale were such major figures as Hans Holbein, Sebastiano Serlio and Benvenuto Cellini; perhaps more typical were minor figures such as the painter Jacob Binck, born in Cologne in about 1500. He was a court painter in Copenhagen in the 1530s, subsequently working in Sweden and in Königsberg for Duke Albrecht of Prussia, as well as visiting Antwerp to order tombs for the Danish court. He was also a prolific engraver, producing many figure subjects and about fifty-one prints of ornament, many of them pirated from the prints of others.[21] The latter were almost certainly not aimed at the courts but at craftsmen and artists supplying the merchant class, an increasingly important source of patronage. This idea seems to be supported by the tendency for a burst of engraved ornament to appear after, rather than during, the birth of a style in a court centre, such as the mid-sixteenth-century French and Flemish prints in the Fontainebleau style of the 1530s or the French prints of the late seventeenth century inspired by slightly earlier models from Versailles.

While it is interesting to speculate on the reasons why most ornament prints made between 1500 and 1550 are German it would probably be wrong to deduce that the German merchant classes were more influential or wealthier than those in other countries. In England, also a country of merchants, the great scarcity of home-grown printed ornament was made up before the middle of the eighteenth century by the importation of foreign prints but perhaps more significantly by the presence of foreign craftsmen. In sixteenth-century London the goldsmithing trade contained a large number of Germans and Flemings, whose styles were adopted wholesale.[22] This tendency of craftsmen to travel, either as journeymen or masters, encouraged a uniformity of design in certain types of object, such as jewellery in the sixteenth century.

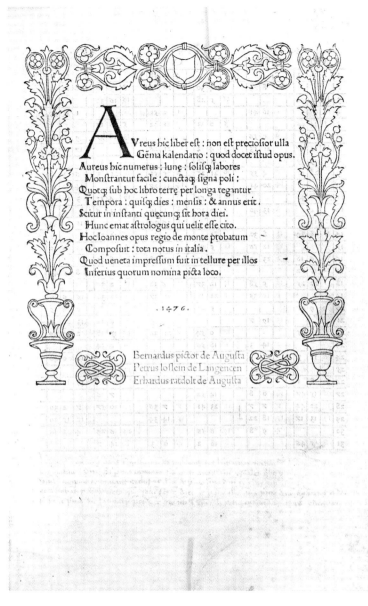

17. Title page from Regiomontanus (Ioannes
Müller), *Calendarium*, published in Venice by
Pictor, Loslein and Radtholt in 1476. Woodcut and
metal type. New York, Pierpont Morgan Library.

18. Plate from a set of prints of candelabrum
ornament, engraved by Giovanni Antonio da
Brescia following a design by Giovanni Pietro
da Birago, *c*.1505. London, Victoria and Albert
Museum.

Italian ornament in Germany

In Germany the ground had been prepared for the arrival of Italian ornament prints by the Renaissance architecture and decorative elements in the great propaganda woodcuts made for the Emperor Maximilian, notably the *Triumphal Arch* designed in 1515 by a number of artists in Augsburg and Nuremberg, including Albrecht Dürer. The example of Dürer, the greatest engraver who has ever lived, established printmaking as the work of artists rather than goldsmiths.

The first German ornament printmaker to use the Renaissance style, Daniel Hopfer of Augsburg, was a painter, although he also carried out the etched decoration on armour. His ornament prints, taken off acid-bitten steel plates like his armour, were probably the first etchings.[23] Almost all of them are indebted to prints by others, including those of Giovanni Pietro da Birago, and Nicoletto da Modena, but their characteristic feature is the frequent combination of Renaissance and Gothic elements. Made from about 1500 (he died in 1536), they also extended the range of ornament print subjects to new areas, including furniture (a bed or cupboard dated 1527), interior decoration and fittings (ceilings, wash basins and towel rails), church fittings (tabernacles and altars) and daggers, at that time a significant item of male adornment. This was the start of a great increase in the types of ornament print, and was followed, in about 1525, by the first designs for secular goldsmiths' work (by the painter Albrecht Altdorfer). Hopfer's practical approach is demonstrated in a square design which shows eight variations in one image, probably the first example of this economical and later much-used method of designing ornament prints (plate 19).

Dürer's influence was particularly strong on a number of German printmakers, including Jacob Binck, who are now usually grouped together as the 'little masters' because of the generally small size of their prints.[24] In fact some were personally known to each other and their habit of copying resulted in the emergence after about 1520 of a coherent group of prints in a unified style, the first in the history of engraved ornament, in which Italian ideas were tamed into useful ornamental formats. Figures in Mantegna's famous print of *The Battle of the Sea Gods*, engraved in the 1470s and drawn by Dürer in 1494, inspired a wallpaper frieze by Hans Sebald Beham[25] as well as an ornamental panel dated 1537 by the Master CG, whose source was probably Beham rather than Mantegna.

19. Eight variations of ornament in one print, *c*.1520–36. Etching by Daniel Hopfer. London, Victoria and Albert Museum.

20. Design for black-on-white embroidery, *c*.1523. Woodcut from Johann Schönsperger, *Furm- oder Modelbuchlein*. New York, Metropolitan Museum of Art.

The emergence of the set: textile pattern books

The patchy survival of early ornament prints makes any assessment of their methods of production and distribution very difficult, if not impossible, to determine. It seems likely, however, that in spite of the example of drawn craftsmen's modelbooks, they were issued as single sheets, struck off as required by an engraver engaged in the production of various types of print, rather than as 'pattern books'. Such 'books' were not, of course, bound books in the modern sense but sets of prints sold loose, or lightly held together by temporary stitching. The production of ornament prints in groups must have been encouraged by the introduction of sets of figurative prints with title pages, such as Dürer's *Apocalypse* of 1511, but like other types of print set they did not really take hold until the emergence of specialist engravers and print publishers towards the middle of the century.[26] In fact the earliest titled sets of ornament prints were closely linked to the book trade, which frequently sold prints as well as books.[27]

The first such set, Johann Schönsperger the Younger's *Furm-oder Modelbuchlein* ('little shape or pattern book') published in Augsburg in about 1523, was the product of rather particular circumstances. Containing twenty-four plates showing highly specialized geometrical and foliate designs for black embroidery on white collars and cuffs, it was probably inspired by Schönsperger's experiments with printing designs on textiles, combined with his experience as the son of a book publisher (plate 20). Significantly, it was aimed not at professional embroiderers, who would presumably already have a stock of designs, but, like most textile patterns since, at female amateurs, who could directly trans- fer the patterns to the cloth by pricking through with a pin, eventually resulting in the destruction of the book. They were also provided with several blank pages at the end of the book on which to draw their own designs.[28]

The success of Schönsperger's *Modelbuchlein* led him to publish another in 1524, which was rapidly followed by a flood of little books published (with many reprints) chiefly in Venice, but also in Augsburg and Lyons, for embroidery, cutwork (from 1542) and lace (from 1557). The patterns were often ruthlessly pirated from those in other model books, indicating a large and widespread market. The designers, who in at least two instances were manuscript illuminators, also took their designs from other printed sources, including an Italianate ceiling design by Daniel Hopfer. The first Italian

embroidery book, Giovanni Antonio Tagliente's *Essempio di recammi* published in Venice in 1527, copied a number of plates from Schönsperger but was also genuinely innovatory in including the first printed examples of Islamic interlace patterns.[29] Although the 'belle e virtuose donne' (beautiful and virtuous women) to whom these model books were commonly addressed must have remained their main market, the patterns were on occasion used elsewhere, a possibility anticipated in Giovanni-Andrea Vavassore's *Corona di racammi* of 1530 which is also addressed to goldsmiths and painters. Tagliente's interlace Moresques, which were repeated in several editions and extensively copied, were used for decorated bindings ordered by the great Parisian collector Grolier.

German pattern books
and the uses of printed ornament

Although the painter Albrecht Altdorfer had produced a set of designs for secular silver cups in about 1525 (later copied by Jerome Hopfer)[30] it was not until about twenty years later that the first set of goldsmiths' designs with a title appeared. The thirty-nine clearly designed woodcut plates in Hans Brosamer's widely influential *New Kunstbuchlein* ('new little art book') added the first printed designs for jewellery to the usual late Gothic and Renaissance cups.[31] Its title and format link it both to the textile pattern books and to a tradition of craftsmen's model books still very much alive when it was printed.

Heinrich Vogtherr the Elder's *Kunstbuechlin*, first published in Strasbourg 1537 (with seven editions in German, French and Spanish before 1556), was a sign that the use of ornament prints had become sufficiently widespread to justify the production of a set of patterns aimed at a varied audience and that such prints enabled artists and craftsmen to respond to changing styles and market situations. Its fifty-one woodcut plates were, in effect, a compendium of Renaissance ornamental motifs, including arms and armour, head-dresses, cartouches, capitals, column bases and candelabra. The images are broken up into useful parts and are shown many to a page, strongly recalling the layout of artists' or craftsmen's model books (plate 21).

The *Kunstbuechlin* was the first pattern book to give, in title and text, a clear idea of its market and, almost uniquely, the reasons for its production. Fully translated its title reads: 'A new and wonderful little art book such as has never been seen by anyone or published; very useful for painters, wood carvers, goldsmiths, stone cutters, carpenters, armourers, and cutlers.'

In the short introduction Vogtherr goes on to explain further:

Because the Good Lord, through Divine Ordinance, has brought about a marked reduction of all ingenious and liberal arts here in Germany, causing so many to turn away from art and try other trades, that in a few years painters and woodcarvers would seem to have all but disappeared. To prevent painters, goldsmiths, silk embroiderers, stone carvers, cabinet makers, and so on from giving up and tiring, I, Heinrich Vogtherr, painter and citizen of Strassburg, have assembled an anthology of exotic and difficult details that should guide the artists who are burdened with wife and children and those who have not travelled. It should store stupid heads and inspire understanding artists to higher and more ingenious arts until art comes back to its rightful honour and we lead other nations.[32]

Vogtherr's call to raise the quality of German art is a curious anticipation of the views of British design reformers of the 1830s and 1840s. Indeed, the *Kunstbuechlin*, with its anthology of motifs, prefigures the encyclopaedias of ornament promoted by the later reformers. This nationalistic message apart, his introduction perfectly expresses the role of printed design and ornament right into the nineteenth century. Lesser craftsmen ('stupid heads'), economically burdened, unable to travel and lacking the time or ability to produce their own designs, were nevertheless in constant need of new and fashionable design ideas. For them printed ornament provided the perfect quick fix. More able craftsmen ('understanding artists'), used printed ornament for inspiration in their own designs, but only indirectly.

21. Page from Heinrich Vogtherr, *Libellus Artificiosus*, 1540, a reissue of woodcut illustrations originally made for *Ein frembds und wunderbars Kunstbuechlin*, first published in 1537. The page shows varieties of armour. London, Victoria and Albert Museum.

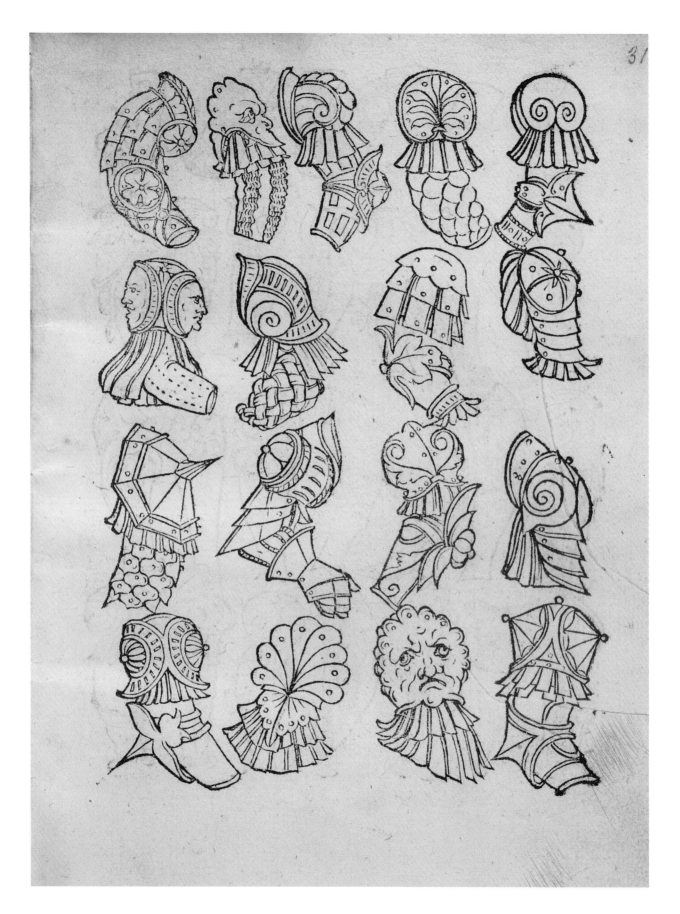

Italian ornament prints and the architectural book

Italian ornament prints, with their 'exotic and difficult details', so avidly studied by Vogtherr and other German printmakers, were crucially different in their approach from those of the north. Apart from textile model books none were addressed to particular trades and all were concerned with Renaissance and classical ornament and architecture. In 1528 Sebastiano Serlio, with Agostino Veneziano as his engraver, revolutionized architectural publications in a set of prints which for the first time illustrated the bases, capitals and entablatures of the antique Doric, Ionic and Corinthian orders in a clear, systematic and reliable way.[33]

Seven years earlier Cesare Cesariano's Italian edition of Vitruvius, published in Como, had become the first accessible translation of the only architectural text to survive (unillustrated) from antiquity as well as the first printed architectural book to be illustrated.[34] Unlike Serlio, however, the 110 highly decorative woodcut plates showed not ancient examples, which were unavailable to Cesariano, but modern Renaissance architecture. It was left to Serlio himself to combine text and pictures in the first comprehensive illustrated architectural treatise, published in six books between 1537 and 1551.

The first volume to be published, (actually the fourth book), contained not only the earliest illustration of the orders as a complete and authoritative series but also plates showing Serlio's own decorations for ceilings and woodwork (plate 22). Serlio's treatment of modern as well as ancient architecture helped to make his treatise the most influential architectural publication of the next 150 years. As the books appeared they were rapidly translated, without permission, into Dutch, German and French by the Antwerp publisher Pieter Coecke, who carefully reproduced the illustrations. Fourteen of Serlio's plates were also copied by Walther Hermann Ryff for the first German translation of Vitruvius, published in Nuremberg in 1548 with the stated aim of making Vitruvius accessible to craftsmen. The 193 woodcut illustrations were also taken from a wide and revealing range of other sources, including Cesariano, which provided most of the plates, a Paris edition of Vitruvius, prints in the famous Italian dream book *Hypnerotomachia Poliphili* and engravings by Agostino Veneziano and Marcantonio Raimondi.[35]

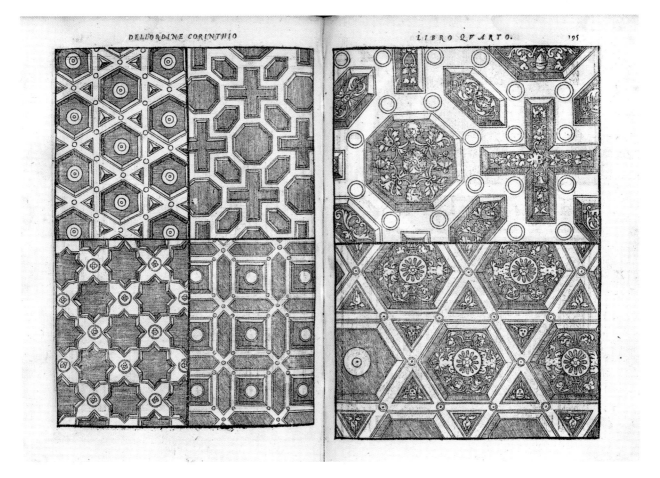

22. Patterns for ceilings and woodwork, 1537. Woodcut illustrations from *Regole generali di architettura*, book IV of Sebastiano Serlio's architectural treatise. London, Victoria and Albert Museum.

23. Vase, 1531. From a set by Agostino Veneziano engraved in 1530 and 1531. This print is from a mid-sixteenth-century reissue published by Antonio Salamanca. London, Victoria and Albert Museum.

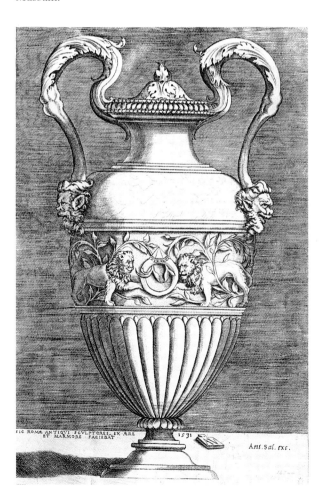

The spread of antique themes: the archaeological vase

The prints being made in Rome by engravers like Agostino and Marcantonio were at least as important in promoting Renaissance and classical ornament as architectural books. Produced in a tourist centre which both led modern design and was the main source of ancient exemplars, these engravings lie at the root of the spread of such motifs in prints made across Europe for the next two and a half centuries.[36] Among these prints the two most significant categories were those showing vases and those showing grotesques, but their treatment and effects were fundamentally different.

Ancient vases, whether made of pottery, glass, bronze or stone, were as much symbols of antiquity to the Renaissance as columns and capitals, and in a sense were even more meaningful, as they had no equivalent in the medieval world. As an immediately identifiable 'universal vessel', the message of the vase form's antique origin was able to survive both extreme changes of style and the transition from the three dimensions of its origins to the two dimensions of flat decoration.[37]

The earliest set of vase prints was engraved by Agostino Veneziano in Rome in 1530 and 1531 (plate 23).[38] Although the Latin inscriptions on the prints, 'In this manner the ancient Roman sculptors used to make in bronze and marble', make a claim for their archaeological accuracy, as does their illusionistic presentation, many incorporate details, especially in the handles, which are clearly modern. In fact most antique remains were, and are, fragmentary. In completing and arbitrarily reinterpreting the ancient specimens on paper Agostino was doing no more than he had done in engravings of other classical remains, or than contemporary Roman restorers of actual antiquities and statues were doing.

Some of Agostino's prints were copied in Enea Vico's vase engravings of 1543, and they also inspired Vico's illusionistic presentation and lettering: 'From Rome drawn from the antique'.[39] In terms of invention, however, Vico is considerably in advance of Agostino, adding fashionable Mannerist elements to create vessels quite unlike those of antiquity (plate 24). The disjunction between the style of the vases and the inscriptions, which may have been evident to knowledgeable people in Rome, would not have been noticed by others. Indeed, the tone of the legitimizing inscriptions, with their emphasis on Roman antiquities, suggests that these prints, like so many in sixteenth-century Rome, were chiefly aimed at tourists and other foreign markets.

Their effect outside Italy was greatly increased by the publication of a large set of etchings of vases and other vessels by the French architect Jacques Androuet

24. Vase, 1543. From a set engraved by Enea Vico. London, Victoria and Albert Museum.

25. Vase, c.1550, its design adapted from a print by Enea Vico. From a set etched by Jacques Androuet Ducerceau. London, Victoria and Albert Museum.

26. Vases in a Roman landscape. Engraving, perhaps by G.C. Cimmert, from Joachim von Sandrart, *Der Teutschen Academie*, volume II, 1679. The vase on the far left is taken from Enea Vico, and two on the right from Vico and Agostino Veneziano; the large central vase is adapted from Polidoro da Caravaggio. London, Victoria and Albert Museum.

Ducerceau, who is supposed to have visited Rome in 1533 and after 1544.[40] Ducerceau's prints (plate 25) took images from both Agostino's and Vico's sets and reduced them all to the same format. This crucial shift, which involved a reduction and standardization of scale and a change in the quality of line and viewpoint, had the effect of turning an apparent archaeological record into images of immediate use to craftsmen, a process aided by various subtle alterations and refinements in design. Whether seen in Ducerceau's set or from reprints of the original issue, Agostino's and Vico's forms had a direct influence on sixteenth-century goldsmiths' work, including a London-made ewer of 1583–4.[41]

An illustration in Joachim von Sandrart's *Teutsche Academie* ('German Academy'), published in Nuremberg in 1679, shows that a hundred years later these prints had lost none of their power as representations of ancient objects (plate 26).[42] Arranged before a contemporary view of the ruined palaces on the Palatine hill is a group of vessels. All of them are taken from sixteenth-century prints, two of them from Vico, but not via Ducerceau. They are accompanied in the text by a short poem praising their great age, elegance of design and the skill and taste of their makers. As Sandrart was aiming to supply models for painters rather than craftsmen, some of the vases are shown in a convincingly broken and incomplete state, linking them to the ruins behind. Ironically, the fragmentary Vico vase has lost its body, the only part of the vessel which would now be regarded as reasonably close to the antique.

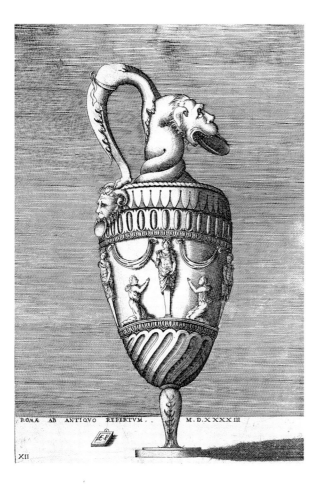

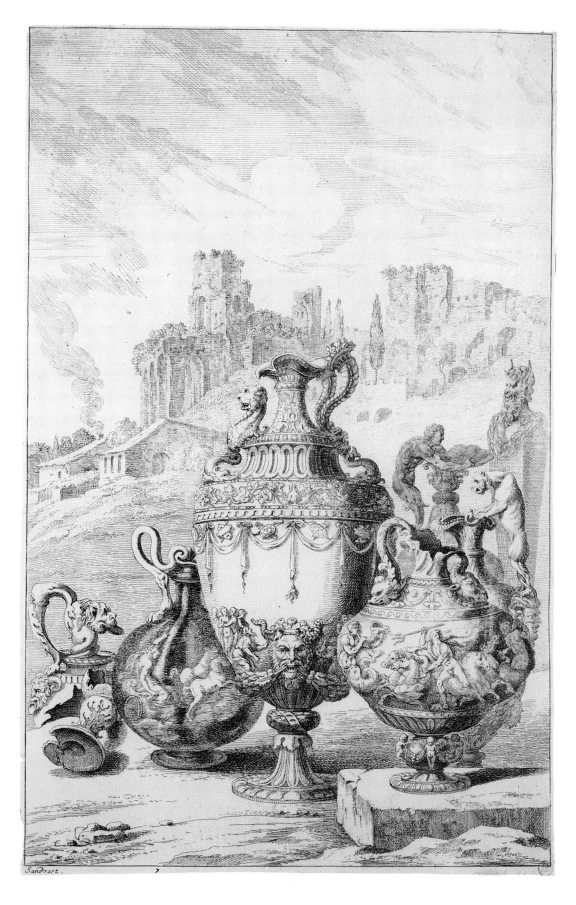

Sandrart.

7

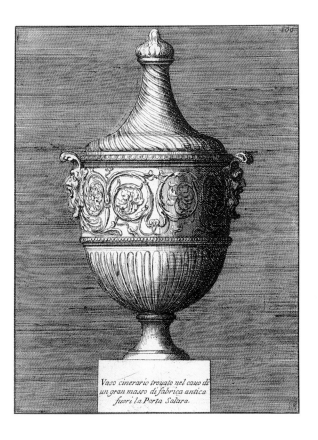

It was not until twenty-five years after Sandrart that Pietro Santo Bartoli put together in Rome the first large group of accurate representations of antique marble vases (plate 27),[43] which also carried with them information on their find sites, as part of a larger work on antique tombs. Like the vases of Vico and Agostino they became a standard treatment of the subject and were not only repeatedly reissued in Rome (in 1704, 1727 and 1764), but were also copied in Leyden in 1728 and in numerous archaeological works. The initial effect of these truly archaeological prints on the world of design was limited to architectural and garden urns and exercises of virtuosity in ivory (plate 28). After about 1750, however, the 'vase mania' of neo-classicism turned such archaeological publications into pattern books, leading not only to reissues like the Santo Bartoli of 1764 but also to new works like Sir William Hamilton's illustrated publications on Greek ceramic vases, one of the stated aims of which was the provision of models for artists and craftsmen.

The spread of antique themes: the imaginative vase
Ornament prints played a different role in the vase designs of another artist working in Rome, Polidoro da Caravaggio. Never a printmaker, Polidoro was a decorative painter who, in the 1520s, executed number of murals on the façades of Roman buildings. Composed of illusionistic classical figure scenes, trophies and vases, they were not only highly visible but also revolutionary in design. Most remarkable were the vases painted on the Palazzo Milesi shortly before 1527, which Vasari, even though accustomed to the distortions of later Mannerist design, described as being 'so curiously wrought that it would be hard to find anything more beautiful or novel'.[44] Perhaps because they had no need even to pretend to archaeological correctness, Polidoro's vases carried fantasy a good deal further than those of Agostino or Vico.

27. An ancient Roman cinerary urn found in a tomb on the Via Appia Antica in Rome. Engraving by Pietro Santo Bartoli from *Gli Antichi Sepolcri, overo Mausolei romani ed etruschi, trovati in Roma, ed in altri luoghi celebri*, 1697. London, Victoria and Albert Museum.

28. Vase. French, probably made in Dieppe, early eighteenth-century. Ivory, with a silver knop. The handles and the base are later additions. London, Victoria and Albert Museum.

The vases rapidly became famous and were drawn by many artists in Rome. By 1544, versions had appeared in a Roman set of prints and some of the designs reached France in the middle years of the century through interpretations by Ducerceau and René Boyvin. It was not, however, until 1582 that the first set of prints dedicated to them alone appeared, engraved by Cherubino Alberti in Rome.

The Palazzo Milesi vases, being on the second floor, were accordingly severely distorted so that they would read correctly from below. Unlike the earlier printmakers, Alberti made no attempt to correct the distortions. Shown in their distorted form but viewed from straight ahead (plate 29), the striking boldness and complexity of Polidoro's ideas was considerably increased, setting in train a long series of reissues, copies and other versions. Alberti's set was reissued in 1628, but it had meanwhile been copied line for line (but in reverse) by Aegidius Sadeler in Prague in 1605 (reissued by Marcus Sadeler). Other reversed copy sets of Alberti included examples published in Paris and London in the eighteenth century, and a number of Alberti-inspired vases were shown against landscape backgrounds in a Roman set of 1713, reissued in 1719. In 1658 redrawn versions of the vases appeared in a Roman series showing all the Palazzo Milesi decorations, which were reissued in 1660 and about 1690 and copied in a set under the name of Robert Adam in 1821.

Although prints after Polidoro's vases led to many imitations in metal, stone and ceramic, including eighteenth-century porcelain (plate 30), their strongly pictorial presentation and picturesque shapes made them equally or perhaps more influential as a source of motifs and pictorial props for decorative and easel painters, including artists like Sir Joshua Reynolds and, much later, Cézanne.[45] Their most important effect, however, was to license the distortions, rearrangements and additions to the classical language which characterized the increasingly bizarre baroque and rococo vases conceived in the hundred years after about 1660. Essentially pictorial like the vases of Polidoro, these reached their fullest expression in paintings and in prints. The prints especially, with their low viewpoints, monumentality and dramatic lighting, clearly betrayed their debt to Polidoro.

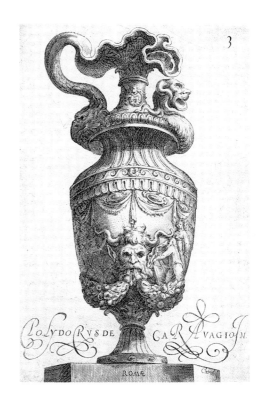

29. Vase, 1582. From a set engraved by Cherubino Alberti, after a fresco by Polidoro da Caravaggio on the external walls of the Palazzo Milesi, Rome. London, Victoria and Albert Museum.

30. Vase, c.1775. Porcelain, made by the Derby factory. London, Victoria and Albert Museum.

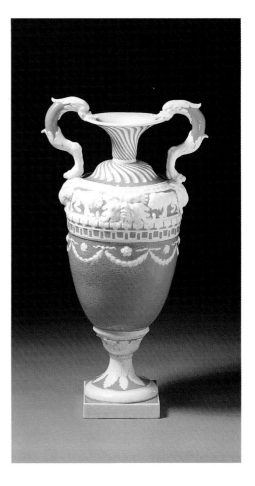

Prints and the spread of antique themes: the grotesque

Between 1518 and 1520 Polidoro was one of a number of artists working under Raphael on the painted decoration of the loggias, or covered arcades, in the Belvedere court-yard of the Vatican in Rome. Raphael's scheme, princi-pally carried out by Giovanni da Udine, organized the ancient Roman decorative system known as the grotesque into a usable form, establishing it as the basis of European surface ornament until the nineteenth century.[46]

As an ornamental system the grotesque was uniquely adapted to change and development; indeed, beyond the necessity for a framework filling the space, it positively invited invention. Vitruvius had already recognized this in his attacks on the original Roman grotesques, pointing out their lack of scale and logic and distortion of architectural elements. The grotesque was, in effect, a necessary counterpoint to the strict systems of trabeated classical architecture, inviting healthy rule-breaking while always being linked to its ancient origins.

In 1507 the painter-engraver Nicoletto da Modena scratched his name on the walls of the Domus Aurea, the Golden House of the Emperor Nero. Buried and lost for centuries under the Baths of Trajan, the painted and plaster decorations of these cave-like rooms or *grotte* had not only, by 1502, given the Roman form of decoration its modern name but were among the first and most important sources of that ornament. The earliest modern use of the grotesque was, appropriately, in mural decorations painted by Bernardino Pintoricchio in the 1480s, which by about 1510 had been imitated by painters of maiolica (plate 31). The first printed grotesques, engraved by Nicoletto da Modena probably about the time of his visit to the Domus Aurea, record this early type (plate 32). Its structural framework, which is partly derived from the candelabrum ornament in use since the 1460s, supports and has suspended from it a weird collection of fantastic and other figures from classical mythology, baskets, candelabra, musical trophies and other motifs which densely fill the space. Although considerably different in character from the light and open Roman model, the figurative and decorative elements of this early grotesque significantly incorporate a serious classical theme: the flourishing of the arts under the Emperor Augustus. This type of Roman grotesque print had an almost immediate influence in Italy as well as the rest of Europe, particularly in Germany. The Nicoletto engraving, which is from a set of four, was copied in 1516 by Giovanni Antonio da Brescia and by Lambert Hopfer in Augsburg and was used for a relief on the façade of the University of Salamanca;[47] elements from another print in the set were engraved by Urs Graf in a design for a sword sheath of 1512 and were copied in 1518 on the epitaph of Jacob Fugger in the church of St Anna in Augsburg.

31. Roundel, *c.*1510. Tin-glazed earthenware (maiolica), made in Siena. The colours and composition of the grotesque ornament decoration are very similar to those of Bernardino Pintoricchio's painted decorations in the Piccolomini library in Siena Cathedral, painted in 1503–8. London, Victoria and Albert Museum.

32. A grotesque. Engraving by Nicoletto da Modena, *c.*1507. This print is a mid-sixteenth-century reissue published by Antonio Salamanca. London, Victoria and Albert Museum.

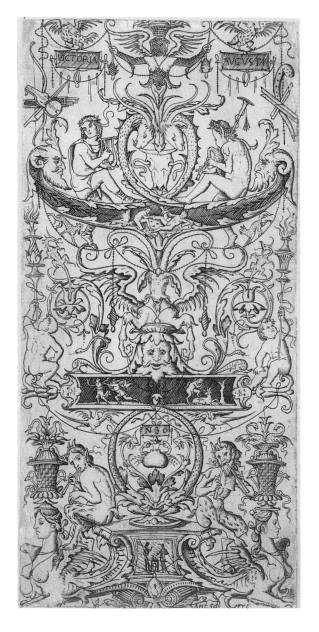

Il poeta el pittor Vanno di pare
Et tira il lor ardire tutto ad un segno
Si come espresso in queste carte appare
Fregiare dopre e dartificio degno

Di questo Roma ci puo essempio dare
Roma ricetto dogni chiaro ingegno
Da le cui grotte oue mai non saggiorna
Hor tanta luce asi bella arte torna

The Vatican loggias

Raphael's and Giovanni da Udine's achievements in the Vatican loggias[48] were based on a return to the open light structures of the Domus Aurea grotesques, creating a completely coherent system for filling rectangular panels with ornament of quite remarkable freshness and liveliness. Interestingly, no printed representations of the complete decorations appeared until the archaeological revival of the later eighteenth century (see plate 4, p.11), when the loggias wielded at least as much authority as antique exemplars in the general return to ancient purity. With the exception of a set of prints of details of the loggias made by the visiting Flemish engraver Cornelis Bos in 1548, and an Agostino Veneziano print of 1521,[49] few of the Roman engravings in Raphael's style can be linked to specific schemes. A typical example of 1532 (plate 33), by the anonymous engraver known as the Master of the Die, is accompanied by a poem extolling the poetic and artistic beauty of the ancient grotesques now brought to light in Rome.

The role of prints
in the development of the grotesque

The effect of Italian grotesque prints at a crucial moment in the development of northern European ornament is very clearly demonstrated in the great set of grotesque etchings published in Orleans in 1550 by Jacques Androuet Ducerceau.[50] The story begins with one of the most important of the Raphaelesque sets, published in Rome between about 1530 and 1541. The first plate of this set (plate 34) explains its contents in Latin in bold classical lettering: 'lighter and, as can be seen, extemporaneous pictures which are commonly called grotesques which the ancient Romans used for decorating their dining rooms and other separate places of their houses which have been variously selected and reduced with great faithfulness and care from many ancient chambers and ancient walls'.[51] Here, the printmaker is saying, are the decorations the ancients had at home, thus immediately striking one of the most powerful sources of the appeal of the grotesque to Renaissance artists and designers. In fact, he has greatly adapted the ancient originals, correcting their unfortunate tendency to sprawl without a coherent structure by containing them within the upright frameworks which were crucial to the later development of the grotesque form.

33. A grotesque, 1532. Engraving by the Master of the Die. This print is a later sixteenth-century reissue published by Antonio Salamanca. The theme of rediscovery is echoed at the top by female figures in ancient and modern dress. London, Victoria and Albert Museum.

34. Title page for a set of grotesques, c.1530–41. By an anonymous engraver working in Rome. London, Victoria and Albert Museum.

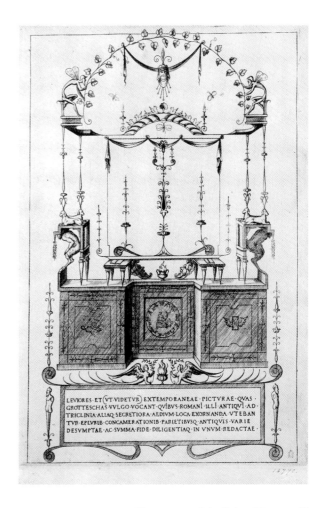

LEVIORES · ET (VT · VIDETVR) EXTEMPORANEAE · PICTVRAE · QVAS · GROTTESCHAS · VVLGO · VOCANT · QVIBVS · ROMANI · ILLI · ANTIQVI · AD · TRICLINIA · ALIAQ · SECRETIORA · AEDIVM · LOCA · EXORNANDA · VTEBAN TVR · EPLVRIB · CONCAMERATIONIB · PARIETIBVSQ · ANTIQVIS · VARIE DESVMPTAE · AC · SVMMA · FIDE · DILIGENTIAQ · IN · VNVM · REDACTAE ·

Ducerceau's inspiration was not this early set but a copy of it, with the images shown in reverse, engraved by Enea Vico and first published in Rome in 1541. His immediate source, however, was a Roman reissue of 1542 (which included four added plates), which lay behind almost half of the fifty plates, the rest being derived from Flemish and slightly earlier Roman grotesque prints. In setting out to create a useful compendium of fashionable Italian (as the title states) grotesques Ducerceau not only etched them all in the same format but treated his sources in ways that can be taken as typical of ornament printmakers in general.

In most of the prints he made straight copies of the originals, which in the process came out in reverse. In some cases, however, he made up partial copies by putting together elements from different plates, or adding elements to the spaces in an existing idea (plates 35–7). In other cases he made 'free copies', some of which still clearly betray their sources, while others can only be said

to have been loosely inspired by them. The success of these prints prompted Ducerceau to etch a second, larger, set in 1562. This copied most of the earlier images, modified and improved others and added eleven new plates taken from the same Italian and Flemish sources.

The after-life of Ducerceau's grotesques can be traced in numerous reprints, copies and free adaptations. The copper plates survived into the eighteenth century to be reprinted many times by Jean Mariette between about 1720 and 1740. Mariette's plates were reissued again by Charles-Antoine Jombert in his compendium of reissues of French ornament prints, the *Repertoire des Artistes* (1752–65). In 1594 Johann Sibmacher, a keen copyist of French prints, published in Nuremberg a set of straight copies, acknowledged on the title page, of plates from both of the French sets. As in all the sets back to before 1541 the title is a long Latin text referring to Italian grotesques, and, in this case, recommending the prints to painters and goldsmiths.

35. A grotesque, 1541. From a set engraved by Enea Vico and published in Rome by Tommaso Barlachi. The set was copied from the plates in the anonymous set in plate 34. London, Victoria and Albert Museum.

36. Grotesques, *c*.1530–41. From a set by an anonymous engraver working in Rome. London, Victoria and Albert Museum.

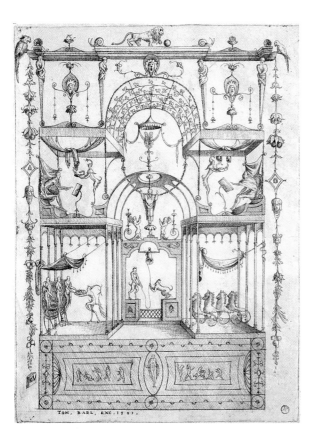

Of greater significance for the future was the set of grotesques designed by Hans Vredeman de Vries, published in Antwerp in 1565 and reissued in 1605 (plate 38). The images were described in the title as 'grotesquery – in various ways most elegant, pleasant, and fruitful for painters, stained glass painters, carvers and all those who are fond of elegant antique ornaments'.[52] As always in Vredeman de Vries's numerous ornament prints, they used the strapwork ornament developed in Antwerp in the 1540s and 1550s but here it is combined with the grotesque decoration of Rome freely adapted from the prints of Ducerceau, with whom he was on friendly terms. The resulting combination was not only one of the first examples of the lighter grotesque characteristic of the next fifty years but also played a major role in forming the grotesques of the French court designer Jean Berain more than a hundred years later.

Print publishers and a revolution in the trade

Ducerceau and Vredeman de Vries were characteristic of a new type of print producer linked to the publishing houses which emerged in the middle of the sixteenth century, profoundly affecting the production and consumption of all types of printed image. Ducerceau ran his own publishing house, established in Orleans by 1550, with the aim of producing a range of publications on architecture and ornament. As well as sets of vessels and grotesques he published prints of cartouches, trophies, friezes, terms and caryatids, Moresques and a great series of books of architecture. In more specific areas he produced the earliest sets of furniture designs as well as designs for locks and keys and goldsmiths' work.[53] Ducerceau's publishing house was mainly devoted to putting out his own ideas; larger houses usually commissioned work from a number of different designers and employed specialist engravers and etchers.

37. A grotesque, 1550. From the set *Petites Grotesques* etched by Jacques Androuet Ducerceau. It borrows loosely from plate 35 and more directly from plate 36. London, Victoria and Albert Museum.

38. A grotesque, 1565. From the set *Grotesco, in diversche manieren* after Hans Vredeman de Vries. London, Victoria and Albert Museum.

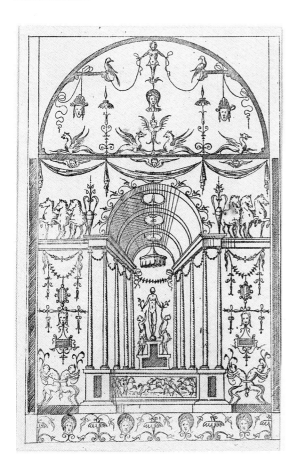

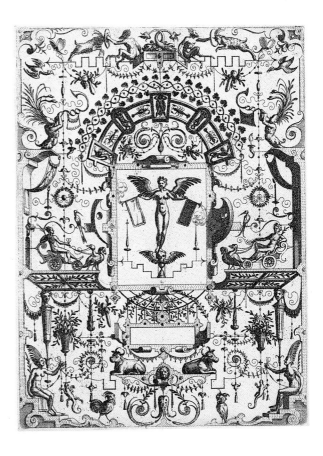

This was the case with Vredeman de Vries, who designed, but did not engrave, prints put out by a number of publishers, chiefly in Antwerp. The most important was Hieronymus (Jerome) Cock, whose house *Aux quatre vents* (at the Sign of the Four Winds) published over a thousand prints of all types between 1546 and 1570.[54] Cock had been inspired to found the business by witnessing on a visit to Rome the methods of the first big print publishers, Antonio Salamanca and Antonio Lafrery. The Roman trade was based on prints of views and antiquities sold to tourists; in the much bigger arena of Antwerp, Europe's largest commercial centre with over a thousand resident foreign merchants, the possibilities were much greater.

Henceforth European print production was dominated by wholesaling publishers based in merchant cities. By the early seventeenth century printmakers from the leading centre of Antwerp had established businesses in most of the major cities of Europe. For ornament prints Antwerp was followed in importance by Nuremberg, which had built up great wealth as a principal staging post for land trade between Italy, northern Europe and the East, and was also the biggest manufacturing centre in Germany for art and luxury goods. The chief Nuremberg publisher, Virgil Solis (plate 39), employed a large workshop of woodcutters and engravers to produce over 700 ornament prints between about 1540 and 1572, including 124 designs for goldsmiths' work and 114 plates of Moresques.[55] Unlike Cock, however, he was heavily reliant on the prints of others to keep up to date, making his output into an important index of available ornament. Of the thirty-eight artists he copied, nineteen were German or Swiss, but most of these were earlier 'little masters' working in the Renaissance style. For Mannerist ornament his chief sources were French and Netherlandish.

Towards the middle of the seventeenth century the centre of European printmaking moved from the Netherlands to Paris, where it stayed until the French Revolution. The close link between politics and art and design which characterized the court at Versailles turned French ornament prints of the reign of Louis XIV into a vehicle for French culture and political influence, while even after that date they never lost their lead as stylistic models. In terms of sheer quantity of images, however, the greatest number of ornament prints in the eighteenth century were made in Augsburg, which played a role very similar to that of its neighbour Nuremberg two centuries before, and where, it was said, engravers outnumbered bakers.[56]

One group of Augsburg prints consisted of baroque and rococo ornament and religious and allegorical figures, frequently highly ornamental in their presentation. The former were often directed at the goldsmiths' trade, of which Augsburg was then the chief German centre, while the latter were related to south German plasterwork and painted decoration. Another equally important category of Augsburg ornament prints consisted of straight copies of French baroque and rococo engravings (plate 40).[57] The sheer number of Augsburg ornament prints made between about 1730 and 1760 shows that they were principally intended for export, probably chiefly to the Catholic world. This included the vast Hispanic market, embracing South and Central America as well as the Iberian peninsula, for which Augsburg publishers produced special prints.

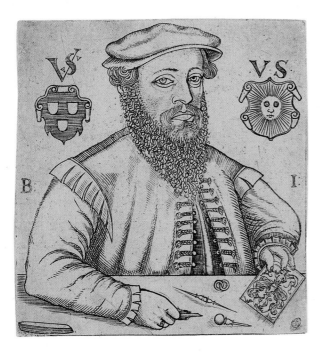

39. Balthasar Jenichen. Portrait of Virgil Solis, 1562. Engraving. He holds a burin and engraved copper plate. A text describing his life has been cut from the bottom. London, Victoria and Albert Museum.

40. Title page of a set of rococo designs published by Johann Georg Merz in Augsburg, probably in the 1740s. It copies, in reverse, Jean Mondon's *Sixième Livre de Formes Rocailles et Cartels ornés de Figures Françoises*, 1736. The sheet is stitched to others in the set: this is how print sets were bought from printsellers. London, Victoria and Albert Museum.

Print sets, classification and organization

The development of the printed set, which was central to the marketing methods of the big publishers, both encouraged and was encouraged by a growing interest in the classification of experience. Prints, including ornament, could, for instance, form part of the evidence of the material world rationally organized in sixteenth-century *Kunstkammer* or collectors' cabinets. In Samuel Quicchelberg's account of 1565, the ideal *Kunstkammer*, or 'theatre of universal knowledge', contained three shelves for prints which, in effect, stood in for all those parts of the world which could not actually be contained in the cabinet itself. According to Quicchelberg they should show religious images, portraits, scenes of warfare, natural history, philosophy, poetry, spectacles, the arts, antiquities, costume, heraldry, geography, tools, machines, and architecture and ornament.[58] Recorded examples of discrete collections, like that of over 5,000 prints made by Archduke Ferdinand of Tyrol between about 1565 and 1595, were similarly arranged not by artist but by topic, including volumes on ornament and figure subjects for goldsmiths' work, grotesques and Moresques, and vases. At least one volume was used to supply ideas for the decoration of the archduke's castle.[59]

A similar, but more detailed method of organization was described in 1664 by Michel de Marolles, who sold his exceptionally large collection of 123,000 prints to the French crown in 1666. Having separated off fine art by or after the great masters and prints on printmaking, he divided the bulk of the collection into seventy different categories by subject, a true mirror of the world.[60] Accepting that any of the categories might at some time have been used for the decoration of objects, nearly a third of them clearly fall within modern definitions of ornament prints. These are: calligraphy, architecture, vases, fountains, gardening, flowers, ruins, perspective, clocks, watches, goldsmiths' work, prints for joiners, works in iron and copper, embroidery, laces, grotesques, cartouches, devices, medals, emblems and arms and armour. Several more categories might also be included as ornament, such as antiques, catafalques, tombs, funeral pomps, entries and processions.

Ornament prints, courts and collectors

The high status of ornament prints at the end of the sixteenth century is clearly suggested by a rare surviving group of 1,280 such prints pasted into a folio album dated 1616, now in the Royal Library at Stockholm.[61] They had been assembled by Paul Freher (1571–1625) a doctor of law, with the probable assistance of his brother Marquard, a celebrated lawyer, diplomat and professor at the University of Heidelberg who was described by one of his biographers as a lover of antiquities and painting. The prints were put into the album in ten subject categories: cups, beakers and vases, panels, grotesques, masks, architectural ornament, jewellery, weapon decoration, cartouches, Moresques and alphabets. Some of the differences between these categories and those of de Marolles can be accounted for by the emergence or greater development of certain types of ornament in the first half of the seventeenth century, such as clocks and watches, gardening, flowers, prints for joiners and works in iron and copper. Other differences can perhaps only be explained by the collectors' tastes; de Marolles has no Moresques, while Freher did not collect emblems or textile patterns.

The Freher album contains all the major sets of ornament made in France, Germany, Italy and the Netherlands between about 1540 and 1616. As a compendium of Mannerist design and decoration collected for its own sake it is probably typical of, though perhaps larger than, most private ornament collections of the period.[62] Similar collections were made by courts keen to emulate the great centres, such as those gathered in Paris by Carl Gustav and Nicodemus Tessin and Carl Johan Cronstedt for the court designers in Stockholm in the late seventeenth and eighteenth centuries. In the Swedish case, however, the prints were a relatively minor adjunct to a vast assemblage of drawings which carefully recorded every aspect of French court design. Prints, being largely restricted to single motifs and often not at the leading edge of design, were simply not up to the task of transmitting design and ornament sufficiently specific or fashionable for a court anxious to emulate its contemporary at Versailles.[63] In fact, like all ornament prints, they were chiefly aimed at a quite different and less exalted market.

Analysis of prints entering Portugal, for instance, has shown that it was precisely those countries furthest from the style centres with a largely craft-based artistic production that benefited most from ornament prints. The successive waves of images, starting with Serlio, then moving on to Antwerp prints, Roman and French prints in the seventeenth centuries, Augsburg prints in the mid-eighteenth century and finally another wave of French prints, are like a history of engraved ornament itself. In the Portuguese context they must indeed have been the main conduit of stylistic change.[64]

Ornament prints in the craftsman's workshop

Trying to find out what prints were kept by craftsmen and designers is even more difficult than tracking down the assemblages of print collectors. This is not only because of the generally humble nature of tradesmen but also because the prints themselves were often severely damaged while in the workshop, and thus rendered unsuitable for later collectors. Half the sketchbook drawings of the Zürich goldsmith Dietrich Meyer the Younger, made during his journeyman years in Basel, Augsburg and (possibly) Amsterdam between 1670 and 1680, are copied from the prints of Stefano della Bella, Jean Le Pautre and Johann Conrad Reutimann. All are of floral and acanthus ornament of direct application to Meyer's own work, although the fact that he copied them probably shows that he did not own the prints themselves (plate 41).[65]

At the other end of the scale is the great French ébéniste (cabinetmaker) André Charles Boulle, a keen collector of prints and drawings, who had in his possession at his death in 1732 sets by all the main seventeenth century French printmakers as well as Ducerceau and the Italian baroque etcher Agostino Mitelli.[66] Although the prints have not survived it is certain that they were stored in portfolios or volumes.

41. Page from a sketchbook made by Dietrich Meyer the Younger, drawn in Basel in 1674. Pencil and red chalk. The upper ornament is copied from a print by Jean Le Pautre dated 1671, the lower from a print by Stefano della Bella dated 1646. Zürich, Kunsthaus.

A quite different approach was taken by the London wood carver and gilder Gideon Saint, whose design and pattern book of about 1760 is a uniquely suggestive demonstration of how ornament prints were used in the workshop of a lesser craftsman. The 364 pages of the book are divided into twelve clearly marked sections, each one dealing with a specific type of furniture. Within the sections are pasted drawn designs and cut-up prints. The prints can be divided into three groups. The first consists of French furniture and carving engravings in the baroque and *régence* styles by Jean Berain, A.-C. Boulle, Pierre Mariette, Nicolas Pineau and François Roumier. The second, and much larger, group consists of rococo prints by Saint's fellow carvers (and rivals) in the London trade, Matthias Lock and Thomas Johnson as well as the engraver Henry Copland. The third group of prints is a small gathering of ornamental trade cards. By cutting up the prints and rendering them anonymous

42. Design for a picture frame from a pattern book put together by Gideon Saint *c*.1760. It combines Saint's own ink drawing with three etched designs cut from pattern books, two from a plate in Matthias Lock's *A New Drawing Book*, *c*.1746, one from a suite of carvers' designs by Thomas Johnson, published in 1758. New York, Metropolitan Museum of Art.

through the removal of their lettering Saint created a pattern book useful both in the workshop and as a source of ideas to show to would-be clients.[67]

Although Saint on occasion made up designs by combining different prints (plate 42), comparison between Saint's own drawings and the engravings in the design book suggests that he saw the prints chiefly as a source of general inspiration, like the 'understanding artists' addressed by Heinrich Vogtherr's *Kunstbuechlin* discussed above. In fact an examination of the decorative arts before 1800 tends to show that this approach to ornament prints was the norm, at any rate in the case of pure non-figurative ornament. When direct borrowings of such ornament do occur they are largely restricted to individual motifs.

This process is amusingly shown in the title page to a set of grotesque motifs of 1610 by the Nuremberg goldsmith Christoph Jamnitzer (plate 43). Well-dressed craftsmen are seen selecting and purchasing individual motifs, while the shop man leans on a book (of patterns?). Some of the motifs are so independent that they have taken on a life of their own and are flying away. Single motifs thus selected from prints often play a leading role in setting the stylistic tone of an ornamental composition.

43. Second title page of the *Neuw Grottesken Buch*, 1610, etched by Christoph Jamnitzer. London, Victoria and Albert Museum.

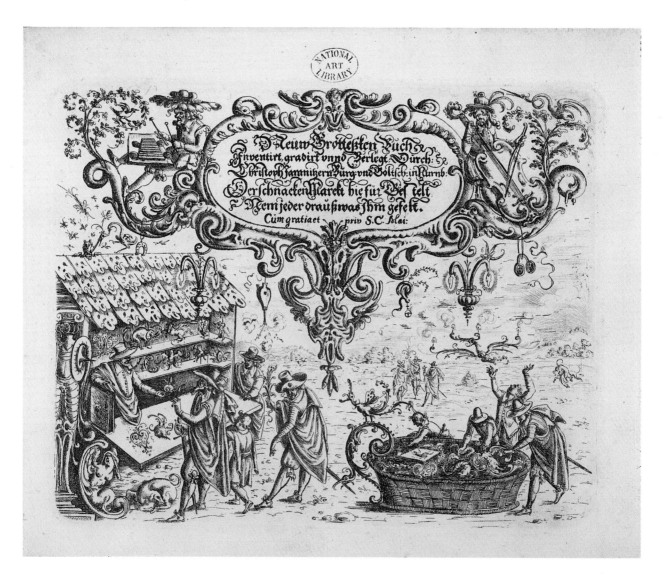

44. Design for a pier table and mirror, c.1761–3, by John Vardy. Pen and ink and wash. The furniture was intended for the 5th Duke of Bolton at Hackwood Park, Hampshire. London, British Architectural Library, RIBA.

45. A sofa made for Count Bielenski in 1735. Etching and engraving by Gabriel Huquier after Juste Aurèle Meissonnier. London, Victoria and Albert Museum.

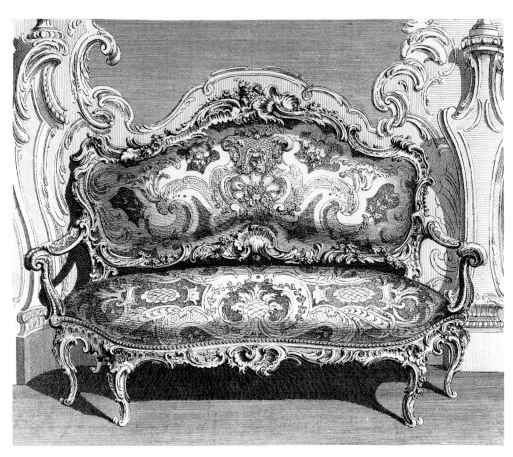

Interesting examples of this process can be found in the use in England of French rococo ornament by Juste Aurèle Meissonnier. In designing a pier table (plate 44), the architect John Vardy borrowed a shell and scroll from a print of a sofa designed by Meissonnier (plate 45). Vardy's normal manner was a softened version of William Kent's Palladian style; by borrowing a single motif he was able to give the whole table a rococo feel. In the event, the table was made with a simpler top rail echoing that of the bottom of the mirror.[68]

A more subtle approach to Meissonnier prints was taken in a pair of candlesticks designed by the London gold chaser George Michael Moser, a leading figure in the group which introduced the rococo style to England. A shell after Meissonnier forms the central motif on the bases (plate 46), but has been so well integrated with the surrounding *rocaille* scrolls that its separate origin is completely disguised. A number of other prints seem to lie behind the general design of the candlesticks. On a strictly iconographical level Moser was inspired by Gian Lorenzo Bernini's famous statue of Apollo and Daphne, but the dominating twisting element in the composition was a rococo idea which Moser seems to have borrowed from French prints. These probably included one by Meissonnier which may also have supplied a general idea for the base (plate 47).[69]

46. Pair of silver candlesticks with the stems formed as figures of Apollo and Daphne, *c*.1740. Made after a design by George Michael Moser. London, Victoria and Albert Museum.

47. A candlestick designed in 1728. Engraving by Louis Desplaces after a design by Juste Aurèle Meissonnier. This is one of three prints of different sides of the candlestick. London, Victoria and Albert Museum.

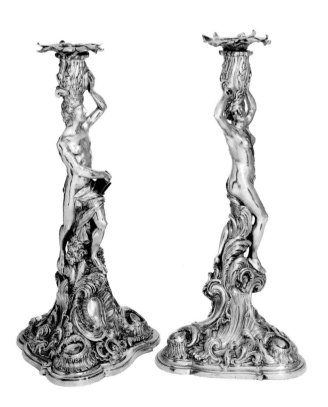

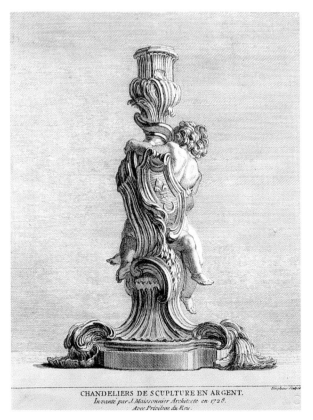

CHANDELIERS DE SCULPTURE EN ARGENT.
Inventé par J. Meissonnier Architecte en 1728.
Avec Privilege du Roi.

The special role of figurative prints

The fashion for classical and other figures used as decoration on objects created special demands on craftsmen which, in many cases, only prints could satisfy. They often led to the wholesale copying of printed images, but on other occasions to selective adaptations similar to those of non-figurative motifs. Two different print sources were, for instance, used on a silver waiter marked by Benjamin Pyne in 1698 (plate 48). The chased outer border of demi-putti, dogs and acanthus scrolls is taken from an etching made about forty years earlier by the highly influential printmaker Stefano della Bella (plate 49).[70] The print cannot easily be repeated as a continuous frieze, but by adding another leaf element the designer

has been able to divide it into three parts perfectly adapted to the six sides and angles of the waiter. The main event of the decoration is the engraved armorial cartouche in the centre. This again is a composite. The putti are copied from the title page of a set of figure etchings by Abraham Bosse after Paolo Farinati, first published in 1644 (plate 50). In the eighteenth-century reprints these figures are described as drawing exercises; they are all shown isolated and out of context and clearly intended to be extracted for use. The designer of the waiter has used them to top off a curly cartouche which follows in its design the conventions of contemporary armorials. It may be of his own invention.

48. Waiter. Silver-gilt, marked with the sponsor's mark of Benjamin Pyne and London hallmarks for 1698–9. The centre is engraved with the arms of Sir William Courtney, perhaps by Simon Gribelin. London, Victoria and Albert Museum.

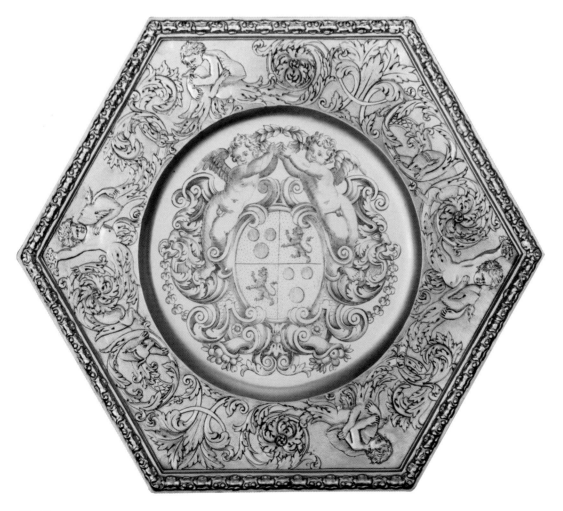

49. A frieze. Engraving by Stefano della Bella
from the set *Ornamenti di fregi et fogliami*, after
1647. London, Victoria and Albert Museum.

50. Title page of the set *Diverses Figures à l'eau
forte de petits Amours…*, engraved by Abraham
Bosse after the designs of Paolo Farinati.
Originally published in 1644, this impression is
a reissue of 1736, in *Receuil de Figures pour
apprendre à Dessiner*, published by C.A. Jombert.
London, Victoria and Albert Museum.

Craftsmen who were required to produce complete figure scenes as decoration frequently used prints as sources for whole compositions. In this they were merely following the common fine art practice of reproducing admired and popular models. As a result, decorative art forms such as the *istoriato* ('story-painted') maiolica of the sixteenth century effectively become records of the penetration of prints to provincial centres like Urbino and Faenza. Among the drawings pinned to the walls of the painters' workshops (plate 51) would have been prints by Dürer and Schongauer and, after about 1520, the Roman engravings of the school of Raphael.[71] Although the painters did not usually alter the poses of the figures, they frequently made their own compositions using single figures or groups and nearly always had to adapt the rectangular print subject to the circular format of an earthenware dish (plates 52–3). The skilful compositional compressions and other adaptations, not to mention the use of colour, created objects which were works of art in their own right. Ceramics, with their easily paintable surfaces, remained the chief area for figurative decoration and prints their main source of ideas. In the eighteenth century the major ceramic factories built up huge archives of suitable figurative and other images for their decorators; by the 1760s that of the Royal Porcelain Manufactory at Berlin contained some 2,400 prints, many of them dating from the previous century.[72] The final logical step in this process was the transfer to ceramics of actual printed images, beginning in the 1760s.

51. Maiolica painters in their workshop. Detail from a pen and ink drawing and manuscript text by Cipriano Piccolpasso in the *Tre Libri dell'arte del vasaio* (The Three Books of the Potter's Art), 1557. London, Victoria and Albert Museum.

52. Plate decorated by the Master of the Milan Marsyas. Tin-glazed earthenware, Urbino, *c*.1530. The scene shows Helen carried off by the Trojan warriors. London, Victoria and Albert Museum.

53. Helen carried off by the Trojan warriors. Engraving attributed to Marcantonio Raimondi (*c*.1481–1527 to 1534). London, Victoria and Albert Museum.

The end of the ornament print

In about 1800 the great stream of ornament prints began to dry up. By 1850 it had been replaced by a number of different vehicles for printed design images, all of which are still with us: trade catalogues, style and design magazines, design manuals and encyclopaedias of historic and modern ornament. This fundamental change was a response to the general shift towards industrialized and centralized methods of production. These had the effect of removing the craftsman customers for engraved ornament, encouraging a new class of specialist designer and creating a large buying public eager for guidance and information. Vital to these developments was a move from printmakers to book publishers, the advent of cheaper wood-pulp paper and the invention of rapid methods of image production, especially lithography.

54. Print from an engraved catalogue of embossed gilt leather, 1670s. Inscribed on the back with prices and pattern name (Bacchus and Ceres) by the Amsterdam manufacturer Maarten van den Heuvel. London, Victoria and Albert Museum.

Trade catalogues, style guides and magazines

The origins of the trade catalogue lay in the very nature of ornament prints. Any ornament print made by a craftsman had the potential to be an advertisement for his own wares as well as a source of ideas for those of others. Only extremely rarely, however, was the leap made to prints which were more catalogues than pattern books and even then they were only identifiable as such by manuscript inscriptions on the back indicating prices and patterns, as in the case of a set for stamped leathers (plate 54). That declaration, however, signals a fundamental change, for a catalogue presupposes that the goods shown can be repeated exactly, as stamped leathers can be. The true trade catalogue, made up of many bound pages, emerged in the 1760s from the mechanized metal manufacturing industries of Sheffield and Birmingham. It was probably inspired by the best-known of all advertising pattern books, Thomas Chippendale's *The Gentleman and Cabinet-Maker's Director*, first published in 1754. In one case, that of Matthew Boulton, the printed catalogue developed directly from the small record drawings of designs which were kept by the firm and sent to customers.[73]

Although initially designed to sell goods, the power of the images in trade catalogues makes them highly influential ambassadors of style. The early metal trade catalogues, carried by agents all over Europe, played a large role in introducing the English neo-classical style to silver made on the continent (plate 55). Their more recent descendants, the catalogues of design-conscious shops like Liberty & Co., Habitat and Laura Ashley, have been so powerful in spreading stylistic influences across groups of objects that they have given their names to particular ways of living.

The all-embracing nature of this type of shop catalogue, with its emphasis on domestic furniture and interiors, was pioneered in ornament prints of the late seventeenth and early eighteenth centuries, which aimed at transmitting the court style of Versailles. Later in the eighteenth century illustrated publications on the work of designer-architects like William Kent and the Adam brothers continued the idea. *The Works in Architecture of Robert and James Adam*, published in parts between 1773 and 1822, dealt not only with external architecture but also with the integrated schemes of furniture and interior decoration for which the Adams were famous. It was in effect a style guide and, carrying a text in both English and French, had a profound influence abroad.

The polemical tone and broad subject range of these architectural publications was further developed in Charles Percier and Pierre Fontaine's *Recueil de décorations intérieurs* (1801), and its English counterpart, *Household Furniture and Interior Decoration Executed from Designs by Thomas Hope* (1807). Both books, but especially Hope's, were aimed at raising the standards of design.[74] Working at a more popular level were the earliest illustrated magazines, such as the *Journal des Luxus und der Moden*, published in Weimar from 1787, and the *Repository of Arts*, which started in London in 1809 and was linked to a shop of the same name selling books, prints and fancy articles.

Although they were aimed at the consuming public rather than makers, these magazine images of furniture, textiles and interiors were of the greatest significance; for the first time absolutely up-to-date designs could be put into wide circulation. This not only had the effect of speeding up the process of dissemination but also played a key role in promoting the rapid evolution of styles which became characteristic of nineteenth-century design.

55. Engraved page from a commercial traveller's catalogue of fused plate, made in Sheffield, *c.*1785. The prices are in sterling, but the inscriptions are in French. This catalogue was found in Turin. London, Victoria and Albert Museum.

Designers and design manuals

Prints aimed at instruction in the processes of design had appeared by the eighteenth century. Their chief aim was to teach the drawing of ornament, an essential skill in those crafts in which apprentices had to present a design for their finished 'masterpiece'. The prints concentrated on methods of constructing and drawing the freer types of motif, especially leaves and flowers. Towards the middle of the eighteenth century these forms became an essential part of the developed rococo style, spurring the production of a large number of drawing exercises which were used not only in craft workshops but also by drawing masters and by the new schools of design set up in the 1750s. The schools had been founded in recognition of a need for training in design. Some were linked to particular trades, such as Jean-Jacques Bachelier's school for apprentices at the Vincennes porcelain factory, and others were encouraged by institutions, such as the Society for the Encouragement of Arts and Manufactures, which was aiming to improve the design and competitiveness of English luxury goods against those of the French.[75]

Perhaps significantly, the prints used by the drawing schools linked to the Society of Arts from 1758 onwards were not those engraved by London drawing masters but were French (plate 56). They were often made in the brand-new crayon manner technique, which imitated the effect of chalk drawings.[76] Crayon manner ornament prints were soon being used in a teaching method, long established in academies of art, which progressed from copying the drawing-like prints to copying plaster casts (plate 57). The same methods were still in use at the end of the nineteenth century, but with photography replacing the old hand-produced prints.

Linked to the establishment of design schools was the gradual emergence of the designer in the modern sense.[77] Ornament prints made before about 1750 show that although some craftsmen, like Christoph Jamnitzer, were very able designers in their own right, they were ultimately always linked to the workshop. Court centres, however, had long contained figures like Louis XIV's *Dessinateur du Roi* Jean Berain, artists whose abilities in painting, drawing and ornamental composition qualified them to carry out any designing job that was required by the court, from a coach to a firework display. Their work was highly influential, especially when turned into ornament prints. Often equally influential was a third type of designer, many of whose executed projects were in the field of architecture, but whose prints covered a far wider range of subjects. Finally, by the early eighteenth century, there were the pattern drawers, specialists in the textile field, who worked independently, selling their designs to different weavers.

Towards the middle of the eighteenth century a new type of designer emerged. A specialist in the design of ornament, he was often both a drawing master and a producer of ornament prints. In Paris, Gabriel Huquier (1695–1772) not only engraved his own designs but was a major publisher of the designs of others, whose compositions he often subtly embellished and modernized. As a drawing master his collection of drawings was regularly available for the study of students.[78] In London, Matthias Darly was a publisher of ornament and satirical prints and an engraver of trade cards, book illustrations and coats of arms on silver, as well as being a drawing master. He sometimes described himself as an architect but in 1771 called himself 'professor and teacher of ornament' and 'The Political Designer of Pots, Pans and Pipkins'.[79]

56. A leaf. Engraving by Gabriel Huquier after Alexis Peyrotte, from the set *Divers Ornemens*, part II. An impression of this print was used for copying in the Society of Arts Competition of 1758. London, Victoria and Albert Museum.

57. A drawing class at the Glasgow School of Art, *c*.1900. Photograph by Thomas Annan. A class of female students is drawing plaster casts of ornament in a part of the school known as the Museum.

Ninety years later, with the production of ornamental art very largely industrialized, the commercial designer had become completely established. One of the leading practitioners of the second half of the nineteenth century, Christopher Dresser (1834–1904), had a studio staff of ten turning out ideas for all sorts of goods, from teapots to carpets, made by a wide range of manufacturers.[80] A graduate of the government School of Design, he added his own contributions to the ever-growing pile of teaching manuals on ornament needed by the design schools, which in Britain and a number of other European countries were organized into a system of state controlled design education (plate 58).

The earliest government-sponsored design publication was the *Vorbilder für Fabrikanten und Handwerker* ('Examples for Manufacturers and Craftsmen'), issued by the Prussian trade delegation in Berlin.[81] Put out in parts between 1821 and 1837, its large lithographed plates, some of which were coloured, showed architecture, ornament, furniture, textiles, ironwork and ceramics, chiefly in the official neo-classical style of the architect and designer Karl Friedrich Schinkel (plate 59). The *Vorbilder* was not for sale; it was in fact given out free to craftsmen and manufacturers who Schinkel and his collaborator Peter Beuth considered would benefit from the patterns. To have sold it openly would, they felt, have cheapened the designs by putting them in the context of the great mass of more fashion-conscious printed images in the trade. In fact the *Vorbilder* was very different from these images, being arranged as a careful progression through the application of ornament to objects of different kinds; it was, in effect, an encyclopaedia of ornament.

58. Plate from Christopher Dresser, *The Art of Decorative Design*, 1862. London, Victoria and Albert Museum.

59. Plate from *Vorbilder für Fabrikanten*, 1821, showing antique bronze lamp stands. Engraving by J.M. Mauch after Louis Sellier. London, Victoria and Albert Museum.

Encyclopaedias of Ornament

The encyclopaedias of ornament which emerged in the first half of the nineteenth century can be said, both in form and function, to be the true descendants of the 'pure' ornament prints of the previous centuries, just as the trade catalogues, and style and design magazines replaced prints aimed at particular trades. Although the encyclopaedic approach was already evident in compendia of motifs such as Vogtherr's *Kunstbuechlin* of 1537, the idea was not often repeated until the publication by Charles Antoine Jombert of the *Répertoire des artistes* in 1765. Significantly, Jombert's huge collection of 688 plates was entirely made up of reprints of copperplates, all of them inherited from Jean Mariette, none of which were younger than fifty years old and some older than two hundred. As we have seen, such time spans were not unusual for reprints, but Jombert's approach was crucially different in that he took a historical view, indicated by the inclusion of short biographies, and sometimes criticisms, of the artists represented.

The conscious return to historical styles began with the Gothic revival in mid-eighteenth-century Britain. Horace Walpole, one of its earliest enthusiasts, relied heavily on the easily understood images of prints to organize his response to the Gothic in designing the interiors and furnishings of his house at Strawberry Hill.[82] Walpole's sources, however, were not medieval prints, which were unknown to him, but the illustrations in comparatively recent historical works. By the second quarter of the nineteenth century three distinct types of print had emerged in order to serve the ever-widening demand for ornament in historical styles: more or less accurate modern representations of historical objects and buildings, designs for modern objects and buildings in historical styles, and reproductions of ornament prints, at first made by hand and later photomechanically.

The title page of a cheap set of reproductions like the *Répertoire de l'ornemaniste* (plate 60) shows that by the early 1840s there was a complete grasp of the range and nature of historical ornament prints. The prints are already organized into the schools and subject divisions in which they are catalogued today. Indeed, the very architects and designers who collected such prints for practical purposes also helped to establish their scholarly study and publication.[83] Significantly, however, the 1840s *Répertoire* title also includes several authors of very recent prints, although none working in the neo-classical style. Of about the same date as the *Répertoire* is the first compendium of ornament to be called an encyclopaedia, Clerget and Martel's *Encyclopédie universelle d'ornements antiques*. The subjects go beyond Europe to Islamic, Egyptian, Chinese, Indian and Japanese orna-ment, signalling the scope of the most celebrated and significant of all encyclopaedias of ornament, Owen Jones's *Grammar of Ornament*, first published in 1856 with 100 chromo-lithographed plates.[84]

Jones was a member of a design reform group led by Henry Cole, which founded the government Department of Practical Art, revitalized the design schools and in 1852 established the first public museum of decorative art, now known as the Victoria and Albert Museum. *The Grammar of Ornament*, directly inspired by the work of the department, added several more categories to those of Clerget and Martel (including Celtic and the ornament of 'Savage Tribes') and prefaced each of them with a thorough historical account, turning the book into a standard history of ornament. Jones, like his near-contemporary Christopher Dresser, was one of a new breed of professional designers whose practical observations led them to analyse the common principles of ornament, in terms both of design and of colour. In adding a general preface on this subject to the almost entirely historical contents of the *Grammar of Ornament* Jones not only anticipated the modern view that most such ornament is a matter for museums, alluring but essentially dead, but also opened up the idea that the creation of new types of ornament was not only possible but thoroughly desirable.

60. Title page of the *Répertoire de L'ornemaniste*, 1841. Among the more recent designers of ornament named in the shield at bottom left are Henry Shaw, Aimé Chenavard, A.W. N. Pugin and James Murphy. London, Victoria and Albert Museum.

ARCHITECTURE
SCULPTURE
DECORATION
ETOFFES
MEUBLES
ORFEVRERIE
BRODERIE
ETC

A. DURER
P. VAN MECKEN
ALDEGRAVE
V. SOLIS
D. HOPFER
H.S. BEHAM
L. KRANACH
ETC

ANDREA
LA BELLA
A VENITIEN
ROSSO
LE PRIMATICE
ETC

A. BOSSE
A. BRAUN
T. BALG
H. BANG
JANSSEN
V. VRIES
C. FLORIS
ETC

A COLLAERT
D. MIGNOT
T. DE BRY
BLONDUS
DUCERCEAU
E. DE L'AULNE
G. L'EGARE
ETC

RÉPERTOIRE

DE

L'ORNEMANISTE

Recueil de Matériaux pour
l'Ornementation.

Compositions ou Fac-Similés de
Dessins, de Gravures et de Manuscrits,
de tous les Styles, de tous les Maîtres,
de toutes les Époques.

Gravés

Par O. Reynard, H. Devergèses et Blaisot.

OUVRAGE PÉRIODIQUE
Paraissant par Livraison de 5 Planches
tous les Lundis.

SONDERLAND
CHENAVARD
PUGIN
SHAW
M'LEMAN
BENDEMAN
MURPHY
ETC

WATTEAU
GILLOT
LEBAUTRE
MEISSONNIER
D. MAROT
BERAIN
LEMOINE
ETC

PUBLIÉ A PARIS
Par Blaisot Graveur-Editeur, 25 Rue Guénégaud

Imp. de Lesauvage.

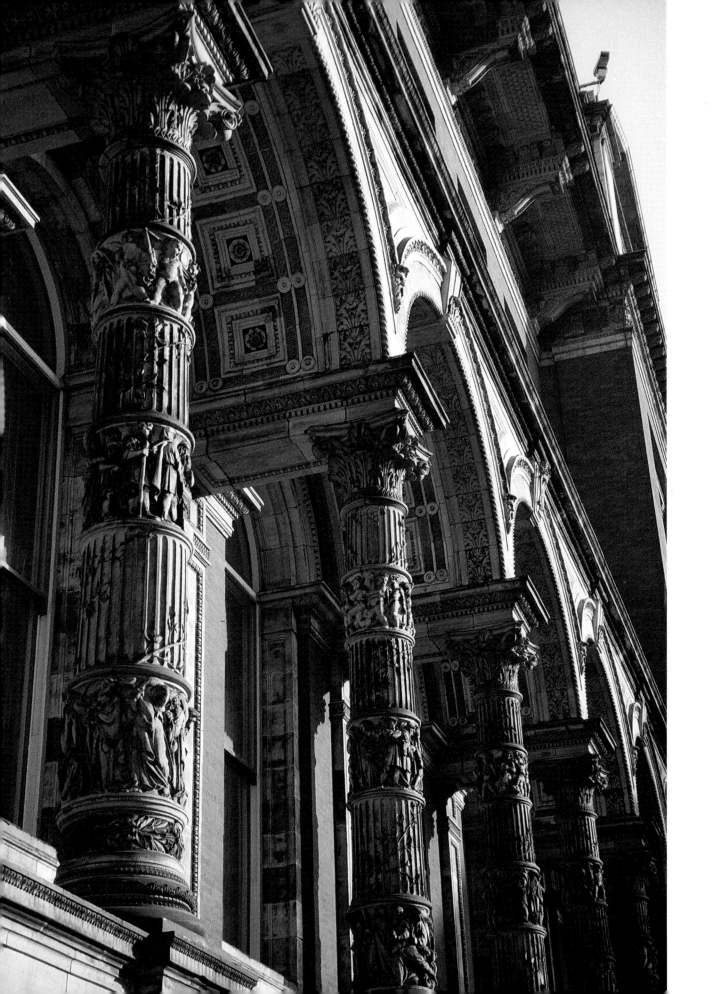

2

Ornament and Building

Ornament serves architecture in the same way that it serves other kinds of objects made by human hands. It serves the practical end of linking parts of an object together so that it seems to be the natural conclusion of the process of making. Ornamented door- and window-frames, chimney-stacks, even guttering and drainpipes, separate off the working parts of the structure, help us to recognize the means of access and lighting, and disguise the joins between masonry or brickwork in order to present a coherence of design. Ornament can, however, do more than this. It can bring life to the surfaces of a building where otherwise there would be blank spaces. It can also proclaim, through lettering, coats of arms or symbolism associated with the owner (whether a private individual or a corporate body), how a particular building functions, who paid for it, and who lives or works within it. Changes in the type of ornament, whether external or internal, can signify the relative importance of one part of a building *vis-à-vis* another; the east end of a Christian church, for example, where the altar stands, may be more richly decorated than the rest of the building to show that this area is the focus of worship, the activity for which the whole building was intended and to which the eye must be drawn. There is a point, however, at which we may feel the amount of ornament on a given building may have slipped over into an excess beyond the needs of either practicality or an indication of function. The very potential for excess has meant that the role of ornament in architecture has been the source of much debate in the past five hundred years of European and American history.

61. Detail of the Science Schools building in brick and terracotta by Henry Scott and Henry Cole, now part of the Victoria and Albert Museum, London, 1867–8.

The terracotta columns used along the upper loggia of the Science Schools building at the Victoria and Albert Museum, London, of about 1868, for example, are certainly decorated in a way that has nothing to do with their primary supportive role in the structure (plate 61). If, however, we begin to ask questions about the period at which they were made and the nature of the building they enhance, we find that the impression we may initially have of an excess of ornament is not the result of mere wilfulness on the part of the architect. This building belongs to a time when prohibitive taxes on glass, windows and bricks had been repealed, encouraging builders to increase the expense and effort spent on enriching the surfaces of their commissions. Technical inventions, such as the development of plate glass, helped to set new standards of luxury and convenience. A richly wrought front such as this is a measure of the general confidence of the period that display of this sort signified the conquest of materials and technical processes. [1]

In this particular building, however, we find that there is still more to be understood about the ornament once we ask what the building was for and what significance it had. The purpose of the museum's foundation was to raise standards in the fine and decorative arts and thereby promote a thriving manufacturing sector in the economy. But the collections gathered within its walls were not the only means of teaching and promoting those standards. The very building itself was designed to be an object of wonder at technical achievement and experiment; indeed the very material of terracotta, used here to decorate the columns, symbolized the revival of a traditional form of ornamental material. In England, only at one period before this had terracotta been used extensively for architectural decoration; this occurred in the early sixteenth century when it was laboriously (and often technically badly) produced. In the nineteenth century it could be made with all the technical ease and know-how of an industrialized society. The decoration

that we see is saying something about the nature of the building itself; it celebrates an important aspect of the ideals of promotional function and purpose of the new museum. Students of architecture would be taken to see and learn from this building.[2]

If, however, in coming to understand these intentions, we feel able to accept the richness we see here on its own terms, we can do so only in the context of this particular structure. We would probably say that such decoration would be totally out of place on the average terraced Victorian house built at the same time, since a house did not serve the function of a place of education and of the consequent demonstration of pride in skills of manufacture. Here we would be making a distinction between a building that is large and public, the museum, and one that is small and private, the house, and assuming that the decoration of each would be different because of the different roles they fulfilled. This appropriateness of decoration in circumstances linked to the function of buildings, the notion of *decorum*, has a long and complex history. Let us first examine this history with reference to one of the most ubiquitous forms of building known to modern Western society, the shop, or retail outlet.

Ornament for sale: the architecture of shops

At the end of the twentieth century, the common visual experience of walking along the main shopping street of any fairly large British town is the seeming continuity of modern plate-glass shopfronts. This is because in recent times any ornament original to the building at the ground-floor, or shop entrance, level has usually been obliterated. At this level, the needs of modern window-dressing, with the availability of sophisticated lighting and mass-produced advertising material, have demanded large, neutral spaces and unobtrusive framing to display a carefully selected range of goods and entice the potential buyer. If, however, the buildings are of any age, if, that is to say, the town enjoyed nineteenth- or early twentieth-century prosperity, the chances are that above the shop the old façade survives and there we find a complete contrast (plate 62). Forms of architecture that originated in ancient Egypt, Greece or Rome, or the art deco of the 1920s and 1930s, are often seen, reflecting the fact that such styles were thought appropriate not simply because these were public buildings demanding some grandeur but because shops were in a sense markets of the exotic. They gathered for sale objects from all

quarters of the manufacturing world which, contrary to the selective and consciously 'designed' modern window display, were massed together in the windows as testimony to the abundance on offer.

The vast majority of these shop façades date from the period between the Great Exhibition of 1851 and the outbreak of the Second World War in 1939. Great department stores led the way in having distinctive, individually recognizable styles. Often the ornament on the exterior was continued within the building, as with the baroque revival grandeur of Selfridges, London (begun in 1908) (plate 63) or the dense, foliate ornament of Louis Sullivan's famous Carson, Pirie and Scott store in Chicago (built originally as the Schlesinger and Mayer store) of 1899–1904 (plate 64).[3] Today we can see something of a reversion to previous practice in the way modern chains of stores may be built in a style that suggests that the shops themselves are an extension of the comfortable interiors of our homes. Stores are carpeted and goods are made easily accessible to be handled.

62. In the dense urban landscape of a town like Brighton, Sussex, the main shopping centre along North Street (running across the centre of this photograph) shows a contrast at the upper levels between different twentieth-century interpretations of the classical language of building and between these and the art deco of the 1930s, with its arrow-head glazing bars and use of colour.

63. Selfridges, Oxford Street, London, by R. F. Atkinson and David Burnham, begun in 1908.

64. Iron grillework over the entrance to the Carson, Pirie and Scott (originally the Schlesinger and Mayer) store, Chicago, by Louis Sullivan, 1899–1904.

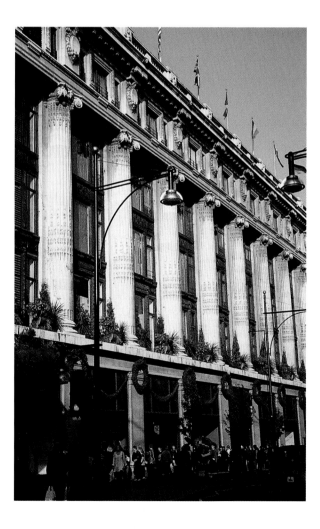

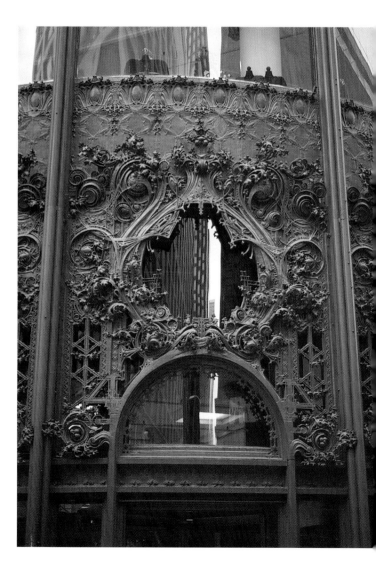

The proliferation of chains of book stores in Britain during the 1980s, for example, engendered a deliberately archaic style of shop front, often with a simulated wooden frame, covered in dark-toned paint and with small panes of glass in order to evoke an association between the habit of reading and the cosiness of a quasi-domestic environment (plate 65). Indeed, once we venture inside the store, pedimented bookcases, dark panelling and thick-pile carpet evoke the atmosphere of a private library. This reassertion of values of the past and the transplanting of architectural detail from grand buildings of former times into small and intimate contemporary environments can be associated with the movement we have come to call post-modernist.

65. A bookshop in Maidstone, Kent, shows the blend of some older fittings of the street frontage (the door at the left) with new plate glass windows topped by leaded lights to lend an air of age to a modern retail outlet.

A street of nineteenth-century shop fronts demonstrates for us very sharply the way in which different kinds of architectural ornament can be used for different commercial purposes but nevertheless coexist cheek by jowl. They are a collection of façades, each signalling a different emporium of goods. It is significant that the various styles will include those taken from past, especially ancient, civilizations. Shops encourage us to buy and are a place for the conduct of commerce. Using architectural façades as a means of persuasion is something particularly associated with ancient Rome, and especially its imperial phase when the Roman style of building was transplanted all over Europe, the Middle East and North Africa as a sign of political, and therefore cultural, conquest (plate 66).[4] This notion of a façade 'applied' to the basic structure of a building is of fundamental importance in the development of what architectural ornament has come to mean in the Western tradition. The application of ornament means a choice is possible in the final appearance of the building; basic structures can be universal in type but meanings are 'put in place' by the choice of motifs and the way they are arranged.

Ornament and architectural theory

It was the Renaissance theorist Leon Battista Alberti (1404–72) who first set down what became a traditional notion of the separation of function and ornament in the form of a theoretical guide to building, his *De re aedificatoria* (On matters concerning architecture) of 1452 (first printed in 1485). Alberti's demarcation between structure and ornament became part of the standard discussion of the principles of architecture for the following centuries, though their separation meant that ultimately the dependence of one upon the other could be denied.[5] In the twentieth century, as we shall see, the argument was put forward that buildings do not need an artificially applied system of ornament at all and this led to the rejection of ornament by the Modern Movement, most famously articulated in the essay 'Ornament and Crime' by Adolf Loos.[6]

The shape of Alberti's text in the form of ten 'books' on architecture and the assumption he made that each building needed to conform to an accepted set of rules appropriate to its function, followed antique precedent. Vitruvius' *Ten Books on Architecture* was dedicated to the Emperor Augustus, who died in AD 14. This text held an overriding importance for the Renaissance since it was

66. The Theatre at Palmyra, Syria. Imperial architecture of the second century AD, built about a hundred years after the Roman conquest. The theatre was originally decorated with statues of emperors, magistrates and officials.

the only surviving ancient source that both discussed the practical aspects of architecture and gave a view on what was believed to be the correct application of ornament. Indeed, Vitruvius is the only surviving ancient text of any description whose self-proclaimed intention was to deal exclusively with matters to do with the visual arts. This gives the text an extraordinary, and perhaps misplaced, importance. In the twentieth century we have come to see Vitruvius as having a highly individualistic view of the buildings of his time; as excavation has uncovered more evidence of the building fabric of ancient Rome and the cities of its empire, we find that the incidence of ornament was far more varied than Vitruvius prescribes. Many of his words of advice that later architects were to take as rules for building were in fact only one interpretation of the use of a whole range of decorative possibilities.[7]

The fact remains, however, that for the period after 1450, when our survey of ornament begins, there was a perception of rule and order, of decorum, based on Vitruvius, amongst architectural writers that set the agenda for all discussion. By the early sixteenth century this body of theory on architecture circulated in printed texts, which were illustrated with woodcuts and, later, engravings. To begin with, these showed only buildings of the ancient world, but gradually modern buildings which were felt to embody the qualities of their ancient forebears were introduced.

The books of Sebastiano Serlio (1475–1554) were especially influential on a wide European audience and the appearance of his texts in the inventories of libraries throughout Europe by the mid-sixteenth century demonstrates that the educated audience for understanding architecture was an ever-widening one.[8] Debate about ancient buildings and their modern counterparts from the sixteenth down to the nineteenth century was kept alive not only by the ever-improving quality of illustration but by an increase in the information available. Ancient Greece was acknowledged to be the source of many of the basic precepts of classical architecture but, as part of the alien Ottoman Empire, it was largely inaccessible to Europeans until travellers from the mid-eighteenth century onward braved the dangers of travel and disease to make measured drawings of the chief monuments. These resulted in important publications, the most notable being James Stuart and Nicholas Revett's *Antiquities of Athens*, the first volume of which appeared in 1762.[9] The eighteenth century also saw the discovery of the towns of Pompeii and Herculaneum, which added considerably to the repertoire of known Roman classical motifs, particularly in the field of interior decoration.

Ornament and political identity

Among those educated in architectural theory in Renaissance Europe, it was accepted that the range of styles found in the classical tradition formed the guidelines of modern decoration. It was also understood that when this ornament was applied to building it carried intrinsic meaning; it was, that is to say, a metaphor for the building's type and function. When, however, from a twentieth-century standpoint we look at the history of classical ornament as metaphor since ancient times we can see that the emphasis of meaning has shifted considerably, though each shift has added to a cumulative sense of the possibilities of what a range of meanings offers. One way of understanding the evidence from ancient Greece is by seeing specific styles of ornament as having regional significance in the rivalries between the great city states. One kind of ornament was associated with one city or people and if that city or people became associated with certain political, social or moral values, so the ornament of their buildings followed suit.[10]

The city of Corinth, for example, was an especially well-developed urban society, wealthy through trade in luxury goods. The style of ornament deriving from the city's name thus became one of implied luxuriousness and complexity (plate 67). Vitruvius indeed goes so far as to make the style gender specific; the 'Corinthian' is associated in his text with the female deities in the pantheon of ancient Roman gods. For the contemporaries of Vitruvius, these female associations would have embodied a rather ambivalent message. The female world was that

67. 'The Discovery of Corinthian'. Engraving from Roland Fréart de Chambray, *A Parallel of the Ancient Architecture with the Modern*, from the 1723 edition of John Evelyn's 1664 translation of Fréart's book, published in Paris in 1650. Vitruvius' story of the origin of Corinthian underpins his gender specific interpretation of the order. He recounts how the nurse of a dead virgin of Corinth placed a basket of vessels on her grave, putting a tile on top to keep it dry. Acanthus grew around it from a root beneath, inspiring Callimachus to design the capital.

of domesticity, gentleness and the benefits of culture that peace could bring but in this it was an antidote to, and a potential detraction from, the essential military preparedness that a well-run, well-protected state always needed. Corinthian therefore embodied more than a hint of decadence and of implied corruption of basic, honourable values. These latter are embodied for Vitruvius in the style he associates with male deities, the Doric, originating in a Greek city whose simple qualities and way of life were somehow felt to be nearer to the basic aspirations, or ideals, political and social, of the city state (plate 68).[11]

If Vitruvius and his Renaissance successors as writers on architecture sought to define the meaning of different kinds of ornament according to a range of political ideals, one section of the audience for their books among the rulers of Renaissance Europe at first used classical styles and their meanings in a less subtle way. It was the style of late imperial Rome, the greatest and most powerful empire Europe had known, that especially appealed to certain powerful kings and dukes. Its bombast and rhetoric, the overwhelming persuasion of the architecture of an ornate and message-bearing façade, proved to be their most readily identifiable prototype.

68. Detail of the giant Doric portico to the Clarendon Building, Oxford, erected for the University Press in 1711–15, designed by Nicholas Hawksmoor.

From the court of the Visconti Dukes of Milan in the 1490s to the Valois court of Francis I of France (1515–47) to that of the Tudor king Henry VIII in England (1509–47), the language of triumphal arches, commemorative columns and complex surface richness became the ornament of self-propagandization and power. This manifested itself particularly in the temporary structures and decorations created for court festivals and entertainments (plate 69).[12] Art historians have conventionally come to judge the degree of understanding of classical art by these Renaissance patrons mostly by reference to their ability, or lack of it, to copy closely the original inspiration of their design and content, the buildings of ancient Rome. More to the point, however, in trying to understand the contemporary attitude, is the fact that we need to be aware that a sense of decorum is here subservient to a richness of invention in pursuit of the latest 'classical' fashion. From each court, foreign rivals to the host country were kept informed by the letters of ambassadors who conveyed news of activities and thereby fostered a keen competitiveness.[13] Slowly, that inventiveness was to bear fruit in the creation of versions of classical types of ornament associated with specific countries. Classicism was thus kept alive by the reinvention of its meaning in modern, nationalistic terms. Each nation state appropriated the ornament of the antique world to its own uses and then proceeded to claim the invention of a new species of classical ornament for itself, as if it were an extension of that triumphal past.

Columns and mouldings:
from buildings to candlesticks

It is often said that we have only a fragmentary understanding of the buildings of the ancient Greeks because the kinds of building that survive from that civilization are largely great temples where the very grand size makes the essential signs of the meanings of ornament physically remote from us.[14] We have to stand back to look up at the capitals atop the columns and the remains of sculpture on high friezes or pediments to understand something of the purpose of the building before us. But even if our knowledge of ancient Greek building is constrained by the lack of the more mundane and domestic structures like those we possess from ancient Rome, the evidence suggests that it was with the buildings of the ancient Romans that ornament became truly visible at ground level and was related for the first time to the personal, human experience of architecture. The great range of building materials that the Romans employed also encouraged a surface richness (plate 70).[15]

69. Arch for Henri II of France's entry into Lyons, 1548. Woodcut from Maurice Scève, *La Magnificence de la superbe et triomphante entrée de la noble antique cité de Lyon faicte au Très-chrestien Roy de France Lyon*, Lyon, 1549.

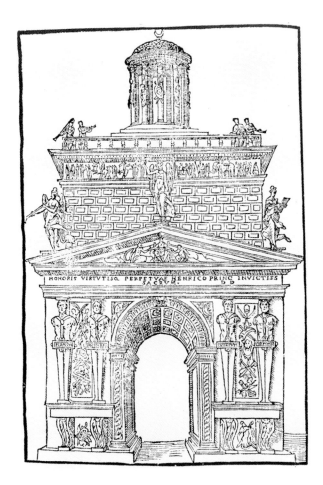

70. The 'colonnace', Forum of Nerva, Rome, late first-century AD. In their ruinous state, Roman buildings are eloquent about the application of rich materials, such as marble or porphyry, to the fronts of buildings, door surrounds or colonnades, especially here where an architectural illusion, to give an impression of greater width to the forum, was intended. The Romans also used basic materials such as brick or tufa (volcanic matter) in patterned configurations at eye level.

Matching the visual experience of architecture to something within the reach of the average human being also extended to the perceptual understanding of what it was all about in human terms. Again it was the writings of Vitruvius that exerted an enormous influence on the Renaissance in claiming that the origin of forms in architecture were related to the size and proportions of the human body (plate 71).[16] We have already seen that forms of ornament could be associated with particular human types, with the people of particular towns, and with male and female characteristics. In this debate, the role of the column was crucial because column shaft and capital were equated with body and head. From its proportions and type, its 'character' as Doric, Ionic or Corinthian, all other aspects of the building followed suit.

Each column type and its dependent supportive features came to be part of a system of decoration known collectively as the orders, which were rules by which every part of the column, from the base and plinth beneath it to the frieze and architrave above, formed a sort of set of readily identifiable companions within a given type.[17] They were all related to each other in size by being fractions or multiples of a common unit of measurement, taken from the column shaft itself. It is interesting, in terms of the language employed here, that Vitruvius did not use the word 'order' but the more generalized word *genus*, meaning 'type'. It was during the Renaissance that the word 'order' first came into use for this system. It derived from the Italian *ordine* with all the associative meanings of the word to do with logic, rule and a sense of strict organization. Hence there came into being the notion that these 'rules' could not be broken without challenging the weight of tradition. In the architectural treatise, it became the convention to display each order as a diagram of the column, replete with all its detailed, interdependent measurements. On their journeys to the great buildings of ancient and modern Italy, aspiring architects took copies of printed treatises in order to annotate these drawings against the originals; sometimes they would note a difference of opinion with the text or draw on their experience to suggest a better example of a particular feature from another ancient site.

In this way, the column became the seminal reference point of the classical tradition and acknowledging this became the way through which a range of other objects in the visual arts were taken seriously. Specific forms which echoed its shape, such as the military cannon or items of street furniture such as lamp-posts or bollards, took on not just the form of the column but the crucial items of its decoration. When the cabinetmaker Thomas

Chippendale published the first comprehensive book of furniture designs, *The Gentleman and Cabinet Maker's Director*, in 1754, he was anxious to assert the status of his craft by reference to architecture: 'Of all the ARTS which are either improved or ornamented by Architecture, that of CABINET-MAKING is not only the most useful and ornamental, but capable of receiving as great assistance from it as any whatever.'[18] To emphasize the significance of his designs, he illustrated the five orders directly from James Gibbs's *Rules for Drawing the Several Parts of Architecture* of 1732 (plate 72). In the apprentice drawings of a Mainz cabinetmaker, a column is drawn beside a bureau to indicate that the care that was taken with the proportions of one is equally applicable to the other.

So it was that the system set up by the orders influenced the shape and design of all manner of objects whose makers took for granted the central authority of the classical tradition. Classical mouldings are the parts of the orders that had their origin in a practical function, for they threw off rainwater. They then developed into a visually pleasing appearance: when seen together, they give an interesting sequence of light and shade which draws the eye to the edge of each of the building's constituent parts. Mouldings for the Ionic order, and subsequently for the Corinthian and Composite as well, were often enriched with decoration the descriptive names of which have passed into the history of decoration more generally; names such as egg and dart, bead and reel, Greek key. The use of these mouldings spread from architecture to all objects in the decorative and applied arts that were structured in a way that imitated or paralleled architecture (so anything of a regular shape, square, oblong or round, with clearly defined edges and sides) and had a practical use (plate 73).

71. The Composite order from John Shute, *The First and Chief Groundes of Architecture*, London, 1563. Shute's illustration to his treatise, the first in English on the orders, here demonstrates the relationship between the proportions of the Composite order to the heroic female form.

72. The Ionic order, from Thomas Chippendale, *The Gentleman and Cabinet-Makers Director*, London, 1754. London, Victoria and Albert Museum.

The mouldings that we see, for example, at the base of an eighteenth-century coffee pot or candlestick take their form, in origin, from the mouldings of the base of the column. Any object that needed to be bounded by a framing device which defined its edges and corners would assume the rules of the classical orders for that purpose. From the late fifteenth century until the end of the nineteenth, the vast majority of items of domestic furniture, like cupboards, chests and tables, were surmounted and framed by forms derived from classical architecture and assumed the proportions of classical columns and entablatures. It is only at the very end of the nineteenth century that we find the first pieces of furniture without the familiar classical moulding as the surmounting feature; the cabinets of Otto Wagner, Charles Rennie Mackintosh and Adolf Loos (plate 74)[19] are a case in point. The dominance of classical mouldings was equally true of the picture-frame, the device which visually sets up and defines for the viewer the 'picture-window' world of the image in perspective which dominated the tradition of European and American painting until the early twentieth century. Indeed, if we look at many great altarpieces from the Renaissance, the classical columns that frame the image end in capitals exactly at the height of the heads of the figures of saints in the picture, not only guiding our eyes to the significant parts of the composition but also stressing the connection between the inner logic and proportion of the column and that of the analogous human figure, as discussed by Vitruvius and the writers who followed his example.[20]

73. Chocolate Pot, English, silver with London hallmark 1722–3. Mouldings originating in architectural ornament here define and strengthen the joints and edges of the object. London, Victoria and Albert Museum.

74. Chest of drawers by Adolf Loos, c.1900. A piece of furniture from the turn of the century which breaks conventions by the absence of classical mouldings. London, Victoria and Albert Museum.

Classicism: authority and invention

Careful study of classical prototypes became the way of signalling to an audience, especially the customers of any practitioner of either architecture or an art dependent upon it, that rigorous training in the classical tradition had taken place. Before early nineteenth-century visitors went through to the house and professional office of the architect John Nash in Regent Street, London, they passed through a gallery displaying scale models, made to order for Nash in Paris, of the great buildings of antiquity (plate 75). These models were intended as the essential introduction to the visitor's understanding of the man and his designs for modern architecture, new commissions for which were of course open to negotiation in the office beyond.[21] However, this knowledge was but the starting-point. To equal ancient buildings in their command of ornament, architects were aiming not to copy their example slavishly but to build creatively upon the past within the rules laid down by tradition.

75. Model of a tomb at Palmyra. French, *c.*1820. Plaster of Paris with metal armature, probably made by Jean Pierre and François Fouquet of Paris. London, Victoria and Albert Museum.

Certain modern buildings came to be seen as points of reference in the imaginative use of antique precedent. Bramante's Tempietto, built in Rome in the first years of the sixteenth century to mark the supposed spot of St Peter's martyrdom, became one of the seminal buildings both in its use of the Doric order and in the exploitation of the perfect shape of the circular building, used for small temples in antiquity and here appropriated for Christian commemoration (plate 76).[22] It was first illustrated by Serlio as one of a handful of modern buildings, most of them by Bramante, that equalled the achievements of the ancients.[23] When the Tempietto's form was adapted for the design of many centrally planned small buildings throughout Europe, the process of copying was rarely exact; rather the idea of 'Doric' was explored through the ornament of the building. If the 'copy' was a non-religious building then it might seem especially permissible that the theme of Doric should be extended and made more elaborate. A nineteenth-century wooden model of the building, almost certainly made for the purposes of teaching, repeats the pilasters found on the first storey of the original building on the upper storey, thus enlarging on what Doric could express as a means of ornament.

This exploration of the potential of a particular order could be an inventive process. An eighteenth-century London doorway in Doric uses the full range of the decorative possibilities of the order in all its parts and details (plate 77). Indeed, since the application of Doric here is to an individual feature of a building rather than to the building as a whole, certain liberties are taken with convention that would not be permissible if Doric were being used across a complete façade. Most notably, whilst in a Doric arcade both arches and columns, or applied pilasters, would have a continuous entablature above them, here the semicircular arch above the door, providing a fanlight to the space beyond, breaks through the frieze. The whole message of 'Doric' is thus contained within the doorway itself; the rest of the façade of such a London town house may not have borne any further indication of the order at all. On the underside of the projecting parts of the doorcase are panels of flat, round objects that look at first, from beneath, to be shaped like coins or counters, though in fact they are somewhat cone-shaped and taper slightly upwards. These are the guttae, or tiny drops, that conventionally hang beneath the triglyphs of the Doric frieze made into three-dimensional form. In a group of buildings, all of the early eighteenth century, in the English West Midlands, these are interpreted as if they were small hanging bells.[24] Clearly the local craftsmen using Doric in this case may have misinterpreted the information they gleaned from

76. The Tempietto at S. Pietro in Montorio, Rome, by Donato Bramante; the date of the construction is disputed between 1499–1502 and 1508–12.

77. Detail of a doorcase, English, c.1770. Pine with a glazed fanlight. From Abingdon House, Wrights Lane, Kensington. London, Victoria and Albert Museum.

78. A detail of the exterior of the extension to the Guildhall, Bath, begun in 1891 by John McKean Brydon. Just as the ancient Romans used Composite to express imperial power and responsibilities, so here it was thought appropriate to represent the municipal tasks of the city, such as education, hospitality and recreation.

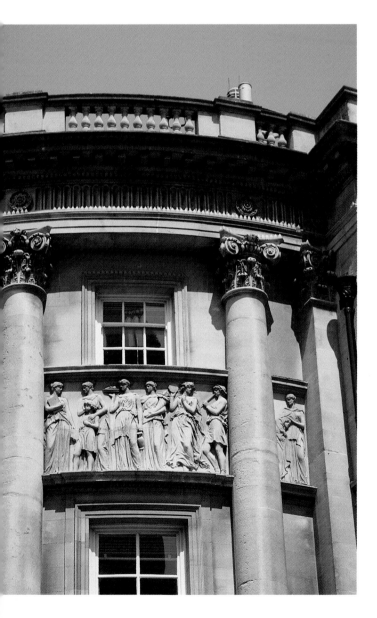

prints in treatises or pattern books. It is also possible, however, that it was simply felt permissible to stretch the point and, while retaining the original reference, express it as a familiar, everyday shape. An exercise in using the Doric Order then, could be an inventive, even witty, process and not simply a restatement of hard and fast rules.

This kind of invention is particularly interesting when we look at the ways in which architects outside Italy interpreted the language of the classical orders in such a way as to give them a nationalist slant. The history of this idea may have originated in ancient Rome itself, for the Composite order is found in Roman architecture from about AD 50 (and therefore post-dates the time of Vitruvius, who does not mention it) and it is thought that it may have originated as an order with particular patriotic importance (plate 78).[25] With the books and illustrations of the sixteenth century to hand, others were to do the same with the raw material of the classical legacy. When the French queen mother, Cathérine de Médicis, ordered extensions to the palace of the Tuileries in Paris in the 1550s she is said to have demanded from the architect Philibert de l'Orme an enriched Ionic order. The architect used tendrils of oak and vine leaves to create curling swag motifs around the usual Ionic form of the volute. This type of capital was taken up by other French architects, not only on the Tuileries but elsewhere so that it became identified with French royal buildings and became known as the 'French' order.[26] Classical ornament was later adapted for an American setting (plate 79).

The case of the expression of guttae as hanging bells discussed above raises an important issue about the way the inventive use of the classical orders has often been judged according to the perception of the architect's command of his material in the first place. It was implied that, because we cannot be certain of the degree of architectural education enjoyed by the local craftsmen of the buildings under discussion, we have to leave the question open as to whether or not the transposition of ornament was intentional. If a famous architect did this we might be inclined to suppose that he knew exactly what he was doing. His interpretation of the source would be based, we would assume, on knowledge. It is an old adage of the world of entertainment that comedians who depend for laughs on the audience believing them incompetent when in fact their jokes or tricks are deliberately made to misfire, have to know how to do the thing right in the first place in order to work at getting it wrong. In building, it was believed that only those who knew the rules and had demonstrated a capacity to follow them were entitled to break or even bend them.

79. (*Right*) Cast of an Ionic capital of the mid-sixteenth century from the palace of the Tuileries. French, *c.*1884. Plaster. London, Victoria and Albert Museum. *(Below)* Wallpaper, made in France in the early nineteenth century for the American market. The corn-cob in this design is a further example of how a standard classical motif, in this case from pilaster decoration, can be adapted to make a national symbol. The American Museum, Claverton Manor, Bath.

Classicism: challenging the canon

In writing about his revered contemporary, Michelangelo, in his *Lives of the Artists* (second edition, 1566), Giorgio Vasari praises his work in the Medici Chapel in Florence, carried out in the 1520s and 1530s, for its skill and inventiveness but notes the dangers of this freedom of interpretation when it is done by incompetent hands:

For the beautiful cornices, capitals, bases, doors, tabernacles and tombs were extremely novel, and in them he departed a great deal from the kind of architecture regulated by proportion, order and rule which other artists did according to common usage and following Vitruvius and the works of antiquity but from which Michelangelo wanted to break away. The licence he allowed himself has served as a great encouragement to others to follow his example; subsequently we have seen the creations of new kinds of fantastic ornament containing more of the grotesque than of rule or reason (plate 80).[27]

Michelangelo's challenge in the Medici Chapel was extraordinarily complex. From an initial commission to design the tombs of Medici dukes he slowly evolved an architectural language that suited the new form of wall monuments that he was seeking to assemble. Hitherto, during a century or more of the revival of classical forms for tombs, the antique had largely been mined for imagery stressing the glory of the achievements of the life of the dead person. So we find, for example, much use of the idea of the triumphal arch and military imagery for the earlier Renaissance tombs of the Doges of Venice (plate 81). Michelangelo sought a more spiritual evocation of the passing from life to death for what was originally a sealed and private space in which mass was said continually for the souls of those buried there. The ornament of the tombs and the surrounding architecture was meant to transport the viewer into a state of contemplation of death, and the disturbance to the classical canon was designed to serve that end.[28]

81. Tomb of Doge Andrea Vendramin by Pietro and Tullio Lombardo, 1480s–1490s, marble. Venice, Basilica of SS. Giovanni e Paolo. The use of the Roman triumphal arch here encloses a representation of the Doge lying in state, a reference to the burial of his earthly remains, while above, under the arch, his spirit is presented to the Virgin and Child in heaven.

80. Detail of frieze showing grotesque heads from the tomb of Lorenzo de' Medici, by Michelangelo, 1520s–1530s, S. Lorenzo, Florence.

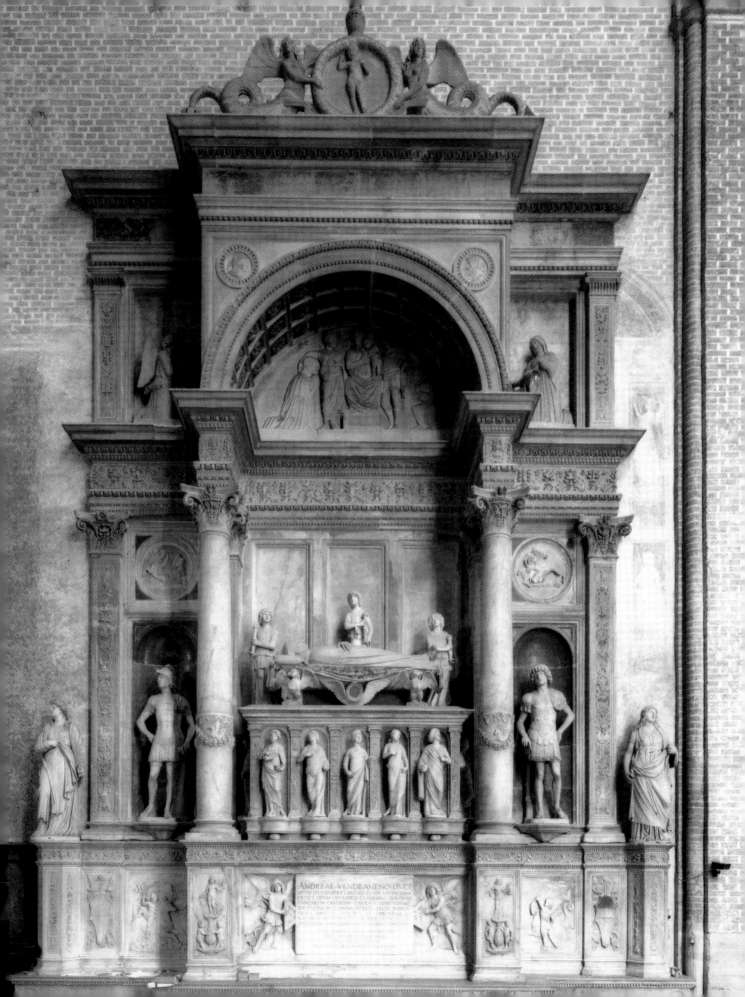

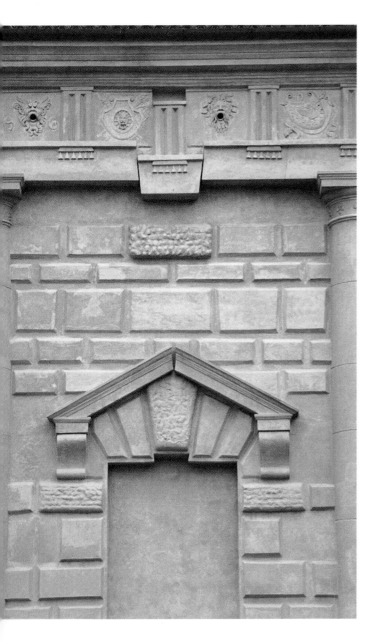

82. Detail of the courtyard of the Palazzo del Te, Mantua, by Giulio Romano, c.1526–34, showing the dropped triglyph motif.

Vasari's comment on Michelangelo has often been used as a handy critical text to open discussion of the architecture of the phenomenon called Mannerism, often characterized as a movement in the arts which challenged and disrupted the rules of classical harmony.[29] Examination of the reasons for that disruption in the Medici Chapel suggests that context is all-important and that no set of rules can be universally applied when the range of uses of classicism is so great and will at all times be expanding. Even on a single building, Renaissance architects could change the manner of ornament to fit changes of function. On the public façade, facing the city, of the Palazzo del Te, built for the Duke of Mantua, Giulio Romano even bends the rules by allowing the keystones of the ground-storey windows to touch the string course above them; indeed on the three central arches giving entry to the courtyard, the keystones actually break through the string course altogether. But it is within the court, in the more private space that the duke and his courtiers would enjoy, that the architect manipulates the Doric conventions most emphatically by dropping every third triglyph over the arcade a few centimetres below its usual position, creating a more varied effect of light and shade at frieze level (plate 82).[30]

Similarly, Renaissance architects created new forms of ornament within the classical tradition by moving things from one context to another and thereby suggesting novelty. It is now generally agreed that the baluster motif is recognizable as a feature of classical antiquity in sculpture. It was during the Renaissance that it was moved into architecture. Then its most recognizable form, the double-bulb shape, came into being and was used in a repeated form to make the balustrade, which took the place of the classical convention of the parapet wall. It later became decorated with a variety of shapes and decorative motifs.[31] In the seventeenth century the baluster became ever more extravagantly used and architects often eschewed the carefully measured proportions that balusters originally had. From these beginnings, the baluster became a widely used form for all kinds of objects, both architectural and non-architectural (plate 83).

The freedom to invent ornament out of the plethora of antique example began with the physical evidence of antique remains and the widely distributed illustrations of these. The quest for the fullest understanding of the classical world did not stop there, for many architects attempted to recreate, with imagination and a good deal of poetic licence, lost buildings or those that survived in only the smallest fragments. The wealth of fragments of different structures at Hadrian's villa at Tivoli, for example, spawned many such reconstructions. An archi-

tect such as the seventeenth-century Italian Francesco Borromini took as much from this wealth of speculative material about ancient building as he took from treatises and careful measurements to create the complex geometric shapes and sinuous lines of his Roman buildings and their ornament (plate 84).[32] Far from adhering closely to a strict appropriateness of types of analogous buildings, Borromini would look at a quite small-scale, but complex and ornate, Roman tomb for inspiration for a much larger building. This willingness to take imaginative risks and to aggrandize scale are keys to an understanding of the work of the most influential of eighteenth-century British architects in the field of ornament, Robert Adam.

83. Three balusters: Netherlandish, late seventeenth-century, oak; English, *c*.1725, mahogany; English, 1871, earthenware with enamel colours. London, Victoria and Albert Museum.

84. Detail of the church of S. Ivo della Sapienza, Rome, by Francesco Borromini, begun in 1643. As well as a free interpretation of classical mouldings and capitals, the architect incorporates in the ornament stars and stacked hills, motifs from the arms of the Chigi Pope, Alexander VII (1655–67).

In many ways the work of Robert Adam can be viewed as a high-water mark of the imaginative mind at work on the sources of classical ornament, and surveys of his work which include his designs for interiors and their furnishings show the extent to which the language of classical ornament had pervaded a vast range of objects.[33] The exteriors of his buildings often meet the criteria set out in the introduction to the *Works in Architecture* which he published with his brother James, the first volume of which came out in 1773: movement or 'rise and fall, the advance and recess and other diversity of forms' (plate 85),[34] an adherence to the classical tradition of creating patterns of light and shade to evoke something of the grandeur of the classical past. But even here, and more especially in his interiors, Adam employed ornament with a very light touch. He sought to replace, as he saw it, the heavy and ponderous version of correct classicism that had pervaded British taste in the first half of the eighteenth century. Often he seems to work within the traditions established in the Italian Renaissance concerning the appropriate application of the orders to different kinds of building in Christian society; so his churches of Gunton and Mistley employ the Tuscan order, while for the public commission of Edinburgh University he uses the Doric.[35] But it is the way he rethinks the ordering of details that reveals a new confidence in the handling of his sources. Even his Doric capitals (which are usually left plain) are often decorated on their necks with leaves or feathers. He used a new order both in architecture and the applied arts based on some unusual capitals that he had seen at Diocletian's palace at Split: here the capital is divided into two bands, the lower of palmette ornament and the upper with a series of short flutes, a truncation of the ornament that we usually associate with the decoration of columns (plate 86).[36]

85. Kedleston Hall, Derbyshire. The south front, designed by Robert Adam, 1760s. The most celebrated example of Adam's 'rise and fall, the advance and recess' in architecture.

86. Detail of 'The Duchess of Manchester's Cabinet' showing the use of the Diocletian order of capitals, designed by Robert Adam, 1771. Various woods with ormulu mounts, made by Matthew Boulton, framing marble intarsie. London, Victoria and Albert Museum.

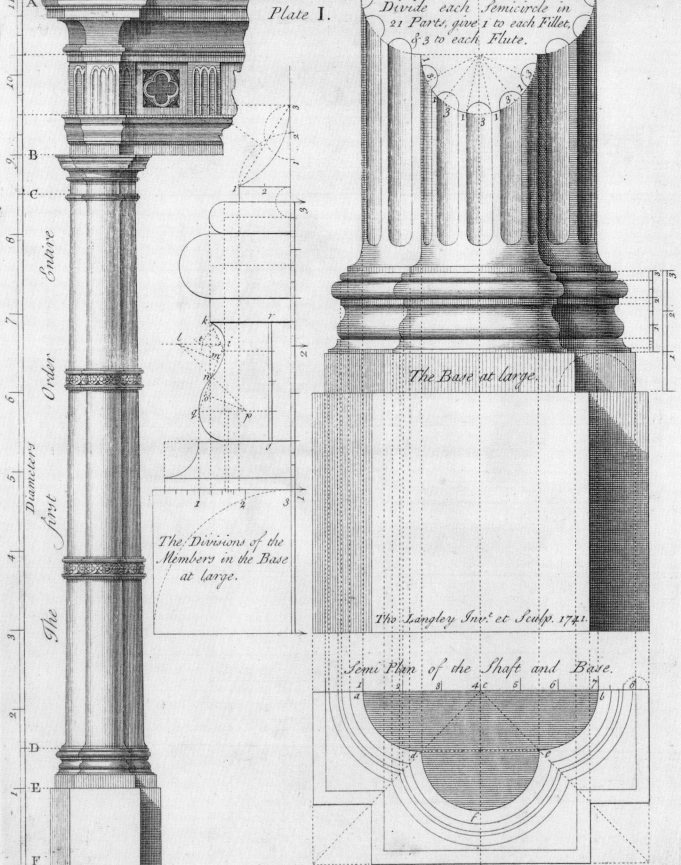

Plate I.

Divide each Semicircle in 21 Parts, give 1 to each Fillet, & 3 to each Flute.

The Base at large.

The Divisions of the Members in the Base at large.

Tho: Langley Inv.t et Sculp. 1741.

Semi Plan of the Shaft and Base.

The first Order Entire

The Diameters

Divide AF. the entire Height into 11 Parts, give 1 to EF. the Subplinth, ½ the next to DE. the Base; the next 7 to CD the Shaft; the next ½ to BC the Capital, and the upper 2 to AB the Entablature.

The nineteenth century: nature and nationalism

It has already been suggested that the triumph of the classical style and its ornament came about between the fifteenth and the eighteenth centuries all over Europe and eventually America because certain messages from the ancient world could be transplanted to bolster the identities of modern nation states and their rulers. Reaction to the dominance of classicism focused on an alternative national identity rooted in the time between the ancient world and the Renaissance, and particularly the last phase of this period when the style we have come to call Gothic prevailed. It was not, however, simply a question of Gothic ornament being asserted as an alternative mode to the classical. A false start along these lines was made by the English writer on building, Batty Langley, whose *Ancient Architecture Restored and Improved* of 1742 attempted to establish a series of 'orders' for Gothic architecture, supplanting one kind of vocabulary of ornament by another but keeping to the proportions and the relationship of parts one to another that had held sway under classicism (plate 87).[37] An eighteenth-century candlestick demonstrates this attempt very well: the idea of the column shaft and its proportions keep to classical convention, but the mouldings and decoration are Gothic-inspired (plate 88). The true path, as proselytized by great nineteenth-century writers, lay not in the validity of Gothic ornament itself but in what it represented about the nature of medieval society and the mainsprings of creative invention in ornament that contradicted the classical tradition.

For the nineteenth century, the 'discovery' of the medieval past was the equivalent of the classical discoveries of previous centuries. It was not that medieval buildings had been overlooked, ignored or even viewed disrespectfully as the classical style prevailed, but that they had been seen in a general and really rather low light as 'antiquarian'. The early nineteenth century documented them, measured them, and discovered the richness and inventiveness of their ornament by having to restore them, often after centuries of neglect.[38] If one key notion can be said to link together the enthusiasts for medieval ornament in the nineteenth century it was the sense that ornament should be generated from the building itself and from the very practice of handling and crafting its materials. Augustus Welby Pugin (1812–52) wrote of the current, as he saw it deplorable, state of building, that 'styles are now *adapted* instead of *generated*, and ornament and design *adapted to*, instead of *originated by* the edifices themselves'.[39] So the notion of taking ideas from printed illustrations, the bedrock of learning in the classical tradition, was wrong: 'Nothing can be more dangerous than looking at prints of buildings, and trying to

87. 'Five new orders of columns', plate 1 from Batty Langley, *Gothic Architecture Improved*, (the retitled edition of his *Ancient Architecture*), London, 1747. London, Victoria and Albert Museum.

88. Candlestick, English, Sheffield hallmark for 1773–4. Silver, made by Samuel Roberts & Co. London, Victoria and Albert Museum.

imitate bits of them.'[40] In trying to understand how medieval builders went about the process of construction, modern architects would find new inspiration for ornament. For Pugin, this was necessarily to be directed to the service of the evangelical revival that was taking place; Gothic expressed the true spirituality of Christianity and it was as if the string of subtle compromises made since the Renaissance to harness classical ornament in the service of the Church were to be denied.[41]

It was the critic John Ruskin (1819–1900) who most clearly articulated the need for a clean break between ornament and the structure which it decorated.[42] Since Alberti, it had been held that the ornament which 'dressed' the building gave it life and meaning. In Ruskin's view, ornament need not simply be at the service of a building's construction and function: it could speak with its own voice as the celebration of the creative use of the wealth of detail in the natural world around us. You should not, he argued, 'connect the delight which you take in ornament with that which you take in construction or in usefulness. They have no connection, and every effort that you make to reason from one to the other will blunt your sense of beauty. ...Remember that the most beautiful things in the world are the most useless; peacocks and lilies for instance.'[43] If construction was a science, then ornament was an art which should not compromise the notion of use, the idea of utility. Ruskin found his ideal guiding spirits in the work of the craftsmen responsible for the styles which he saw as the greatest achievements of the medieval period: the Pisan Romanesque, the Venetian Gothic (in *The Stones of Venice*, the first volume of which was published in 1851) and English Decorated, the very name for which had only been invented earlier in the nineteenth century as the styles of English Gothic were categorized and severally praised, each for its distinctive qualities (plate 89).

Both Pugin's and Ruskin's writings were enormously influential on more than one generation of British architects but it is interesting that we can see perhaps the clearest influence of the sense of a new species of ornament arising afresh out of each new building – a unique blending of the characteristics of site, materials, function and structure – in the work of some of the great late nineteenth and early twentieth-century American architects, and pre-eminently the Chicago architect Louis Sullivan. This is due in no small measure to the fact that Sullivan could stand above the battle of the styles that pervaded the nineteenth century because he was creating the blueprint for completely new structures made possible by modern technology, especially the warehouse and the skyscraper. Nature remained, as it had been for classical and Gothic, the chief source of inspiration but

89. The thirteenth-century nave bay design of York Minster, a standard reference-point for the English Decorated style in the nineteenth century. From John Britton, *Cathedral Antiquities*, 1836.

now it was used as the basis for a new vocabulary of orna-
ment. His early decorative style of the 1880s consisted of
quite bold, yet abstracted shapes, precisely defined by
one critic as 'sharply delineated botanical abstractions
[that] consisted of fan-shaped leaves and petals, spiral
leaves with scalloped edges, broad leaves resembling
scallop shells, and smooth-edged leaves'. This developed
into his later, flatter, more organic style of the 1900s
which resembles at first glance the fine and delicate iron-
work of late medieval art, yet again is abstracted away
from its source in nature (plate 90).[44]

90. Terracotta panel from the Felsenthal Store by
Louis Sullivan, 1906. The abstract shapes of shields
and ovals are mixed here with naturalistic berries
and leaves. The borders of the panel equally
contrast the shapes of ovals and bars (abstracted
from the classical 'bead and reel' motif) with
a natural vine ornament. Chicago, Art Institute.

Modern times: the fall and rise of ornament

Looking back over some of the most influential writings on ornament since Vitruvius, many compilers of dictionaries and compendia of ornament have sought to find certain universal principles in the way natural and geometric shapes are used and re-used. However, we constantly find that the moment writers use the language of their day to justify one kind of ornament over another they are inevitably entering wider debates to do with the prevailing beliefs and radical issues of their time. Vitruvius' attack on the excesses of the non-naturalistic style of late Roman wall-painting may seem, on first reading, to be a working architect's appeal for the use of logical, rational perspective and a correct, relative scale of objects when creating illusion on the wall surface.[45] His treatise has, however, recently been interpreted not in

such absolute terms but rather as a way of reasserting the middle-class values of the previous republican era over the effete (as he saw it) aristocratic tastes of his own age.[46] Pugin and Ruskin were faced by a different set of problems in the struggle to keep ornament as a creative, personal tool for the craftsman. Industrialization threatened, in their eyes, the move of all forms of ornament away from valuable, individual achievements towards a cheap and valueless common product. So that when we arrive at the first statement that sought to undermine the value of ornament on architecture no matter what the source or means of production, it should be located with some historical accuracy. Adolf Loos's 1908 essay 'Ornament und Verbrechen' (Ornament and Crime) was his response to the extravagant ornament of art nouveau, most particularly the work of Henry Van de Velde and Joseph Olbrich, whom he singles out as responsible for the mistakes of the recent past. Loos was also very much attuned to the latest thinking emerging from Vienna about the need to understand phenomena such as ornament in psychological terms, stemming from the deepest needs of human beings for erotic expression. His essay is a polemic against all forms of decoration, taking as its starting-point the power of ornament to deceive and deny the intrinsic quality of the materials it decorates.[47]

The twentieth century's dispute with ornament has taken place on a number of levels. At one stage, it was much concerned with the feeling that there was a need to reject the past as a collection of tired and moribund styles that no longer applied to the buildings of modern times. This was the inevitable result of the battle of the styles of the nineteenth century which elevated historic styles into a contest and, in so doing, implied that there was an ideal form of ornament to reach for. At the end of the century there was something of a stand-off in this battle as many past styles coexisted in a period of high eclecticism, often expressed through an overload of ornament which added nothing new to the basic vocabulary. It also got caught up with the rhetoric of class struggle which for past styles had been the preserve of aristocratic and authoritarian regimes; industrialization during the nineteenth century had offered the working class no more than cheap imitations of the luxury china and fabrics of the past. The appropriation of a particularly monumental and faceless interpretation of classicism by Fascist governments of the inter-war years probably did much to alienate people from that style's potential for grandeur and sense of occasion, in both physical space and time. Yet it was the reaction to a kind of architecture that initially sought to be the expression of its time (through the celebration of modern materials such as pre-stressed concrete which allowed little, if any, orna-

ment) and to serve the needs of ordinary people (by the clearing of old and poor urban housing and its replacement by mass, high-rise units of housing) that prompted a reversion to the language of classicism in the buildings that most clearly reflected changing lifestyles in the West during the 1970s and 1980s. To distinguish it from what had gone before, this movement has come to be termed 'Post-modernism' (plate 91).[48]

This new phase became possible when it came to be accepted that the classical past need not be authoritarian nor need it have won an intense battle over its challengers from other epochs of the Western past. In fact, its architectural language might well be able to sit comfortably beside styles once seen as its rivals if the forms and shapes could be preserved but its former strict hierarchy of parts, some dominant, others subordinate, could be handled more freely. The message of classicism had once been conveyed in a such a way as to imply an order and decorum that was quite strictly stratified by the building's public or private use, defining the audience thereby through a process of inclusion and exclusion. Post-modernism sought rather to appeal to different audiences at the same time: in the words of one of its most influential historians, it 'speaks on at least two levels at once: to other architects and a concerned minority who care specifically about architectural meanings, and to the public at large, or the local inhabitants, who care about other issues concerned with comfort, traditional building and a way of life' (plate 92).[49] Post-modernist buildings have been criticized as much as they have been praised in Europe, perhaps because the mixing of classical with vernacular (or local and traditional) styles has seemed more intrusive alongside buildings of great age that are especially revered. In the United States, where many of the twentieth century's new building types (cinemas, supermarkets, leisure and sports centres) first had to establish their architectural identity, the reassertion of the importance of detail on buildings has lent personality to environments that might otherwise have seemed arid and alien because the transient, short-lived services they provided had no traditional values. Careful proportioning and considered relationships of scale may now seem less important but the basic classical forms have been invested with a new frame of reference in the out-of-townscapes of recent times.

91. Shopping development, St Ann's Square, Manchester, 1980s. The Post-modernist language here occurs through projecting window bays, rising through all floors, expressed like elongated projecting pilasters supporting a pediment and the introduction of colour in external fittings such as the window frames and mock-railings.

92. Tesco Supermarket, Purley, Surrey, 1980s. The Post-modernist appeal to the past here comes through the use of materials; bands of detailed roof-tiling copied from patterns previously used on vertical surfaces and half-timbering on the gables.

93. Necklace and earrings, French, *c.*1840, enamelled gold. London, Victoria and Albert Museum.

3

Ornament and the Human Figure

In that day the Lord will take away the bravery of
their tinkling ornaments about their feet, and their
cauls, and their round tires like the moon,
The chains, and the bracelets, and the mufflers,
The bonnets, and the ornaments of the legs, and the
headbands, and the tablets, and the earrings,
The rings, and nose jewels,
The changeable suits of apparel, and the mantles,
and the wimples, and the crisping pins,
The glasses, and the fine linen, and the hoods,
and the vails.[1]

The terrible punishments awaiting the people of Judah and Jerusalem as prophesied in the Book of Isaiah are echoed throughout the Bible whenever the sin of excessive visual luxury is judged to rule those who have strayed from righteousness. In the Bible, what we identify, in the Western tradition, as the fine and applied arts, generally get a bad press. During every religious upheaval and reform of the Christian Church of the past two thousand years, strictures against over-ambitious building and against self-indulgent forms of dress and decoration of the human figure were the foundation for many a sermon based on biblical texts such as that cited above. Among the many ways of spending both time and money on visual luxury (plate 93), decorating the body seemed especially sinful because its purpose, whether to improve upon God's gifts by artifice, to express personal vanity or to incite sexual attraction, went against Christ-ian teaching about personal humility and submissiveness.[2]

However, whilst Christian society has viewed the body as dangerous in one sense, in another it has been seen as the receptacle of ideal values, ideal forms. If warnings of its danger came from Christian teaching, the idealism came from the legacy of classical, or pre-Christian, society. During the fifteenth century, a concept of the body closer to the thinking of the Greek and Roman world came back into discussion of the figurative arts and the theoretical writing that lent the arts intellectual respectability. The idealized, unclothed body as created by artists was given an elevated position as a standard of perfection that nature was always striving unsuccessfully to achieve. The ideal human body encompassed all the necessary ground rules for proportion, symmetry and order that were a paradigm for creativity throughout the arts, including the process of devising a building (plate 94).[3] So to mark the body, or to deck its shape with ornament of any kind, was in a sense a disfigurement on two counts, since it contravened ideals both religious and philosophical.

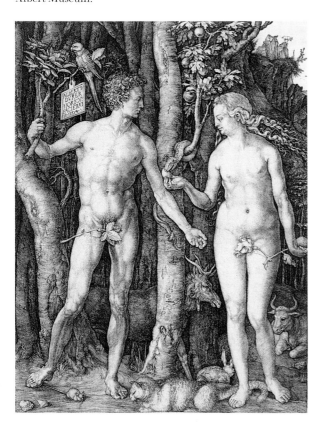

94. Albrecht Dürer, *Adam and Eve*, engraving, 1504. The idealized human form, here based on prints after classical sculpture, in the hands of a northern European artist. London, Victoria and Albert Museum.

Western conventions can be tested by comparison with the art of the Far East, where the naked body has conventionally had little meaning unsupported by decoration; in the great civilizations of China and Japan the body has been viewed rather as a blank field on which elaborate ornament has to be placed to convey any meaning at all. It was painted or tattooed to denote, for example, military prowess or sexual attraction.[4] Equally, the traditional clothes of Far Eastern civilizations did not suggest the shape of the body beneath, with its message of activity and suppressed eroticism, as in the West, but were loose and voluminous. When such Eastern forms of dress became fashionable in seventeenth- and eighteenth-century Europe, they were often used as nightgowns or informal, usually private, day wear, so the activities with which they were associated did not involve any physical exertion or appearance in a public place (plate 95).[5]

The history of ornament and its application to the human body in Europe and America during the past five hundred years was, as a result, one of constant flirtation with the boundaries of excess, of hinting at the erotic without actually revealing the objects of desire, of many changes in fashion. If, on one level, Western society has seen the marking of the human form as potentially disfiguring, it has not ignored the importance of ornament of the body and its clothing as means of conveying distinction, particularly between social classes. Differences of ornament can convey subtle messages of rank and position. At the same time, the leeway for personal statement, even eccentricity, is often carefully explored by individuals who wish to appear members of a group, but special within it.

Changes in style in the presentation of the body are invariably to do with a change of image rather than practical needs.[6] Newly invented and revived styles of ornament were more carefully modulated and more finely judged in relation to their application to the body than to any other object of art or craft made by Western hands. At all times issues of decorum are paramount. Where dress is concerned, the deliberate flouting of the norm designed to cause outrage is generally less effective in the long run, and certainly less likely to start a trend in fashion, than those slight, and often witty, modifications which question the detail but do not upset the framework of convention. The human body is basically symmetrical but its working parts carry out very different functions; clothes and their ornament give the body, in repose and in motion, a unified appearance. The 'suit' for both men and women has come to be particularly equated with the need for a formal appearance, a sense of composure and self-possession on important occasions or for a role in a working life. The ornament of the suit, be it through overall pattern or the edging of each part stitched into the whole, aids and underlines that unity and formality. For upper-class women, sets of jewellery, known as *parures*, from hair to waist, have at times been the fashionable way to ensure that the ornamental unity of the body was understood in terms of wealth and position. Just as there has been this constant return to basic rules of what ornament can do for the human form, so the sources of motifs for the ornament itself over the past five hundred years have returned to the most readily recognizable and well-established vocabulary, notably taking inspiration from nature in the form of flowers and from Western civilization's own sense of its past in the ornament of the ancient world of Greece and Rome. In this sense, clothes and their ornament can be paralleled in many other forms of applied art where similar recourse to established norms took place. This chapter will explore the ways in which changes in ornament can be seen rather as a history of the recapitulation of ideas than as a catalogue of the seemingly ephemeral things we have come to call 'fashion'.

95. Dressing-gown, with stylized Eastern motifs, English, 1708. London, Victoria and Albert Museum.

Marking the body: the tattoo as ornament

Humans can decorate their bodies in two principal ways: by adding ornament to the flesh itself and by adopting clothing that does more than simply meet practical needs. Ornamenting the natural body can take various forms. The skin itself can be marked or punctured for permanent or temporary effect (plate 96). With the use of cosmetics, the skin surface can be painted to change the hue of the flesh and to sharpen or de-emphasize the features. Human hair can be cut and shaped (in the revival of severe, sharp-edged styles during the 1980s, 'sculpted hair' became a common descriptive term) or braided and interwoven with other material substances. Today it is perfectly socially acceptable to do none of these things but in earlier times someone from the upper or respectable classes who failed to conform to fashionable norms of 'dressing' the face and hair when appearing in public would have been accused of breaking convention. Clothing the body has, on the other hand, always been a prerequisite for decency and social order over the past five hundred years, though the accepted wisdom about the amount and appropriateness of dress for particular activities has changed considerably. In the late twentieth century it is not indecorous to appear in public wearing very little for all kinds of working and recreational activities, and indeed many fashionable forms of dress in very recent times have been inspired by clothes initially devised for sport.

In a great many instances of marking the body itself, the ornament depends for its potency as a symbol on the relationship of the individual to some group identity. It may often be quite discreet and subtle in its message and need not depend on the additive materials of cosmetics but derive from the skin and hair of the body itself. A scar on the face of a man can signify distinction in battle, whether for his country or, if he lives in a social group that values such things, as a token of honour, virility and survival. At one time, as the outcome of a code of conduct strictly followed by gentlemen, the scar would arise from a duel; in more recent times, perhaps equally governed by an unwritten set of rules, it is more likely to happen within a social environment where battles are between groups for territory or between factions engaging in crime. Equally, human skin or hair can be a sign of quite specific meaning for or against a particular group allegiance. In the nineteenth century, Anabaptist males, strictly pacifist in their attitudes to war and violence, deliberately shaved their upper lip to show their distinction from the fashion for moustaches among young soldiers. The shaving of the upper lip survives into modern times among their religious descendants, the Amish people of central Pennsylvania.[7]

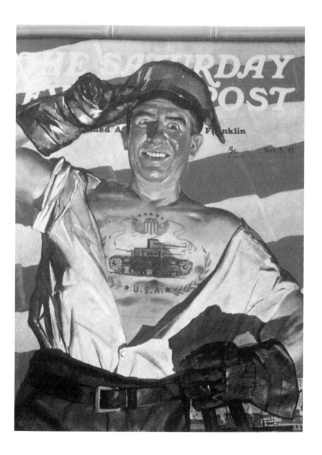

96. The *Saturday Evening Post* cover of November, 1941, just before the attack on Pearl Harbour. A tattoo is here a patriotic sentiment: the maker of tanks has one on his chest.

Scarring the skin for the purposes of ornament need not, of course, be accidental but may be a positive decision. Western society has long had an ambivalent attitude towards the art of tattooing. Social scientists and anthropologists, observing the world as a whole, tell us that no other form of body decoration more clearly indicates the need for group solidarity and the individual's safe haven within it.[8] The permanent quality of the tattoo stratifies the people of many non-Western societies into a hierarchy of functions, particularly gender roles: males are characterized as warriors and hunters, females as mothers and wives. In Western society there is much evidence that tattooing was widespread among certain nations until, by the tenth century, Christian teaching had largely outlawed the practice. It reappeared once more following European colonial expansion from the sixteenth century onwards. The word itself derives from *tattow* or *tatau*, Polynesian for knocking or striking. The knowledge that the tattoo was prevalent in societies which came to be identified as 'primitive' enabled the practice once again to be castigated as barbaric and disfiguring. The fact that Captain Cook could notice that 'by adding to the tattooing, they grow old and honourable at the same time'[9] meant that there was some understanding of the signification of the art, yet revulsion was ultimately the standard reaction because the practice hinted at customs and social hierarchies outside European norms (plate 97).

Tattooing has, however, flourished in the West during some periods in the past two centuries. One reason for this is the common culture and security it affords to people who otherwise feel themselves cut off from a group to which they once belonged, or will one day lose; hence the association of the practice with sailors and those whose only home has been an institution. Equally, people may wish to discard identity with a particular group: the power of the tattoo as stigma and as a permanent mark of identity is evidenced by the fact that a significant part of the medical budget in British prisons is spent on the removal of tattoos, granted on demand.

The mobility enjoyed by Western society in the late twentieth century means that people are often travelling to unfamiliar places; body ornament is one way of telling others who we are when amongst strangers and changing those strangers into friends. The late twentieth century is also a time when many alternative lifestyles and their attendant modes of dress have flourished alongside each other as never before; the fleeting fashions that determined the position of hemlines, the width of lapels or the height of heels of the second quarter of the century have given way to a greater variety of choice. Amongst these choices, tattooing is perceived by some as a way of underlining their commitment to a chosen style. Nevertheless, in the dominant culture the tattoo has come to be seen as a manifestation of primarily working-class culture.[10] Yet it has not always been so. Tattooing has enjoyed short periods of favour among the fashionably chic who dispose of considerable income. There was a celebrated vogue among the English upper classes in the late nineteenth and early twentieth centuries when King George V of England (as Duke of York) and Tsar Nicholas II of Russia were tattooed by the famous Far Eastern tattoo artist, Hori Chiyo. Titled women had small tattoos of patriotic symbols placed on their forearms following the coronation of Edward VII in 1901. The significance of these symbols was that they were meant to be seen in public on the exposed arm, and were especially visible during the wearing of evening dress. The vogue soon passed and by 1920 Lady Randolph Churchill, who twenty years earlier had commissioned a discreet tattoo of a serpent on her forearm, took to covering this tattoo with a bracelet whenever she appeared in public.[11]

97. Maori with a tattooed face, watercolour by Sydney Parkinson, artist on Captain Cook's expedition, 1770. London, British Library, Add. MS. 23920.

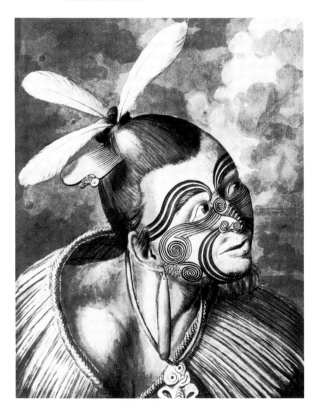

98. Cape, Spanish, 1620s. Red velvet and yellow satin. The velvet is worked with a pomegranate pattern. London, Victoria and Albert Museum.

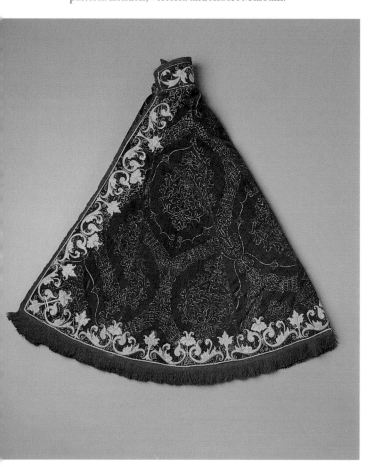

Ornament as the demarcation of class and status

Lady Churchill sported her tattoo while it was fashionable because other women of her rank were doing likewise. She would have been conscious of a complex etiquette that enabled her to identify members of her class on sight not only by the cut of their clothes but also by the ornaments which those clothes bore, especially on formal or ceremonial occasions. Industrialization during the nineteenth century had made certain fabrics much more widely available and also gave rise to the production of cheaper substances to imitate materials as diverse as precious metals and silk that were rare and costly. The codes of etiquette among European upper classes tightened in order to preserve their self-perceived distinction and many traditions were invented to keep ahead of the industrial momentum.

In earlier times, governments had laid down rules as to what clothes classes of society could or could not wear as a means of preventing the sheer power of money (usually gained through trade) breaking through codes of sartorial practice belonging to the nobility of blood.[12] A sumptuary law passed in the England of Edward III forbade 'belts, collars, clasps, rings, garters, brooches, ribbons, chains, bands or seals, or any other thing whatever in gold or silver' to craftsmen and yeomen, and their wives and children.[13] The later sumptuary laws of Renaissance Europe during the fifteenth and sixteenth centuries proscribed certain colours for certain classes of society, identifying the colour blue as fit for the servile population and allowing red fabrics and gold tissue only to nobility (plate 98). Throughout the centuries, the practice of the handing down of unwanted clothes from the wealthy or high-born to their servants was always attended by rituals of stripping the ornament that gave garments their upper-class distinction. This relocation of the garment in its new social place is what Richardson is referring to when in his novel *Clarissa* of 1747–8 the heroine decides to give her maid 'a brown lutestring gown, which, with some alterations to make it suitable to her degree, would a great while serve her for Sunday wear'.[14]

The need for careful demarcations of social groups, whether on the basis of age, gender or functional role, means that at all times ornament is used to separate castes of societies one from another and then to make even finer distinctions within those castes (plate 99). Sometimes these demarcations have their origin in long-established custom; at other times they constantly mutate. The wearing of ermine by the upper ranks of the British nobility is now quite strictly observed: according to the rules, position in the ranks of earls, marquesses and dukes up to those of the royal blood is expressed by

the number of rows of black ermine tails that edge the robe. During the seventeenth and eighteenth centuries, however, writers on heraldry disagreed as to custom and practice not only about entitlement but whether it was proper to line the robe with ermine as well as edge it.[15] In a portrait of the widowed Duchess of Somerset, Allan Ramsay painted his sitter in her choice of mourning clothes, and in the opening of the black jacket she wears, appears the ermine that she had gained as a distinction of apparel through marriage and had preserved as an entitlement into her dowagerhood (plate 100).[16]

99. Detail of *The Adoration of the Kings* by Rodrigo de Osona the Younger, Spanish, early sixteenth-century. Oil on panel. To reinforce an already familiar story, the use of ermine with its associations with royalty would have told the earliest viewers of this altarpiece about the status of this worshipper at the birth of Christ. London, Victoria and Albert Museum.

100. Allan Ramsay, *Charlotte Finch, Dowager Duchess of Somerset*, 1750. Oil on canvas. Private collection.

Demarcation by ornament is especially important where the basic garment is essentially the same for all ranks of a class or profession and has remained unchanged for many years or through many generations. Academic and clerical dress are interesting in this regard; the academic gown lends distinction to the wearer by its length, sometimes its colour if it breaks with the traditional black, and sometimes the quality of its material. At the University of St Andrews in Scotland, for example, it was traditional that the undergraduate gown should be made of pure wool (plate 101). This originated in part from the need to support local manufacture of woollen cloth but it also survived as a mark of qualitative difference as other institutions adopted a range of coloured gowns. Most especially it is the trimmings that lend an internal pecking order to academic dress: the accompanying hat, the coloured edging to the gown, braid, ribbons and even the form of folding and puckering of the material. Clerical dress is often described as a veritable museum of past styles of dress, locked as it is into highly antiquated modes of basic shape and signification by affixed symbols of rank and function.[17]

Some forms of affixed ornament that signify rank have become quite familiar to a wide public; most people today can tell something about the rank of an officer in the military by the number of stripes on his or her sleeve. At its most basic level, decorating the body for battle is a process of creating signs of identification. In the course of conflict, it is important to be able to recognize allies from enemies and equally to recognize ranks so that orders are efficiently transmitted and obeyed. The capturing of the enemy's insignia and weapons, and the subsequent display of these on the field of battle by the triumphant side, a practice which originated in ancient times, marked the appropriation of the key elements of identity and loyalty among the vanquished (plate 102).[18] Identification in death may be equally important in other circumstances than military conflict, making ornament of clothing significant; traditional sweaters worn by the fishermen of Jersey and Guernsey are said to include the parish crest of the wearer so as to help identification in the case of death at sea, ensuring burial in the appropriate churchyard even if the individual cannot be named. Military uniforms also have another function, increasingly important during the past century as technological advance has made armies less visible, less directly active in the field, and the set-piece battle redundant. The parade-ground gives the individual elements of military dress a collective visual coherence; the movement and marshalling of troops in their most colourful, most gold-braided, full-dress uniforms make patterns across the open spaces where they gather. When we speak of other kinds of ceremonial – involving athletes at the beginning of the Olympic Games for example, or the performance of a troupe of dancers – as having 'military precision' we are judging that precision by the regularity and order of the patterns of ornament before our eyes (plate 103).

101. St Andrews University students in red gowns on 'Raisin Monday'. Traditionally, the manner of wearing the gown indicates the student's status: off the shoulder for students in their final year of studies.

102. Detail of the tomb of Doge Pietro Mocenigo by Pietro Lombardo, 1476–81, marble. Venice, Basilica of SS. Giovanni e Paolo. The piling up of trophies, including items of armour and dress, on the battlefield after victory in ancient times became thereafter a symbol of military prowess.

103. Patterns of ornament are always prominent when military bands put on displays for public entertainment, as here in London with the Massed Bands of the Guards' Division.

In many cases the language of braid, tassels and lappets is restricted to a small group of initiates not only within localized social conventions but also perhaps through a shared body of learning that is the key to making sense of what is displayed; without this learning, the meaning is obscure and arcane (plate 104). This is particularly true where the wearers of these distinctions are participating in roles where they have no wish to step completely out of character or social position. At seventeenth-century courts, such as those of Charles I of Great Britain and Louis XIV of France, theatrical performance by leading nobility or indeed the King himself was a way not of allowing the high-born to impersonate fictional characters but of expanding on their established self-identity and personal qualities. For the court of Louis XIV, the architect and ornamentist Jean Berain created hundreds of designs for costumes that were all essentially the same in basic shape; the bell-shaped skirt was common to men and women (though longer for the latter), sleeves were full and made up of a complex interlace of various materials, and footwear consisted of boots with heels (plate 105). What distinguished each figure was the added ornament in the form of lappets, tassels and insignia, conveying the message that this was the figure of Time, that one Music or, in the case of the King himself, the Sun God, Apollo.[19]

At St Andrews, first-year undergraduate students are traditionally presented with tokens of affiliation by older students as part of initiation ceremonies. These tokens are then worn attached to the red woollen gown for the rest of the undergraduate's career. Nowadays this denotes only the maintenance of tradition and usually only the loosest and undemanding webs of friendship and social intercourse. Among the Black Greek Letter organizations in the United States, however, belonging to an academic fraternity or sorority carries much deeper obligations since these organizations grew up as a response to racial discrimination and social deprivation; the first group was set up on the predominantly white college campus of Cornell in 1906. Here the rules on the entitlement to ornament of dress are quite strict and involve a complex interaction of objects that are worn or carried during the pledge period and subsequent rituals and political events. The sweater becomes the all-important object because it allows the greatest field area for design, working the signs and letters of the group into customized patterns. Though Black Greek Letter clothing serves as a quasi-uniform, like many shared group affiliations expressed through dress, enormous attention is given to personalized statement within the rules of the group (plate 106).[20]

104. A coatee with shoulder wings and shoulder belt over a mess jacket and waistcoat from the West Kent Regiment 37th Light Infantry Militia, 1845. Maidstone Museum and Art Gallery.

105. 'Hercules' in Lully's tragédie lyrique *Atys* by Jean Berain, 1679. Watercolour, pen and ink. London, Victoria and Albert Museum.

106. Members of the Phi Epsilon Phi national honorary fraternity at the University of Colorado at Boulder, 1936. Minority groups encouraged highly individualistic sign language on clothes to challenge traditional Greek Letter organizations such as this with their uniformity of dress.

107. Locket commemorating the escape of Charles II from the parliamentary forces by hiding in the 'Boscobel Oak'. English, 1660s. Gold. Personal objects, such as this and memorabilia of Charles I, were made as tokens of loyalty to the Stuart dynasty. London, Victoria and Albert Museum.

Ornament for religious and political affiliation

It is expected of members of American Black Letter organizations that they embrace an active political stance. The use of ornament to denote political affiliation has sometimes been secret, sometimes proudly public. After the execution, seen by Royalist sympathizers as the martyrdom, of King Charles I in 1649, lockets were made of his image that could be worn under the shirt and next to the skin (plate 107).[21] The cause of the Royal House of Stuart after the flight of James II in 1688 prompted the invention of a range of semi-covert political ornament such as the white cockade. Popular political support may be manifest in the wearing of a particular item of dress, such as the blouse worn by Garibaldi's supporters during the campaign for Italian unification in the nineteenth century or, in recent times, the black and white scarf signifying sympathy with the Palestinian cause (plate 108). Never perhaps was the signification of dress, both in its basic forms and materials, and its accessories, so politically charged as in France during the Revolution. A sympathy for radical politics (and it became increasingly dangerous to appear otherwise) was associated with an affected carelessness of dress, to contrast with the elaborate attention to detail formerly seen at court. Short, cropped hair, simple, hard-wearing materials like wool, in place of silk, even neglecting to wash, were all noticed by foreign travellers. The tricolour worn as a cockade in the hat became the universal sign of allegiance to the new order. Among jewellery and ornaments, the towers of the Bastille and, later, the guillotine, were common in pins, earrings and brooches.[22]

108. Garibaldi, English, 1860s. Earthenware, press moulded, decorated in on-glaze enamels. The cult of Garibaldi as a hero of Italian unification manifested itself in such commemorative ware. The famous red shirt worn by the leader and his followers as a uniform originated in the buying of smocks made in Montevideo for the butchers of Argentina. Brighton, Royal Pavilion, Museum and Art Gallery, Willett Collection, no. 161.

The above examples are all to do with the politics of persuasion, moving and encouraging further support for causes that have yet to be won or having to keep up a strong and often threatening 'uniform' to secure a lasting grip on power by a new political elite. Ornament can also be used to maintain the status quo and identify the servants of a regime. Body ornament might then be a fragment of a wider system of visual signs. At the early sixteenth-century courts of Henry VIII of England and Francis I of France, for example, the King's servants wore not only the specified royal colours but also the King's device, or personal emblem, as a hat badge or stitched on to their clothing (plate 109). A visitor to the French court at this period would then see the royal salamander, the device of King Francis, everywhere, over fireplaces (such as those still *in situ* at the château of Blois), on cushions, in stained glass, on tapestries as well as on the 'movable objects', the people surrounding the King. All signified the presence of the sovereign and his ultimate 'ownership' of everything and everyone around him (plate 110).[25] The parallel in modern times is the corporate identity found in an industrial or business concern by a common form of ornament across a range of uniforms, furnishings and letterheads. The wearing of uniform in distinctive colours and with recognizable symbols by the employees of airline companies, for example, continues the traditions of coaching and railway companies of a previous age.

109. Hans Holbein, *Portrait of a Man in a Red Cap*, *c.*1534, tempera and oil on wood. New York, Metropolitan Museum of Art. Bequest of Mary Stillman Harkness, 1950.

110. Fireplace, showing the salamander device of François I, from the François I wing, Château de Blois, France, 1515–19.

Ephemeral fashion and the image of an age

Minute differences of emphasis and of the placing of ornament on the body are not only signals of complex internal structures of signification. They have also become, in the modern mass media, triggers of fashion that exploit a broader crowd mentality that seeks at the same time both to follow and to be different. A classic case in recent times is the particular angle at which Frank Sinatra wore his rather conventional form of hat, suggesting new fashion and glamour to a mode of dress already familiar and threatened with being identified with only the older, less fashion-conscious, generation. Slight changes in ornament can prolong the life of a fashion craze and keep the designers busy. In the late 1980s the polo shirt was revived as a mode of dress for both men and women. The classic type usually has two buttons of the same colour as the shirt to close the neck, but in the attempt to keep the basic format alive in the

111. The Classic two-button polo shirt from a long-established clothing manufacturer contrasts with the multi-button fashion of the late 1980s.

public eye, high street shops in the early 1990s were selling a huge variety of styles that deviated from the norm (plate 111). Sometimes these modifications took the form of buttons of a colour that contrasted with the shirt, or there might be a row of up to twelve or fifteen close-set buttons extending a considerable way down the front, with no practical point except to vary the basic idea and suggest distinction from the rest on offer. This exaggeration of an article of clothing, in this case through ornament, finds echoes in the past. The headgear for women at the courts of Europe in the fifteenth century was conventionally tall but the extreme fashion for pointed hats up to half or three-quarters of a metre in height, now the conventional pantomime-medieval style for theatre and television, was in fact found at the court of Burgundy, and to a lesser extent those of France and England, only for a few years in the mid-1470s (plate 112).[24] The more extreme the fashion, the quicker it usually dies, whilst the classic type remains and eventually comes back into its own as the standard form.

Ornament can convey the right signals within groups not only in the present but across time, encapsulating a moment, a style, a particular figure, factual or fictional, by a particular mode of dress. Theatre groups putting on plays of the Elizabethan and Jacobean period need only adopt a simple ruff around the neck to sum up for the audience the equivalent style of dress. The rest of their costumes need not conform to period; indeed the simpler, darker and more non-ornamented the rest of the costume is, the stronger the 'message' of the ruff will come across. Ever since the 'Juliet cap' was invented for the actress Theda Bara in 1916 it has provided an instant way of recognizing the young heroine of Shakespeare's play, at least in traditional productions, and it has offered the semblance of Juliet's youth to many an actress beyond the age of fourteen years.[25]

112. Mary of Burgundy at prayer, detail of a manuscript illumination from a Book of Hours, c. 1480. Vienna, National Library, Cod. 1857.

Jewellery as adornment
and the repository of memory

Jewellery, which we nowadays normally associate with no particular function, is perhaps the form of ornament that was in the past most variable according to occasion and often, though not always, movable between items of clothing. It conventionally carried a message about wealth, since it was often made up of rare materials, though these are not necessarily constant from one age to another. Sometimes the arrangement of jewellery worn in public could be visually complex. In the great sets of jewellery, or *parures*, first found in the sixteenth century but more fully developed subsequently to include a clasp for the bodice, necklace, earrings, brooches, hair-piece and perhaps buttons, the effect is of providing a sense of order over the upper part of the body that is not conveyed by the dress itself.[26] Jewellery of this kind becomes an integral part of clothing itself and serves to gather in and fasten both materials and the constituent parts of under-and over-dress. A portrait of Princess Beatrice of Battenberg, Queen Victoria's youngest child, painted in 1904, shows us how the contemporary fashion for diamonds here makes an elaborate *parure* the centre of our attention; it gives the sitter rank and dignity, but it is of itself truly the subject of the painting (plate 113). Not all ornament that is worn in public, however, advertises easily recognizable public messages, or messages to do with the wearer's public role; sometimes, by tacit agreement within social classes, a generalized signal is recognized but not always its personal content. This is especially true of the wearing of personal jewellery that has been generally categorized as 'sentimental'.

In order to choose from a range of subject-matter for this kind of jewellery, patrons and their designers turned, from the sixteenth century onwards, to an ever-increasing range of published emblem books (plate 114). These provided visual symbols of personal qualities that a patron aspired to, or admired in the future recipient of the commission, such as heroism, chastity, constancy or obedience.[27] The choice was then worked into a visual language for tokens of love or friendship that could be passed as gifts between couples or close friends. The motif of the serpent, which we have already encountered as late as the dawn of the twentieth century, was first presented as a symbol of eternity in Alciati's *Emblemata*, published in 1531. We find it in clothes too, for it appears on the arm of Queen Elizabeth I in the famous '*Rainbow*' portrait of *c.*1600 at Hatfield House (plate 115).[28] For an exchange between lovers, motifs included cupids, bows and arrows and lovers' knots. The direction of the message may be a private one and only the general language became increasingly shared; hence

113. *Portrait of Princess Beatrice, daughter of Queen Victoria* by Joaquin Sorolla y Bastida, 1908, oil on canvas. London, National Portrait Gallery.

114 A serpent, the coat of arms of the Visconti family, from Andrea Alciati, *Emblematum Liber*, Augsburg, 1531.

115. *The 'Rainbow' Portrait of Elizabeth I*, English school (sometimes attributed to Marcus Gheeraerts the Younger), *c.*1600. Oil on canvas. The Marquess of Salisbury, Hatfield House, Hertfordshire.

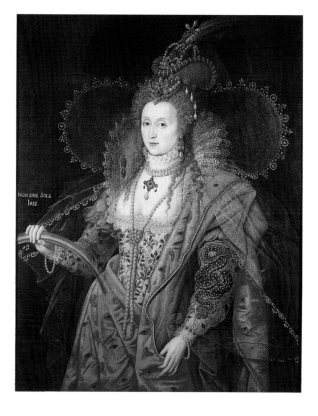

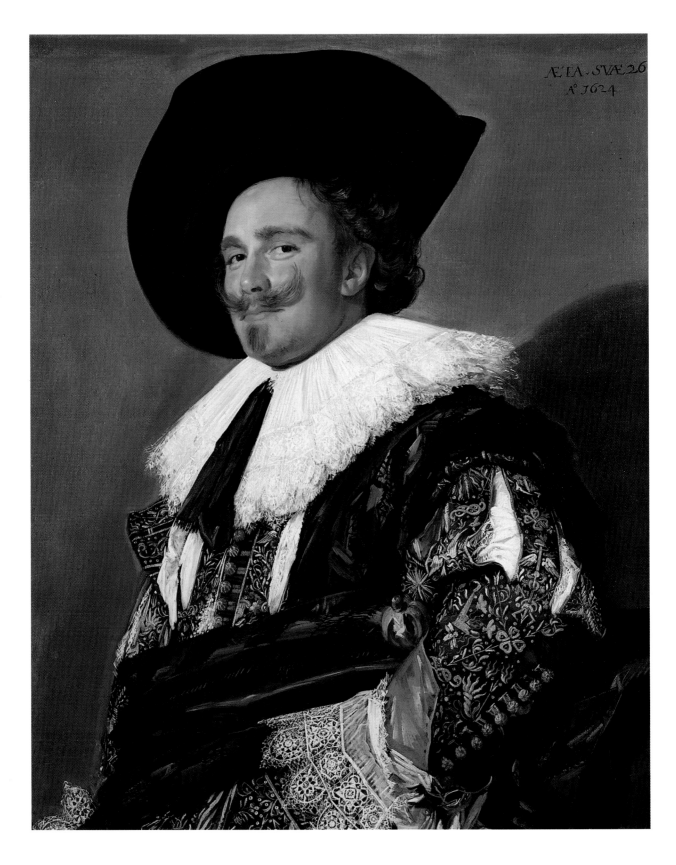

116. Frans Hals, *The Laughing Cavalier*, 1624,
oil on canvas. London, The Wallace Collection.

when we see the devices of love on the sleeve of Frans Hals's *Laughing Cavalier* in the Wallace Collection we read in his expression a certain complicity with any viewer of the painting but we cannot, and perhaps even the unknown sitter's contemporaries could not, enquire into the personal circumstances which these motifs reflected (plate 116).

The personal quality of customized jewellery meant that, like a great deal of privately commissioned art of the past five hundred years, it tended to be an art of occasion, produced at important events in people's lives and, of course, their deaths. An enormous industry grew up around the cult of mourning jewellery in the nineteenth century when, led by the tastes of Queen Victoria, the British and many Europeans took to the wearing of black jet from the Yorkshire coastal town of Whitby.[29] The nineteenth century also made into a mass market something that had been fashionable since the seventeenth century: the wearing of jewellery which incorporated the hair of a loved one, alive or dead (plate 117). Often these took the form of lockets or slides with coils of hair in the back of them but sometimes hair was used in a more elaborate way. The straps of bracelets, for example, were sometimes made up entirely of braided and twisted hair. In the nineteenth century, jewellers were working so fast to keep up with demand for this kind of work that they were, probably justifiably, suspected of discarding the precious snippets of hair produced by their customers and keeping stocks of ready-mades classified by hair type and colour. *The Lock of Hair*, published in 1872, sought to take its readers 'into the midst of the art or mystery of hair-working', thus bypassing the experts (plate 118). With, significantly, a palette as the working surface, the writer demonstrates how the hair can be cut, curled and shaped into a range of motifs, serving both social occasions and the privacy of mourning, such as the Prince of Wales's feathers and 'the tomb and the willow tree'.[30]

117. Pendant, English late eighteenth-century. Gold frame with composition in hair, metal and seed pearls on opaline paste of an urn with initials F W beneath a willow. An example of the use of hair in commemorative jewellery. London, Victoria and Albert Museum.

118. Page from *The Lock of Hair*, Alexanna Speight, London, 1872. London, Victoria and Albert Museum.

Ornament disguising the structure, indicating the points of attraction

As we have seen, jewellery has not always been purely an optional adornment to dress; sometimes its role of fastening makes it of practical use. Similarly, running bands of ornament have long been used on clothing to underline the shape or line of the body, the boundary between fabric and skin. The point at which exposed flesh is revealed at hem, cuff or neckline is often stressed ornamentally and often in a colour that contrasts with the rest of the clothing and the flesh itself. Not only the edges of the garment but also the joints between its constituent parts may be covered, through wings over ties, bands running along the join of the sleeves to the trunk of the garment. These disguise the essentially fragmentary nature of a garment by imposing an overall grid of lines which read, visually, as the framework of dress. They also serve the practical purpose of hiding wear and tear at those points where, structurally, the garment is weakest.

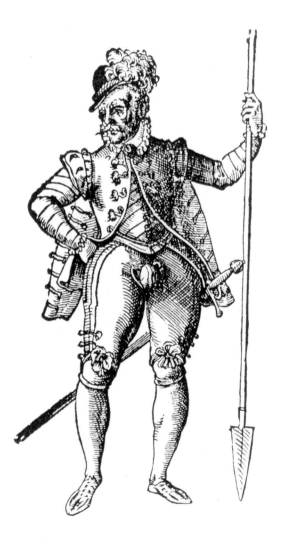

Ornament can also take over from strict functionalism when parts of dress originating as purely protective or preserving of modesty become so decorative that they draw attention to themselves. One of the most famous examples of this is the development in the fifteenth and sixteenth centuries of the codpiece over the male private parts (plate 119).[31] In many instances something originating for a functional purpose steps over into ornament for no logical reason other than patterning an otherwise plain surface or functional shape. A helmet dating from the early sixteenth century needed raised ridges to increase its strength and therefore capacity to protect the head. But the particular way in which the ridges are arranged becomes an ornamental feature, as do the holes of the visor: these are equally necessary for breathing but are given their own pattern and arrangement (plate 120).

A key determinant of this ornament and its purpose is the degree of control that is shown. The history of European costume since the Renaissance is full of examples where the skirt is pulled apart at the front, the cuff turned back or the collar lifted to reveal just a hint of rich decoration on the garment beneath or in the lining of the top clothes. For a century or more from the mid-nineteenth to the late twentieth century, the only hint of colour permissible in the drabness and darkness of male formal attire, particularly at those times when even ties were subdued in colour, was the flash of a bright handkerchief in the top pocket of the suit. Control in polite dress enables the suggestive, both of the body's shape and of the things about it that are, publicly at least, unrevealed. As opposed to one kind of sophistication, arising from the world of the city and the court, which can sometimes be restrained and suggestive, many forms of peasant or 'folk' dress found throughout Europe exhibit a remarkable degree of densely packed ornamentation (plate 121). It has often been argued that whilst the basic shapes and patterns of this kind of dress show an extraordinary similarity across Europe, the minute distinctions of the highly wrought ornament enables people to retain a sense of where they came from, or where their ancestors came from, whilst living in the towns and cities of a post-industrial society; such clothes become, in fact, fancy dress for holidays and occasions of personal significance. Over-elaborate ornament sometimes has the effect of depersonalizing the garment, of abstracting its functional uses; hence the suggestion that it can best be admired not on the wearer but laid flat in a museum display case, where the amount of work and effort spent can best be appreciated.[32]

119. Soldier dressed in the German fashion, from the *Kunstbüchlin* of Jost Amman, 1578. In Northern Europe the codpiece, along with broad shoulders and close-fitting hose, formed part of a generally flamboyant accentuation of male virility in costume.

120. Close helmet with fluted skull, probably Austrian, *c.*1510–20. Steel, possibly by Konrad Seusenhofer who worked at Innsbruck. London, Victoria and Albert Museum.

121. Apron, Czech, twentieth-century. Wool and cotton, resist dyed, and lace. London, Victoria and Albert Museum.

Functions sometimes live on through ornament even when the initial purpose has ceased to be of use. Many of the later, more elaborate, codpieces were used as receptacles for small possessions carried about the person such as money or private papers. The lapel on the coat, originally a flap for buttoning across to keep the wearer warm, has often been pinned back and ornamented. A coat of the 1790s in the Victoria and Albert Museum shows how the turned-back lapel has now entered into a complex dialogue with the whole ensemble of the upper part of male dress (plate 122). It has become a foil, or mounting pad, for the folding out of the flaps of the waistcoat, bringing the decorated under-garment over the top layer of dress. The front of the figure, from being a simple overlay of coat over waistcoat over shirt, has become a pattern made up of triangular segments of all three, as intricately conceived as origami. New inventions may make certain functional features redundant, but the dictates of ornament insist that they remain. A woman's boot of the 1860s, also in the Victoria and Albert Museum, has been liberated from the tight and time-consuming lacings of previous generations by the provision of an elasticated gusset on the side to ease access for the foot. Yet up the front of the boot there are still fourteen pearl buttons, the leather around them slit and stitched as if they functioned as real buttons which opened and closed over the foot (plate 123).

122. Double-breasted coat and waistcoat, French, *c.*1795–1805. Silk warp and worsted weft. London, Victoria and Albert Museum.

123. Boot with false pearl eyelets, English, late 1850s. London, Victoria and Albert Museum.

124. *Portrait of Margaret Laton*, English, *c.*1620. Oil on panel (before restoration). The actual jacket, covered with floral motives, that the sitter wears also survives. London, Victoria and Albert Museum.

125. Rembrandt van Rijn, *Saskia van Uylenburgh in Arcadian Costume*, 1635, oil on canvas. London, National Gallery.

126. Tulips, from Pierre Langlois, *Livre des Fleurs*, Paris, 1620. 'Tulipomania' resulted in a huge number of illustrations which were later applied to dress, china and marquetry. Latin names are given here, and the flowers are opened and tilted forwards to show striped petals, pistils and stamens. London, Victoria and Albert Museum.

Ornament and tradition: back to nature, rediscovering the antique

A history of ornament and its relation to the body needs to ask how adaptable the needs of the body were to new inventions, new fashions of ornament as they came along. If the history of ornament is to have a place in the wider history of art, then the question needs to be asked: Were the major preoccupations of the fine arts at all reflected in the developments in ornamental vocabulary? Two major themes have long been crucial to the history of art of the past five centuries. First, the constant recourse of artists to nature as the standard of one kind of perfection and as a source of refreshing inspiration. Second, the importance of the antique as a second benchmark of perfection, one that is created by mankind when it was supposedly at its most civilized, or most powerful, depending on which era of the antique was referred to. How was ornament from these two sources used in relation to the human form?

The most cursory perusal of any of the world's great collections of costume, supported by the wealth of pictorial evidence that survives in the form of portraits, shows us that flowers have always played a major role in the vocabulary of motifs for dress (plate 124). Flowers were of course themselves the centre of developments in fashion as new species were introduced from the Orient or the Americas; witness the 'tulipomania' which developed at the beginning of the seventeenth century (plate 126).[33] They were also invested with nationalistic meaning, as in the cult of the rose associated with England from a very early period and, later, with the cult of the cottage garden so redolent of Englishness, the popularity of the pansy in English design.[34] The highly naturalistic rendering of plants and flowers alternated with a high degree of stylization at different times, and not all parts of Europe behaved in the same way. In the Renaissance, for example, it has been argued that in Italy too naturalistic a rendering was avoided because, at its most lifelike, the plant or flower suggested transience and therefore acted as a reminder of death, or *memento mori*. Northern Europe, by contrast, particularly in the later sixteenth century, embraced naturalism precisely because it defined individual qualities, the sense of uniqueness. Specific flowers were associated with human qualities and their depiction on fabric may have had a similar intention to the choice of emblems discussed earlier in this chapter. During the seventeenth century it seems that floral motifs were less fashionable among the upper classes and wealth was displayed in the richness of materials used for attire, particularly when these could be rendered in paint with the authority of Van Dyck or Terborch. Flowers were retained for allegorical repre-

sentation, where the mixture of the carrying of flowers, or wearing them in the hair or as jewellery, with the contours and fabrics of everyday dress, created the very ambiguity of identity that sitters or their painters wanted, as in the rendition of his wife Saskia as Flora by Rembrandt in the National Gallery, London (plate 125).[35]

In the eighteenth century, led by the skills of silk weavers, naturalistic flowers came back into fashion in both dress and jewellery. The import of great new quantities of diamonds from Brazil and new techniques of cutting them gave a singular brilliance and presence to highly naturalistic pieces which trembled on the fine wiring of their attachments as the wearer moved about and reflected the light off their complex facets. In the nineteenth century this naturalism was augmented with the increasing use of porcelain and enamel among precious stone settings. But the mimicking of the real world can always ultimately be mocked, in certain circumstances, by reference back to the source of the invention. At some periods, real flowers were praised as symbols of modesty so that the wearing of them in place of jewellery

might suggest a humble attitude. Lampooning extravagance of dress by reference to the advantages of 'natural' ornament became part of general advice literature to young women in such publications as the *Lady's Magazine* during the eighteenth century. In a fictitious encounter described in that journal in 1773, for example, an overdressed heiress covered in diamonds is put to shame by meeting a young woman dressed more simply, in less expensive materials and, rather than jewellery, wearing a 'bouquet of orange and myrtle sprigs, mixed with Indian pinks' (plate 127).[36]

Highly veristic depiction of nature works at its best when concentrated on the single motif. The moment the motif is repeated across the width of a fabric, stylization comes into its own because it is easier to make a pattern with shapes that are regularized. Repetition across the surface of a fabric will anyway detract from the naturalistic origin of the motif, however accurately shown.

127. Charles Jervas, *Henrietta Howard, c.*1724, oil on canvas. The unadorned dress contrasts with fabrics of the period covered with floral ornament; the subject also wears no jewellery. English Heritage, Marble Hill House.

Some of the earliest sources for depicting the natural world in fabric were the books of plants, or herbals, that began to circulate from the 1480s. It was, however, the single print that was able to render natural motifs in stylized forms. Even in the seventeenth century, when scientific interest in recording the natural world inspired a formidable array of closely observed natural phenomena in the visual arts, in paintings, enamels, and marquetry as well as textiles, prints became the medium whereby those observations were given longer inspirational life: by formalizing the structures of flowers and plants they suggested a wide variety of applied uses.

If floral motifs had to be systematized and abstracted to create suitable decoration, the antique vocabulary of ornament came ready packaged for it was a language particularly associated with architecture and therefore a system of component parts. It may not be surprising that the chief kind of dress that became especially associated with antique ornament was fifteenth- and sixteenth-century armour, for armour is the most 'architectural' of body wear at this period, both in the way it can be disassembled and because the sharply defined components are marked by definite ridged lines which provide fields for decoration similar to those of the pilaster or the pedestal (plate 128).[37] In addition, of course, the skill of engraving on armour was close in some technical ways to that of etching on copper plates, and a skill, therefore, familiar also to makers of ornament prints, a theme explored in the chapter on prints above. As for the rest of dress in the early modern period, we find the most fashionable antique decoration most often in the accoutrements of dress rather than its basic forms. Just as fashions travelled via the luxury trades of small-scale household objects, such as spoons and scissor-cases, so it was items of jewellery that seem to us, if we look back and attempt to trace the journey of fashionable ideas across Europe, to be particularly avant-garde.[38] So hat badges might be in the shape of antique roundels, dagger hilts and cases decorated with grotesque work and small classical figures sit atop interlaced pendants. Certainly it is in the work of small luxury items for the court that the most celebrated court artists, such as Hans Holbein at the court of Henry VIII, drew most heavily on ornament prints after the antique.[39] Strapwork must have been a particularly useful invention for the jeweller as it was for the carver of all kinds of framing devices in wood, stone and other materials. Strapwork's quality of simulated cut leatherwork suggested a pliable, interlaced ornamental band that offered, more than previous Renaissance decorative motifs, a three-dimensionality which made it especially applicable to the applied arts (plate 129). For fabric design, however, some areas of the new vocabulary

128. Page of drawings from the design book by Filippo Orso of Mantua, 1554. Classical ornament applied to the sharply divided areas of armour. London, Victoria and Albert Museum.

129. Two designs for jewellery, engraved by Mathis Zündt, using strapwork as the framing device, German, c.1555. London, Victoria and Albert Museum.

were more useful than others. For example it is rare to find, from the evidence of contemporary portraiture, grotesque work used as an all-over motif on fabric, though the Moresque was much more adaptable, especially for the rich underskirts of female Court clothes. When the fashion for a more thoroughgoing antique mode of dress, as opposed simply to revived ornament, truly came into being in the seventeenth century, it was not the ornament as such but the simplified lines and cut of antique clothes that signalled an interest in the classical past (plate 130).[40]

Inspiration from the classical world was never at a standstill; the antique was constantly reinvented as new things were discovered and new sites explored. Nineteenth-century technology offered, it must have seemed, the closest imitation of all because everything seemed possible. The Castellani workshop, founded in Rome in 1814 and later operating also in Naples, offered a range of jewellery that passed itself off as perfect copies of classical prototypes, and particularly of the granular surface that had hitherto seemed technically unrepeatable, a true classical secret (plate 131).[41] The Castellani range led to a craze for 'wearing archaeology', a specious authenticity that was lampooned in *Punch* in July 1859 with a drawing of a woman bedecked with jewellery of this fashion (plate 132); as the writer says to her friend in the accompanying spoof letter, supposedly written from Rome, 'you have nothing to do but lay down scudi enough, in order to be made perfectly classical, in appearance and style. Only think of that! Everything there is taken exactly from the antique, so that you are quite safe in choosing whatever you like, and cannot go wrong.' But the silk purse cannot be made from the sow's ear... 'very classical, to my ideas, she looks when she is dressed, as you will admit, I think, when you see the sketch I enclose. It's true that her nose is not strictly classical, indeed it has the least in the world of a turn-up, and her hair cannot be induced by any artifice to grow low on her forehead, as one sees in antique busts of Pompeian beauties, but surely that does not matter when the brow is surmounted by a "Victor's chaplet" in thin beaten gold!'[42] What is highlighted here is that ornament alone cannot guarantee the decorum of the human figure; that somehow comes from an appropriateness of time and place which needs the exquisite judgement of a slight tilt to the hat or a fresh sprig of flowers.

130. Anthony Van Dyck, *Portrait of Sir John Suckling*, c.1635–6, oil on canvas. New York, The Frick Collection.

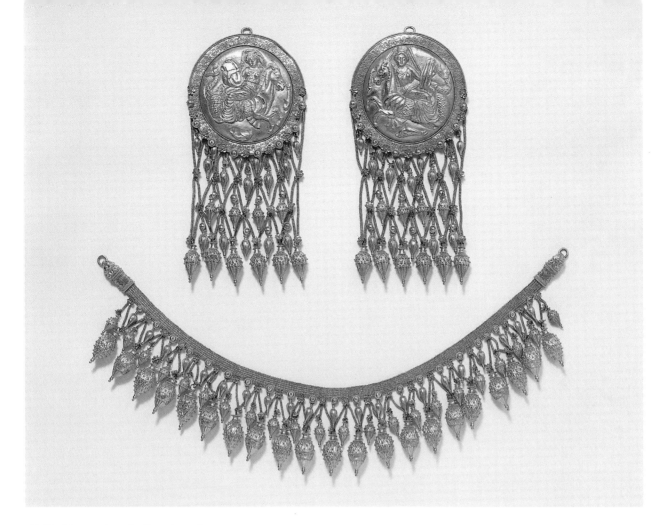

131. Necklace and a pair of pendants from
a diadem. Castellani workshop, Rome, *c.*1865.
Gold. London, Victoria and Albert Museum.

132. *A Young Lady on the High Classical School
of Ornament*, from *Punch*, July 1859.

A YOUNG LADY ON THE HIGH CLASSICAL SCHOOL OF
ORNAMENT

4

Ornament and the Domestic Interior

133. The State Bedchamber at Powis Castle, Powys, *c*.1668. The example of Versailles made itself felt as far as this bedchamber built to accommodate Charles II who never used it. The bed and other furniture are later. National Trust.

In Anglo-Saxon cultures today the word 'ornament' is most commonly applied to a decorative object displayed in an interior. Indeed, for most people in the Western world, conscious recognition of the idea of ornamentation is largely restricted to the embellishment of the domestic interior, or 'interior decoration'. On the face of it this is not surprising. Ever since Vitruvius the interiors of buildings have been seen as a field of greater variety of ornamental treatment than exteriors.

But the widespread notion that 'interior decoration' is a process entirely separate from the design and ornamentation of the outside of a building is of comparatively recent date. Also fairly recent is the idea that interior decoration can be an expression of the occupier's personality. Both of these developments have been very greatly encouraged by the wider availability of cheaply manufactured goods since the middle of the nineteenth century.

Nowadays most people in the West can afford to turn a 'house' into a 'home'. The first is simply a building; the second carries a far greater charge. A home is both a place and an idea; a shelter, but also a private expression of the self and a public statement of social and cultural values. This deeper message is conveyed through a complex combination of decorative elements on walls, ceilings and floors and more or less carefully chosen and arranged furniture and other objects. Although the element of choice implicit in the huge range of goods for the home seems to favour it as a sphere of private expression, as a 'factory of private illusions', the large number of books and magazines on interior decoration is evidence of the continuing need for advice on appropriateness and decorum, making it 'a catalogue of ready-made tastes, values and ideas'.[1]

At least some of the present-day ideas of appropriateness and decorum in interior decoration stem from a time before the nineteenth century when the chief purpose of the planning, design and ornament of the decorated domestic interior was to express the social status of the occupant. Although ostensibly for everyday life, many of these decorated rooms were essentially ceremonial and echoed the architecture of the great palaces and other public buildings, with their complex imagery of state and power. The formal qualities demanded by such interiors encouraged highly structured architectural treatments which incorporated in their design the movable elements such as furniture and paintings. Changing attitudes to the formal and informal, the impersonal and the personal, lie at the heart of the treatment of the interior ornament discussed here.

Formality and informality

When Sir Christopher Wren visited Versailles in 1665 he was not impressed:

The Palace, or, if you please, the Cabinet of Versailles call'd me twice to view it; the Mixture of Brick, Stone, blue Tile and Gold makes it look like a rich Livery: Not an Inch within but is crouded with little Curiosities of Ornaments; the Women, as they make here the Language and Fashions, and meddle with Politicks and Philosophy, so they sway also in Architecture; Works of Filgrand, and little Knacks are in great Vogue; but Building certainly ought to have the attribute of eternal, and therefore the only Thing uncapable of new Fashions. The masculine Furniture of Palais Mazarine pleas'd me much better where is a great and noble Collection of antique Statues and Bustos.[2]

In claiming a status for architecture above the shifts of fashion Wren was also taking a moral view of the decoration of interiors. At the heart of the argument lies the treatment of ornament: the architect produces a controlled scheme of interior decoration which, being essentially structural and sculptural in its decorative treatment, has 'the attribute of eternal'; 'fashion', in the form of the taste of women, leads to shifting and unstructured ideas based on the accumulation of disparate decorative elements.

At first glance this opposition seems to resemble the conflicting approaches to interior design which have often been taken by architects and interior decorators in the last century and a half, but such a conclusion would be quite wrong. In fact the interiors seen by Wren were highly structured formal machines in the functioning of the court and the role of the king.[3] The *cabinet* was the King's inner sanctum, the first truly private room in a controlled linear sequence of rooms of increasing significance, which together formed an *appartement* in the palace. The degree to which a person was able to penetrate the set of *salon, ante-chambre, chambre* and *cabinet* was a measure of his importance. For the King himself to move forward to meet the visitor was a mark of the very greatest favour. As they increased in importance the rooms became both smaller and more magnificently ornamented. The decoration of the *chambre*, a sort of state bed-sitting room, culminated in the canopied bed, placed in an inner room or alcove which was separated from the rest of the *chambre* by an open archway and a decorated balustrade and distinguished by its raised and specially decorated floor or *parquet* (plate 133).

The formality of this theatre of state in the *chambre* was in marked contrast to the treatment of the *cabinet.*

Here the real business of government could be conducted in complete privacy. It was the opportunity for the King to demonstrate his personal cultivation and taste in the display of collections of coins, medals and curiosities, and as such was the true descendant of the *studio* or closet of the great houses of Renaissance Italy, where the idea of the sequential apartment was first developed.[4] The small size of these private rooms also allowed for greater intensity and experiment in decoration. Freed from the need for great allegories of state and power in paint or tapestry, walls could be clothed in panelling expensively inlaid or painted with grotesque patterns, or, as in the tiny Queen's closet at Ham House, covered with brocaded satin and striped silk (plate 134).

134. The Queen's closet, Ham House, London, *c.*1675. National Trust.

135. The Music Room from Norfolk House. The gold and white wall panels were designed by Giovanni Battista Borra. The furniture was not originally in the room. London, Victoria and Albert Museum.

136. Section of a town mansion, by John Yenn, 1774. Pen and ink and watercolour. London, Royal Academy of Arts.

The idea of the sequential apartment, fully developed in France, was imitated in the late seventeenth and early eighteenth centuries by courts all over Europe as well as being taken up by noblemen and others. Great houses in Britain were no exception, as Ham House shows, but, as in other countries, there were local variations and developments. In England in the 1730s the saloon lost its central importance when the formal dining or eating room emerged. A little later, away from the royal palaces, changing social needs transformed the hierarchical apartment into a set of rooms of equal status for the general entertainment of 'assemblies'. The main floor of Norfolk House in London, reached by a grand central staircase, consisted of a circuit of rooms, all of which were in use at the opening assembly of 1756. An antechamber was succeeded by a music room, two reception rooms, a great reception room, a dressing room, a state bedchamber and a closet, according to Horace Walpole,

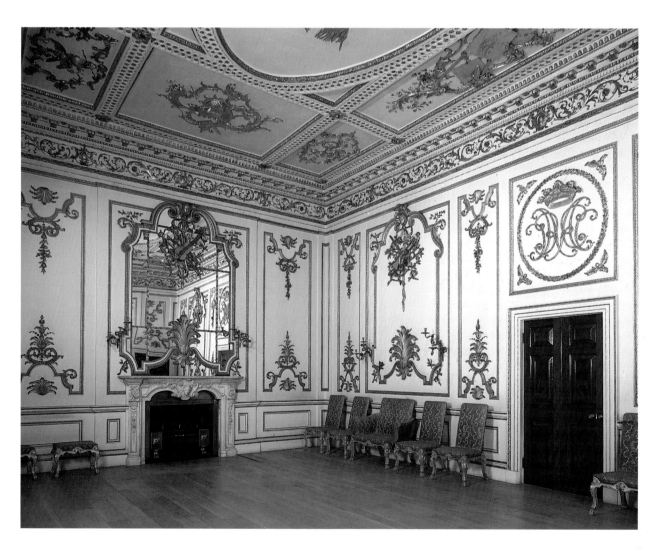

'filled with an infinite number of curiosities'.[5] The last two rooms having become largely symbolic, the only room with a higher status than the rest was the great reception room, as demonstrated in its expensive decoration of tapestries. The decoration of the other rooms expressed their equal status, although, in the interest of variety, it was different in each case (plate 135).

Viewed as a totality, however, the decoration of English houses of the eighteenth century spoke a language of social control at least as pervasive as that at Versailles, and ultimately much more lasting. In a scheme such as John Yenn's design for a house of 1774 (plate 136) the hierarchical sequence is immediately evident in the wall treatments, beginning with the plastered surfaces of the relatively public hall and staircase. The eating room at the back , although further up the hierarchy, is also plastered, probably because textile wall coverings were thought to retain food smells. The sequence of public rooms continues on the first floor with a grand reception room hung with a boldly patterned textile, and a state bedchamber with a rather quieter effect. Above these lie two more levels of rooms reached only by the back stairs, with striped and, in the windowless attic, chequered walls.

These wall treatments are incorporated into a carefully modulated progression of architectural ornament based on the characteristics of the classical orders as described by Vitruvius and elaborated by the Renaissance theorists. The basement is plain Doric as befits its lowly nature, actually and metaphorically. The entrance floor is Ionic. In the hall the pilasters, deeply modelled entablature and white doors impart a suggestion of external architecture entirely in character with its function as a buffer between the inside and outside, a waiting place for lesser visitors and an impressive beginning to the house. The character of the eating room is less severe: it has a shallow modillion cornice and no frieze, but it nevertheless has a rectilinear quality in keeping with the contemporary idea that such rooms were masculine.

The greater importance of the first floor is signalled by the more elaborate Corinthian order and such details as the pedimented doors. The reception room is given a coffered coved ceiling, the grandest in the house, which complements the rich wall covering. The curves in the decoration and furniture may have been linked to the feminine character such rooms were thought to have. Across the landing the relatively more modest state bedroom has a simple cornice and a delicate frieze. On the

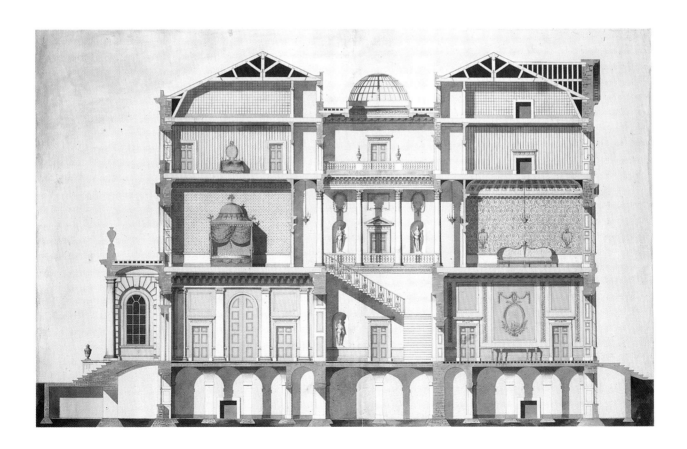

next floor the bedrooms, although quite grand, have much lower ceilings and omit the frieze and dado. In the attic the only ornament is a plain skirting board.

A similar hierarchy of architectural ornament was to be found in the interiors of most English and many American eighteenth-century houses, although often limited to chimneypieces and mouldings around doors and windows, floors and ceilings.[6] Such was the strength of this tradition that parts of it survived in the suburban terraced house of the early twentieth century, long after it had ceased to have any real meaning. In a typical two-storeyed London example of about 1910, the short and narrow space of the hall is given a distinct architectural character by its tiled floor and a separate ceiling cornice terminating with a decorative arch which marks off the space and helps to conceal the view up the stairs. The mahogany newel post at the foot of the stairs is especially large and elaborate, in marked contrast to smaller and simpler softwood posts upstairs. On the ground floor the dining room and adjacent living room have elaborate ceiling mouldings, picture and dado rails and deeply moulded door surrounds and skirting boards.

The main bedroom upstairs has a moulded ceiling, a door surround like those to the reception rooms, but a simpler skirting board like that in the hall and stairs. The adjacent second bedroom has a similar door surround on the outside, but a much plainer one inside, and an unmoulded skirting. Like the remaining rooms in the house (two more bedrooms, a bathroom, kitchen and scullery) it is otherwise devoid of architectural ornament except for the chimneypiece and door. As in the rest of the house, these are part of a distinct hierarchy. The doors to the lesser rooms present a relatively modest but still decorated face to the public areas of hall and landing; on the back they are completely plain, suggesting that the rooms were intended for servants or children. In fact houses of this type were designed to meet the conservative tastes of the lower middle classes; this one was occupied by the local stationmaster, who certainly had children but probably no servants.

Making changes

The fossilized classical hierarchies just described, are, of course, only part of the picture. Whether formal and public or informal and private, interiors have always evolved in their planning, ornament and contents to reflect social imperatives, making them the most accurate and complex social barometer in the whole field of design. In private interiors the accumulation, disposal and rearrangement of furniture and objects is a continuous process which makes a definite contribution to the decorative effect of a room, and is often pursued for that purpose alone (plate 137). Bigger shifts of taste are marked by changes, usually less frequent, to the treatment of walls, floors and ceilings. These shifts can sometimes be accommodated relatively easily by removing a few key elements. In 1845 Charles Dickens set to work on his London house: 'I should like to new-paper the drawing-room; taking away the ugly hand [i.e. dado] rail, and bringing the paper down to the skirting board.'[7] British and American books on household decoration of the 1870s and 1880s are full of advice on how to adapt such Dickensian interiors to the new 'Queen Anne' taste. In particular, dado rails were to be put back, re-establishing the old classical wall divisions of dado, 'filling' and frieze, albeit in different proportions than before. Fixtures like chimneypieces could not usually be removed (most houses being leased or rented), but they could be adapted by covering the offensive white marble with drapery and topping them off with a picturesque mirror and shelf (plate 138). From the 1930s to 1960s such Victorian interiors were often modernized simply by concealing the disturbing ornament beneath boarding and suspended ceilings. Since the 1970s a whole industry has grown up around the recovery of such nineteenth-century details, supported by the manufacture of replacement parts and 'period' wallpapers.

In other contexts, existing decorative effects can be intensified; when Frances, Lady Waldegrave, inherited Horace Walpole's villa at Strawberry Hill in 1846 she found many of its early Gothic revival interiors both too small and too tame. As well as adding a large new ballroom and drawing room she intensified the gothic effects in the villa by incorporating stars, fleurs-de-lys and other decorative elements into the original scheme so successfully that her contributions have often passed undetected. In the 'Turkish Boudoir' at Strawberry Hill the reverse is the case; at first sight a cushioned and tented room in the Moorish style of the nineteenth century, it actually incorporates, unaltered, Walpole's original Gothic chimney-piece of 1748, copied from a design by William Kent.

Changes in style and ornament in interior design also result from changes of use. The eating room at Houghton

137. John R.J. Taylor, living room looking towards the dining table, 1985. This photograph is from a set recording a single house and the thoughts of the people who lived there: 'The armchairs... they're all gone. Oh my God, I hated them. My mother-in-law... I bought them... to keep her on the sweet side. That jug I loved and then my sister Barbara took it because it belonged to her.' From *Ideal Home; a detached look at modern living*, 1989. London, Victoria and Albert Museum.

138. 'An Ordinary Mantelpiece'. Illustration from Mrs (Lucy) Orrinsmith, *The Drawing Room; Its Decorations and Furniture*, 1878. London, Victoria and Albert Museum.

139. Living halls old and new. Illustration from
E.W. Gregory, *The Art and Craft of Home-Making*,
1913. On the left is the famous medieval hall of
Penshurst Place in Kent, on the right the hall of a
typical suburban house. London, University of
Middlesex Library.

The kind of hall you dream of.

The kind of hall you get.

Hall, for instance, one of the earliest English state dining rooms, is decorated with vines in the carving and plaster-work alluding to the chief use of the room: prolonged and heavy drinking by the men after the women have left the table.[8] The supposedly masculine nature of the dining room, and its opposite, the feminine drawing room, became a cliché of decorating books well into the twentieth century. Their characters were appropriately reflected in the decoration: heavy solid furniture and often wood panelling in the dining room and silk or wall-paper in the drawing room, which by the late nineteenth century had been established as the centre of the ceremony of afternoon tea.[9]

The emergence of such new room types, often resulting from changes in social patterns, has nearly always produced readjustments in planning and shifts in decorative emphasis. At the conclusion of the twentieth century we are at the end of a process of relaxation in the planning of living spaces which began to gather pace shortly after the middle of the nineteenth century. In both Britain and America the first sign, which appeared as early as 1816,[10] was a reaction against the formal 'parlour', with its stiff furnishings and unused air. In direct opposition to the ever more specialized types of room advocated for great Victorian country houses,[11] writers on middle-class interiors in the 1870s and 1880s began to suggest that rooms might be used for more than one purpose and in a more relaxed manner, an idea which ultimately led to the modern concept of the living room open to all comers. Perhaps the most radical suggestion, however, was the installation of a fireplace and softer furnishings in the entrance hall so that it might be turned from a waiting room to a 'living hall'. At one stroke the old hierarchical progression of rooms was destroyed.

While the 'living halls' of smaller houses might not always have come up to their owners' medievalizing imaginations (plate 139), fully developed examples had the effect of opening up the interior. This effect was even more marked when conventional doors gave way to doors that slid into the wall, textile *portières* and (especially in America) wide open archways.[12] The numerous oblique viewpoints which resulted marked a fundamental shift from the formal progression through the straight enfilade of doors of the old *appartements*, in which each room could only be seen as a separate event. Even with relatively conventional arrangements some degree of decorative coordination was now necessary, as the author of *The Art and Craft of Home-Making* observed: 'walls of three rooms are often visible at the same time if the doors are open. The wall-papers must either be all the same pattern and colour, or must harmonize pleasantly with one another' (plate 140).[13]

140. The hall and sitting room of a house seen from the dining room. Illustration from E.W. Gregory, *The Art and Craft of Home-Making*, 1913. London, University of Middlesex Library.

The ultimate development of the changes thus ushered in occurred in the houses of Frank Lloyd Wright, built from about 1900 onwards.[14] By removing conventional walls and doors between the living and eating areas and using screen-like dividers, Wright effectively dissolved the corners of his rooms, allowing the spaces to flow freely one into the other. His ideas sprang from a belief that a building's design arose from a principle of organic unity encompassing its site, plan, elevation, structure, materials and ornament. Up to this point the chief task of ornament in the domestic interior had been to make sense of, or adorn, a box; now, as part of an organic entity, it was 'wrought in the warp and the woof of the structure. It is constitutional in the best sense and is felt in the conception of the ground plan' (plate 141).[15]

Wright's solutions to the problem of designing and decorating the freely planned interior were to be frequently echoed as twentieth-century living radically changed the use and status of rooms. Propagandist Modern Movement books like Elizabeth Mock's *If You Want to Build a House*, published by the Museum of Modern Art in 1946, encouraged people to believe that 'a building [can] develop as inevitably as the movement of a symphony'.[16] Although Mock regarded the 'decoration'

141. Interior from the Dana House, Springfield, Illinois, designed by Frank Lloyd Wright, 1903.

of modern interiors as desecration, even to the extent of eliminating 'useless footboards' (skirting boards), the use of materials in the service of 'positive poetic expression' was recommended. In order to reduce a sense of confinement and open up the room to the exterior, walls should be treated as separate planes. Above all, 'every cubic inch must contribute to good living'.[17]

In the real world, where rooms usually came ready-made in traditional shapes, they were nevertheless adapted to more or less link together the areas for living, eating and cooking as first put forward by Wright. American decorating books of the 1950s, like Mary Brandt's *Decorate Your Home for Better Living*, asked their readers to start by considering first who would be using a room and what it was to be used for.[18] The most important room, the 'heart of the house', was the living room. Its demanding task, according to Terence Conran in 1974, was to reflect 'the interests and aspirations of all its users and be the social and recreational centre of the house'.[19]

In designing living rooms in the modern style the chief problem was the creation of significant centres. One solution, particularly popular in the 1950s, was to cover individual walls with different wallpapers or colours, the Modernist separate plane (plate 142). In other cases the

142. A combined living and dining room. Illustration in a Greaves and Thomas furniture catalogue, late 1950s. London, Geffrye Museum.

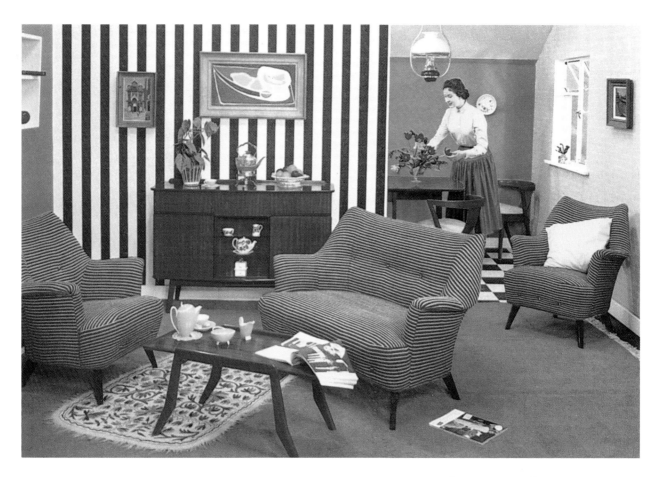

fireplace, although largely redundant, was given special decorative treatment as a symbol of family unity. It could have its impact increased by being built of rugged Wrightean stone or being brought to the centre of the room like a primitive hearth. In rooms without fireplaces a centre could be created using groups of furniture set around a low hearth-like coffee table, or even in a hole in the floor as a 'conversation pit' (plate 143).

Character, individuality and personality

The notion that ornament can be an indicator of a building's use and character was central to ideas of architecture in the Renaissance. Such ideas were drawn from the writings of Vitruvius, in which the classical orders were seen to have distinct characters, related to those of certain types of people. These notions were elaborated by Renaissance scholars and architects to a whole system covering every form of architectural embellishment, including doors, windows, arches and wall treatments.[20]

143. Design for a living room: drawing by Ralph Adron after a design by Max Clendinning, 1968. Poster colour and collage. The design is drawn in exploded form to show the ceiling, walls and floor. A sunken 'conversation pit' is on the right, with as its focal point the television and other electronic equipment. London, Victoria and Albert Museum.

At the same time, the idea that the decoration of a building might express the character of its owner also emerged. In general, this was conceived in the widest sense, although the idea was recognized that a person's home was linked to a sense of self and relationship to the world. 'Every man's proper Mansion House and Home,' according to Sir Henry Wotton in 1624, was 'the Theater of his Hospitality, the Seate of his self-fruition, the Comfortablest part of his own Life, the Noblest of his Sonnes inheritance, a kind of private Princedom ... an Epitome of the whole World.' It therefore deserved to be 'decently and delightfully adorned', but only 'according to the degree of the master'.[21] The rule of *decor* (decorum), 'the keeping of due Respect betweene the Inhabitant, and the Habitation',[22] must not be broken. To do otherwise would be to incur the risk of 'a kind of conflict, betweene their *Dwelling* and their *Being*'.[23] Wotton's notion, then, was very far indeed from the modern idea of an individual's private self being expressed in the decoration and disposition of the home.

Wotton makes it clear that he regards the proper adornments of a building to be Picture (painting) and Sculpture, there 'to dresse and trimme their mistress' Architecture.[24] In the interior, paintings were to be displayed according to the function of the room: cheerful paintings in feasting and banqueting rooms, 'graver stories' in galleries and 'landscapes and boscage and such wilde works' in open terraces or summer houses.[25] It is interesting to compare these notions with those of the Venetian Pietro Aretino, writing in the 1530s and 1540s on the subject of reading a person's *animo* (character) from his *habitazione*.[26] Like Wotton, Aretino looks at both the exterior and interior of the building, seeing the whole as an expression of character. A building can, for instance, express grandeur of spirit or be compared in its calmness and beauty with the face of the owner.

Aretino's deeper readings, however, spring from observing the owners' collections of *objets d'art*, especially of sculpture : 'delight in such refined carvings and such casts does not spring from a rustic breast, nor from an unworthy heart'.[27] The 'refined carvings' described by Aretino belonged to Andrea Udone, who is shown with his collection in a small and evidently private room (plate 144). The sculpture of Aretino's other subject, Tommaso Cambi, was larger and on public display. To Aretino it represented 'the generosity which gives sustenance to your [Cambi's] heart'.[28] This distinction between private, aesthetic, small-scale, adornments of one building and the larger, more public architectural ornaments of another, can be compared with Wren's comments on Versailles quoted earlier and as such expresses a dichotomy of approaches to interior decoration which is still with us today.

144. Lorenzo Lotto, *Portrait of Andrea Udone*, 1527. Oil on canvas. Collection of Her Majesty Queen Elizabeth II.

Architectural interiors

Since the sixteenth century, the expression of a person's 'official personality' in a domestic interior has been in more or less professional hands. Court artists, in addition to carrying out easel paintings, could be used for any task involving design. The painter Giulio Romano, working in Mantua from the 1520s to the 1540s, also designed architecture (the Palazzo del Te), mural decorations, silver, jewellery and tapestries. In England, Inigo Jones designed architecture and interiors for James I and his Queen, but his chief activity was the design of sets and costumes for court masques (plate 145). In spite of such evidence, the extent to which such court artists influenced the total appearance of a court interior is unclear.

145. Design by Inigo Jones for a chimney-piece and overmantel at the Queen's House, Greenwich, 1638. Pen and ink and wash. London, British Architectural Library, RIBA.

The first certain example of a single controlling mind at work is in the schemes carried out for Louis XIV at Versailles and elsewhere. Charles le Brun, from 1660 *premier peintre du roi*, was both a designer and the superintendent of a team of designers and craftsmen. The result encouraged courts dependent on the French example to coordinate the design of the architecture, furniture and silver and textile furnishings of state interiors to produce a unified style.[29] In Holland and England the French *émigré* Daniel Marot was the first court designer to make prints showing a whole state interior (plate 146). Suddenly it was not enough to know what fashionable objects looked like; you had to know how they all fitted together.

One of the effects of such powerful examples was to encourage the standardization of styles at other levels of society. More relevant to our subject here is the gradual emergence of the idea that, in the hands of an architect, a furnished domestic interior could be elevated to the dignity of a unified work of art, often linked to the architecture of the building. The high cost of specially designing and manufacturing every part of a room, including the furniture, has tended to make the fully designed architectural interior a rarity. On the other hand, such interiors have frequently been the principal sites of stylistic and ornamental innovation, especially before about 1850, when the wealthy and powerful were the first to be served by new ideas in design.

In Britain, after about 1700, the sponsorship of new ideas in architectural interiors passed from the court to the nobility and their design was gradually taken over by what would now be recognized as professional architects. Associated with this development was the increasing degree of control which architects gained over all aspects of the building, including decorative details of the interior such as mouldings, which had at first been entirely in the hands of craftsmen.[30] By the end of the eighteenth century British architects were not only specifying such details by name but also producing drawings for craftsmen to follow (plate 147).

The first great English designer of interiors of the eighteenth century, however, began as a painter. William Kent came to the design of interiors via decorative mural painting in the baroque tradition. His task was to create a new type of interior for the revived Palladian style promoted by his patron, the architect Lord Burlington.[31] At Houghton Hall in Norfolk he not only painted the ceilings but designed whole interiors, including the chimneypieces, picture hanging schemes and furniture (plate 148). Certain parts of the rich ensemble, such as the chimneypieces, were taken from the designs made by Inigo Jones a hundred years earlier, but other parts,

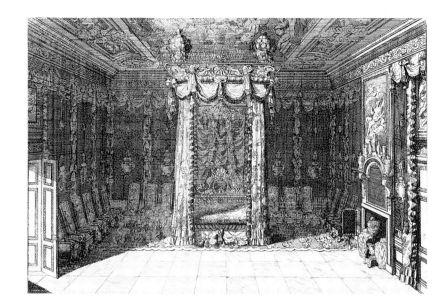

146. Design for a state bedchamber by Daniel Marot, *c.*1690. Etching. London, Victoria and Albert Museum.

147. Full-size working drawings for making doorway architraves in the principal corridor at East India House in the City of London. Pen and ink. The building was designed by Richard Jupp from 1796. London, Victoria and Albert Museum.

148. William Kent. Project for the decoration of the saloon at Houghton Hall, 1725. Pen and ink and wash. London, Sotheby's.

notably the furniture, had to be designed from scratch. Although all formal furniture at this date, and indeed until 1800, was designed to be seen ranged against and related to the walls, Kent's furniture, like that of most architectural interiors, was remarkably architectonic in its decorative treatment, combining the weight of ancient Rome with modern Italian baroque ornament. Interestingly, while the more traditional elements of the Kentian interior were rapidly imitated in lesser

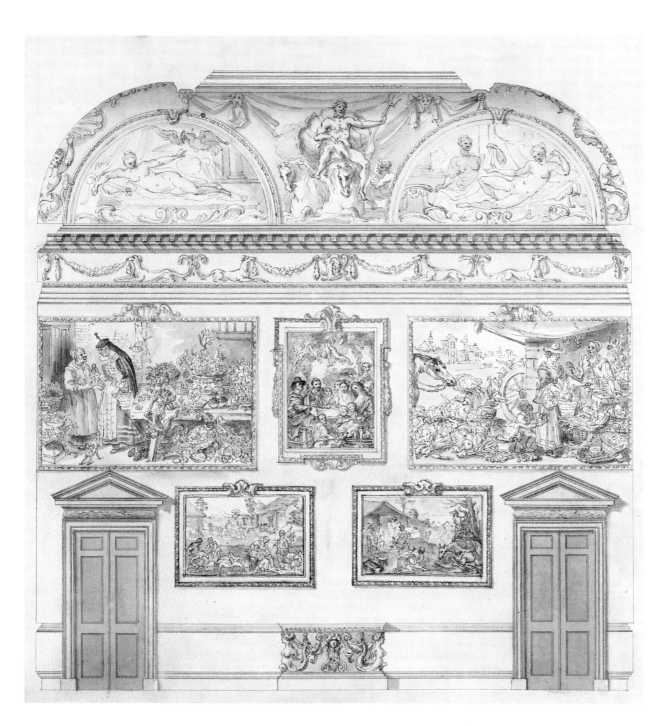

contexts, his furniture was not, with the exception of his picture frames. This was perhaps because furniture had not at that date fully fed into the idea of a total style for an interior.

This was certainly the case by the time John Yenn produced his house design of 1774 (see plate 136), in which not only the wall coverings and fixed ornaments are seen as the legitimate field for the architect, but also the major pieces of furniture such as beds, dressing tables, mirrors and sofas. Much of the credit for this development can be given to Robert Adam, in whose work the total architectural interior reached maturity.

The aesthetic success of Adam's unified interiors was largely due to the use of a fairly limited repertoire of classical ornament which, because of its small scale, could be applied to all elements of the interior in a varied and interesting way.[32] The unique adaptability of Adam's ornament to objects of all types gave eighteenth-century neo-classicism in Britain a greater sense of unity than any style before or since. In publishing his own designs, Adam, like Daniel Marot (see plate 146)

included perspective views to illustrate the way the interior spaces worked and the manner in which the different parts, including fixed pieces of furniture such as mirrors and pedestals, were combined in the total effect. In the case of Derby House (plate 149) the room is shown empty of movable furniture, presumably because that element would have been designed and supplied by an upholsterer or cabinet maker, working either from an Adam sketch or on their own in the Adam manner. For other schemes Adam supplied designs for furniture and on several occasions designed displays of silver as well as the sideboards on which it stood.

149. The third drawing room at Derby House, Grosvenor Square, London. Engraving by B. Pastorini, 1777, after a design by Robert Adam, published in *The Works in Architecture of Robert and James Adam*, II, 1779. London, Victoria and Albert Museum.

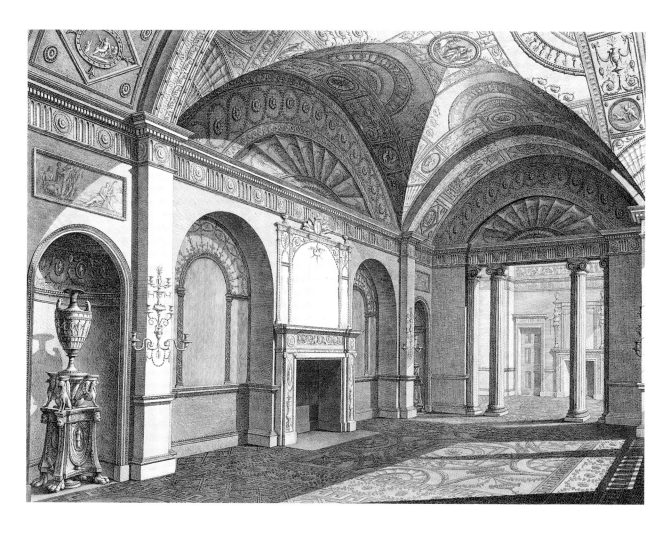

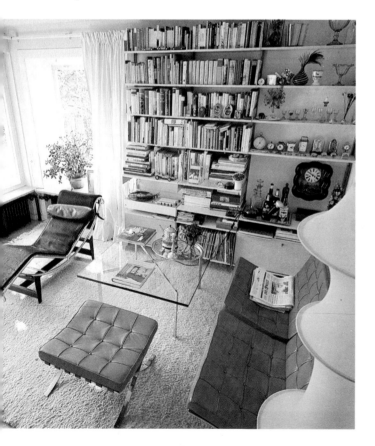

150. A living room, *c*.1974. The *chaise longue* prominently posed in the window was designed in 1928 by Le Corbusier in collaboration with Charlotte Perriand and Pierre Jeanneret; copies were made from 1965 onwards. The other chairs were designed by Mies van der Rohe as royal seats for the Spanish Pavilion at the Barcelona International Exhibition of 1929; they were reproduced from 1950 onwards.

Standardization and anti-standardization

The patrons of eighteenth-century architects like Robert Adam very often took an active part in the design of their interiors, suggesting improvements and modifications which displayed considerable aesthetic judgement as well as knowledge of classical sources. While the decoration of such interiors might display the patron's wealth and demonstrate his taste in fashionable ornament, it was never an expression of individual personality, either of patron or architect. This de-personalizing approach, unremarkable under the eighteenth-century central rule of taste, was often revived by those architects and designers (often within institutions) who sought to control the huge diversity of available styles which accompanied the introduction of mechanized production in the nineteenth century.

The furniture designed by Walter Gropius and Marcel Breuer at the Bauhaus in the 1920s was quite deliberately conceived to be rationalized, standardized, de-personalized and beyond the reach of fashion. According to Breuer, 'A piece of furniture is not an arbitrary composition; it is a necessary component of our environment. In itself impersonal, it takes on meaning only from the way it is used or as part of a complete scheme'.[33] In wartime Britain, 'utility' furniture, the only kind available, attempted to turn public taste towards solidly made plain pieces in 'good' taste. In the 1950s the public returned with relief to 'proper' furniture, veneered, ornamented and made in groups for particular functions.[34] Pieces by Bauhaus and other Modern Movement designers (or copies of them) have, on the other hand, tended to become essentially decorative as icons of Modernism, proudly isolated demonstrations of the taste, discernment and social position of their owners (plate 150).

The idea that a domestic interior could express in its fixed decorations, contents and arrangement the individuality of its creator first took positive form in the nineteenth century. In the architectural interior there was a fundamental shift away from the self-effacing rule of taste towards the notion that an architect was 'in the first place an artist, responsible for beauty, for unity of conception and completeness of design'.[35] Architects like Mackay Hugh Baillie Scott in Britain, Josef Hoffmann in Austria and Frank Lloyd Wright in America produced schemes that were seen, with all their specially designed contents, as *Gesamtkunstwerke*, total works of art. Reactions against the dominating taste of the artist-architect were fostered by a parallel movement which, since the 1870s, had been encouraging people to express individuality in their own arrangements. In Britain, 'architect-designed' has since become a synonym for the non-standard, if not the positively quirky. In 1903,

Punch filled an interior with Baillie Scott furniture, with the ironical message that only an architect could add 'art' to the home (plate 151). Uncomfortably seated is Baillie Scott himself, being given a taste of his own medicine.

The ideal inhabitant of such an interior, and the imaginary client of numerous architectural competitions, was the 'art lover'. The 'Poor Little Rich Man', the subject of a cautionary tale by Adolf Loos published in 1900, employs an architect to introduce Art, the 'great sorceress', into his home, in order that his cares might be charmed away.[36] The architect starts by throwing out all the furniture and 'quicker than you could blink an eye, Art was captured, boxed in, and taken into good custody within the four walls of the rich man's home'. Not a detail was forgotten: 'Each room formed a symphony of colours, complete in itself. Walls, wall coverings, furniture, and materials were made to harmonize in the most artful ways. Each household item had its own specific place and was integrated with the others in the most wonderful combinations.' At first the rich man 'revelled in art with enormous fervour', reassured by praise of the art journals and by the architect's obscure claim that 'these were no ordinary architect's arts; no, the individuality of the owner was expressed in every ornament, every form, every nail'. But, the house having been filled with objects of the architect's own design, each with its particular place, nothing more could be allowed to enter. Forbidden from acquiring and displaying anything of his own choice, including his own clothes, the rich man 'was precluded from all future living and striving, developing and desiring. He thought, this is what it means to learn to go about life with one's corpse. Yes indeed. He is finished. *He is complete!*'

151. 'The latest style of room decoration. The home made beautiful. According to the "Arts and Crafts".' Caricature by R.C. Carter in *Punch*, 11 March, 1903. London, Victoria and Albert Museum.

THE LATEST STYLE OF ROOM DECORATION. THE HOME MADE BEAUTIFUL.
According to the " Arts and Crafts."

House and home

To Loos, a person prevented from accumulating and displaying objects in his or her own dwelling was being denied an essential expression of individuality. To the modern mind this idea, central to the concept of 'home', is so commonplace as to hardly need stating. To Loos's generation, however, its full expression was comparatively new, although it had been slowly developing since the Renaissance. The root of the idea seems to lie in assembly of private collections such as that of Andrea Udone described by Aretino. Not only were such collections of works of art and books essentially private, but they were housed and contemplated in the *studio* of the Renaissance house, a private and intimate space arranged according to the personal taste of the owner. To later collectors, like the scholar and antiquary William Stukeley, writing in 1751, such interiors were essential to a real existence: 'I have now fitted up my library (& 'tis just full), so that I may properly say I begin to live. I have adorn'd my study with heads, bas reliefs, bustos, urns… my study is my elysium.'[37]

152. John Carter, the Holbein Chamber, Strawberry Hill, 1788. Watercolour. The Holbein Chamber, designed to contain objects related to (or believed to be related to) the court of Henry VIII, was made in 1758–9. Yale University, the Lewis Walpole Library.

The interiors of Horace Walpole's villa at Strawberry Hill, begun in 1747, developed the idea by extending it to most of the rooms of the house.[38] Walpole, like many antiquarians, collected objects mainly for their associations rather than their aesthetic merits, but he differed from them in that his collection was arranged in an informal but decorative way in a series of specially designed, and stylistically innovative, interiors in which he actually passed his daily existence, at any rate in the summer (plate 152). The quirky rooms of earlier antiquarians were transformed into a new type in the mainstream of interior design, called by Clive Wainwright the 'romantic interior'. Significantly, Strawberry Hill was the subject of the earliest sustained illustrated account of a house, its contents, and its interiors. Strawberry Hill was both public (the illustrated account grew out of a guide for visitors) and private. In its contents and design it was intended to be a conscious evocation of Old English Hospitality, an antiquarian idea partly derived from Renaissance and medieval buildings and accounts, as well as literary sources. The idea of homeliness had become indissolubly linked to the comfortable, the additive and the personal. Designers after Walpole were able to combine these ideas with precedents from a broadly medieval past, the cottage and the great hall, creating images of home very different from the formal, classically derived modern interiors of their day: the medieval hall and the cottage.

The years during which Walpole started work at Strawberry Hill also saw the beginning of the idea of 'interior decoration' as a process separate from architecture. As long as walls could be covered only with expensive textiles, painting or panelling, relatively few people could afford to decorate their rooms in an up-to-date style, or even at all. The spread of wealth to the middle classes, combined with technical advances in the manufacture of decorative materials such as wallpaper, enabled interior design to become a branch of the fashion trade, with a commensurately rapid turnover in styles. By 1750 a London hostess like Mrs Montagu could write that she was 'sick of Grecian elegance and symetry, or Gothic grandeur and magnificence' and was seeking instead 'the barbarous gout of the Chinese'.[39] Some people hunted out their own wallpaper,[40] much in the modern manner, but others employed an upholsterer or 'upholder' who could design and supply a whole scheme, including furniture, textiles and floor and wall coverings (plate 153).[41] Although they might at first sight seem to resemble modern interior decorators, upholders emerged from the cabinetmaking, carving or housepainting trades and were not on an equal footing with their clients.

V. A. M.

E.263-1929

153. John Linnell. Design for an interior, *c*.1755.
Watercolour. At this date Linnell was designing for
the furniture making firm of his father William.
London, Victoria and Albert Museum.

The concept of 'interior decoration' was well established by the time the words themselves first appeared in print, in the title of Charles Percier and Antoine Fontaine's *Receuil de décorations intérieures*, published in serial form in 1801 (and as a book in 1812). Indeed, the authors' aim was to control through good exemplars of modern design a form irretrievably dominated by changes in fashion. In England Thomas Hope's *Household Furniture and Interior Decoration*, published in 1807, was inspired by Percier and Fontaine's example and had similar reforming aims, except that it was entirely devoted to the rooms and furnishings of a single house, Hope's own London residence. Hope, like Walpole, opened his house at Duchess Street to the public, and, like Strawberry Hill, it was the setting for a collection, but their aims were very different. Hope was not interested in object association but in design reform. At Duchess Street

154. The Picture Gallery at the house of Thomas Hope. Illustration from Thomas Hope, *Household Furniture and Interior Decoration*, 1807. The curtains on the wall protect the pictures from the sun. London, Victoria and Albert Museum.

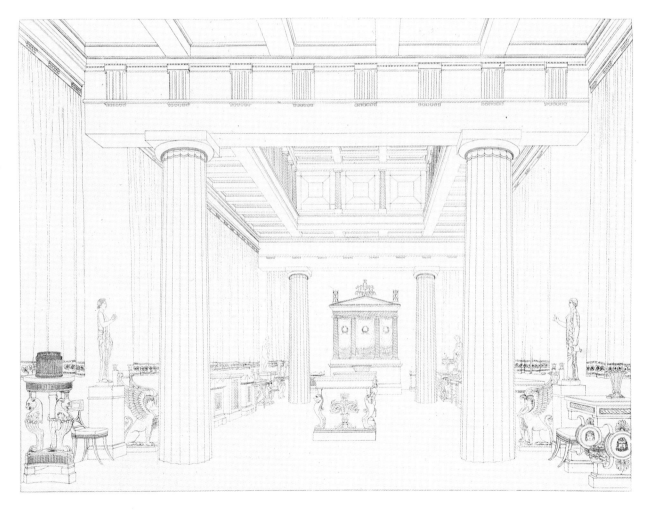

'the entire assemblage of productions of ancient art and of modern handicraft' (designed by Hope himself) were 'intermixed, collectively, into a more harmonious, more consistent, and more instructive whole' (plate 154).[42] It was a *Gesamtkunstwerk* in embryo.

In all these developments the idea that the decoration of a room might express a person's individuality had yet to emerge, although the notion that a house could be turned into a home expressing the inhabitant's sensibility became common currency in the first half of the nineteenth century, especially if applied to a cottage or villa.[43] 'To have a "local habitation",' wrote Andrew Jackson Downing in 1841, 'a permanent dwelling that we can give the impress of our own mind and identify with our own existence — is the ardent wish of every man.' Such a building must, in its design, be 'indicative of the intelligence, character, and taste of the inhabitants'.[44] For the decoration of interiors Downing recommended a system of decorum in which 'correct artistical propriety demanded an expression of purpose in each room', giving it 'a kind of individuality'. The hall should be 'grave and simple', the library 'sober and dignified', the dining room 'cheerful', the drawing room 'lively and brilliant' and 'adorned with pictures and other objects of art', while bedrooms should be 'simple, or only pretty'.[45]

The full expression of a person's individuality through their interior could only come with the complete breakdown of classical rules of taste presaged by such Romantic interiors as those at Strawberry Hill, backed up by the Picturesque idea that architectural and design values lay in qualities of character and association (as perceived by an individual observer) rather than absolute, and chiefly classical, forms.[46] By the middle of the nineteenth century some writers on interiors were beginning to suggest that a single style, with the control it exercised over every object in an interior, was both restricting and undesirable.[47]

By the 1870s a flood of books of furnishing advice were coming out in Britain and America, designed to guide householders through the new eclectic and informal 'art' style. These manuals, such as those in Macmillan's 'Art in the Home' series, were crucially different from their predecessors; they were addressed to middle-class women and were often written by women from the same group. The upholder, the professional supplier of rigid, formalized interiors, was seen to have failed. For the first time householders were being encouraged to modify the decoration and arrangement of their rooms in order to express their own individuality. In the 'art' interior every element could be seen as expressive, including the furniture, but the chief vehicle for expression was the individual 'ornament', just as it had been in the

Romantic interior: 'It cannot be too strongly insisted,' asserted Mrs Orrinsmith in *The Drawing Room*, 'that the most trivial details of decoration in the surroundings of our daily life are important; for who can define the pleasure that the numberless trifles in a well-garnished drawing-room may be made to afford the eye, and thus to sooth and satisfy the mind?'[48] The cottage ideal of domesticity, with its emphasis on objects as decoration, tended to centre 'ornaments' on the chimneypiece, where they remain to this day.

The intense interest in the domestic interior as an arena for art, which dominated the later nineteenth century, not only made it the principal site for developments in design but on occasion turned it into a vehicle for the most concentrated personal expression. The Duc des Esseintes, the aesthete hero of J.-K. Huysmans's novel *A Rebours* (Against Nature), published in 1884, 'had discovered in artificiality a specific for the disgust inspired by the worries of life'.[49] His interiors and all their contents, including food and plants, enabled him to escape from the present-day world into 'an atmosphere suggestive of more cordial epochs and less odious surroundings'. [50] It is not, perhaps, surprising that the same years saw the emergence, in the United States, of the earliest interior decorators in the modern sense. Like many of her successors, and unlike her trade predecessors, Elsie de Wolfe, the first true professional interior decorator, came from the class for which she worked.[51] The job of the interior decorator, then and now, was to express, at least ostensibly, the personality of the (most often) woman of the house. A later American decorator, Emily Post, set the seal on the idea with her book *The Personality of the House*, published in 1930. The house and its owner were now perfectly joined: its 'personality should express your personality, just as every gesture you make — or fail to make — expresses your gay animation or your restraint, your old fashioned conventions, your perplexing mystery, your emancipated modernism — whatever characteristics are typically yours'.[52] Interior decorators were greatly helped in this task by having no belief in the permanence of their creations or their ideas. Their work, unlike that of the creator of the architectural interior, was and is a branch of fashion.

In the daunting task of selecting from the thousands of paint colours, wallpapers and furnishing textiles now available, the householder doing his or her own decoration can be guided by numerous specialized books and magazines. These are often dedicated to the presentation of particular 'looks', shown as combinations of quite specific types of object and forms of decoration. At first glance, 'looks' are the modern expression of that plurality of styles which enabled a nineteenth-century house

155. The College Prep Room (detail). Illustration by Laura Jean Allen from Mary Furlong Moore, *Your Own Room: the Interior Decorating Guide for Girls*, 1960.

156. Cover of *How to Turn a House into a Home*, 1979. London, Victoria and Albert Museum.

to have an Adam drawing room, a Jacobean hall and a Turkish smoking room. But a 'look' is in fact far vaguer than an architecturally based historical style, because it usually has its origin in the artfully casual inventions of professional interior decorators seeking to express the 'personality' of a client. The link is clearly shown in books like *Your Own Room*, an American guide for teenage girls published in 1960.[55] 'Are you hip to your own room, and sure it's decorated to groove your personality?' it asks, presenting 'six dream rooms personally yours', which include a Ballerina Room, a Room-with-Its-Arms-Around-You, and an Indoor-Outdoor Room (plate 155). In fact all the rooms conform to accepted contemporary 'looks', from colonial to Scandinavian modern. The aim of the book was to give experience for 'when comes the happy time to decorate your very own *home*'.

The concept of 'home' is now the dominating factor in the manner in which people in the West approach the ornamentation of their own interiors. A typical English guide of the 1970s, *How to Turn a House into a Home*, defines interior decoration as 'the creative art of home-making', the putting together of a warm, welcoming and 'homelike' environment (plate 156). 'Having a warm home that looks good and works well and that you, your family and friends enjoy must be one of the most worth-while things in life.'[54] This act of homemaking not only encompasses decoration in the pure sense, but also the accumulation and display of objects both useful and dec-orative As in the Romantic interior and in the crowded middle-class rooms of the last century, it is largely through more or less decorative objects that modern householders are able to say something about personal identity, even if only on the mantelpiece (plate 157).

157. The mantelpiece of Michael Bentine, 1992. This photograph by Peter Fraser was made for a series of interviews in the *Daily Telegraph Magazine*, in which people discussed the significance of the objects on their mantelpieces. The actor and comedian Michael Bentine's includes mementoes from all stages in his life, including Second World War bullets, a Peruvian medal and ornaments made by his children. The objects contrast interestingly with the more traditional decoration of the picture frame and chimney-piece.

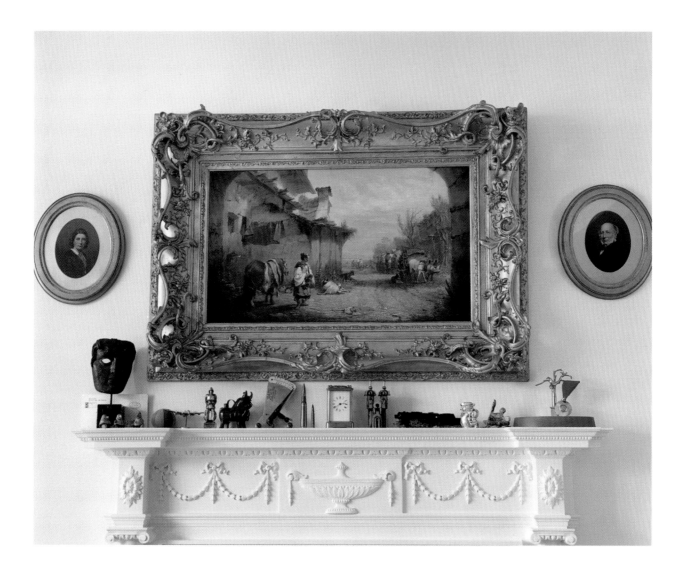

The moral interior

As a chief arena of taste and social differentiation, the decoration of the interior, like bodily adornment, has often been a moral battleground. The moral messages of the forms, construction and application of ornament in the domestic interior were of particular concern from the mid-nineteenth century onwards. Three main elements can be identified: the condemnation of sham, the positive moral benefits of beauty and the beneficial effects of simplicity. All three notions have had a marked effect on the ways interior decoration has been handled since about 1850.

Vitruvius carried the rules of structure to fictive interior decoration. His attack on the illogical absurdities of the grotesque wall-painting led Sir Henry Wotton to approach the form with caution, restricting its use to friezes.[55] Vitruvius was, however, no objector to sham architecture in paint. For centuries thereafter the imitation in paint of richer materials, from the painted curtains on medieval walls to such oddities as an ordinary Swedish chair painted to resemble marble (plate 158), attracted no comment. Equally accepted was the use in the eighteenth century of sham materials like scagliola to complete sets of ancient marble columns, such as those used by Robert Adam at Syon House, or the employment of painted papier mâché and *trompe-l'oeil* wallpaper, to represent plaster mouldings.

The real attack on sham in the interior did not begin until the greatly increased manufacture of fictive materials in the second half of the eighteenth century threatened to debase the quality of furniture and other domestic objects. The first shots, fired by Percier and Fontaine in 1801, attacked both false materials and the use of ornament as structure, as in a chair leg formed entirely out of decorative motifs.[56] While Percier and Fontaine's ideas had a certain moral edge, they stopped short of suggesting that the object's creator or possessor might be immoral.

That task was left to A.W.N. Pugin, who in his writings, notably *The True Principles of Pointed or Christian Architecture*, published in 1841, linked sham and false construction with the Protestant classical style and honesty with Catholic gothic (plate 159). Similar ideas, developed by Ruskin and the government design reformers at South Kensington, led to a general idea in the middle of the nineteenth century that certain types of ornament, especially those which appeared to falsify the material from which they were made, were badly designed, immoral in themselves and their owners immoral by extension. Henry Cole's display of objects exemplifying 'false principles' of design, set up in the government Museum of Manufactures in 1852 and

158. Chair painted to resemble marble, Swedish, *c*.1750. The chair comes from the kitchen of the Swedish manor house of Thureholm, which was painted with blue and white chinoiserie scenes and fitted out to display imported blue and white ceramics. Stockholm, Nordic Museum.

159. Modern upholstery, a page from A.W.N. Pugin, *The True Principles of Pointed or Christian Architecture*, 1841. London, Victoria and Albert Museum.

28 PRINCIPLES OF POINTED OR

MODERN UPHOLSTERY

over windows, instead of the appropriate valance or baldaquin of the olden time. It is proper in this place to explain the origin and proper application of fringe, which is but little understood. Fringe was originally nothing more than the ragged edge of the stuff, tied into bunches to prevent it unravelling further. This suggested the idea of manufacturing fringe as an ornamental edging, but good taste requires that it should be both *designed and applied consistently*.

In the first place, fringe should never consist of *heavy parts*, but simply of threads tied into ornamental patterns.

Modern Fringe, composed of turned pieces of wood. Ancient Fringe, composed of threads.

160. William Holman Hunt, *The Awakening Conscience*, 1854. Oil on canvas. London, Tate Gallery.

161. The Drawing Room, 118 Mount Street, London, 1894. Photograph by Bedford Lemere. The room was put together for a Miss Walford by the fashionable decorator Howard Hanks. London, Victoria and Albert Museum.

quickly dubbed 'the chamber of horrors', included a great many examples of household decorations, especially carpets, wallpapers and furnishing textiles. Carpets in particular seemed to have caused a lot of trouble, especially as they frequently bore patterns which were three-dimensional in effect: 'on the carpet vegetables are driven to a frenzy in their desire to be ornamental'.[57]

The mid-Victorian drawing room or parlour, 'the very head-quarters of the commonplace',[58] became the object of quite extraordinary condemnation in the furnishing books of the 1870s and 1880s, which often contained several pages of detailed description calculated to enrage their readers into a suitably aggressive spirit of reform. The strongly moral tone of these accounts had its origins in the 1850s. In Wilkie Collins's novel *Basil*, published in 1852, the eponymous hero, of good and ancient family, visits North Villa, the home of his true love, the daughter of a *nouveau riche* businessman. He is shown into what he presumes is the drawing room:

Everything was oppressively new. The brilliantly-varnished door cracked with a report like a pistol when it was opened; the paper on the walls, with its gaudy pattern of birds, trellis-work, and flowers, in gold, red, and green on a white ground, looked hardly dry yet; the showy window-curtains of white and sky-blue, and the still showier carpet of red and yellow, seemed as if they had come out of the shop yesterday; the round rosewood table was in a painfully high state of polish; the morocco-bound books that lay on it looked as if they had never been moved or opened since they were bought; not one leaf even of the music on the piano was dog-eared or worn. Never was a richly furnished room more thoroughly comfortless than this – the eye ached at looking round it. There was no repose anywhere. The print of the Queen, hanging lonely on the wall, in its heavy gilt frame, with a large crown at the top, glared on you: the books, the wax-flowers in glass cases, the chairs in flaring chintz covers, the china plates on the door, the blue and pink glass vases and cups ranged on the chimney-piece, the over-ornamented chiffoniers with Tonbridge toys and long-necked smelling bottles on their upper shelves – all glared on you. There was no look of shadow, shelter, secrecy, or retirement in any one nook or corner of these four gaudy walls. All surrounding objects seemed startlingly near to the eye; much nearer than they really were. The room would have given a nervous man the headache, before he had been in it a quarter of an hour.[59]

A nightmare of newness and novelty, the room epitomized exactly the brash and gaudy ornament which had so horrified the design-reforming judges of the Great

Exhibition of 1851, but Basil's reaction to it sprang from a source very different from theirs. To the judges, newness in itself was not an offence. They believed they could reform design. For Basil, accustomed to the gradually accreted contents and faded colours of an old family interior, the glaring drawing room of North Villa was a moral judgement on newly acquired wealth. An even stronger moral message is carried by the very similar room in Holman Hunt's painting *The Awakening Conscience*, shown at the Royal Academy in 1854 (plate 160).[60] Every detail is used to carry the message of the picture, in which, according to the artist, a kept woman recalls 'the memory of her childish home'[61] while her shallow lover sings on. The illicit liaison is not only directly symbolized by such details as the pattern of the wallpaper, in which the corn and vine 'is left to be preyed on by thievish birds', but is also, as Ruskin pointed out, symbolized by 'common, modern, vulgar' objects in the room, all of which are imbued with a 'fatal newness'.[62] Newness is fatal because, like the lovers' relationship, it is false. In this context the standard symbol of the mid-Victorian parvenu, the over-bright rosewood veneer of the furniture,[63] functions as a far deeper moral condemnation. Such a room could never be the setting for sound values or a real home.[64]

There were two ways out of the problem of the immorality of a new interior, the first based on art and the second on honesty. According to Catherine Beecher and Harriet Beecher Stowe, whose ideas were published in 1869, beauty was of positive benefit in the home, having 'a constant and wholesome power over the young' and contributing much to 'the education of the entire household in refinement, intellectual development, and moral sensibility'.[65] For these two authors beauty lay in the fine arts and nature; for most of the cultured middle classes of the 1870s and 1880s, however, 'art and artistic feeling are as much shown in the design of furniture and other accessories as in what have been hitherto considered the higher or "fine" arts of sculpture and painting'.[66] While such a unified concept could lead, in the hands of a des Esseintes, to an expression of depravity, it was usually regarded as being positively beneficial, often against all reasonable evidence: 'It would be impossible to commit a mean action in a gracefully furnished room.'[67] It is nevertheless often hard for the modern observer to detect the moral content in the 'Art' interiors of the 1870s to the 1890s perhaps because their clutter and striving for novelty now tend to spark off in us reactions very similar to those inspired by the interiors of the 1850s which they were trying to replace (plate 161).

162. Catalogue for Divertimenti (Mail Order) Limited, 1994. The cover design plays on the idea of the ornamental effect of hanging cooking utensils by suspending Christmas tree decorations and a chestnut pan on the same rail.

163. 'Functional'. Illustration by Osbert Lancaster from *Homes Sweet Homes*, 1939. Seated on the stool is the avant-garde critic Herbert Read.

Still evidently 'moral' in feeling, and consequently a continuingly potent influence on modern ideas on interior decoration, are the results of the drive towards 'honesty'. While the 'dishonest' mid-Victorian interior derived its style from the formal, notably French, interiors of the previous century, the 'honest' interior of the Arts and Crafts Movement, although taking some of its ideas from Pugin, was to a significant extent inspired by a vision of the 'styleless' and informal cottage room. The country cottage as an idealized concept of home took solid form in the first half of the nineteenth century. In such a cottage, in America in 1850, 'all ornaments which are not simple, and cannot be executed in a substantial and appropriate manner, should at once be rejected; all flimsy and meager decorations which have a pasteboard effect, are as unworthy of, and unbecoming for the house of him who understands the true beauty of cottage life, as glass breastpins or gilt-pewter spoons would be for his personal ornaments or family service of plate'.[68]

The 'true beauty of cottage life' could only be appreciated by those who could afford silver. In fact real cottagers imitated, as best they could, the tastes of the unreformed middle classes: 'I still remember the shock and disappointment when I first entered,' wrote one observer in 1919, 'and found walls covered with ugly patterned papers of unpleasant colours and thickly hung with Christmas supplements and enlarged photographs of the family. Although the rooms were a good shape, they were spoilt by being crowded up with many useless oddments, and the lovely view I had hoped to see through the windows was only visible through the mesh of Nottingham Lace curtains.'[69]

'Honesty' in interior decoration today can go in one of two directions, both of them carrying a moral charge. The first, derived from the ideas and work of the Arts and Crafts Movement, is nowadays chiefly located in kitchens. These can, for instance, be either fully fitted out with elaborately decorated and more or less handmade cupboards ('English Country') or have plain walls, the main ornament being the numerous hanging, and often entirely decorative, cooking implements ('French Country') (plate 162). The message here is one of honest and generous homeliness, a true descendant of the Old English Hospitality expressed in the haphazard and additive arrangements of the Romantic interior. In recent years the wooden fittings of such interiors have been painted or grained, with no diminution of the moral message.

The second moral direction is concerned with the rejection of ornament. Adolf Loos's linking of ornament with criminality, and a lack of ornament with virtue, found its expression in the Modern Movement interior.

Its controlled and formal spaces are largely uncoloured ('whitewash is extremely moral')[70] and cleared of all mouldings, including those whose main function is to conceal the difficult joints between floors, walls and ceilings. Although intended to be a new architecture with a universal application, these interiors have come to speak of an existence on a higher moral and intellectual plane (plate 163). A similar moral charge is carried by the interiors of the Shaker religious sect in the United States. To the Shakers, who laid down their 'Millennial Laws' in 1823, all decoration is immoral. Every part of the interior is strictly utilitarian. Mouldings, although used out of necessity in the construction of doors, windows and other fittings, are reduced to their simplest form. Also cleared away are all personal belongings, and such communally owned objects as are allowed are made to standard patterns. These starkly simple objects, with their fundamentalist message, have exercised a deep fascination for non-Shakers, whose reaction has often been to turn them into ornaments (plate 164).

164. Shaker furniture and other objects, as sold by the Shaker Shop, London.

5

Ornament in Public and Popular Culture

165. Well-dressing representing the passage from Exodus 20:5. Stoney Middleton, Derbyshire, 1994.

166. Charles Wild, *The Champion of England entering Westminster Hall at the coronation of George IV*, 1821. Watercolour. The coronation of George IV is celebrated for its lavish, if poorly rehearsed ceremonial. This was the last time that the Champion challenged the sovereign's enemies at the coronation banquet. London, Victoria and Albert Museum.

At the end of the twentieth century many configurations of words, letters or distinctive patterns are known to people throughout the world thanks to advertising and the vast communications network that promotes it. Today we share meanings attached to certain forms of ornament with people across the globe. In earlier times, the 'public' for particular kinds of ornament was more localized and based on regional or national custom and practice. This chapter will look at ornament in public life and culture, covering a range of evidence from social and religious rituals both old and new to the visual images created to sell goods and services by great modern corporate industries. Certain patterns of ornament emerge that reveal an ever-evolving sense of how a public, large or small, can be persuaded to feel a sense of belonging, whether in the act of attending an annual ceremony, or simply when buying a common, everyday product.

Rituals: government and the community

In all societies, people participate in public rituals which confirm a sense of identity and shared values. The traditional venues for these ceremonies in European and American culture are the public spaces of streets, squares and market-places, churches and town halls. Rituals are invariably concerned with the display of objects which carry the message of the significance of the occasion and may have talismanic or magical powers associated with them. Often such objects will be greatly venerated, expensively made and accompanied, on the occasion of their periodic display, by complex and elaborate framing devices such as archways, platforms, moving carts or wagons. Between their periodic moments of exposure to public view, some objects will be securely housed, perhaps in elaborately decorated containers, and will be often invisible to everyone other than those entrusted with their care. Other objects are made anew for each celebration.

Rituals betray their different origins when we examine their content and purpose. They can appear to reinforce the practice of power and authority, as in the coronation of a sovereign, a procession of civic dignitaries like the annual Lord Mayor's Show in London, or simply in the everyday or weekly ceremonial attached to the practice of Christian religious worship. The latter is particularly evident where the the church is 'established' and therefore linked to the authority of the state, as the Church of England has been since the Reformation. On the other hand, rituals may be equally concerned with community life yet appear detached from political power; these are ceremonies which are generally believed to have sprung from custom and folklore, from the calendar of the lives of ordinary people. These popular

events are often determined in their timing and content by their coincidence with the celebration of the changing seasons of the year and the appropriate seasonal pastimes and enjoyments, such as giving thanks for harvest, for example. In some places these customs survive against the odds, though only by suspending contemporary daily activities; when roads have to be temporarily closed for an event, such as a procession or an annual street fair, this underlines the occasion's pecularity in our modern environment. Sometimes the continuance of long-established ritual into modern times may be unashamedly for purposes other than those for which the practice originated. In the English county of Derbyshire, wells were 'dressed' for a few days each year with patterns of natural objects such as flowers as thanks for the provision of water in this rocky upland area (plate 165). The practice persists, and now in about twice as many villages as fifty years ago, in order to raise funds for charity and, through involving many inhabitants in preparing the display, as a way of preserving each individual village's sense of community.[1]

There is less of a gap between official and what we might call popular art than is often imagined. Looking at Europe in the period after the mid-fifteenth century, it may appear to us that official ritual readily took on the trappings of revived antique decoration to signal power and authority, whilst popular ritual preserved less sophisticated, naive images and patterns. These visual differences are, however, only skin deep. One significant thread which runs through both is an appeal to tradition, to the idea that venerable objects and the way they are periodically displayed are somehow part of legend and have been in existence for longer than written documents can prove. They can thereby represent the very roots and unchallengeable nature of authority or community. A closer inspection reveals, however, the way that traditional ornament can conceal or deny the changing social and political circumstances in which people live, for the substance of tradition is often an illusion. The visual culture, the artefacts of ritual and of long-held values, are constantly reworked and refashioned. The ceremony of coronation is a case in point. Whilst

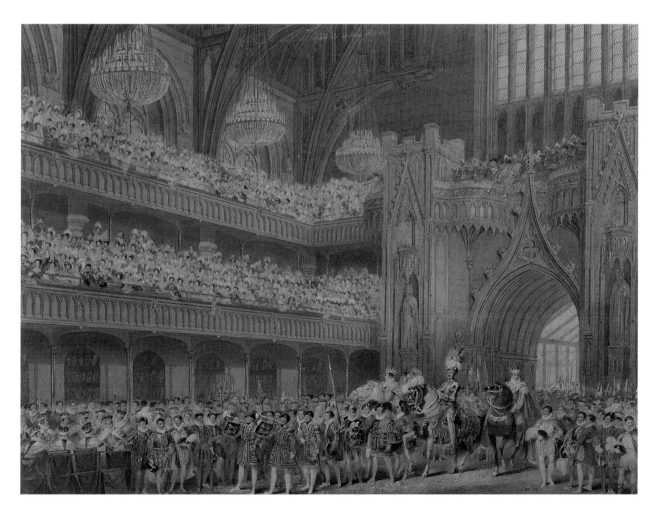

some of the meanings of the objects and localities associated with the crowning of British sovereigns, such as the orb and sceptre and particularly the venue for the ceremony, Westminster Abbey, date back many centuries, the arrangement of the ritual and the organization of festivities attached to the event of the coronation have been revised and reinvented many times (plate 166).[2]

Sometimes the ornament of popular artefacts challenges the seriousness of official or authoritarian culture and breaks conventional rules. In some instances the flouting of rules is manifest in forms of visual excess; in the overblown and exaggerated art of the fairground, for example, in both its colour and line and its size of motif relative to the surrounding picture field. As well as this, the art of the streets and public places, whether popular entertainment or the triumphal entry of a dignitary into a city, often betrays a *horror vacui*, a need to fill every available space with ornament and overstated message. Sometimes this is crude and unsophisticated, but not always. For the language of ornament in this sphere is skilled at the exploitation of puns, both verbal and visual. It can also, whether intentionally or not, betray a passion for the fantastical that shows a use of the standard repertoire in new and creative ways. Sometimes continual reinvention is part and parcel of the changing and responsive message, so for example in modern packaging there is a constant effort to make sure that the product's essential, known qualities are retained, but the latest signal on the advertisement hoardings will present

a new pattern of familiar ideas to challenge and engage the viewer's attention. So gold is the constant signifier of Benson and Hedges cigarettes to the point where all else can be excluded from an advertisement, including the name itself, if the constant of gold is kept before the public's eye and prompts recognition (plate 167).

Heraldry as ornament

No visual sign appears more authoritative, more indicative of an institutionalized social order, than a coat of arms, yet the story of heraldry is one of constant shifts of emphasis and traditions invented to meet new political realities.[3] In origin, the use of heraldry has a practical purpose, for the placing of a shield or coat-of-arms on an object is a sign of ownership, especially in public places where the object may be competing with many others for attention or identification; in a public procession for example, or among the crowded tombs and memorials in a great cathedral or local parish church (plate 168). Yet very soon after the first recognizable heraldic motifs appeared in European culture, around the end of the twelfth century, heraldry was being used collectively in such a way as to imply that it was purely, or at least largely, decorative in intention; in other words, coats of arms or personal badges originally intended to be seen and understood separately as pieces of information became ornament when displayed alongside each other. This is especially noticeable when heraldry was given permanent form in architecture and immovable internal

fittings. In the mid-thirteenth century Henry III of England ordered the shields of the royal houses with whom he was connected to be placed in the spandrels of the aisle arcades of the newly built nave he had commissioned for Westminster Abbey. These we can still partly see, but what we can now only see fragments of are the heraldic tiles, metalwork and wall paintings, recorded in the royal accounts, that once filled the interior and reinforced the decorative message of a host of heraldic furnishings.[4]

At the point at which this book takes up the story of ornament, in the early modern period, there was an explosion of interest in the subject of heraldry and its decorative application. This came about because the newly ennobled families of new and powerful nation states sought to underpin their credibility by seeking grants of increasingly elaborate arms in an attempt to inculcate an idea of their status and the supposed longevity of their family's importance.[5] Each succeeding generation used heraldry across a different range of material possessions to display the status they believed was theirs. In the early sixteenth century there was a pronounced vogue for decorating the exterior of private houses with heraldic devices (plate 169).[6] In the eighteenth century it

167. Benson and Hedges advertisement, 1991. The tablecloth is folded to echo the cigarette carton and all the clues are given to enable the viewer to understand the image with the familiar logo, crest and lettering.

168. The chancel of Bottesford Church, Leicestershire, with the sixteenth-century tombs of the Earls of Rutland demarcated by their particular heraldry.

169. Brympton d'Evercy, Somerset, c.1520. Royal heraldry among quatrefoils and lozenges on what was probably originally the solar block to an English country house.

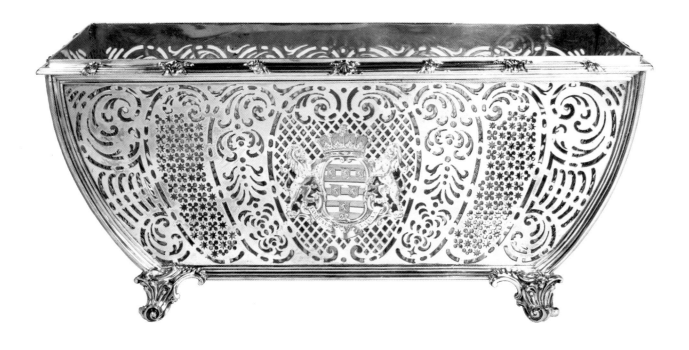

170. Cheese dish, engraved with the arms of the
Earl of Exeter. Made in London by Edward
Wakelin, 1760. Silver. London, Victoria and Albert
Museum.

171. Pair of Lock Cases with handles. French, end
of the nineteenth century. Gilded cast brass, made
by Fontaine frères et Vaillant. London, Victoria
and Albert Museum.

was more evident on other possessions such as domestic silver or the painted panels of the sides of coaches and carriages (plate 170). By the nineteenth century, prominence was given to what has come to be described as the 'buttonmakers' heraldry of crested stationery and the livery buttons of servants, which was especially important to the new grandees of industry and commerce.[7] This Europe-wide phenomenon differed in emphasis from place to place. English heraldry is noteworthy for its ability to abstract an idea through line and colour, whereas the content of French and German heraldry always remained closer to the depiction of recognizable natural objects.[8]

The aggrandizement of power through heraldry became highly personalized when the insignia of a powerful individual became all-pervasive. The heraldry of the Napoleonic regime in France of the early nineteenth century displays a fascinating dialogue between heraldic tradition and invented iconography. The Emperor sanctioned the incorporation of his personal imperial insignia such as eagles, bees and the crown into the heraldry of the towns and cities of France. Most of these reverted to their former heraldry at the fall of the regime in 1814, though the town of Fontainebleau still retains the arms it earned from the Emperor as a 'good' (meaning loyal) town. Fashions of the day were utilized in place of traditional motifs, so to indicate noble rank among the new Napoleonic aristocracy the traditional trappings of the shield of arms, such as as animal sup-

porters, helmets and mottoes, gave way to a carefully devised system of plumed hats and toques. One very simple symbol proved especially potent. Rulers had long used the initial of their name as ornament for propaganda and as if to suggest the royal presence everywhere, but this device was used even more widely by Napoleon (plate 171). The 'N' of course was read as standing for no other name, no other word beginning with that letter, wherever it was displayed.[9] The power of the message was not lost on Bonaparte's nephew, the Emperor Napoleon III, who reasserted the Napoleonic imagery some fifty years later.

If the science of heraldry began in royal and aristocratic circles and became the means of personal aggrandizement among the nobility of Europe, it also quickly became the name-sign of many other authorities, especially collective bodies of citizens of a particular place or workers in a particular craft.[10] As new towns developed, heraldry became adept at expressing their individuality and industrial productivity. Traditional heraldic motifs on medieval civic shields showed a particular town's patron saint as protector, such as St Nicholas on that of the borough of Brentford in the old English county of Middlesex (plate 172). Equally, it could make some reference to the town's geographical location, so that when a bridge appears on the shield of a town this indicates that the fording of a river led to the original foundation; examples include the English towns of Cambridge and Tonbridge (plate 173). Woolpacks were from early times

172. The arms of the borough of Brentford and Chiswick in the 1930s, with the image of St Nicholas.

173. The traditional arms of the town of Tonbridge, Kent, showing the bridge over the river from which its name derives.

used on shields to express the thriving wool trade which dominated English exports in the later Middle Ages. By the time of the industrial revolution, the depiction of new machinery, such as a steam-hammer for the town of Eccles and a blast furnace for Redcar, continued this idea (plate 174).[11]

Just as towns might alter their arms to include a significant honour such as the grant of corporate status by the Crown, so from the seventeenth century onwards military regiments included in their badges some reference to their history and achievement. Five British regiments, for example, including the Gloucestershire and the Devonshire and Dorset, bear a sphinx to represent 'Egypt' after service there (plate 175).[12] The collective spirit of the corporate heraldry of urban life passed into the pride of spirit of some industrial concerns, most notably transport companies. Before the nationalization of the railways in Britain after the Second World War, the 'house style' of the great regional concerns reflected a sense of belonging to an organization akin to something like the great medieval household, with not just the trains, but station buildings, furnishings and staff uniforms carrying the familiar livery of carefully chosen colours and distinctive insignia.[13]

174. The coat-of-arms of the town of Eccles, Lancashire, over the door to the public library, built in 1907.

175. The badge of the Devonshire and Dorset Regiment with a sphinx and the name Marabout, commemorating the battle at the fort outside Alexandria in 1801.

Ornament as information in the public street

This mixture of tradition and of allusion to the present in heraldry is found in a great range of ornamental signs which both provide information and act as a point of reference in public places. Indeed, this practice pre-dates the medieval science of heraldry as we know it, for since ancient times traders have devised ornament in the form of signs hanging outside their doors to indicate what is on sale, or what service provided, within (plate 176). Some of these display the product itself, such as a pair of shoes or breeches. Others display the means by which the product is made; a chisel indicating a carpenter, for example. Yet others use a symbol to represent a wider ethos: the ship incorporated into the great clock completed in 1928 for Selfridge's department store in London symbolizes commerce (plate 177).[14]

176. Cigar-store figure of an Indian princess. American, c.1860. Carved and painted wood. Life-size painted figures were used as signs of cigar-stores because it was believed they were the first to smoke tobacco. The princess holds a bundle of cigars in her hand and the feathers she wears are reminiscent of tobacco leaves. The American Museum, Claverton Manor, Bath.

177. The figures of the 'Queen of Time' and a ship over the main entrance to Selfridges, Oxford Street, London, completed 1931. Portland stone, faience and various metals.

The literal quality of signs never loses its potency even when new associations have supplanted the old. The Roman sign for a vintner was of two slaves carrying an amphora of wine suspended on a pole carried between them; the modern development of this theme into the British public house sign of the 'Jolly Brewers' or 'Two Brewers' has turned the amphora into a barrel (plate 178). Some of the earliest examples of the amphora motif are found at Pompeii; also there is the earliest known sign of a chequerboard, for which two origins have been suggested. It could indicate the address of a money-changer, since chequers were the abacus of that profession. Alternatively, it may simply have indicated that board games could be played inside, in which case the building would probably have been an inn.[15]

It is clear from this display of trades and occupations in pictorial form that signs such as these served the important function of enabling recognition of the function or service of a place through ornament at a time when literacy could not be taken for granted.[16] This has led to a great deal of folklore about the origin of names, particularly of inns and public houses, that supposedly derive from misunderstandings of the sounds of words. At Colnbrook, near London's Heathrow airport, an inn sign of an ostrich is believed to be a misappellation of the word 'hospice', the common medieval term for a traveller's rest house, frequently run by a religious order. The origin of the name 'Elephant and Castle' in London is likely to derive from an emblem of the Cutlers' Company and its links with the ivory trade (plate 179). However, the famous and appealing idea that it derived from a popular malapropism for the title 'Infanta of Castile', referring to a Spanish princess who lodged nearby, shows that in popular myth people rather like the idea that these things spring out of local street-talk and were conveyed from that into a recognizable visual form. The sign for a pawnbroker, the three balls, is likely to come from the heraldry of the Medici family of Florence, who became bankers of European significance; but it is appealing to believe instead that the sign became appropriated in the popular imagination as the sign of three meaning that the odds were two to one against an item ever being redeemed. One of the most popular tales about the origin of the barber's pole, which still acts as the sign of the hairdresser in many places, is that a pole wrapped with bandage was given to patients to grip during blood-letting in the days when barbers also performed minor surgery (plate 180). Increasing literacy in nineteenth-century England meant that pictorial signs gave way to lettering of all kinds and there has been a revival of the painted sign in Britain only since the 1930s; an exhibition of inn signs at the Building Centre in Bond Street, London in 1936 displayed examples of what were considered to be good work and encouraged the revival of craft skills. Signs that survive from this period have now taken their place in the history of inter-war nostalgia (plate 181).[17]

178. 'The Two Brewers' public house sign, Monmouth Street, London, established in the 1930s. Though the allusions date back to ancient times, the figures here are based on old 'Cries of London' publications.

179. The 'Elephant and Castle' public house signs, Vauxhall, London

180. A Barber's red and white pole sign. Charleston, South Carolina.

181. 'The Printer's Devil' public house sign, Clifton, Bristol. In a revival of traditional lettering and simple outlines, signs such as these depended not on heraldry or symbolism but on the inspiration of book illustration.

Advertising a local facility or service, such as an inn, by an elaborate sign was one way in which competition thrived in the towns of Europe in the early modern period. In England, one of the most extraordinary inn signs was that for the White Hart at Scole in Norfolk, erected at a cost of £1,000 in 1655; here a great frame passed over the street outside (plate 182). From early descriptions and surviving representations, it appears to have resembled in ambition the great temporary triumphal arches made for civic occasions. It carried scenes of deer and hunting dogs, and the figures of Diana and Actaeon.[18] The size of such structures was controlled by an Act of Parliament of 1667 and some of the more extreme disappeared, but a few more modest signs that invade the space of the street, or even cross it, remain today to remind us of their once dominant presence. In modern times, strict planning controls in some places have tried to limit street signs to the façades of buildings; angles and depth of projection of signs in Britain are much more tightly controlled, to safeguard the narrow

182. The sign of the 'White Hart' at Scole, Norfolk, which straddled the Ipswich to Norwich road, from an eighteenth-century print.

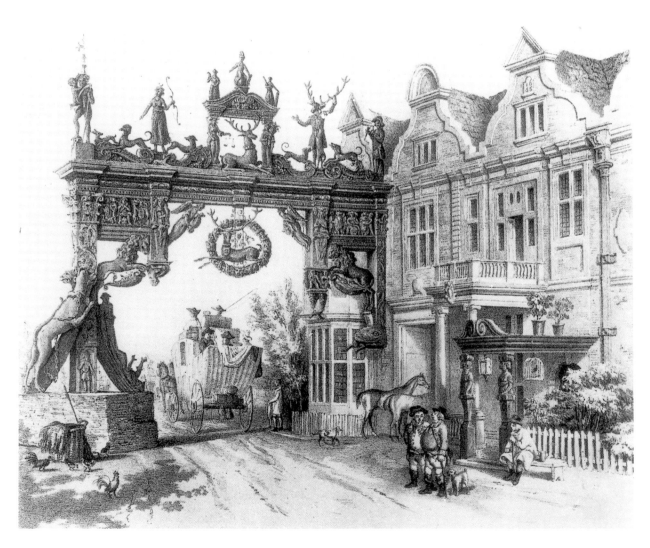

streets of old urban environments, than in the United States, where greater space often allows more freedom of display.

Criticism of the commercial ornament of streets is not a modern phenomenon. In an essay of 1710, Joseph Addison complained of the fantastical nature of the public inn signs of the time; he refers to the streets filled with 'blue boars, black swans and red lions; not to mention flying pigs and hogs in armour, with many other creatures more extraordinary than any in the deserts of Africa'. He castigates unusual pairings of animals, or animals and inanimate things: 'what has the fox and the seven stars to do together? And when did the lamb and dolphin meet, except upon a sign-post?'[19] Addison's attack on the fantasy and incongruity of such pairings borders on a probably wilful misunderstanding of the origin of some of these names. Some derived from the essentially religious purpose of the original building. The urban houses of the great monastic orders of the Middle Ages often ran rest houses for pilgrims, or indeed other travellers, under such names as the Seven Stars (for the Crown of Mary) or the Crossed Keys. With these names, however, as with so much else, the fine line between religious and secular origin is sometimes hard to define. The Lamb and Flag, for example, is still a quite common name for an English public house (plate 183). These symbols are found on the arms of the Portuguese royal family of Braganza, from whose line came Catherine, the queen consort of Charles II, and they also appear on the arms of the Merchant Taylors Company. However, the most likely origin is in the symbol of the religious military order, the Knights Templar, formed in the early twelfth century to assist the defence of the crusading state founded by the Christian nations of Western Europe in the Holy Land.[20]

183. The 'Lamb and Flag' public house sign, St Giles, Oxford.

Ornament: religious and secular authority

Beginning our history of the social context of European ornament in the middle of the fifteenth century, just a century before the Reformation, means that we must acknowledge the long shadow of the Catholic Church on the development of all kinds of ornament in public life. For it was the ritual and ceremony of the Church that originally determined the occasions of the year when communities gathered together. These set the patterns of appropriate ornament for different kinds of event and the way they appeared on dress, on the objects people carried in procession, on the moving platforms on which they stood and in the decoration of streets. This Catholic legacy remained dominant even in those parts of Europe that became Protestant and where secular ceremonial supplanted religious celebrations after the Reformation. In London, the Lord Mayor's Show originated in the need for the new Lord Mayor to present himself to the sovereign at Westminster, a practice that began in the early thirteenth century. After the Reformation it became a more elaborate event, with pageant cars and due ceremonial displaying the city's power and prestige. In so doing, it replaced the midsummer church festivals dedicated to St John the Baptist and Saints Peter and Paul. By the nineteenth century the Lord Mayor had ceased to undertake the journey as far as Westminster and simply processed around the square mile of the old city of London. The ceremony had also been retimed to take place in the month of November, as remains the practice today (plate 184).[21]

184. The Lord Mayor's Show. Early nineteenth-century 'Penny Plain' print showing the street and river processions. London, Victoria and Albert Museum.

LORD MAYOR'S SHOW.

Printed & Sold by D. Ash, 27, Fetter Lane Fleet Street.

Triumphal entries into towns and cities by the rulers of early modern Europe used a mixture of sources to underpin authority and suggest the recipient's beneficence. The close interweaving of Catholic ritual and folk custom is well demonstrated in one of the surviving paintings of a series commissioned in Brussels to commemorate the triumphal procession of the Archduchess Isabella, Regent of the Netherlands for the Spanish Crown, in the city on 31 May 1615. In the Netherlands, these processions were collectively known as 'ommegangen', from the Flemish *ommegang*, to go about, or go around (plate 185).[22] Here too the event was a mixture of secular and religious because the day in question had originally been dedicated to the Blessed Virgin. Some of the pageant cars we see in the painting had been used under this previous dedication and were more than half a century old. Pageant cars representing scenes from the life of the Virgin are mixed with classical scenes such as Apollo and the Muses and – emphasizing the ever-present fascination with the fantastical and exotic – scenes of Turkish cavalry, of real camels and a wickerwork dragon. In this ceremony ornament brings together the traditional and the particular associations of royalty through the implied equation of the Virgin Mary with the archduchess as patron of the city and its guilds. In common with other public ceremonies at this time, the houses around the Grand Place are decorated with foliage symbolizing the fullness of late spring, the time of year when the event took place.[23]

Historians have long noted the way that Protestant nations in the sixteenth century replaced the overt and highly visual ceremonial of the Catholic Church year by new, secular ceremonies as a way of preserving public order and support for authority.[24] The ability of Catholicism to use the whole range of decorative device, to plunder nature constantly for ideas, to be unashamed about the use of the excessive, the overblown in the service of the faith, has always characterized public life in the streets of Catholic Europe as opposed to the restraint of Protestant societies. An apprenticeship in work for the Church and a skill in fine wood or stone sculpture has often been suggested as the reason for the ready employment of French and Italian craftsmen in particular in a variety of jobs in essentially Protestant societies where virtuosity is called for, whether in the rococo plasterwork of eighteenth-century England or the fairground sculpture of early twentieth-century America.

185. Denis van Alsloot. Detail of the triumphal procession of 1615 known as the *Ommegang* showing Christ among the doctors. Oil on canvas. London, Victoria and Albert Museum.

186. Design for the device of a fishing boat for the Fishmongers' Company at the Lord Mayor's Show, London, 1616, by Anthony Munday. The allusion was both religious and secular: to the story of the calling of St Peter and to the English vessels that daily 'enricheth our kingdome with all variety of fish the sea can yeelde.'

187. Triumphal arch of chairs set up at the Guildhall, High Wycombe, for the passing of Prince Edward through the town, 1880. High Wycombe was, and still is, a centre of furniture manufacture. The arch echoes those of the Guildhall to the left, built by Henry Keene.

Ornament and the traders

The wealthy guild companies of Renaissance Europe readily took up the challenge of rivalling royal authority by spending excessively on annual or occasional ceremonial. The ornament employed often celebrated the goods and trades of the companies, using puns and visual puzzles to express a richness of invention. For the Lord Mayor's Day procession in London in 1616, the mayoralty of Sir John Leman of the Fishmongers' Company was initiated by a spectacular pageant laid on by his company, with extensive use of the imagery of the sea alongside the new mayor's personal crest, the lemon tree, in a series of pageant cars led by a mock- amphibious 'Fishing Busse' (plate 186).[25]

Down to modern times, commercial interests have continued to provide the stuff of pageantry on important civic and national occasions. Ornament of the objects on view has always been directed towards celebration of whoever was footing the bill. Local mining industries provided arches built of coal at Wolverhampton during a royal visit in 1866 and for the visit of Queen Mary, consort of George V, to Dowlais in South Wales in 1912. To celebrate the opening of a technical school at Northwich in 1897, the salt manufacturer of the town commissioned an arch made of blocks of salt. And to welcome Lord Brassey, the popular local Liberal Member of Parliament in 1900, the fishermen of Hastings constructed a triumphal arch made up of nets of all descriptions,

crossed oars, anchors, crab and lobster pots, all the paraphernalia of the fishing industry (plate 187).[26] In Britain, the tradition of manufacturers paying for such things has largely died out, though retail outlets have to some degree taken over the role. Just as most department stores still decorate the façades and interiors of their buildings at Christmas, so occasions in the nation's history have prompted the spending of money on lavish decoration. No one was more keen to stress his loyalty to the establishment than the American-born businessman Gordon Selfridge, who provided, on the exterior of his Oxford Street store, the most striking decorations in the whole of London for the silver jubilee of King George V in 1935, for the coronation of the same king in 1911 and for that of his son, George VI, in 1937 (plate 188). Here a tradition of ornament for occasion, combining heraldry, banners and imagery, kept alive traditions of display reminiscent not only of Renaissance triumphal processions but also of the affected dignity associated with state funerals of the past.[27]

In decorating his department store, Mr Selfridge was of course drawing attention to the building itself and its place in the nation's commercial prosperity. The placing of statues of Science and Art by the outer doors of the store suggested that the role played by this emporium of goods in the nation's well-being was the same as that of the great national museums of the nineteenth century, especially those at South Kensington, dedicated to quality of design and manufactures. The devising of ornament which suitably conveys a corporate image, which sells goods or services such as entertainment or journeys, is highly sensitive to a range of pressures, nationalistic, political and, increasingly at the end of the twentieth century, environmental. Products, in the broadest sense, need to retain their reputation for constant quality, the implication of a guaranteed, standardized performance by the manufacturer, while also appearing to regenerate themselves constantly, to remain up to date. In the post-industrial world, such modernity has been particularly associated with a command of new technology, since this

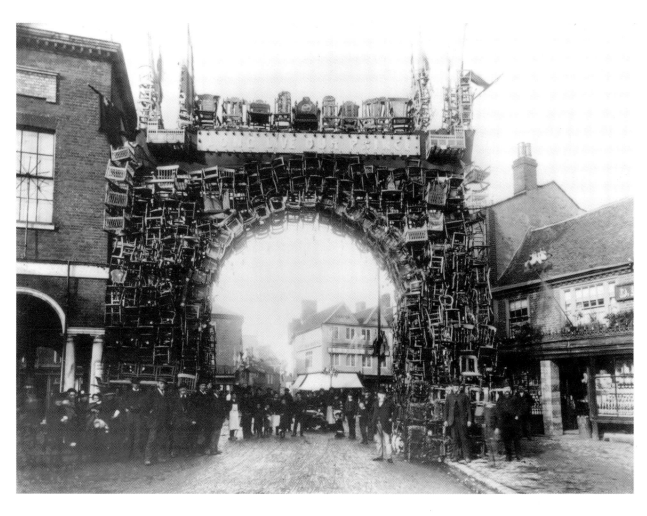

188. The Orchard Street front of Selfridges decorated for the coronation of George VI, 1937, by Clara Fargo Thomas. The legend reads, 'A conventional picture of the great seaports of the Empire with border illustrating the Home Flags and Funnel Markings of many of the Shipping Companies of Great Britain'. The ground level of the building, most visible to passers-by, is clearly sacrificed to a grandeur of scale which increases upwards.

189. The new crest of the Royal Bank of Canada in the 1960s.

190. The EL AL logo of the 1970s with Hebrew and Roman lettering.

not only leads to the most efficient method of production but is also glamorous and fashionable. In recent times, the world's major companies have periodically re-vamped their 'image' through a complete reprogramming of all the visible signs of their presence in the market-place. They have come to accept that design excellence is a function of business. The processes by which each new image is created are well recorded because design consultants are called in and their dossiers, their working drawings, often survive the creative process, documenting the evolution of ideas rather in the way that great workshops of the Renaissance devised decorative schemes for the princes of their age.

An example of political sensitivity is the overhauling of the company image, through its ornamental sign, that the Royal Bank of Canada underwent during the 1960s (plate 189). Anxious to retain their heraldic image and acknowledging that a royal sovereign remained head of state, yet seeking to decentralize the visual link with the British Empire of the past, the bank removed Queen Elizabeth II's arms from their device whilst retaining the lion, globe and crown. However, in visual deference to French-speaking Canadians, they placed a prominent fleur-de-lys motif on top of the crown.[28] Large companies have often had to portray themselves in a national guise, and often indeed in national colours, partly because it usually pays to give the impression of a well-respected and nationwide concern, but also because in some countries large companies and service industries have been nationalized, making them integral to the identity of the state. When the Israeli state airline EL AL was set up, it was felt that politically the service needed to emphasize its key role as the bridge between the young state of Israel and the rest of the world. Its lettering was therefore devised as an intermingling of the Latin and Hebrew forms of the letters, the one reading left to right, the other in reverse. Similarly, to get across the message of the new country's geographical locality and thereby encourage tourism, the airline's interior fabrics and furnishings were coloured in the hues of the Mediterranean: orange, pink, brown and yellow (plate 190).[29]

In 1984–5, British Airways spent £42 million on changing the company's image at a time when the airline was about to move in the opposite direction and be privatized.[30] Transport companies in modern times are especially sensitive to the need for an image which encompasses the idea of speed alongside convenience and service, for without the latest technology any transport company is behind its competitors. It was decided that the familiar bird image of the company should be abandoned since, it was argued, jet-powered flight was now three-quarters of a century old and everyone knew

that humans could fly. It was replaced by the 'speedwing' motif of a half-arrowhead in the single colour of red, running along the side of the aircraft fuselage with the head of the arrow forming the angle of the bar in the quartered union flag on the tail fin (plate 191). This was a sign, it was argued, of the age of the laser; precise and hard-edged. It was also an update of a well established twentieth-century motif of a series of lines, parallel to each other and the edge of the object, representing speed, for the technology that enabled faster travel was seen as the great achievement of the modern age.

The British Airways campaign is a good example of the careful reshaping of an image where the basic ingredients of colour and message are retained to ensure maximum continuity of recognition, yet following the fashion for the technological toys of the age. The moment has to be right and sometimes tradition has to take a back seat until the new imagery is firmly in place. When Canadian National Railways was revitalized in a campaign that began in the late 1950s and ended only in 1970, the svelte, austere look of the company's new, modern image was felt to be so crucial to its success that a planned exhibition of old locomotives and railway cars

was withdrawn lest it give the impression of railways as an image of the past, and of antiquated forms of transport.[31]

Once in place, the new ornament needs to be unobtrusively pervasive throughout a company's services and personnel. Transport organizations have taken over from the age of the stagecoach the perception of the importance of a uniformity of décor that speaks of an assurance of efficiency and comfort. Again the sense of belonging, temporarily, as an honoured guest in a great household, is a useful analogy. British Airways realized that old notions of hierarchy had to be abandoned in the shake-up of the mid-1980s discussed above. Some ornament disappeared, like the rings on the sleeves of the crew's uniforms which had previously denoted rank, rather in the mould of the old wartime airforce. The absence of this feature was intended to leave the impression that the personality of the individual crew member was now of more importance in establishing his or her credentials for the job.[32]

191. The tail fin of British Airways aircraft as re-designed in the 1980s. In the background, another airline also plays on the use of the British flag.

Railway companies were the first transport concerns, in the post-industrial era, to follow the idea of dressing both conveyances and staff in common designs, common colours and a distinctive company insignia. The railway companies of Britain in the years between the two world wars used different colours from each other or, where they found they had chosen the same colours, used them in different combinations, or in different places on the rolling stock and stations. When the Great Western Railway developed its familiar 'GWR' monogram, the letters circumscribed within an oval, it was soon to be found all over the company's network westwards from London: on station furniture like the cast-iron supports of the benches in waiting areas (plate 192), and in the new trains of the 1935 'centenary' stock, on antimacassars, carpets, cutlery and tableware. It even featured, for purposes of identity when materials were in short supply, on dark material used to black out light against bombing raids during wartime.[35]

Where companies spread their interests, then monograms, colours, distinctive types of outlining and lettering followed, as when the London, Midland and Scottish Railway provided, again between the two world wars, both horse transport and furniture removal services by

192. Great Western Railway station platform benches of the inter-war years. Didcot Railway Centre.

road in vans carrying the same livery as their railway carriages.[34] Canadian National Railways extended this idea in the 1960s to the smallest items offered on their services, such as matchbooks, sugar bags and soap wrappers, foreshadowing the common practice on airlines today.[35] The more sophisticated design campaigns made the customer an active presence. The supersonic Concorde fleet employed by British Airways and Air France in the 1980s required the most simple of exteriors for practical reasons. The aircraft needed to be white all over, save in British Airways' case for the speedwing down both sides, since their maximum travelling speed broke the sound barrier and this meant that they had to be almost entirely of a colour which reflected the heat produced. This uncompromising plainness continued in the interior of Concorde, which was largely fitted out in shades of grey with very simple coloured edging. It was argued, in response to criticism, that the clothes and hand luggage of the passengers would add colour to the overall interior design.[36] This reminds us that ornament is not always perceived as a static, passive phenomenon that we simply observe and take messages from; it can sometimes complement, reinforce and make sense of the activities its public performs around and amongst it.

Once the corporate image is established, its attraction may become so strong that customers want a piece of it to take away. At the end of the twentieth century there is a mass world market in goods originating in one place but sold everywhere, a spin-off of the global success of certain multinational companies, particularly in media-related fields. One of the first entrepreneurs in selling the image of the firm as ornament across a wide range of goods was Walt Disney, and it was his company that quickly saw the need to preserve its copyright. The image of Mickey Mouse, early in his corporate life depicted as ornament on clothes and all kinds of paraphernalia associated with leisure activities, has proved one of the most durable in the history of twentieth-century advertising (plate 193).

193. Set of Mickey Mouse Tennis Balls. USA 1991. Synthetic materials. London, Victoria and Albert Museum.

Mickey Mouse is truly a phenomenon of ornament both modern and traditional; a product of twentieth-century technology and mass entertainment, he nevertheless stands in a long tradition of invented, fabled creatures that have populated everything from the entrances to ancient tombs to the margins of books, supports for overmantels of fireplaces and the newels of stairs. The investment of animals with human characteristics gives authority to the domination of the human race over the natural world and neutralizes the things we are afraid of. Soft toys encapsulate the things about ourselves that we like. Half-human, half-animal forms ornamenting a door-frame protect us from a world beyond our reason that we cannot understand.

Modern commercial activity is dependent on devising suitable ornament to demonstrate a command of the latest technological resources. This is especially potent when what is on sale is technology itself. The IBM company advertises itself with the three letters of its title split into horizontal strips, as if the name of the company were made of the magnetic tape it originally retailed (plate 194). In more recent times, the same sign conveys the sense of an image coming together before our eyes like the image-retrieval processes that are part of computer technology today.

The IBM sign takes obvious pride in the fact that the lettering we see, though composed by human hand, appears to be from a computer. In stark contrast to the technologically led corporate ornament we have been examining, ornament associated with popular and traditional arts and crafts has always been demonstrably made by hand and many of its present-day practitioners resist any new methods that might assist or ease the laborious process of handicraft skills. The expenditure of hard physical work and long hours on an object is felt to infuse meaning and give the object value that is not purely monetary, depending as the labour does on a long tradition of handed-down skills.

A specialist skill: the paradox of popular art

Around the concept of the hand-made object there has grown a mythology of anonymity and a wish to believe that the skills needed are somehow born of innate dedication rather than the discipline of professionalism. The belief that the users of everyday objects must also be their makers is very powerful. The most famous example of this is probably the now-discredited idea that the ornamented borders of medieval manuscripts were created by unknown, untrained monks in the *scriptoria* of monasteries. With many popular arts, research has revealed that expertise has historically been based in well-established centres of production. Far from the ornamentation of the artefacts of popular culture remaining static and unchanging, technical invention has often prompted new forms.

The art of the fairground in Britain and America, and particularly the traditional carrousel ride, seems in some ways to betray what one critic has described as a 'stubborn romanticism' over the past three-quarters of a century.[37] It asks us to ride amid a world of whales, dolphins, dragons and caparisoned horses, the last reminiscent of the medieval joust, in a society increasingly enamoured of the motor car. But like other forms of ornament, that of the fairground evolved as the technology of the rides became more complex. As the cone of shutters at the core of the carrousel became ever larger to disguise the huge machinery that made the horses gallop, so did its triangular and trapezoidal shapes, which could then be covered with elaborate ornamental motifs. Born of practical needs, since excessive ornament followed the size of the machine itself, the making and decoration of carrousels became a highly specialist craft. During its great period, from the latter half of the nineteenth century until the Second World War, the making of this most distinctive fairground entertainment was the achievement of just a few great workshops. Both the English and American markets were dominated for the first half of that period by the business of Frederick Savage (1828–97), based in Norfolk in the east of England. Savage adapted the steam engine and its new power to the machinery that rotated the carrousel platform.

Other features emerge from the study of carrousels and their ornament which echo themes we have touched on previously. First, it is interesting how many of the skilled painters of carrousel horses for the great fairs of America were continental Europeans from Catholic countries who emigrated to the United States, like the Sicilian Salvatore Cernigliaro who worked for the Dentzel firm at Philadelphia from 1903 (plate 195).[38] It was always recognized that the full-blown style of ornament required was associated with the great period of

194. The IBM (International Business Machines) logo, designed by Paul Rand in 1960.

195. Detail of a fairground horse, carved by Salvatore Cernigliaro for the Dentzel Company, Philadelphia, *c.*1920. Painted wood. Abbott Collection, Clarkston, Michigan.

European decorative art; in Savage's order books the style is generically termed 'Louis XV'. Second, it is noticeable how fairground art kept alive that aspect of heraldry which dealt in the fantastic world of animals, fabulous beasts and cherubs as supporters to shields and crests. These hybrid creatures cling to the necks of horses, and flank saddles and drapery. It is certainly also an art concerned to fill every available space with decoration and then to underline the impact of the message through bright colour and emphasis; lettering is frequently double-lined around the edges, perspectivized *and* given shadow (plate 196).

This location of expertise in a few hands is also true of other branches of popular art that have been sentimentalized in the telling of their history. 'Traditional' gypsy caravans with their distinctive Romany ornament were, like fairground carrousels, a product of the late nineteenth century when what we think of as 'folk art' became set in its forms in opposition to the more universal ornament found on manufactured goods. Like the carrousels, these caravans were produced in just a few places where the requisite skills were gathered (plate 197).[39] The great banners made for carrying in procession not only by trades unions but by Sunday Schools, friendly societies and the churches of Britain were largely produced in one workshop, that of George Tutill who was in business by 1837 and had large premises in the City Road, London by the end of the 1850s. It has been estimated that nearly three-quarters of the famous surviving banners from this time until the Second World War originated in the Tutill firm (plate 198). This explains why the ornament of such items is not undisciplined or born of amateur enthusiasm but skilled and controlled, however ostentatious and colourful.[40]

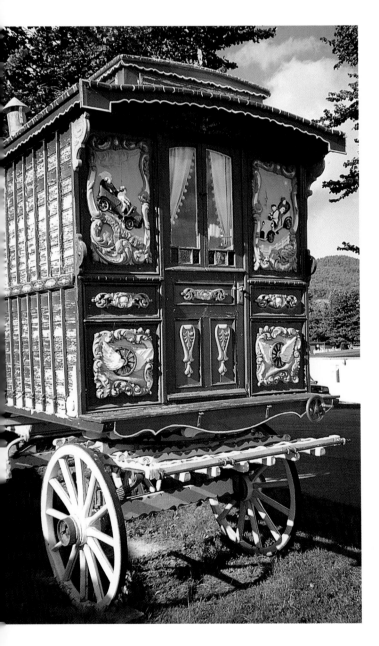

196. Traditional fairground lettering using four colours to give the illusion of shadow and projection, which would be accentuated when coloured lights flashed around them.

197. Gypsy caravan, near Otterton, Ladram Bay, Devon. Though the density of ornament here recalls the folk art origins of caravan decoration, the subject-matter also plays with mythological and symbolic themes.

198. Banner of the Amalgamated Society of Woodworkers, Chatham District, 1917. In this banner by the Tutill firm, classical architecture and ornament is used to lend authority and tradition to Trade Union imagery. Manchester, National Museum of Labour History.

Closely allied to the art of the fairground is that of the circus, partly because the world of all travelling entertainers is close and self-protective and partly because the showmanship of the circus ring has traditionally been, like the fairground, larger than life, with performances of exaggerated gesture matching décor and costumes of bright, assertive colours to accompany the skills and daring displayed. Some of the intensity and spontaneity of the fairground and circus is conveyed by the posters that have traditionally been printed to announce their arrival at each venue. These work on the eye in a quite different way from other posters, such as those for the theatre, in their particularity of layout and sharply contrasted areas of colour and juxtaposition of objects.[41] One example of this genre usefully shows us the crossing-place of ornament both serious and comical, decorative and yet illustrative. In the surrounding border to a poster for the Happy Family Miniature Circus, acrobats on horseback stand on top of each other in an improbable but evocative reference to the feats and skills of circus performers (plate 199). This reminds us in a very direct way of one of the seminal (and certainly the earliest in the history of literature) criticisms of ornament and its function. The Roman architect and writer Vitruvius castigated ornament that seemed unnatural and improbable in the modern decoration of his time: 'For how is it possible that a reed should really support a roof, or a candelabrum a pediment with its ornaments, or that such a slender, flexible thing as a stalk should support a figure perched upon it, or that roots and stalks should produce now flowers and now half-length figures? Yet when people see these frauds, they find no fault with them but on the contrary are delighted, and do not care whether any of them can exist or not.'[42] Clearly, as Vitruvius is perhaps wilfully ignoring here, in the world of public ornament, a regulated framework of reference to nature which set the orders, rules and proportions of the architecture that Vitruvius was justifying, cannot strictly be applied. Whether by taking nature simply as raw material to play with, as in the mythical beasts of the fairground carrousels, or by abstracting and simplifying its shapes, as in the speedwing of the British Airways plane for commercial persuasion, the role of ornament in the public domain is to invent and embody the collective fantasies and desires of communities at work and at leisure.

199. Wyllie's Happy Family Miniature Circus poster. London, Victoria and Albert Museum.

6

Looking Out: the Uses and Meanings of Exoticism in Western Ornament

Nowadays the word 'exotic' is often used to describe something a little out of the ordinary. This is but a faint echo of the much stronger and more significant role that the idea of the exotic, in the sense of a non-European 'other', once played in Western design and ornament. Some of the key notions that used to be contained within this idea of the 'other' can, however, still be glimpsed in the modern genre of the 'exotic dancer' (plate 200). The impression, openly appealing, is one of richness, excitement and glamour but also one which carries with it more than a hint of a lack of control. It is a presentation of 'barbaric splendour', of rich elaboration without the benefits of 'civilization'. Considered in detail, the decoration of exotic dancers' costumes is both strange and filled with fantasy. This is sometimes underlined by the use of large feathers and tropical flowers and fruit, which are (or were) not only rare and unusual but also suggest to the spectator an unchanging (and uncivilized) world close to nature. In spite of all this, however, this vision of foreignness could never be taken for anything but a European construct made for European consumption.

We can see from the exotic dancer that the sense of 'otherness' which is conveyed is a combination of purely formal qualities and a certain emotional excitement.[1] Both depend on the concept of rule-breaking. In the purely formal sense the rules being broken are those of balance and logic, that is, the qualities of classical architecture and its decoration. The emotional response derives at least in part from an abandonment of decorum, albeit licensed and controlled. It is probably simplistic to claim that this desire for the exotic emerges from a fundamental need to throw over the traces from time to time. In examining exoticism since the Renaissance it becomes clear that it is a complex phenomenon deriving from many different impulses, including trade and imperial conquest.[2] This was also true in classical times, when Egypt emerged as the first Eastern 'other' to the West of the conquering Romans, who not only plundered its monuments, filling Rome with obelisks and sphinxes, but adopted some of its religious cults with their attendant temples and imagery.

200. Carmen Miranda. Still from *Weekend in Havana*, 1941. 20th Century Fox (courtesy the Kobal Collection).

201. The Egyptian House, Penzance, Cornwall, c.1830–35. The façade, shaped as a pylon gateway, is loosely copied, by an unidentified architect, from the Egyptian Hall in London, designed in 1811. Both buildings housed museums; that in Penzance was also an advertisement for the owner's business in stone obelisks and other ornaments.
The Egyptian Hall was one of the first public buildings in the Egyptian style.

For the Romans, although not for later sufferers from 'Egyptomania' (plate 201),[3] Egyptian forms seem to have been smoothly absorbed into the classical repertoire. Since the Renaissance, however, artefacts perceived as exotic have played a leading role in helping designers to free themselves from the controlling devices of classical design, especially the tendency to contain and enframe which applies to most classical ornament. This liberating effect can be felt in most of the many different levels at which the exotic was taken into the repertoire of Western ornament.

At the level of complete absorption, the Moresque motifs of the Near East, although ultimately of classical derivation and often contained within a classical framework, served to push Renaissance pattern towards a new level of complexity and played a key role in the development of the grotesque. At the same time, certain types of exotic artefact became established in the interior, notably carpets and woven textiles from the Near East. While the patterns of the former tended not to transfer to any European-made goods (except other carpets), the frameless 'drop repeats' of the textiles helped to establish a new way of pattern-making which quickly became absorbed into European design.

In other cases the exotic created for a limited period, and often for a particular purpose, a complete and distinct ornamental world. These moments could either be private, as in a Chinoiserie bedroom of the 1750s, or public, as in a 1930s super-cinema or fancy dress ball. This type of exoticism was (and is) often less a matter of individual motifs than of a total impression of ornamental form and colour. An important part of such complete exotic styles was the use (or replication) of previously unknown and often technically mysterious processes of manufacture. In fact the ornamental aspect of the exotic often rode on the back of such magical Eastern materials as silk, muslin, porcelain and lacquer, imported into a wealthy Europe. In many cases the local styles of these objects were adapted in the country of manufacture at the demand of the exporting merchants in order to fit them more closely to European taste.

With the advent of industrialized production methods in Europe in the nineteenth century, Eastern exoticism took its place, already hinted at the end of the eighteenth century, among a huge range of historical and national 'styles' which could be accurately reproduced mechanically. At the same time, they were classified and placed in a hierarchy by the new encyclopaedists of ornament. In reaction to this approach, the actual products of distant lands were once again valued for their materials, but this time because they were made by pre-industrial and supposedly unchanging societies, a new twist on the concept

of 'otherness'. Again motifs and materials were intimately linked.

This was at least part of the drive behind the growing interest in African and South American motifs which tended to replace the devitalized Eastern exotic styles from the end of the nineteenth century onwards. A very similar drive lies behind the dominant expression of exoticism today, often described as 'ethnic', a term which has apparently been stripped of colonialist associations and not only embraces styles from distant places but also European styles made in what is seen as a craft tradition.

Europe and the Near East

Europe's relationship to Islam in the medieval and Renaissance periods was politically one of conflict and often of fear of conquest.[4] Yet the power of a fantasy image like 'El Gran Turco' (plate 202), (ironically a version of a portrait of the Christian Byzantine emperor John VIII Paleologus 'exoticized' by adding purely Western ornament),[5] should not be allowed to obscure the fact that real examples of Islamic design and ornament had long been known to Europeans, owing to a vigorous trade in goods all over the Mediterranean, and especially between Italian mercantile states (notably Venice) and Islamic cultures in the Near East, Egypt and even (until their defeat in 1492), Spain. Contacts were very close: not only were Venetian and other traders actually resident and maintaining warehouses abroad, but in the eleventh century the Normans who had conquered the Fatimid colony in Sicily continued to use Muslim craftsmen and Islamic designs in their court at Palermo, while in Spain a mixed community allowed Islamic elements to appear on Christian and Jewish buildings and artefacts until the end of the fifteenth century and even later. Such contacts also meant that design ideas from China were able to enter Europe before the discovery of the sea route to the Far East round Africa. Thanks to the thirteenth-century Mongol conquest of Asia from China to Persia, silks and porcelain were able to get through, but more importantly Chinese forms adopted by the Mongols were able profoundly to affect certain aspects of Persian and Turkish ornament, which were in their turn transferred to Europe.[6]

202. 'El Gran Turco', engraving attributed to Antonio Polliauolo, c.1475. A fantasy portrait of the Turkish emperor Mehemet II, based on a portrait of the Byzantine emperor John VIII Paleologus which appeared on a medal by Antonio Pisano (called Pisanello) of 1438. The practical Byzantine hat is transformed into a fantastically decorated headdress-cum helmet of a type often used by Renaissance artists to indicate people from the East. Kupferstichkabinett, Staatliche Museen zu Berlin PK.

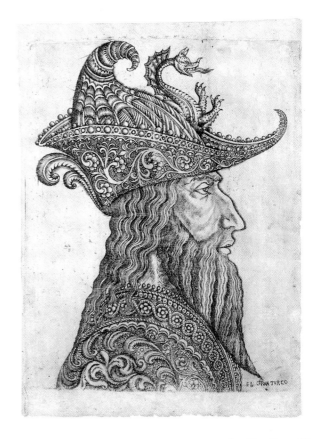

Near Eastern textiles

Until the sixteenth century the chief conduit for such exotic influences was in the field of textiles, and especially silks and carpets.[7] The characteristics and effect of these textiles can be said to have been typical of Islamic imports into Europe. They were luxury products the techniques of which were new to the West, although imitated there after a time. In spite of making no concessions to Western taste in ornamental terms they were smoothly and rapidly integrated into European interiors and clothing, both secular and religious. In fact there was no complete Near Eastern imaginary world to match that of East Asian chinoiserie until the advent of 'Turquerie' in the eighteenth century.

Notwithstanding this high degree of integration, most Western imitations and derivations of Islamic ornament, at any rate up to the early seventeenth century, managed to retain a recognizable Near Eastern quality. In the case of carpets, which were used to soften both floors and furniture and had become an established import by the thirteenth century, European imitations were

203. Anonymous artist, *The Somerset House Conference*, 1604. Oil on canvas. The painting commemorates a peace treaty between England and Spain negotiated at Somerset House in London. Two tapestries with grotesque classical borders (dated 1560), happily occupy the same space as a table carpet from Turkey. London, National Portrait Gallery.

straight copies.[8] This fact, and the prominent role that carpets played in both sacred and secular paintings up to the end of the seventeenth century, suggest that their status as luxury objects of foreign provenance was probably more important to the Western eye than any messages of the 'exotic' in a design sense which we now might read into their complex interlaced patterns (plate 203).

While carpets were directly copied, silks followed a different but no less significant course, although one which is difficult to track.[9] By the twelfth century trade links had helped to create an eastern Mediterranean silk style which combined both Byzantine and Islamic elements. Until the rise of its manufacture in Italy in the second half of the twelfth century, all silk in Western Europe was imported. The evidence of Italian painting from about 1300 onwards and of surviving textiles from churches and burials, as well as of inventories, show that Byzantine, Near Eastern, Persian, Islamic Spanish and 'Panni Tartarici', that is East and Central Asian, silk textiles were all coming into the West.

Imitated and sometimes developed by Italian weavers, imported silks had the deepest possible effect on the future course of European textile design. Geometrical Islamic interlace ornament had appeared by about 1300, when Spanish textile hangings were shown by Giotto and his assistants in the frescoes at Assisi,[10] while curvilinear interlace arabesques of Persian type had appeared as isolated motifs on textiles by the 1340s.

Of greater significance for the future was the adoption of certain types of plant pattern which used waving stems. Developed from Eastern originals by Florentine weavers in the early fifteenth century, they transmitted to the West the idea of the 'drop repeat' plant pattern which is based on a rigidly formal structure but is at the same time naturalistic in effect. As used in the fourteenth century, the stems could be shown parallel, or, more commonly, coming together in repeating hourglass shapes which enclose a flower or fruit.[11] The latter, which had already appeared in its basic form in a Byzantine silk of about AD 1000,[12] was developed in the fifteenth century into the 'pomegranate pattern', which has been in use ever since for textiles and wall coverings. The fame of Italian luxury silks led to the pattern appearing not only in the clothes of English monarchs but also, for instance, as a symbol of heavenly glory in German devotional paintings, where it functions as the sky behind naturalistic landscapes. In other paintings, Italian silks and Eastern carpets come together with a tremendous intensity of colour and pattern probably intended to convey both wealth and power (plate 204).

204. Anonymous artist after Hans Holbein the Younger, *Portrait of William Warham, Archbishop of Canterbury*, after an original painted in 1527. Oil on panel. The pomegranate pattern appears on the cushion, brocaded in gold, and on the curtain at the back. Two Near Eastern carpets cover a chest or table. London, National Portrait Gallery.

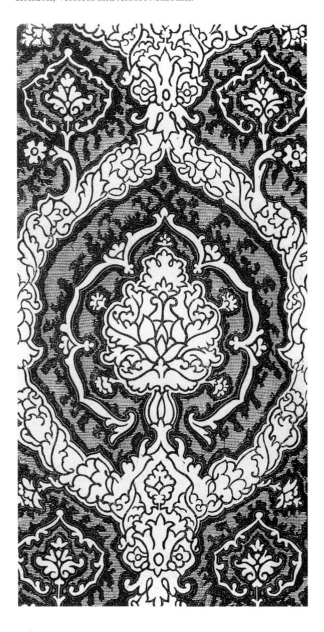

205. Detail of a page from *The Journal of Design*, 1849, showing a silk tapestry in crimson and gold, following a design by A.W. N Pugin for Isambard Kingdom Brunel. London, Victoria and Albert Museum.

Although pomegranate pattern silks and flock wall-papers played a normal and unremarked role in English eighteenth-century wall decoration,[13] the design attracted new interest in the next century, when it was seized on as suitable for furnishings and wall coverings in all sorts of non-classical historicizing interiors. On the basis of its frequent appearence in fifteenth-century paintings and miniatures it was studied and popularized by Gothic revivalists such as the architect A.W. N. Pugin, although a pomegranate silk wall covering designed by Pugin for Isambard Kingdom Brunel was described in 1849 as a 'revival of a good Elizabethen example' probably inspired by the 'Elizabethan' style of Brunel's interior, its Renaissance-style contents and pictures of Shakespearian scenes (plate 205).[14]

By the second half of the nineteenth century the pomegranate pattern had become so 'traditional' that it could be used by William Morris as a basis for arts and crafts textiles, and wallpapers which were not perceived as exotic or even luxurious. But exotic it was, especially in the nature of the 'pomegranate' itself, described in fourteenth century inventories as a pine cone and later as a pineapple or a thistle. It is in fact an imaginary flower, found, like the waving stems, in Chinese and Near Eastern ornament and textiles and was probably born in the thirteenth or fourteenth century of a conjunction between the two. The secret of the protean nature of the 'pomegranate', able to change into a wide range of flowers or fruits either clearly fantastic or identifiably real (plate 206), lay in its descent from the classical palmette, itself already an imaginary flower but one which had the power to take on new identities (notably the lotus) as it travelled to India, the Near East and China.[15]

Chintzes and shawls

Although the pomegranate pattern had introduced the idea of the fantastic plant into the mainstream of European textile design, imaginary plants used in flat pattern continued to be a powerful indicator of the exotic, notably during the main period of exoticism in European design, from about 1650 to 1820. This is clearly shown in the fantastic flowers of eighteenth-century chinoiserie, but most notably in the design of two textile patterns from the Indian subcontinent, the flowering tree pattern on chintz and the 'Paisley pattern' Kashmir shawl. Dating from the period after the establishment of direct trade links with India, they were the result of a complex of influences, not only from Chinese-influenced Islamic Persia and the Persian-influenced Mughal courts but also, and most crucially, from patterns sent by European merchants.

Indian chintzes, painted or printed resist-dyed cotton fabrics, were at first used by the British and Dutch East India Companies as barter goods for their main trade, which was in spices.[16] The best cloths were made either for Persianized Indian courts or for export to Persia, while other cloths, some of comparable quality, were produced expressly for the South-East Asian market.[17] Chintzes were arriving in England in small numbers by 1613, but their chief appeal lay in their novelty, and especially in their bright fast colours then unknown in the West. The directors of the East India Company realized that a mass market in chintz furnishing fabrics could only be created if sufficient numbers were sold to reduce the unit cost. The answer was to combine the appeal of the fabric with designs more calculated to fit to English taste, and in particular into the fashion for chinoiserie. This idea, also seized on by other merchants, meant that Indian chintzes gradually became perfectly adapted to slightly differing French, Dutch and British markets without ever completely losing their distinctly exotic character.

In 1643 the directors of the British East India Company asked that the traditional Indian 'sad red grounds'[18] against which the patterns were placed should be replaced with white grounds. As a result, orders increased twenty times over in the next five years. The next move was to send out, from 1662, actual patterns for the local manufacturers to copy. In 1669 the directors dispatched to India drawings of the 'large Branches for Hangings of Romes' which were the latest fashion in England. The final stage was to control the painters completely (and increase production) by moving them from their villages to settlements close to the trading stations.

The most popular chintz design in England, extensively used for 'palampores' or bedspreads as well as bed

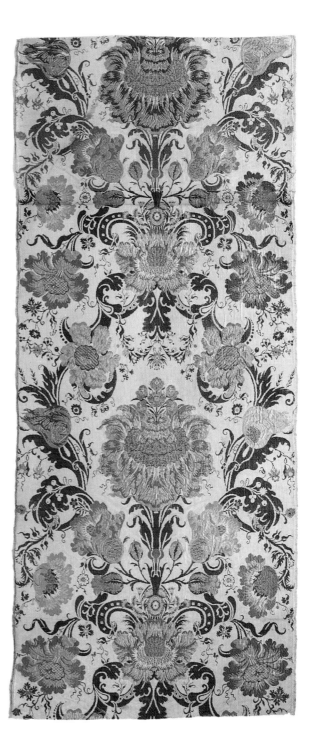

206. Brocaded silk panel. French, c.1725–50. London, Victoria and Albert Museum.

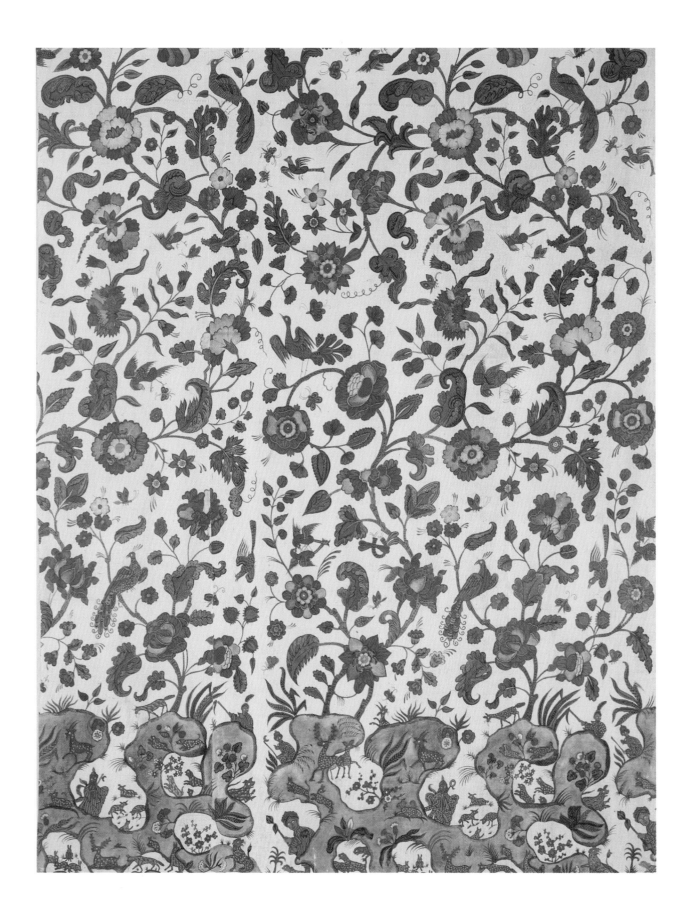

hangings, was the 'flowering tree', a gnarled trunk and branches carrying large leaves and flowers of different and often fantastic types (plate 207). Although the pattern is of Persian inspiration, and crucially indebted in its treatment to Chinese influences, the European flowers clearly announce their origin. They are not only a response to the demand for floral ornament in baroque decorative art but also a reflection of an interest in naturalistic plant ornament in British needlework which had begun in the later sixteenth century. More surprisingly, the extravagantly curling leaves are also Western in origin, and seem to have been based on models ultimately indebted to the lush acanthus foliage of Flemish verdure tapestries of the sixteenth century but misunderstood and wildly distorted in Indian hands. While some flowering tree chintzes clearly show evidence of a deliberate introduction of Chinese elements, bringing them close to true chinoiserie, most flowering tree patterns contain only residual Chinese elements, but enough to allow them to fit in with chinoiserie taste (plate 208) without, however, losing that Indian treatment and sense of design which gives unity to their interesting stylistic mix.

During the late seventeenth century and early eighteenth century, when Indian chintz was at the height of its popularity (so popular in fact that its importation was soon forbidden), the flowering tree was eagerly imitated in English needlework, thus bringing the wheel of borrowings and adaptations full circle.[19] In the marketplace, however, exoticism is nearly always a conjunction of design and manufacturing technique. Thus, when plate and roller printing processes developed in Europe were able to achieve the brilliant results of the Indian printing techniques but at less cost, the market for Indian-made chintz died. By the end of the nineteenth century European textiles were swamping the Indian subcontinent.

Western technological developments also played a key role in the formation and reception of another characteristically 'exotic' design, the 'Paisley pattern' which originated on the shawls made in Kashmir.[20] Like the flowering tree, the Paisley pattern, with its all-important hooked leaf motifs, was neither ancient nor indigenously Indian. The leaf, called a *buta* (or 'Kashmir cone'), only appeared on Kashmiri shawls in the second half of the eighteenth century, and had developed from the coagulation of the blooms on a characteristically Persian (and Mughal) flower motif. Already extensively exported to other parts of India and Asia, the shawls had arrived in Britain by the 1760s and came to wider European notice later in the century, reputedly brought back by French soldiers returning from the Egyptian campaign.

207. Hanging made in Western India for the European market, *c*.1700. This chintz transforms the flowering tree into a number of flowering branches, which seem to show the influence of contemporary printed designs for English embroidery. They grow out of chinoiserie rocks among which a hunt takes place. The hanging came from Ashburnham House in Sussex, where it was part of a large collection of Indian textiles all carrying the same design. London, Victoria and Albert Museum.

208. Bed, from a suite of chinoiserie bedroom furniture made in the early 1770s by Thomas Chippendale for the actor David Garrick. The frame is painted blue and white. The chintz hangings, made in Madras State, were given to Mrs Garrick in 1772 by well-wishers in Bengal, and inspired the creation of the chinoiserie bedroom. Complete flowering trees decorate the palampore and the hanging over the headboard. London, Victoria and Albert Museum.

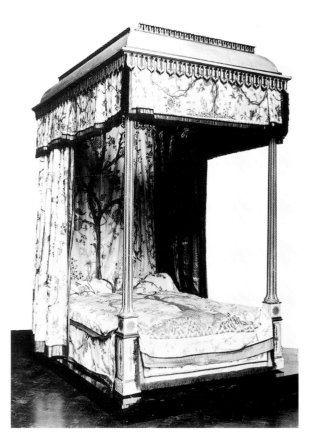

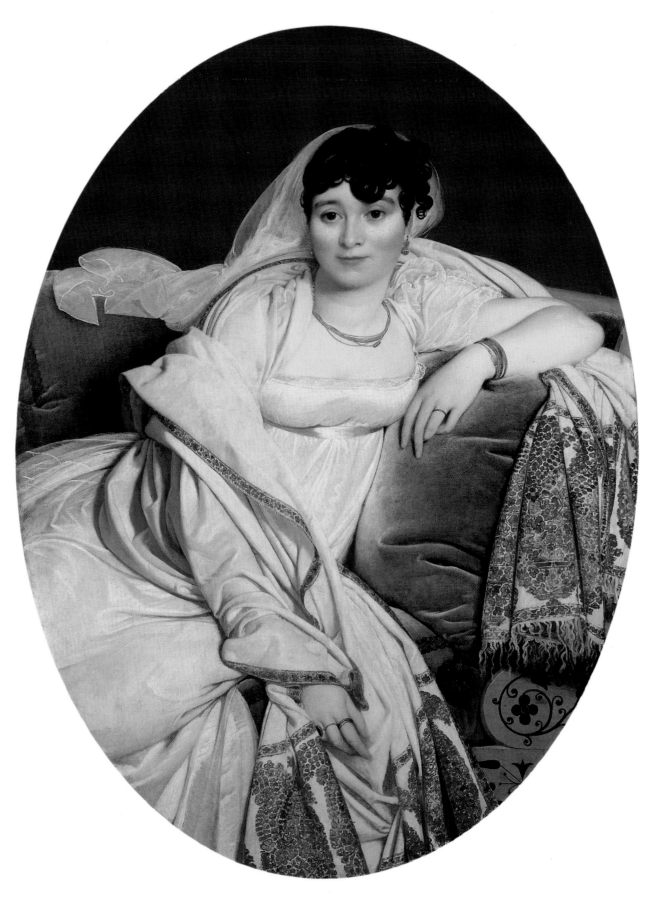

Once again the appeal of an exotic and mysterious pattern (the *butas* were sometimes wrongly taken to be symbolic) was linked to a rare luxury material. Although Kashmir shawls were only worn by men in India, they immediately became an essential part of fashionable dress for French women, not only giving warmth over thin classical-style dresses, but also adding a hint of oriental luxury entirely in tune with current interests in a generalized type of exoticism (plate 209). Some French textile manufacturers reacted by copying the designs and techniques so accurately that their products were taken for the real thing, while one, fearing the fickleness of fashion, commissioned the artist Isabey to produce for Napoleon's court less exotic versions of the *butas* using French flowers.

In general, manufacturers seized on the *buta* motif, some reducing it in size to create the all-over Paisley pattern of today, while the invention of the Jacquard loom controlled by punched cards enabled the most complicated patterns to be made with comparative ease. In India, however, shawl design was not standing still. The Kashmir *buta* was becoming ever larger and more extravagant, leading a French observer to note in 1831: 'the designs today do not have any more the agreeable bizarreness of the those in the past; they are baroque'.[21] The 'baroque' trend prompted French and other European designers to be even more imaginative, developing the *buta* into an extraordinary tree-like plant, and sometimes combining it with Chinese and even Gothic elements (plate 210). From the 1840s, with the aid of French agents, Indian shawls were made to the latest Parisian fashions. While this kept the ailing Indian industry going, it also led to its extinction when shawls suddenly went out of favour in Europe in the 1870s. By then, however, the European view of Indian production had crucially changed. In the 1860s an English commentator was able to regret the substitution by 'purer' French designs of the 'old work of the natives', comparing the former with 'a piece of rococo ornament' and the latter with 'what an artist of the thirteenth century might have produced'.[22]

209. Jean Auguste Dominique Ingres,
Portrait of Madame Rivière, *c*.1805. Oil on canvas.
Sabine Rivière, the wife of a successful and influential civil servant, is known to have had a large collection of Kashmir shawls. Paris, Musée du Louvre.

210. Design for a shawl border. Watercolour, gouache and ink, by George Haité, 1840s. The design is 136 cm high, and was probably made for a printed rather than a woven shawl. London, Victoria and Albert Museum.

Islamic ornament and the Renaissance

The fifteenth century, which saw the development of the pomegranate pattern among Italian silk weavers, also witnessed an increased Italian interest in Islamic goods and decorative forms that was to have far-reaching effects on European design as a whole. It was expressed in the importation of goods other than textiles, including bookbindings, gilded leather, metalwork and the Hispano-Moresque maiolica which was to form the basis of the Italian maiolica industry,[23] as well as the continu-

211. Bookbinding, made in Rome in the 1490s for Cardinal Rafaello Riario. The text is a manuscript copy made in 1495 by the humanist scribe Bartolomeo Sanvito of Cicero's *De officiis*.
The binding is very similar to Paduan bindings of the 1460s in the Mamluk style. London, Victoria and Albert Museum.

212. A knot, from a set of six prints. Woodcut by Albrecht Dürer, probably made during his trip to Venice in 1505–7. London, Victoria and Albert Museum.

ing introduction of Islamic forms like Kufic lettering into paintings,[24] often in specifically Christian contexts. For the future, the most important of these Islamic motifs was a type of interlaced pattern called 'Arabesque' or 'Moresque', the latter named after the Muslims of North Africa and Spain.[25] Like other Islamic motifs, the Moresque tended from the start to be used alongside classicizing Renaissance forms, which were developing in parallel with it and with which it was ultimately to become completely integrated. This process was greatly eased by the fact that the two basic types of Moresque had themselves been developed from late antique classical motifs, the foliated stem type being ultimately derived from the acanthus tendrils and the interlaced bandwork from simpler classical examples.[26]

Among the earliest and most interesting appearances of Moresque interlace outside textiles were the decorations on Italian bookbindings.[27] The first, made in Florence in the 1430s, were inspired by those of Mamluk Egypt, and Islamic forms and layout continued to be the basis of European bookbinding design up to the end of the sixteenth century. As so often with exotic motifs, the Moresque ornament arrived on the back of a number of desirable technical innovations: in addition to the practical advantages of the bindings (they were the first in Europe to adopt the small portable Islamic format), they also introduced to the West the Islamic technique of gold-tooled decoration.

Italian Islamic-style bookbinding really took off with the bindings made in Padua from the late 1450s for deluxe humanist manuscripts. The development of interlace ornament on these bindings seems to suggest that, like the revived classical forms, it answered a need among humanists to employ an ornamental vocabulary untainted by the Gothic devices of the past (plate 211). Certainly, by the 1490s Italian bindings displayed together both Moresque and classical ornament. That Islamic interlace may on occasion have been regarded as just another decorative form, completely lacking a sense of exotic 'otherness', is also suggested by the late fifteenth-century prints of knots or 'groppi', interlacing bands or cords bearing the name of Leonardo, which were copied as woodcuts by Dürer in 1505–7 (plate 212). Whatever their direct purpose may have been, they are certainly an expression of that fascination with the ingenuities of geometry which was characteristic of the Renaissance approach to design.[28]

E.189.'85. ⅗

213. Plate. Tin-glazed earthenware (maiolica), made in Siena about 1510. The shield above the central figure of the god Pan shows the arms of Pandolfo Petrucci, the ruler of Siena. Pintoricchio was one of the painters who decorated Petrucci's *palazzo*, and it may be no coincidence that similar classical motifs appear on the maiolica floor tiles made for the *palazzo*. London, British Museum.

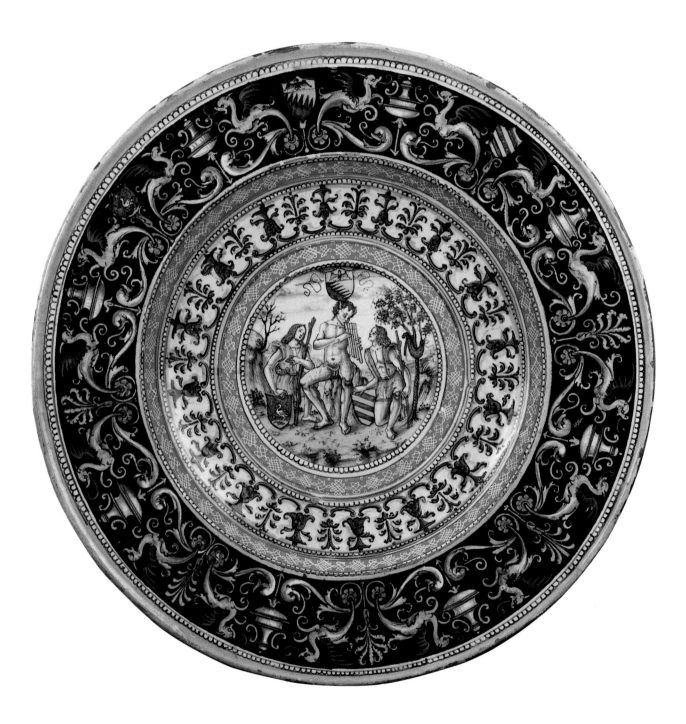

A similar parallelism marked the first appearance of Islamic interlace in Italian fresco decoration, as a band-work border to the earliest Renaissance uses of the classical grotesque. Although Bernardino Pintoricchio's decorations of the Borgia apartments in the Vatican used the idea in 1493,[29] the related treatment of his ceiling of the Piccolomini library in Siena of 1501 to 1506 was probably more influential, as similar combinations of grotesque and Moresques soon found their way on to Sienese maiolica plates (plate 213).[30] These developments marked the start of the spread of Islamic interlace to a wide range of media during the first half of the sixteenth century, including embroidery on dress, for which it was technically ideally suited.

The earliest dated Moresques in printed ornament were the 'groppi moreschi et arabeschi' in Giovanni Antonio Tagliente's embroidery pattern book of 1527 (plate 214).[31] Although they were based on Islamic sources as variously coloured as rugs, tiles, bookbindings and metalwork, their presentation set a trend for reducing printed Moresques to starkly contrasting black and white. This technique also had the effect of emphasizing

214. Two pages of woodcuts from Giovanni Antonio Tagliente's embroidery pattern book *Opera Nuova… intitolata esempio di raccammi*, first published in 1527. The illustration is from an unchanged edition of 1530. On the right-hand page the central leaf-shaped ornament and strip on the left go back to Islamic bookbindings. On the left-hand page an Islamic border, second from the bottom, is surrounded by classical strip ornament. New York, Metropolitan Museum of Art.

the common elements in the Moresques and Renaissance patterns on the same page, making it a crucial factor in the integration of the two styles. That there was a range of views on how best to describe and market such Islamic ornament is suggested by the titles of other embroidery books. At one end of the scale was Francesco Pellegrino's extremely influential *La Fleur de la science de pourtraicture*, published in 1530. Its entirely Moresque *Patrons de Broderie* were described as being *Façon arabique et ytalique*, acknowledging the European and fashionably Italian contribution to the Islamic form. At the other end of the scale the anonymous (probably Venetian) 'Master F', who addressed his set of prints to painters, rug weavers, goldsmiths, stone cutters and glass-painters as well as needleworkers, chose to emphasize the exotic nature of his patterns, stating that they were in the manner of the Persians, Assyrians, Arabs, Egyptians, Indians, Turks and Greeks.[32]

The publication of Tagliente's set echoed the arrival of embroidered interlace in fashionable Italian dress. The idea was soon taken up in France and, by the 1530s, in England (plate 215). Holbein's portraits of Henry VIII and his court, with their dense displays of silks, carpets and Moresque-patterned clothes, represent the most intense application of Islamic and Islamic-derived ornament before the nineteenth century. These textiles were backed up by a wide range of other objects also decorated with Moresques, including jewellery, silver and other metalwork.[33] A wide range of approaches to Islamic ornament was possible by the middle of the sixteenth century, as is shown in the manuscript of Cipriano Piccolpasso, which records the patterns of maiolica painters.[34] In addition to two designs for snake-like 'groppi', there is a Moresque pattern of the foliate type used by Tagliente, appropriately called 'Rabesche' (i.e. Arabesques). Piccolpasso's winding leafy stem design called 'Porcellana', however (plate 216), reflects a contemporary type of Turkish earthenware made at the royal kilns in Iznik which itself set out to imitate in its decoration the peony and lotus scrolls that were to be seen on the imported Chinese porcelain used at the Turkish court. By the time of Piccolpasso, 'alla porcellana' decoration had been current for about fifty years, often painted in a combination of two shades of blue commonly called blue-and-white, that was to become a symbol of East Asian exoticism.[35]

215. Hans Holbein the Younger, *Portrait of Henry VIII*, c.1536. Oil on panel. The embroidered Moresques on the shirt collar and underjacket keep company with Renaissance ornament in the jewels and the classical wave scroll on the doublet. Madrid, Fundación Colleción Thyssen-Bornemisza.

216. Patterns for 'porcellana'(on the left), and 'tirata' (strapwork) on the right. Pen and ink drawing from the manuscript *Tre libri dell'arte del Vasaio* (The Three Books of the Potter's Art) by Cipriano Piccolpasso, 1557. The text underneath states: 'This is a universal design and is paid at two *lire* a hundred and among us twenty *bolognini*.' London, Victoria and Albert Museum.

Interestingly absent from the maiolica tradition as recorded by Piccolpasso is the kind of Moresque pattern shown by Pellegrino which combined angular interlacing bandwork with thin foliate stems (plate 217). This form of Moresque not only became a standard motif in sixteenth-century European ornament, but was to join up with the heavy three-dimensional strapwork which had been invented in the 1530s to decorate the Palace of Fontainebleau. The resulting hybrid, developed in the second half of the sixteenth century, combined the foliage-animated straps and lively invention of the Islamic model with strapwork, producing a form of the grotesque which lay behind much European decoration for the next 250 years. Although the Islamic elements in the new form had completely lost their exotic charge they were the key to the development of the anti-classical rococo style a hundred or so years later (plate 218).[36]

217. Bookbinding, *c*.1550. The gold-tooled Moresque ornament is copied from plates in Giovanni Andrea Vavassore's embroidery pattern book, *Essemplario di lavori*, published in Venice in 1530. The binding was made for the famous French book collector Jean Grolier and contains Agostino Steuco's *Enarrationum in Psalmos, Pars Prima*, published in Lyons in 1548. London, Victoria and Albert Museum.

218. Designs for wall-lights, mirrors and brackets. Engraving from the set *Nouveaux desseins de plaques, consoles, torcheres et médailles* by Nicolas Pineau, *c*.1725–30. London, Victoria and Albert Museum.

219. The east front of the Royal Pavilion at Brighton. Designed by John Nash from 1815. The 'Hindoo style' exterior conceals an extravagant chinoiserie interior.

Islamic ornament and the nineteenth century

The extraordinary stylistic plurality which marked the nineteenth century naturally included its fair share of buildings and decoration in the Islamic style.[37] If we examine these closely, we can detect a wide range of aims and approaches. At one extreme were eclectic buildings like the Brighton Pavilion (plate 219), P. T. Barnum's 'Iranistan' at Bridgeport, Connecticut, or the many 'Moorish' smoking and billiard rooms of the end of the century, all of them expressions of a particular type of heavily Eurocentric 'orientalism'. At the other end of the scale were the ideas and work of a number of designers and architects who sought in the hand-made products of India and the Islamic East and in the geometric ingenuities of Islamic pattern-making the answer to reforming the outburst of machine-made ornament which characterized the middle years of the nineteenth century.

Of all the products on show at the Great Exhibition of 1851 few were more highly praised by the art and design establishment of the British government than the textiles and other products from India and other Islamic

regions.[38] When many Indian examples were acquired for the new Museum of Manufactures they were described by the reformer Owen Jones as 'the works of a people who are still faithful to their art as to their religion, habits and modes of thought which inspired it ... we find no struggle after an effect; every ornament arises quietly and naturally from the object decorated, inspired by some true feeling, or embellishing some real want'.[39] The almost arts and crafts tone of this statement also characterized the approach to products of other parts of the East. Persian carpets were greatly admired, especially by William Morris, whose own work was inspired by them , while potters like William de Morgan found ideas in Persian miniatures and the decoration of 'Persian' (but actually Turkish) Iznik pots that had already been imitated in Europe in the seventeenth century.[40] By the later nineteenth century these things, like the pomegranate pattern, were seen as both Eastern and Western, both old and new.

A rather different flavour marked the other wing of the design reformers' approach to Islamic ornament, the promotion of geometric pattern.[41] The chief propagandist was the designer Owen Jones, who published his lavishly coloured *Plans, Elevations, Sections and Details of the Alhambra* between 1836 and 1845. In the painted plaster and tile ornaments of the Alhambra in Granada, Jones found the expression of his core ideas: that ornament should employ conventionalized natural forms combined with a logical structure and that it should be coloured so as to be flat in effect. The culmination of Jones's reforming efforts was *The Grammar of Ornament*, published in 1856.[42] It was the first attempt to encompass the world's ornament in a single work and link it to a set of 'general principles in the arrangement of form and colour'[43] which were presented in the form of thirty-seven propositions (twenty of which were concerned with colour alone). Only one was specifically linked to 'oriental practice', namely that 'In surface decoration all lines should flow out of a parent stem', while another, that all junctions of lines 'should be tangential to each other' was described as a 'natural law. Oriental practice in accordance with it.' It was clear, however, that most of the propositions, such as that 'All ornament should be based upon a geometrical construction',[44] found their clearest expression in the Islamic examples. Half of Jones's systematically arranged chapters were devoted to ornament outside Europe; Islamic ornament took up no fewer than five of these ten chapters, carefully divided into Arabian (from Cairo), Turkish (from Constantinople), Moresque ornament from the Alhambra, Persian (from manuscripts and pattern books) and

Indian ornament, chiefly from pieces which had been shown at international exhibitions.

At the same time as Jones was evolving his ideas based on Islamic geometric ornament, similar theories were being developed by Pugin, but based on Gothic ornament, and published in such works as *The True Principles of Pointed or Christian Architecture* of 1841 and *Floriated Ornament* of 1849.[45] Both men saw that geometrical forms were the key to developing a type of ornament which could be good in terms of design and could be made by nineteenth-century methods. The perfect fusion of Gothic and Moresque elements in a ceramic luncheon tray of 1859 shows how, on occasion, such ideas could produce a new approach which had no real parallel in the past and little or no hint of the exotic (plate 220). All too often, however, the critics and the public were unable to see the geometric designs which came from 'Alhambra' Jones and his circle as anything other than an attempt to introduce another exotic style. In one sense, however, Jones's ideas have survived to the present day. Although the Jones pattern designs which have been reproduced on the textiles and wallpapers of the Laura Ashley shops have included no Islamic interlace, the East has been represented by a Persian flower pattern which, minus the startling pink ground of Jones's original, has been stripped of most of its exotic message (plate 221).

220. Luncheon tray, earthenware decorated in coloured glazes and stained clays inlaid in the encaustic technique. Made by the Minton factory, 1859. The flowers, leaves and bud-like elements are derived from Islamic illuminated manuscripts, while the fleurs-de-lys are Western. London, Victoria and Albert Museum.

221. Printed cotton, 'Dandelion' pattern, designed for Laura Ashley and first produced in 1983. The pattern is derived from the 'Persian Sprig' wallpaper designed by Owen Jones in 1859, in which the sprigs are shown closer together and against a bright pink ground. Similar patterns in his *Grammar of Ornament* are described as being taken from wall decorations shown in Persian miniatures.

'Cathay' and the distant East

Owen Jones, in *The Grammar of Ornament*, did not entirely approve of Chinese ornament, although he later changed his mind. Its leading characteristic, he maintained, was oddness: 'we cannot call it capricious, for caprice is the playful wandering of a lively imagination; but the Chinese are totally unimaginative, and their works are accordingly wanting in the highest grace of art – the ideal'.[46] Although Jones fancied that he had adduced good theoretical reasons for his judgement (the Chinese were, for instance, too slavish in their imitation of nature), his conclusions were not essentially different from the usual Western view of Chinese design as both odd and, as so often with exotic design forms viewed from the West, essentially unchanging.

In treating Chinese ornament in isolation, Jones was breaking with tradition. For centuries the complex story of the influence of East Asian and especially Chinese design on European ornament had been strongly bound up with the concept of 'Cathay'. In one sense 'Cathay' was a real country: China. In another it was a dream country, the mysterious Eastern source of the wonderful lacquer, silk, chintz, porcelain and paper 'India' goods imported from the early seventeenth century onwards by the East India companies on the back of their main trade in tea and spices. East India merchants were of course well aware of the true Chinese, Japanese and Indian sources of these goods, but this did nothing to prevent the emergence of the idea of 'Cathay' as the established Eastern 'other' to the cultures of Western Europe: an elysium of peace and happiness whose products were made of mysterious, almost magical materials, formed and decorated in a manner which broke all the rules of 'rational' classical design.[47]

By the middle of the eighteenth century, after some 150 years of ever-increasing imports from the East, 'Cathay' had produced its own European-style 'chinoiserie'.[48] Although certain decorative motifs such as dragons, pagodas, lotus flowers and gnarled trees are seen as typical of chinoiserie, it was not only an assembly of ornamental motifs (and characteristic ways of disposing them), but also an evocation of a richly exotic atmosphere composed of certain types of Eastern object made of specific materials, and their European adaptations. Yet again exoticism in design can be seen to be riding on the back of a new material. This was especially so in the case of ceramics, in which the technical excellence of Chinese porcelain led to over two hundred years of experimentation by European potters seeking to imitate the perfect translucent white body. As a result, the decoration of European ceramics is to this day profoundly influenced by Chinese design ideas, which include such basic concepts as the decoration of a plate with an outer border and a picture in the centre.[49]

The last idea is well demonstrated in the famous Willow Pattern, one of the most popular decorations for ceramics ever devised (plate 222).[50] Although now often taken to be of purely Chinese origin, it is in fact an example of chinoiserie, of a type developed from the late eighteenth century by Staffordshire potters who were seeking a design which could be used on porcelain and its white-glazed earthenware imitation ('china') decorated by transfer printing. Their models were a type of 'blue and white' Chinese porcelain, which by the middle of the eighteenth century was being imported in great quantities as display, dinner and tea table ware. Such Chinese pieces were made solely for export, both their shapes and decoration being chosen by the ordering merchants, who on occasion sent out drawings and models to copy. When the merchants' European customers bought jars like those in plate 223 they were getting an image of Cathay carried on its own goods, the one reinforcing the other. If, however, we were able to ask such customers which of these images of Cathay was the most 'Chinese', the one on the jar or the Willow Pattern, the latter might well be chosen. This would partly be because the printing process enables the production of a more complex image than painting, but chiefly because a range of characteristic motifs such as the crooked fence, buildings and flowering trees are depicted in a flat and stylized manner which is diametrically opposed to the naturalistic Western perspective tradition of picture-making. In one important sense, however, it is Western. In drawing from several different Chinese ceramic landscape compositions the Staffordshire designer has produced a peopled image which seems, like a Western genre picture, to be telling a story. This was idea was legitimized in 1849 with the well-known 'old Chinese tale' of two lovers which has been attached to the pattern ever since. But the Chinese jar and the Willow Pattern are united in one fundamental way: they are both decorated in blue on white, one of the most potent indicators of Eastern exoticism.

Blue and white

The blue and white Chinese ceramics which so profoundly influenced Western design started to filter into Europe in the fifteenth century, at first as curiosities only. As we have seen, Chinese porcelains, or Turkish imitations of them, lay behind the 'porcellana' pattern of sixteenth-century maiolica, and were certainly imitated by the makers of 'Medici porcelain'[51] in the middle of that century. It was not, however, until the early seventeenth century that very large quantities of so-called kraak

222. Willow Pattern tea plate. Earthenware, transfer-printed, made by Churchill Pottery, England, *c*.1991. London, Victoria and Albert Museum.

223. Jar and cover. Chinese, reign of K'ang Hsi (1622–1722). Porcelain painted in underglaze blue. London, Victoria and Albert Museum.

224. Plate, made by the Copenhagen factory, *c*.1780. Porcelain painted in underglaze blue. Plastic mug made by Emsa Design, Germany, *c*.1993. The blue decoration, called 'immortelle', 'Copenhagen' and by many other names, is the most widespread ceramic pattern in the Western world. It probably originated in the 1730s or 1740s, and appears to be a translation into blue and white of the coloured prunus branch designs on Japanese porcelain in the Kakiemon style. The plastic mug softens the pattern with a network of lines imitating the 'craquelure' glaze of certain Far Eastern porcelains. London, Victoria and Albert Museum.

porcelain began to be imported by Dutch and Portuguese merchants. The Chinese had for centuries produced specialized goods for export, and the porcelain for Europe was no exception. Although the decoration was entirely Chinese, the shapes of the pieces were mainly European and chiefly designed for display rather than use.[52] Almost immediately imitations of porcelain began to be made in glazed earthenware, nearly always in the key colours of blue and white . So powerful was this symbol that the celebrated but short-lived 'Trianon de Porcelaine', built at Versailles between 1670 and 1672 for the enjoyment of exotic flowers, was a classical-style building covered in blue and white (French) faience,[53] while it

continues to work in a modern plastic mug, printed with a cleaned-up and geometricized version of a pattern based on Japanese models, which originated on Meissen porcelain in the eighteenth century (plate 224).

Although for many people their chief contact with Chinese and Japanese porcelain was with the essential vessels for drinking tea (new in 1660), the main function of porcelain had early on been recognized as display. Indeed, with Italian sixteenth-century maiolica as a precursor, the displays of East Asian porcelain which reached their peak in the early eighteenth century established the modern idea of showing ceramics as ornaments in the home. It was chiefly as a setting for such massed displays that the fully developed chinoiserie interior emerged in the late seventeenth century, with all its implications for the designing of new types of orientalizing furniture and wall coverings imitating lacquer (called 'Japan'), as well as the importation of new types of product such as wallpapers (plate 225). Although such displays showed oriental ceramics, or their European imitations, their formal basis was always resolutely European. Large dishes took on the role of the metal (and maiolica) sideboard displays of the past, while tall vessels and covered 'ginger jars' were arranged in rows like classical vases, an idea which led in the eighteenth century to the 'garniture du cheminée' a mixed group of ceramics of balanced size and shape on the mantelpiece. On other occasions dense displays of hundreds of small pieces of porcelain were laid out to function as the decorative parts of classical architecture, as in the palace at Oranienburg, or lost most of their power in a dazzling effect of mirrors as at Charlotten-burg in 1703. A hundred years later, with such shows no longer the fashion in grand rooms, the idea had passed to other areas: massed displays of Willow Pattern or other blue and white china had become the chief ornament of many a cottage or great house kitchen (plate 226).

225. Design for a lacquered room decorated with porcelain, *c*.1700. Etching and engraving by Daniel Marot. The lacquer decorated with chinoiserie scenes is European; the imported porcelain has been arranged in a manner which emphasizes and enhances the architectural elements of the room.

226. William Henry Hunt, *Hearing Lessons*, 1842. Watercolour. London, Victoria and Albert Museum.

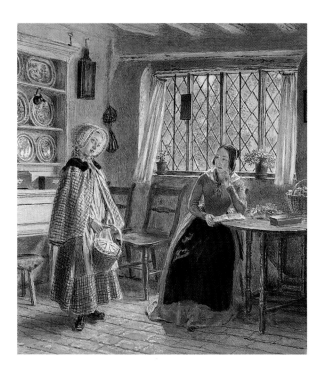

How to recognize Cathay

Designs like the Willow Pattern represented only one end of a range of European reactions to Cathay and its products. At the other we can find such objects as a blue and white Rouen plate (plate 227) in which Cathay and classical design are evenly balanced in a pattern which is a hybrid of a Chinese 'cloud collar' and the pelmet-like lambrequin device which was a main motif of the prevailing Berainesque style. That this design still tends to read as primarily Western in spite of its blue and white colouring is probably due to its strikingly rigorous symmetry.

Asymmetry was such a noticeable expression of the 'oddness' of Cathay that it was even given a name, 'Sharawadgi', first recorded by Sir William Temple in 1683 when describing the lack of symmetry and uniformity, the 'beauty without order', in Chinese garden design, but extended by him to include 'the work upon the best Indian gowns, or the painting upon their best screens or porcelains'.[54] By the time Horace Walpole was expressing a fondness for 'Sharawaggi', 'or Chinese lack of symmetry' in 1750[55] he was following a trend which had by that time become a rage. The first tremors had been felt in the fashion for 'bizarre' silks which swept

227. Plate. Tin-glazed earthenware made in Rouen, *c*.1700. London, Victoria and Albert Museum.

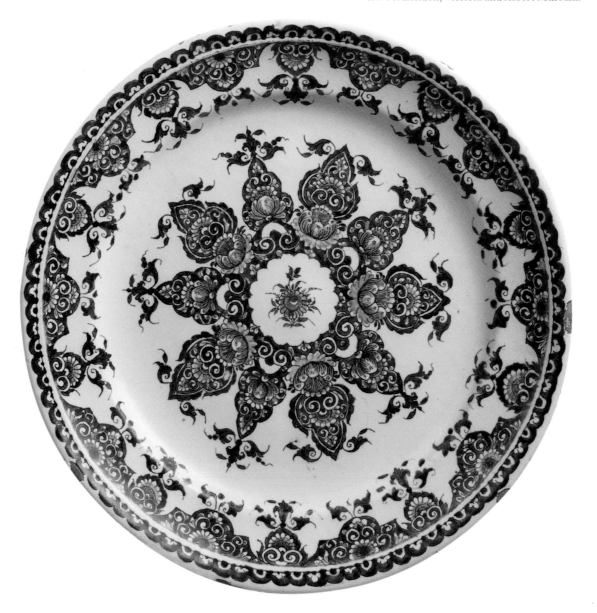

over Europe between about 1700 and 1730 (plate 228). These extraordinary patterns, not matched before or since, can only be explained as an attempt to produce a form of home-grown exoticism to match the chinoiserie (and Indian chintzes) of the day.[56] During the 1730s, however, chinoiserie became established in the mainstream of European ornament by being linked to the emerging rococo *genre pittoresque* style, itself heavily dependent on asymmetry and fantasy and a deliberate antithesis to the balanced certainties of classicism (plate 229). The fantastic creatures derived from the Renaissance grotesque joined up with the Chinese dragon, the rugged rocks of Chinese landscape painting with the *rocaille* of rococo. This was a crucial shift, for in this form chinoiserie motifs could be shown on or made in materials which were not, or did not pretend to be, exotic. From this point on began a general spread of exotic motifs which reached its peak in the first half of the nineteenth century in fields as different as printed cottons and the popular theatre, stimulated by the greater quantity of accurate information about India and East Asia then becoming available.

228. Silk of 'bizarre' type. Made in Spitalfields, London, 1707–8. The pattern places asymmetrical rising stems against a background of architectural pavilions, perhaps intended to be Chinese. London, Victoria and Albert Museum.

229. Design for a mirror. Engraving by George Bickham after Peter Babel, from the set *A New Book of Ornaments… with Trophies in ye Chinese Way*, 1752. This design for a carved and gilt mirror mixes a Chinese house, figure and dragons, with Western *rocaille* and kissing doves. London, Victoria and Albert Museum.

230. Bed. Carved wood, gilded and japanned red and blue. The bed was made between 1752 and 1754 by the firm of William Linnell for the Duke of Beaufort's Chinese bedroom at Badminton House, Gloucestershire. The curtains are modern replacements. London, Victoria and Albert Museum.

231. William Hogarth, detail from *Shortly After the Marriage*, c.1743. Oil on canvas. London, National Gallery.

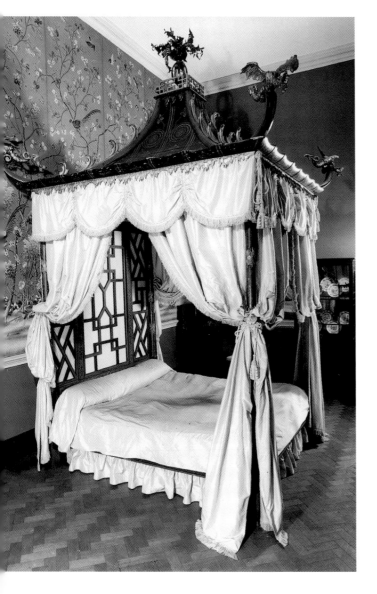

Cathay, fashion and morality

Near Eastern ornament, in spite of its non-Christian origins, seems to have entered smoothly into the vocabulary of European design without drawing comment, either moral or aesthetic. Cathay, however, with its contradictory mix of high fashion, idealism and anti-classicism, produced a range of stronger and better-recorded reactions. On the one hand there was the vision of Cathay as the ideal state, serene, cultured and run on humanist Confucian principles. Even Louis XIV, 'the greatest King in the world',[57] could create a model exotic pleasure palace for his mistress in the Trianon de Porcelaine, while the Chinese Emperor's symbolic spring ritual of personally ploughing the first furrows was imitated in Europe by Joseph II of Austria as well as Louis XV and Louis XVI.[58] The stylized representations of Cathay and its inhabitants, developed from images first imported on goods in the sixteenth century, continue to represent an ideal vision to this day, some two hundred years after the discovery that China is 'just like other countries'.[59]

The negative view of Cathay, as we might expect, was initially based on an anti-classical reading of its art and design. For most of the consumers of chinoiserie, however, it was precisely this emphasized oddness, this 'antick' quality noted in Stalker and Parker's *Treatise of Japanning and Varnishing* of 1688,[60] which was so appealing. With the emergence of a completely Europeanized chinoiserie in the middle of the eighteenth century the trend became so strong that it was possible to approve (ironically) of combinations of chinoiserie with another opposite of classicism: 'It has not escaped our notice how much of late we are improved in architecture; not merely by the adoption of what we call Chinese, nor by the restoration of what we call Gothic; but by the happy mixture of both.'[61] The choice of architecture here is significant, for an interest in Chinese and gothic buildings lay at the heart of the mid-eighteenth-century use of those styles, enabling them to influence the design of many articles about the home, from tea caddies to beds. (plate 230). By treating Chinese design architecturally it was also possible to try to legitimize it by stressing its apparent similarities to classicism, as Sir William Chambers did in 1757, supposedly basing his ideas on first-hand observations made in China.[62]

In *Designs for Chinese Buildings, Furniture, Dresses, Machines and Utensils* Chambers was aiming to 'put a stop to the extravagancies that daily appear under the name of Chinese', extravagancies which marked the height of the English rage for chinoiserie and exotic imports in the middle years of the eighteenth century and which brought to a head a stream of anti-Chinese

satire and criticism. It had begun in the seventeenth century, and was encouraged in 1713 by the Earl of Shaftesbury, who observed with heavy irony in his *Characteristics* : 'Effeminacy pleases me, the Indian figures, the Japan work, the enamel strikes my eye. The luscious colour and the glossy paint gain upon my fancy.'[63] Like the Western 'works of filgrand and little knacks' condemned by Wren in France in 1665,[64] Eastern imports could play no part in the immutable and virtuous world of classicism. Not only did their appeal lie in fancy (or imagination) and the shifts of fashion but they were admired by the wrong people: by women and (according to other writers) by the *nouveaux riches*.[65] While French critics of chinoiserie (and rococo) tended to concentrate on its purely formal faults, the misogyny and snobbery of English (male) critics gave their attacks a special moral tone, linking a style which appeared to be out of control and breaking the rules with two social groups which threatened to do the same. In Hogarth's series of paintings, *Marriage à la Mode*, a delivery of Eastern and other ornaments is being unpacked by a turbanned black servant at the countess's morning levee. Eastern goods reappear in *Shortly after the Marriage* (plate 231), as symbols of domestic discord, loading a mantelpiece strategically placed between the count and countess and surrounding a bust of a disapproving Roman matron.

Not only were such objects in bad taste, they were also pagan and illogical, as pointed out in the *Connoisseur* in 1756: 'ladies would sooner give up a lap-dog than a grotesque chimney-piece figure of a Chinese Saint with numberless heads and arms'. The Vitruvian cast of such strictures was echoed in the frequent satires on the dangerously impractical Chinese railings supposedly being erected at the country seats of the *nouveaux riches* and the claim that a female connoisseur of porcelain would be horrified by the idea that her collection should be of any practical use. In one sense this tradition of satire was correct, for it seems that many of the consumers and providers of Eastern goods were indeed women. Even Chambers, in recommending that the Chinese style should be restricted to certain parts of the house, suggested the bedrooms, a traditionally feminine area. In the public arena, where chinoiserie was linked to gardens, it is possible that the *raison d'être* of the earliest chinoiserie garden buildings was as a setting for the largely female sphere of the tea ceremony, even though the style was rapidly recognized as ideal for the all-encompassing dream world of pleasure gardens and, ultimately, fairgrounds, theatres and cinemas.

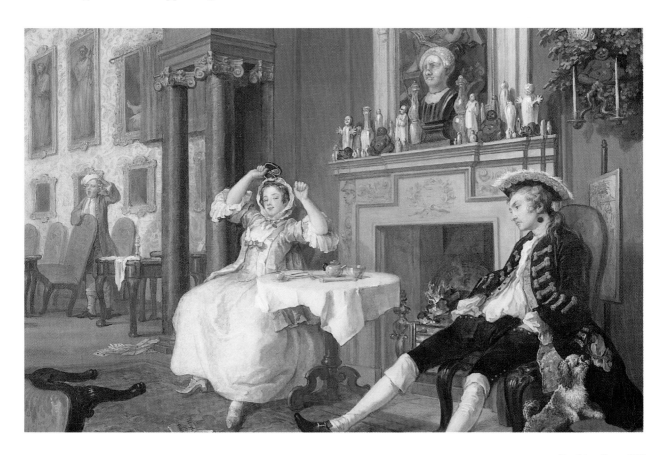

Japan after Cathay

In spite of the fact that Japan exercised a self-imposed policy of isolation between 1637 and 1853, its export products, notably lacquer or 'Japan', and strikingly coloured Imari (or Arita) porcelain made an important contribution to the goods from Cathay.[66] Demand far outstripped supply, leading to the production of more or less good copies both in China and in Europe, where 'japanning' eventually came to mean a hard, shiny (and often black) decorated surface painted on to materials as varied as iron and papier mâché. By the time Japan was forcibly opened up to the world, European ornament had entered the age of the encyclopaedists and design reformers seeking to develop an appropriate style for the second half of the nineteenth century. As a result, 'japonisme', although a European invention like chinoiserie, never had in the background a complete fantasy world, but remained a disparate collection of typical motifs, colours and methods of composition.[67]

In looking today at this nineteenth-century japonisme and its sources in traditional Japanese design we have to beware, for as heirs of the Modern Movement we tend to find in them a sophisticated minimalism and freshness which is somehow eternally up to date. Most Victorians,

232. The Japanese display at the 1862 International Exhibition in London. Woodcut illustration from *The Illustrated London News*, 20 September 1862. London, Victoria and Albert Museum.

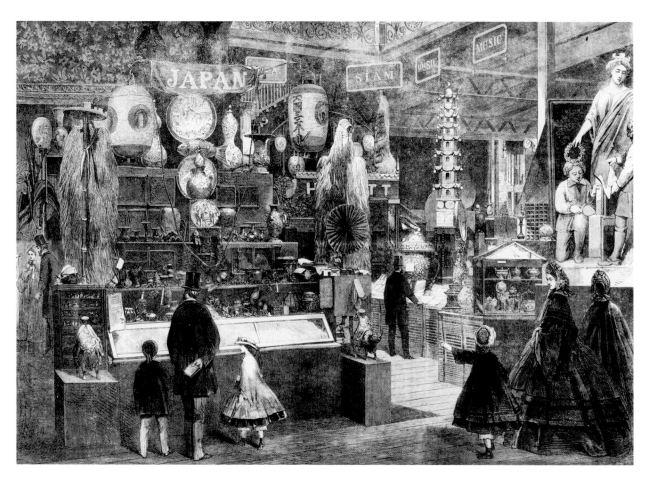

however, saw Japanese things in a rather different way, which was in part a continuation of the traditional Western view of exotic cultures. Japan was a primitive country, inhabited by a simple, happy, childlike people, who, not having mastered the drawing of the figure, could never aspire to the ideal in art. From the reformers' point of view, this primitivism was a good thing, for Japanese artefacts were still made in the ideal way, by craftsmen in small workshops. Indeed, when the first substantial group of highly finished Japanese goods was shown at the London International Exhibition of 1862 the gothic revival architect William Burges was moved to compare them with work of thirteenth-century France, largely because of their method of production: 'Truely the Japanese court is the real medieval court of the exhibition' (plate 232).[68] The reformers' greatest fear was that the Japanese would degrade themselves 'to meet the wants of European taste'.[69]

Furniture and pattern

The word most often used by Victorians to describe Japanese applied art and ornament as well as japonisme was 'quaint'. As a word it carried a more complex message than it does today. A potent combination of the curiously wrought, the informal and the mildly surprising, quaintness represented the essence of that rebellion against officially sponsored art-school systems of design, which resulted in the 'Art Movement' of the 1870s and 1880s. Although the Art Movement subscribed to no single style it was broadly historicist in outlook, thus encouraging a revival in the collection of blue and white china on the back of an interest in seventeenth- and eighteenth-century architecture and interiors (plate 233).

One of the most interesting expressions of quaintness was the Anglo-Japanese style of English furniture, which emerged in the 1860s. Its chief pioneer, the architect E. W. Godwin, never visited Japan, and relied for his

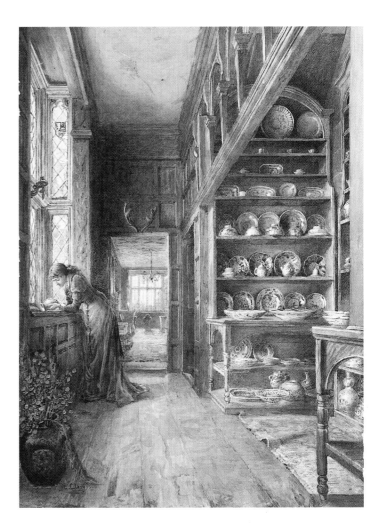

233. Ellen Clacy, *Marigold; the china closet, Knole, c.*1880. Watercolour.
The sixteenth- and seventeenth-century rooms at the great country house of Knole in Kent inspired many Victorian artists seeking to depict 'olden times'. Here the subject has been given an Art Movement emphasis by showing a girl in an Aesthetic dress inspecting the collection of Chinese and Japanese ceramics some of which is said to have belonged to Lady Betty Germain (1680–1769). London, Victoria and Albert Museum.

ideas entirely on illustrations and Japanese woodblock prints. The three main features of the furniture were asymmetry, the use of ornamental open structures of square-section rods, and blackness (plate 234). Although instantly recognizable as 'Japanese', it nevertheless had no precedents in the very small amount of movable furniture in Japanese houses, but was mainly derived from wooden railings and open platforms of temples and other large buildings. The origins of the blackness are more problematical. While it seems to have had no connection with Japanese architecture or furniture, it could have been intended to recall the traditional black of japanning. On the other hand, blackness was a feature of avant-garde furniture in a number of different styles in the 1860s, at least some of which seem to have used that colour to suggest an ancient Englishness.[70] By the 1880s, when blackness had become the norm for all types of 'art furniture', it could work to reinforce both messages in

pieces which combined the classical open pediments of 'Queen Anne' with Japanese galleries and panels.

While Anglo-Japanese furniture had little lasting influence, Japanese ornament had a profoundly liberating effect on Western flat pattern and design, equivalent in its long-term impact to that of Japanese prints on Western painting. A generation whose eyes had been sharpened by the design theories of the encyclopaedists was immediately able to see that Japanese patterns went far beyond the simple devices of chinoiserie in their use of asymmetry and of isolated decorative motifs. A commentator like Sir Rutherford Alcock, in *Art and Art Industries in Japan* of 1878, felt able to cite with approval the Japanese rejection of the 'servile repetition of the parts of a design', the fundamental principle of all Western pattern.[71] In order to create such patterns, japoniste designers did not need to look at decorated objects, but were directly aided by imported Japanese

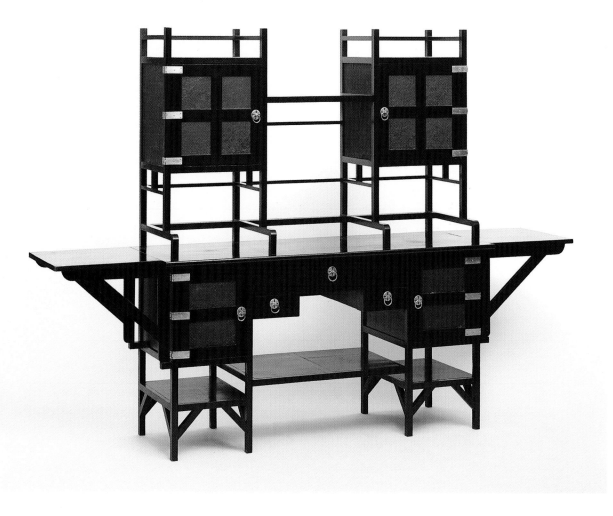

design manuals, while individual motifs could be lifted from such sources as the 'quaint picture books' of 'Native Grotesque Drollery, Beautiful Landscapes, Accurate Naturalistic Sketches of Birds, Insects and Floral Decorations' sold by Liberty's.[72] It was this potent combination of acceptable naturalism and fluently informal composition which eventually entered the common body of European flat pattern design, leaving no trace of its exotic origin (plate 235).

Exoticism and ornament in the twentieth century

We often think of the twentieth-century world, the developed world at any rate, as being characterized by internationalism. Travel is fast, all countries are ultimately subject to the same large economic movements and many products are truly international, made by multinational companies in a world style called 'Modern'. Yet there is still a strong demand for the exotic, which better contacts across the world have made into an international phenomenon. Now the whole developed world can take its pick from a range of styles in order to have something out of the ordinary or engage in a little make-believe. In Japan you can be photographed dressed as a Spaniard, while in England you can buy, via mail order, a real Japanese-made kimono subtly modified for Western tastes to wear (incorrectly) as a dressing-gown.

This international phenomenon is the ultimate result of the classification of world styles and ornament which began with the work of encyclopaedists like Owen Jones. Very soon international ornament and design were being shown full-size in three dimensions, in Owen Jones's architectural style 'courts' at the rebuilt Crystal Palace and increasingly in the national pavilions of international exhibitions, which eventually also came to include whole villages complete with imported natives in costume . While these displays were close to being colonial theme parks,[73] historic and non-European styles and ornament were being shown to a bigger audience than ever before through the medium of Hollywood. Nowadays, with the whole world coming into our living rooms, the process continues.

The lure of the primitive

The *Grammar of Ornament* devoted much attention, as we have seen, to non-European styles, most of them from the accepted repertoire. The exception was 'The Ornament of Savage Tribes', consisting of flat ornament from Polynesia and Melanesia. Jones's reason for this pioneering inclusion lay in his belief that the bark cloths or tattooed heads (then to be seen in museums) of such 'primitive' cultures demonstrated especially clearly the design principles which he was trying to promote in the book. Thereafter 'primitive' ornament, always shown as geometrical, was frequently placed at the bottom of evolutionary hierarchies of art which put the High Renaissance at the top. Considered equally 'primitive' was the art of pre-Columbian Central and South America.[74]

235. Les Patineurs. Design for printed silk by Raoul Dufy for the firm of Bianchini Ferier of Lyons, *c*.1914–20. Gouache. London, Victoria and Albert Museum.

234. Sideboard, 1877–80. Designed by Edward William Godwin, and probably made by William Watt. Ebonized wood, silver-plated fittings and leather paper. London, Victoria and Albert Museum.

Owen Jones was content to study 'primitive' ornament in purely theoretical terms. The adoption of 'primitive' styles by European design did not begin until the late nineteenth century, with such objects as the furniture of Carlo Bugatti, which sought to achieve a sort of strenuous savagery by combining unexpected materials in violently asymmetrical geometrical arrangements (plate 236). The tone was colonialist (in Bugatti's case North African) and the whole phenomenon was linked to the scramble for colonies in Africa and other parts of the world. The colonies, those in Africa especially, added a vital element to that search for completely fresh types of ornament which began with art nouveau in the late nineteenth century. 'African' was modern enough to be included in some of the most lavish Art Deco interiors of the 1920s (plate 237).[75] On the opposite wing was the conscious primitivism of the jazz dancer, whose costume was heir to a tradition of representations of 'Indians' going back to the sixteenth century. In North America, pre-Columbian design and ornament found its way on to the exteriors as well as interiors of buildings, including cinemas, thus spreading the idea to Europe.

236. Chair. Designed by Carlo Bugatti, c.1900. Wood, inlaid with metal and with iron applications, and vellum. The form is that of a Renaissance curule chair, with asymmetrical elements added. New York, Christie's.

237. Chair. Designed by Pierre-Emile Legrain and made by his workshop, c.1923. Lacquered and gilt wood with horn feet. Loosely derived from West African ceremonial furniture, it was made for Jacques Doucet, a major patron of advanced artists and decorators, for whom Legrain decorated a flat in 1922. New York, Christie's.

The exotic and ethnic

The word 'exotic' is not usually applied to that group of styles thought of in the 1990s as 'ethnic' (plate 238). When pulled together in an interior decorator's book like Dinah Hall's *Ethnic by Design*,[76] they turn out to be an assembly of dead or dying European or American folk styles, together with 'looks' assembled using artefacts from the traditional areas of European exoticism: cowboy, Native American, Mexican, Nordic, Celtic, Tyrolean, Mediterranean, Eastern European, North African, tribal, Gold Coast, Japanese, Indian and Asiatic. The appeal of 'ethnic', according to the author, lies in the

238. Sitting room designed by David Champion. The main emphasis is African, but other ethnic and Western objects are also present. From Dinah Hall, *Ethnic by Design*, 1992.

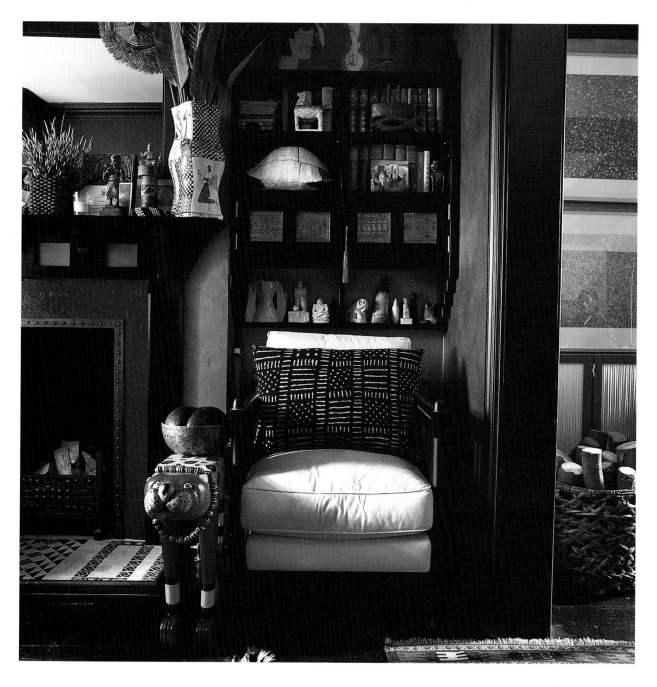

239. Carrier Bag. Designed by Nicolette Tabram and made for Monsoon Limited, 1994. Brown paper printed in blue and white. This carrier bag is for a chain of clothes shops in which much of the stock is made in India and East Asia, often using fabrics printed by traditional methods; the printing on this bag is loosely based on batik prints.

West's 'hunger for imperfection' in the face of the 'soulless perfection' of modern machine-made design (although we might also argue that it is part of a general post-modernist desire for ornament).

This hunt for imperfection, so similar to the drive behind chinoiserie, is not the only link between 'ethnic' and traditional exoticism. Ethnic objects are, for instance, found to have a 'striking similarity of expression and inspiration', notably a 'warmth and vibrancy of patterning' and a 'naive charm'. Above all, ethnic objects are made by hand using traditional materials and are held to possess a 'sense of individual creativity', a direct continuation of the Arts and Crafts approach to exotic objects which began after the Great Exhibition of 1851.

To the moral force of the hand-made, 'ethnic' adds a powerful extra ingredient peculiar to the late twentieth century. 'Ethnic' objects, being made of natural materials by people apparently less urbanized than ourselves, convey to us a closeness and respect for nature which has disappeared from the modern Western world and which we eagerly desire. How reassuring it is to read on the label of an amazingly cheap Indian dress that its fabric is 'from a limited range in which we have used traditional printing techniques dating back hundreds of years', that the 'green comes from adding turmeric and pomegranates to the indigo' and that it is 'printed in family workshops in Rajasthan'.[77] We scarcely notice, in all this talk of technique and nature, that the forms of the pattern are almost entirely Western and that we are about to buy a classic example of traditional exoticism.

A number of these modern exotic elements are present in a carrier bag made for the Monsoon chain of clothing shops, much of whose stock is made of textiles printed in the Indian sub-continent and East Asia (plate 239). Monsoon's bags, like most carrier bags, are marketing tools, but unlike many other high street retailers, the firm has no recognizable sign or symbol beyond its name. Bag designs change at least every season but always need to convey the character of the shops, with their particular blend of exotic patterning and common sense. It is a subtle business, as this bag shows.

A complex technique of overprinting allows the designer to create in the central panel the effect of a hand-printed textile in the batik technique. The bag itself is made of brown paper which, although recognizably Western, reinforces the 'primitive' message in its moral plainness. It is not, significantly, the shiny 'fine' side of the paper which is exposed, but the reverse side with its matt surface and parallel lines originally derived from the paper-making process. It is this decorative pattern of lines, with its hint of the hand-made, which allows us instantly to 'read' the message of the paper, and of the bag.

A technology which allows us to mass-produce ornamented objects which look hand-made does not, for most modern consumers, raise the sort of moral questions that so concerned commentators on ornament in the nineteenth century. We are happy to accept such things for what they are: objects made by machine in a hand-made aesthetic. Technology does, however, have the potential to present us with opportunities which may eventually overturn many of the notions surrounding the use of ornament which have been discussed in this book. A case in point is the frying pan in plate 240. Modern techniques of enamelling have allowed the bottom to be ornamented with the Greek key pattern in concentric rings, while the inside is plain black Teflon. It is not simply that colour and pattern of the pan appear to link a 'low' object type, the pan, with a 'high' object type, an ancient Greek pot. More profoundly, adding ornament to the bottom, usually undecorated for practical reasons, allows the pan to be either a practical object, when on the stove, or a functionless ornament, when hanging up. This would be unobjectionable, except that the positioning of all the ornament on what is normally regarded as the bottom immediately suggests that the pan is principally an ornament. Like the Victorian majolica dish which is the first illustration of this book, the richness and position of the decoration sets up an opposition between utility and ornament, making us question the very purpose of the object. How could we bear to cook with such a pan, knowing that its principal side, beautifully decorated, is being put on the heat? It seems that for the moment at least the rules which have governed ornament for millennia still hold sway.

240. Frying pan. Designed by Spagnolo Design, made by Rondine Italia s.p.a., 1995.
Plastic, aluminium, Teflon and enamel.

Notes to Introduction

1. Owen Jones, *The Grammar of Ornament* (London, 1856), p. 8, proposition 36.
2. Vitruvius, *The Ten Books on Architecture*, trans. Morris Hickey Morgan (1914; New York, 1960), p. 211.
3. Le Corbusier, *L'Art Decoratif d'Aujourd'hui* (Paris, 1925), p. 89.
4. Paul Gauguin, 'Notes sur l'art à l'exposition universelle' from *Ecrits d'un sauvage*, ed. Daniel Guérin (Paris, 1974), p. 48.
5. Owen Jones, *The Grammar of Ornament*, op. cit., p. 6, proposition 13.
6. Walter Crane, *The Claims of Decorative Art* (London, 1892), p. 2.

1. Ornament and the Printed Image

1. For the development and transference of motifs see Alois Riegl, *Stilfragen: Grundlegungen zu einer Geschichte der Ornamentik* (Berlin, 1893); trans. by Evelyn Kain as *Problems of Style: Foundations for a History of Ornament* (Princeton, 1992); E.H. Gombrich, *The Sense of Order: A Study in the Psychology of Decorative Art* (2nd edn, London, 1984), especially chapter 7; Jessica Rawson, *Chinese Ornament: The Lotus and the Dragon* (London, 1984).
2. See Riegl, *op. cit.*; Rawson, *op. cit.*
3. A more accurate, but so far unadopted name would be 'design print'. 'Model print' has also been suggested, see Howard Creel Collinson, *Documenting Design: Works on Paper in the European Collection of the Royal Ontario Museum* (Toronto, Buffalo and London, 1993).
4. The major collections with an international range include those in the Victoria and Albert Museum, the Kunstbibliothek, Berlin, the Museum für Kunst und Gewerbe, Hamburg, the Museum für Angewandte Kunst, Vienna, the Bibliothèque Royale, Brussels, the Bibliothèque Nationale, Paris and the Rijksmuseum, Amsterdam, all of which have published or are in the course of publishing catalogues.
5. Adam Bartsch, *Le Peintre-graveur*, 21 vols (Vienna, 1803–21).
6. Staatliche Museen zu Berlin, *Katalog der Ornamentstichsammlung der Staatlichen Kunstbibliothek Berlin* (Berlin and Leipzig, 1939).
7. But see David Landau and Peter Parshall, *The Renaissance Print: 1470–1550* (New Haven and London, 1994), p.373, for a discussion of the date of printed textiles.
8. For the early history of engraving see Arthur M. Hind, *A Short History of Engraving and Etching* (3rd edn, London, 1923). Reprint of New York 1923 edn, New York, 1963; Landau and Parshall, *op. cit.*
9. William M Ivins Jr., *Prints and Visual Communication* (Cambridge, Mass. and London, 1969), p. 28.
10. See Francis Ames-Lewis and Joanne Wright, *Drawings in the Italian Renaissance Workshop* (London, 1983), pp. 95–193.
11. Simon Jervis, *The Penguin Dictionary of Design and Designers* (London, 1984), p. 62.
12. A. Hyatt Mayor, *Prints & People: a Social History of Printed Pictures* (New York, 1971), fig. 117.
13. Landau and Parshall, *op. cit.*, p. 4.
14. Pierrette Jean-Richard, *Ornemanistes du XVe au XVIIe siècles* (Paris, 1987), p.50. For early goldsmiths' prints see also Johann Micael Fritz, *Gestochene Bilder, Gravierungen auf deutschen Goldschmiedarbeiten der Spätgotik* (Graz, 1966).
15. Paul Tanner and Christian Müller, *Das Amerbach-Kabinett: Die Basler Goldschmiederisse* (Basel, 1991), pp. 89–90.
16. Jean-Richard, *op. cit.*, pp. 89–92.
17. *Ibid.* pp. 92–3; Landau and Parshall, *op. cit.*, p. 82.
18. A Parisian bookseller, Loys Roger, had in stock in 1528 101,860 volumes, of which 98,529 were books of hours: see Roger Chartier, *The Cultural Uses of Print in Early Modern France*, trans. Lydia G. Cochrane (Princeton, 1987), p. 150. For the early book trade see Lucian Fabvre and Henri-Jean Martin, *The Coming of the Book: the Impact of Printing 1450–1800*, trans. David Gerard (London, 1976).
19. Mayor, *op. cit.*, figs 218, 219.
20. Brown University, *Ornament and Architecture: Renaissance Drawings, Prints and Books* (Providence, Rhode Island, 1980), pp. 58–9.
21. Jervis, *op. cit.*, p. 68.
22. See Philippa Glanville, *Silver in Tudor and Early Stuart England: A Social History and Catalogue of the National Collection* (London, 1990), pp. 85–99.
23. See Brown University, *op. cit.*, pp. 63–5; Landau and Parshall, *op. cit.*, pp. 323–7.
24. See Stephen Goddard, *The World in Miniature: Engravings of the German Little Masters 1500–1550* (Lawrence, Kansas, 1988).
25. Janet S. Byrne, *Renaissance Ornament Prints and Drawings*, (New York, 1981), pp. 26–7.
26. Landau and Parshall, *op. cit.*, pp. 299–308.
27. For the print and book trade see *ibid.*, pp. 347–58.
28. For textile pattern books see Arthur Lotz, *Bibliographie der Modelbücher* (Leipzig, 1933).
29. See Chapter 6, p. 000.
30. Byrne, *op. cit.*, p. 101.
31. See Anna Somers Cocks (ed.), *Princely Magnificence; Court Jewels of the Renaissance* (London, 1981), p. 119.
32. Byrne, *op. cit.*, p. 20.
33. Brown University, *op. cit.*, pp. 17–18.
34. *Ibid.*, pp. 34–5.
35. See W.B. Dinsmoor, 'The Literary Remains of Sebastiano Serlio', *Art Bulletin*, 24 (March 1942), pp. 55–91; Brown University, *op. cit.*, pp. 89–92; John Onians, *Bearers of Meaning: The Classical Orders in Antiquity, the Middle Ages and the Renaissance* (Princeton, 1988), pp. 263–86.
36. For the Italian print market see Landau and Parshall, *op. cit.*, pp. 284–309.
37. For a comprehensive treatment of the phenomenon of the vase see Werner Oechslin and Oskar Bätschmann, *Die Vase* (Zurich, 1982).
38. *Ibid.*, p. 151.
39. *Ibid.*, p. 152.
40. *Ibid.*, p. 152
41. J.F. Hayward, *Virtuoso Goldsmiths and the Triumph of Mannerism* (London, 1976), p. 405; Glanville, *op. cit.*, pp. 464–5.
42. Oechslin and Bätschmann, *op. cit.*, p. 161.
43. *Gli antichi Sepolcri, overo Mausolei romani ed Etruschi, trovati in Roma, ed in altri luoghi celebri*, see Oechslin and Bätschmann, *op. cit.*, p. 85.
44. Giorgio Vasari, *The Lives of the Painters, Sculptors and Architects*, ed. William Gaunt (London and New York, 1963), Vol. II, p. 353. See also A. Marabottini, *Polidoro da Caravaggio*, 2 vols (Rome, 1969); L. Ravelli, *Polidoro Caldara da Caravaggio* (Bergamo, 1978); Oechslin and Bätschmann, *op. cit.*, p. 155.
45. Oechslin and Bätschmann, *op.cit.*, p. 267.

46. For the grotesque see especially Peter Ward-Jackson, 'Some Main Streams and Tributaries in European Ornament from 1500–1750', *Victoria and Albert Museum Bulletin*, 3 (1967), pp. 58ff., 90ff., 121ff.; Nicole Dacos, *La Découverte de la Domus Aurea et la formation des grotesques à la Renaissance* (London and Leiden, 1969); Carsten-Pieter Warncke, *Die ornamentale Groteske in Deutschland* 2 vols (Berlin, 1979); Alain Gruber, 'Grotesques', in Alain Gruber (ed.), *L'Art décoratif en Europe: Renaissance et Manièrisme* (Paris, 1993), pp. 193–273.

47. Brown University, *op. cit.*, p. 80.

48. See Dacos, *op. cit.*

49. Brown University, *op. cit.*, pp. 31–2; Jean-Richard, *op. cit.*, pp. 103–4.

50. See Warncke, *op. cit.*; B. Wagner, 'Zum Problem der "französischen Groteske", in Vorlagen des 16 Jh. Das Groteskenbuch des J.H. Ducerceau', *Jahrbuch des Kunsthistorischen Institutes der Universität Graz*, 14 (1979), p. 153ff.

51. Brown University, *op. cit.*, p. 95.

52. Stephen H. Goddard and David S. Ritchkoff, *Sets and Series: Prints from the Low Countries* (New Haven, 1984), p. 11.

53. See Baron Henry de Geymuller, *Les Ducerceau, leur vie et leur oeuvre* (Paris and London, 1887).

54. See Timothy A. Riggs, *Hieronymus Cock: Printmaker and Publisher of Antwerp* (New York and London, 1977).

55. See Ilse O'Dell-Franke, *Kupferstiche und Radierungen des Werkstatt des Virgil Solis* (Wiesbaden, 1977). For goldsmiths' prints in Nuremberg see Gerhard Bott (ed.), *Wenzel Jamnitzer und die Nürnberger Goldschmiedekunst, 1500–1700* (Munich, 1985).

56. See Wolfgang Seitz, 'The Engraving Trade in Seventeenth- and Eighteenth Century Augsburg: a Checklist', *Print Quarterly*, 3, 2 (June 1986), pp. 116–27.

57. See Jacques Vanuxem, 'Notes sur les contrefaçons de gravures et ornements français au XVIIIe siècle à Augsburg et sur leur influence en Souabe', *Bulletein de la Société de l'Histoire de l'art Français*, 1952 (1953), pp. 29–35.

58. See E.M. Hajos, 'The Concept of an Engravings Collection in the Year 1565: Quicchelberg, "Inscriptiones Vel Tituli Theatre Amplissimi"', *Art Bulletin*, 40, 2 (June 1958), pp.151–5; Landau and Parshall, *op. cit.*, esp. pp. 365–8.

59. See Peter Parshall, 'The Print Collection of Ferdinand, Archduke of Tyrol', *Jahrbuch der Kunsthistorischen Sammlungen in Wien*, 78 (1982), pp. 139–84. Parshall also discusses other early print collectors.

60. See Louis R. Metcalfe, 'A Prince of Collectors: Michel de Marolles, Abbé de Villeloin (1600–1681)', *Print Collector's Quarterly*, 2 (October 1912), pp. 317–40.

61. See Isak Colijn, *Katalog der Ornamentstichsammlung Magnus Gabriel De la Gardie in der KGL Bibliothek zu Stockholm* (Stockholm and Uppsala, 1933).

62. For print collecting in the seventeenth century see William W. Robinson, '"This Passion for Prints": Collecting and Connoisseurship in Northern Europe during the Seventeenth Century', in Boston, Museum of Fine Arts, *Printmaking in the Age of Rembrandt* (Boston, 1981), pp. xxvii–xlviii.

63. See Guy Walton, Agneta Bortz-Laine and Astrid Tydèn-Jordan, *Versailles è Stockholm: Dessins du Nationalmuseum. Peintures, Meubles et Arts Décoratifs des Collections Suédoises et Danoises* (Stockholm, 1985); Pontus Grate (ed.), *Solen och Nordstjärnan: Frankrike och Sverige pa 1700-talet* (Stockholm, 1994); *Le Soleil et L'Etoile du Nord: la France et la Suède au XVIIIe siècle* (Paris, 1994).

64. See Marie Thérèse Mandroux-Franca, 'La Circulation de la gravure d'ornement en Portugal du XVIe au XVIIIe siècle', in Henri Zerner (ed.), *Atti del XXIV Congresso Internazionale di Storia dell'Arte*, 8 (Bologna, 1979), pp. 85–108.

65. See Hanspeter Lanz, 'Das Skizzenbuch II von Dietrich Meyer d.J. (1651–1733) – ein Dokument für den Stilwandel in der Zurcher Goldschmiedkunst um 1675', *Zeitschrift für Schweizerische Archaologie und Kunstgeschichte*, 50 (1993), pp. 263–86.

66. Jervis, *op. cit.*, p. 78.

67. See Morrison Heckscher, 'Gideon Saint: An Eighteenth-Century Carver and His Scrapbook', *Metropolitan Museum of Art Bulletin*, 27 (February 1969), pp. 299–310.

68. Michael Snodin (ed.), *Rococo: Art and Design in Hogarth's England* (London, 1984), pp. 46–7; Peter Ward-Jackson, *English Furniture Designs of the Eighteenth Century* (London, 1984), no. 42.

69. Susan Lambert (ed.), *Pattern and Design: Designs for the Decorative Arts 1480–1980* (London, 1983), pp. 56–63; Snodin, *op. cit.*, p. 70.

70. For della Bella's influence see Lambert *op. cit.*, pp. 42–9.

71. See Timothy Wilson, *Ceramic Art of the Italian Renaissance* (London, 1987), pp. 39–73.

72. See Winfried Baer, Ilse Baer and Susanne Grosskopf-Knaack, *Von Gotzkowsky zur KPM, aus der Frühzeit des friederizianischen Porzellans* (Berlin, 1986), pp. 272–548.

73. See Nicholas Goodison, 'The Victoria and Albert Museum's Collection of Metal-Work Pattern Books', in *Furniture History*, II, 1975, pp. 1–30; Christopher Gilbert, *The Life and Work of Thomas Chippendale* (London, 1978); Michael Snodin, 'Matthew Boulton's Sheffield Plate Catalogues', *Apollo*, 126, 305, new series, (July 1987), pp. 25–32; Theodore R. Crom, *Trade Catalogues: 1542–1842* (Melrose, Florida, 1989). The gilt leather pattern books are to be the subject of a future publication by Eloy Koldeweij.

74. See David Watkin, *Thomas Hope, 1769–1831, and the Neo-Classical Idea* (London, 1968)

75. See D.D.C. Allan, *William Shipley, Founder of the Royal Society of Arts* (London, 1968).

76. Snodin, *Rococo, op. cit.*, p. 73.

77. See Charles Saumarez Smith, *Eighteenth Century Decoration: Design and the Domestic Interior in England* (London, 1993), pp. 135–42.

78. See Peter Fuhring, *Design into Art: Drawings for Architecture and Ornament. The Lodewijk Houthakker Collection*, 2 vols, (London 1989), pp. 24–5; Peter Fuhring, 'Two Title Page Designs by Gilles-Marie Oppenord for His Engraved Oeuvre', *Drawings*, 14, 3, (September–October 1992), pp. 49–52.

79. Saumarez Smith, *op. cit.*, p. 140.

80. See Widar Halén, *Christopher Dresser* (London, 1990).

81. See Michael Snodin (ed.), *Karl Friedrich Schinkel: A Universal Man* (New Haven and London, 1991), pp. 187–98.

82. See Wilmarth Sheldon Lewis, 'The Genesis of Strawberry Hill', *Metropolitan Museum Studies*, 51 (1934–6), pp. 57–92; Michael McCarthy, *The Origins of the Gothic Revival* (New Haven and London, 1987), pp. 63–91.

83. See Fuhring, *Design into Art*, pp. 26–9.

84. On nineteenth-century encyclopaedias see Stuart Durant, *Ornament: A Survey of Decoration since 1830, with 729 Illustrations* (London and Sydney, 1986), pp. 11–23.

2. Ornament and Building

1. John Physick, *The Victoria and Albert Museum. The History of its Building* (Oxford, 1982), pp. 114–18 (on the earlier lecture theatre façade), pp. 148–9.

2. Michael Stratton, *The Terracotta Revival* (London, 1993).

3. Alan Powers, *Shop Fronts* (London, 1989); Gordon Honeycombe, *Selfridges Seventy Five Years. The Story of the Store 1909–84* (London, 1984); on the Sullivan store in context, Neil Harris, 'Shopping-Chicago Style', in *Chicago Architecture 1872–1922*, ed. John Zukowsky (Munich, 1987), pp. 137–56.

4. On façadism, Richard Brilliant, *Roman Art from the Republic to Constantine* (London, 1974), pp. 79–84.

5. John Onians, *Bearers of Meaning. The Classical Orders in Antiquity, the Middle Ages, and the Renaissance* (Princeton, 1988), pp. 152–3.

6. A translation of 'Ornament and Crime' is included in *The Architecture of Adolf Loos* (Arts Council exhibition catalogue, 1984), pp. 100–103.

7. Vitruvius, *The Ten Books on Architecture*, trans. Morris Hicky Morgan (1914; New York, 1960). On the greater complexity of Roman architecture see Onians, *op. cit.*, pp. 33–40.

8. On Serlio, see W. B. Dinsmoor, 'The Literary Remains of Sebastiano Serlio', *Art Bulletin*, 24 (1942), pp. 55–91, 115–54; Onians, *op. cit.*, chapter XIX.

9. On Stuart and Revett, see Eileen Harris, assisted by Nicholas Savage, *British Architectural Books and Writers 1556–1785* (Cambridge, 1990), pp. 439–50.

10. Onians, *op. cit.*, pp. 15–18.

11. Vitruvius, *op. cit.*, pp. 102–6.

12. Among the vast literature on the entertainments of Renaissance courts, still central is the collection of essays in *Le Lieu théâtral à la Renaissance*, ed. J. Jacquot (Paris, 1964). Also useful is William Alexander McClung, 'A Place for a Time: The Architecture of Festivals and Theatres', in *Architecture and its Image*, ed. Eve Blau and Edward Kaufman (Montreal, Canadian Centre for Architecture, 1989) pp. 86–108. Specifically on England, Sydney Anglo, *Spectacle, Pageantry and Early Tudor Policy* (Oxford, 1969) and Simon Thurley on 'The Banqueting and Disguising Houses of 1527', in *Henry VIII. A European Court in England*, ed. D. Starkey (London, National Maritime Museum, 1991), pp. 64–9.

13. Henry VIII's enticing of one leading Italian from Francis I is revealed in M. Biddle, 'Nicholas Bellin da Modena: an Italian Artificer at the Court of Henry VIII', *Journal of the British Archaeological Association*, 29, 3rd series (1966), pp. 106–21.

14. On the historiography of the significance of Greece and the relative abundance of Roman remains, see Brilliant, *op. cit.*, Introduction.

15. On the range of Roman building materials, see *ibid.*, pp. 19–32; J.B. Ward-Perkins, *Roman Imperial Architecture* (Harmondsworth, 1981), chapter 4.

16. Vitruvius, *op. cit.*, pp. 72–5.

17. John Summerson, *The Classical Language of Architecture* (revised and enlarged edn, London, 1980); Alexander Tzanis and Liane Lefaivre, *Classical Architecture. The Poetics of Order* (Cambridge, Mass. and London, 1986).

18. Chippendale's preface is discussed in Christopher Gilbert, *The Life and Work of Thomas Chippendale* (London, 1978), pp. 85–9.

19. On the chest of drawers by Adolf Loos, see *Art and Design in Europe and America 1800–1900 at the Victoria and Albert Museum* with an introduction by Simon Jervis (London, 1987), pp. 216–17.

20. On frames, see Peter Humfrey, *The Altarpiece in Renaissance Venice* (New Haven and London, 1993), pp. 146–51.

21. On Nash, see John Summerson, *John Nash* (revised edn, London, 1980). On the models specifically, Geneviève Cuisset, 'Jean-Pierre et François Fouquet, Artistes modeleurs', *Gazette des Beaux Arts*, vol. CXV (1990), 227–37.

22. On Bramante, see A. Bruschi, *Bramante* (English edn, London, 1977) and Onians, *op. cit.*, on the Tempietto, pp. 233–5.

23. Sebastiano Serlio's Book III on the antiquities of Rome was first published in Italy in 1540. Bramante's Tempietto appears on fols 18–19.

24. For the example of Honington Hall, Warwickshire, see Nikolaus Pevsner and Alexandra Wedgwood, *The Buildings of England. Warwickshire* (Harmondsworth, 1966), pp. 313–14.

25. Onians, *op. cit.*, pp. 42–8.

26. On Philibert de l'Orme and the French order, see A. Blunt *Philibert de l'Orme* (London, 1958), chapters 7 and 8.

27. Giorgio Vasari, *Le vite* ed. G. Milanesi (Florence, 1906), Vol. VII p. 193.

28. James S. Ackerman, *The Architecture of Michelangelo* (London, 1961), chapter 3.

29. On the subject of Mannerism, see Craig Hugh Smyth, *Mannerism and Maniera* (New York, 1962) and John Shearman, *Mannerism* (Harmondsworth, 1967).

30. On Giulio Romano, W. Lotz, revised by D. Howard, *Architecture in Italy 1500–1600* (New Haven and London, 1995), chapter 7.

31. On the baluster problem, Paul Davies and David Hemsoll, 'Renaissance Balusters and the Antique', *Architectural History*, 26 (1983), pp. 1–23.

32. On Borromini, see R. Wittkower, *Art and Architecture in Italy 1600–1750* (3rd revised edn, Harmondsworth, 1973), pp. 197–230.

33. Among the vast literature on Robert Adam, the most important for his decorative ornament are Damie Stillman, *The Decorative Work of Robert Adam* (London, 1966); Martha Blythe Gerson, 'A Glossary of Robert Adam's Neo-classical Ornament', *Architectural History*, 24 (1981) pp. 59–82; David N. King, *The Complete Works of Robert and James Adam* (Oxford, 1991).

34. See Leslie Harris, *Robert Adam and Kedleston. The Making of a Neo-Classical Masterpiece* (London, 1987), p.11.

35. King, *op. cit.*, pp. 3–4.

36. *Ibid.*, pp. 5–6.

37. On Batty Langley, see Harris, assisted Savage, *op. cit.*, pp. 262–70.

38. J. Mordaunt Crook, 'John Britton and the Genesis of the Gothic Revival', in *Concerning Architecture*, ed. John Summerson (London, 1968), pp. 98–119; Thomas Cocke, 'The Wheel of Fortune: The Appreciation of Gothic since the Middle Ages', in *Age of Chivalry. Art in Plantagenet England 1200–1400* ed. J. Alexander and P. Binski (London, 1987), pp. 183–91.

39. Cited by J. Mordaunt Crook, *The Dilemma of Style: Architectural Ideas from the Picturesque to the Post-modern* (London, 1987), p. 47.

40. *Ibid.*

41. *Ibid.*, pp. 47–70; Paul Atterbury and Clive Wainwright, *Pugin. A Gothic Passion* (London, Victoria and Albert Museum, 1994).

42. John Unrau, *Looking at Architecture with Ruskin* (London, 1978); Crook, *Dilemma of Style*, pp. 71–80; Mark Swenarton, *Artisans and Architects. The Ruskinian Tradition in Architectural Thought* (London, 1989), chapter 1.

43. Cited by Crook, *Dilemma of Style*, *op. cit.*, p. 72.

44. Lauren S. Weingarden, 'Louis H. Sullivan. Ornament and the Poetics of Architecture', and Martha Pollak, 'Sullivan and the Orders of Architecture', both in Zukowsky, *op. cit.*, pp. 229–50, 251–66.

45. Vitruvius, *op. cit.*, p. 211.

46. Hugh Plomer, *Vitruvius and Late Roman Building Manuals* (Cambridge, 1973).

47. Loos, 'Ornament as Crime', in *The Architecture of Adolf Loos*, *op. cit.* For commentary on this, Benedetto Gravagnuolo, *Adolf Loos* (Milan, 1982), pp. 66–72.

48. Charles Jencks, *The Language of Post-Modern Architecture* (London, 1977); *idem, Post-modernism: the New Classicism in Art and Architecture* (New York, 1987); Mary McLeod, 'Architecture', in *The Post-Modern Movement. A Handbook of Contemporary Innovation in the Arts*, ed. Stanley Trachtenberg (Westport and London, 1985), pp. 19–52.

49. Jencks, *Language of Post-Modern, op. cit.*, p. 6.

3. Ornament and the Human Figure

1. Isaiah, 3: 18–23.

2. V. Steele, *Fashion and Eroticism. Ideals of Feminine Beauty from the Victorian Era to the Jazz Age* (New York, 1985), p. 13.

3. The most important fifteenth-century source on the responsibility of the artist to select the best from nature in the creation of the ideal form is Leon Battista Alberti's 1435 text, *De Pictura*, translated as *On Painting*, ed. John R. Spencer (New Haven and London, revised edn, 1966), pp. 92–3. For an exposition of the importance of a command of the human form for narrative picture-making in fifteenth-century Florence, see Martin Kemp, *Leonardo da Vinci. The Marvellous Works of Nature and Man* (London, 1981), pp. 36–9. On Michelangelo's application of both the symmetry and organic unity of the body to architecture, see James S. Ackerman, *The Architecture of Michelangelo* (London, 1961), chapter 1.

4. Robert Brain, *The Decorated Body* (New York and London, 1979), p. 64.

5. On the general theme of loose dress in Europe and conspicuous leisure see Quentin Bell, *On Human Finery* (2nd edn, New York, 1976), pp. 34–6. On the more complex issues of the meaning of the adoption of non-European dress see Marcia Pointon, *Hanging the Head. Portraiture and Social Formation in Eighteenth-Century England* (New Haven and London, 1993), chapter 5.

6. Steele, *op. cit.*, pp. 46–7. Brain, *op. cit.*, p. 155 ff.

7. On the Amish customs of dress and hair, see John A. Hostetler, *Amish Society* (Baltimore, 1963).

8. On tattooing see Brain, *op. cit.*, p. 50 ff.; John H. Burman on self-tattooing in *Dress, Adornment and the Social Order*, ed. Mary Ellen Roach and Joanne Bubolz Eichner (New York, London and Sydney, 1965), p. 271 ff.; *Body Art: Beauty or Deformity*, exhibition catalogue (University of Essex Gallery, Colchester, 1992).

9. James Cook's copious observations on tattooing throughout the South Seas are recorded in *The Journals of Captain Cook on his Voyages of Discovery*, ed. J.C. Beglehole (Cambridge, 1967).

10. *Body Art: Beauty or Deformity, op. cit.*, pp. 13–14.

11. Brain, *op. cit.*, p. 54.

12. On sumptuary laws see Aileen Ribeiro, *Dress and Morality* (London, 1986), chapters 3 and 4, *passim*. See also Elizabeth B. Hurlock in *Dress, Adornment and the Social Order, op. cit.*, p. 295 ff.

13. Cited by A. Somers Cocks, *An Introduction to Courtly Jewellery* (London 1980), p. 5.

14. Cited by Aileen Ribeiro, *Dress in Eighteenth-Century Europe* (London, 1984), p. 116.

15. Thomas Woodcock and J.M. Robinson, *The Oxford Guide to Heraldry* (Oxford, 1990), pp. 88–9.

16. Alistair Smart, *Allan Ramsay 1713–1784* (Scottish National Portrait Gallery, 1992), cat. 37.

17. On general aspects of both academic and clerical dress see Una Campbell, *Robes of the Realm. Three Hundred Years of Ceremonial Dress* (London, 1989); Janet Mayo, *A History of Ecclesiastical Dress* (London, 1984); Bell, *op. cit.*, p. 151 ff.

18. Rene Koenig, *The Restless Image. A Sociology of Fashion*, (New York, 1973) p. 86.

19. Anne Hollander, *Seeing through Clothes* (New York, 1978), pp. 248–56.

20. Lillian O. Holloman, 'Black Sororities and Fraternities: A Case Study in Clothing Symbolism', in *Dress and Popular Culture*, ed. Patricia A. Cunningham and Susan Voso Lab (Bowling Green, Ohio, 1991), pp. 46–58. See also Alison Lurie, *The Language of Clothes* (London, 1981).

21. Shirley Bury, *An Introduction to Sentimental Jewellery based on the Collection in the Victoria and Albert Museum* (London, 1985), p. 9.

22. Aileen Ribeiro, *Fashion in the French Revolution* (London, 1988), chapter 2.

23. On the proliferation of royal insignia, D. Starkey, 'The age of the household' in *The Later Middle Ages*, ed. S. Medcalf (London, 1981), pp. 272–3.

24. On the excesses of Burgundian fashions see Ribeiro, *Dress and Morality, op. cit.*, pp. 55–8.

25. Hollander, *op. cit.*, pp. 305–6.

26. For a general definition of the *parure* see Harold Newman, *An Illustrated Dictionary of Jewelry* (London, 1981), p. 227.

27. Bury, *op. cit.*, p. 6 ff.

28. Roy Strong, *Portraits of Queen Elizabeth I* (Oxford, 1963), pp. 85–6; Frances Yates, *Astraea* (Harmondsworth, 1977 edn), pp. 216–21.

29. On jewellery and commemoration see Bury, *op. cit.*; Charlotte Gere, *European and American Jewellery 1830–1914* (London, 1975), pp. 56–61; Lou Taylor, *Mourning Dress: A Costume and Social History* (London, 1983); Shirley Bury, *Jewellery 1789–1910. The International Era* (2 vols, London, 1991), chapter 14: 'In and out of mourning'; Nigel Llewellyn, *The Art of Death* (London, 1991), pp. 95–6.

30. Alexandra Speight, *The Lock of Hair: Its History, Ancient and Modern, Natural and Artistic; with the Art of Working in Hair* (London, 1872).

31. Ribeiro, *Dress and Morality*, p. 62.

32. Hollander, *op. cit.*, p. xiv.

33. On flowers and dress see Aileen Ribeiro, '"A Paradice of Flowers": Flowers in English Dress in the Late Sixteenth and Early Seventeenth Centuries', *Connoisseur*, 201 (1979), pp. 110–17. On tulipomania, Simon Schama, *The Embarrassment of Riches. An Interpretation of Dutch Culture in the Golden Age* (London, 1987), pp. 350–66.

34. Geoffrey Munn, 'A Garden of Earthly Delights. Flowers as an Inspiration for European Jewellery Design', *Connoisseur*, 201 (1979), p. 97.

35. M. Louttit, 'The Romantic Dress of Saskia van Ulenborch; its Pastoral and Theatrical Associations', *Burlington Magazine*, 115 (1973), pp. 317–26.

36. Cited by Ribeiro, *Dress in Eighteenth-Century Europe, op. cit.*, p. 118.

37. On armour see Claude Blair, *European Armour circa 1066 to circa 1700* (London, 1958), chapters 4 and 5; *idem*, 'The Emperor Maximilian's Gift of Armour to King Henry VIII and the Silvered and Engraved Armour at the Tower of London', *Archaeologia*, 99 (1965).

38. A useful summary of this remains Joan Evans, *A History of Jewellery 1100–1870* (London, 1953; 2nd edn, 1970), chapters 4 and 5.

39. Drawings for jewellery, fountains and a 'clock salt' (or table ornament) by Holbein were displayed in the exhibition *Henry VIII. A European Court in England*; catalogue ed. David Starkey (London, National Maritime Museum, 1991), cat. nos IX, 15, 16, 17.

40. On Van Dyck's 'arcadian' mode of dress, see Arthur K. Wheelock, Susan J. Barnes and Julius S. Held, *Anthony Van Dyck* (Washington, 1990), cat. no. 63.

41. On the Castellani workshop see Gere, *op. cit.*, pp. 162–4; '"The Archaeological Style" in 19th Century Jewellery' in Hugh Tait (ed.), *The Art of the Jeweller. A Catalogue of the Hull Grundy Gift to the British Museum: Jewellery, Engraved Gems and Goldsmith's Work* (London 1984), pp. 140–62.

42. *Punch*, 16 July 1859, p. 30.

4. Ornament and the Domestic Interior

1. Adrian Forty, *Objects of Desire: Design and Society 1750–1980* (London, 1986), p. 113.

2. Christopher Wren, *Parentalia* (London, 1750; Farnborough, 1965), p. 261.

3. See especially Peter Thornton, *Authentic Decor: The Domestic Interior 1620–1920* (London, 1984), pp. 14–22.

4. See Peter Thornton, *The Italian Renaissance Interior, 1400–1600* (London, 1991), pp. 296–8, 300–12.

5. Mark Girouard, *Life in the English Country House* (New Haven and London, 1978), p. 197.

6. See especially Dan Cruickshank and Neil Burton, *Life in the Georgian City* (London, 1990), pp. 150–255.

7. David Parker, 'The Reconstruction of Dickens's Drawing Room', *The Dickensian*, 396, vol. 78, part 1 (spring 1982), p. 11.

8. Girouard, *op. cit.*, p. 162.

9. See Alastair Service, *Edwardian Interiors* (London, 1982), p. 38.

10. Advocated by Humphry Repton; see Charlotte Gere, *Nineteenth Century Decoration: The Art of the Interior* (London, 1989), pp. 45–6.

11. See Mark Girouard, *The Victorian Country House* (New Haven and London, 1979).

12. See Karen Halttunen, 'From Parlor to Living Room: Domestic Space, Interior Decoration, and the Culture of Personality', in Simon J. Bronner (ed.), *Consuming Visions: Accumulation and Display of Goods in America 1880–1920* (New York and London, 1989), pp. 157–89.

13. Edward W. Gregory, *The Art and Craft of Home-Making* (London, 1913), p. 17.

14. See H. Allen Brooks, 'Wright and the Destruction of the Box', *Journal of the Society of Architectural Historians*, 38 (March 1979), pp. 7–14, repr. in H. Allen Brooks (ed.), *Writings on Wright: Selected Comment on Frank Lloyd Wright* (Cambridge, Mass., 1981).

15. Frank Lloyd Wright, 'In the Cause of Architecture', *The Architectural Record*, 23, 3, (March 1908), p. 59.

16. Elizabeth B. Mock, *If You Want to Build a House* (New York, 1946), p. 54.

17. *Ibid.*, p. 11.

18. Mary L. Brandt, *Decorate Your Home for Better Living* (New York and London, 1950).

19. Terence Conran, *The House Book* (London, 1974), p. 188.

20. See John Onians, *Bearers of Meaning: The Classical Orders in Antiquity, the Middle Ages, and the Renaissance* (Princeton, 1988), esp. pp. 36–9, 271–7.

21. Sir Henry Wotton, *The Elements of Architecture* (London, 1624), p. 82.

22. *Ibid.*, p. 119.

23. *Ibid.*, p. 72.

24. *Ibid.*, p. 82.

25. *Ibid.*, p. 98.

26. Onians, *op. cit.*, p. 299.

27. *Ibid.*

28. *Ibid.*

29. See Guy Walton, *Louis XIV's Versailles* (Harmondsworth, 1986).

30. See Geoffrey Beard, *Craftsmen and Interior Decoration in England, 1660–1820* (London, 1981), pp. 13–14.

31. See Charles Saumarez Smith, *Eighteenth Century Decoration: Design and the Domestic Interior in England* (London, 1993), pp. 63–9.

32. See Martha Blythe Gerson, 'A Glossary of Robert Adam's Neo-Classical Ornament', *Architectural History*, (1981), pp. 59–82.

33. Gillian Naylor, *The Bauhaus* (London, 1968), pp. 119–20.

34. Tim Putnam and Charles Newton (eds), *Household Choices* (London, 1990), p. 94.

35. Charles Booth, 1900, quoted in Stefan Muthesius, *The English Terraced House* (New Haven and London, 1982), p. 254.

36. First published in the *Neues Wiener Tageblatt*, 26 April 1900; trans. in Adolf Loos, *Spoken into the Void* (Cambridge, Mass., 1987), pp. 125–7.

37. Clive Wainwright, 'The Library as Living Room', in Robin Myers and Michael Harris (eds), *Property of a Gentleman: The Formation, Organisation, and Dispersal of the Private Library 1620–1920* (Winchester, 1991), p. 15.

38. See Clive Wainwright, *The Romantic Interior: The British Collector at Home* (New Haven and London, 1989), pp. 71–108.

39. John Cornforth and John Fowler, *English Decoration in the 18th Century* (London, 1974), p. 46.

40. For example the Countess of Hertford in 1741; see Saumarez Smith, *op. cit.*, p. 127.

41. *Ibid.*, pp. 132–4.

42. Thomas Hope, *Household Furniture and Decoration, Executed from Designs by Thomas Hope* (London, 1807; repr., New York, 1971), pp. 3–4.

43. See John Cornforth, *English Interiors, 1790–1848: The Quest for Comfort* (London, 1978), p. 14.

44. From Andrew Jackson Downing, *A Treatise on the Theory and Practice of Landscape Gardening*, 1841, quoted in James Ackerman, *The Villa* (Princeton, 1990), p. 245.

45. Andrew Jackson Downing, *Victorian Cottage Residences* (New York, 1873; repr. 1981), p. 15.

46. Ackerman, *op.cit.*, p. 218.

47. Gere, *op. cit.*, p. 48.

48. Mrs [Lucy] Orrinsmith, *The Drawing Room* (London, 1878), p. 8.

49. Joris Karl Huysmans, *Against Nature (A Rebours)*, trans. Robert Baldick (Harmondsworth, 1959), introduction, p. 7.

50. *Ibid.*

51. See Jane S. Smith, *Elsie de Wolfe* (New York, 1982); Halttunen, *op.cit.*

52. Emily Post, *The Personality of a House: The Blue Book of Home Design and Decoration* (New York, 1930), p. 3, quoted in Halttunen, *op. cit.*, p.178.

53. Mary Furlong Moore, *Your Own Room: The Interior Decorating Guide for Girls* (New York, 1960).

54. *How to Turn a House into a Home: A Step by Step Guide to the Art of Home Making from Nairn Floors Ltd.* (Kirkcaldy, 1979), inside front cover.

55. Wotton, *op. cit.*, p. 95.

56. Charles Percier and Pierre Fontaine, *Recueil de décorations interiéures* (Paris, 1801), pp. 13–14.

57. Mrs Orrinsmith, *op.cit.*, p. 2.

58. *Ibid.*, p.1.

59. Wilkie Collins, *Basil* (Oxford and New York, 1990), p. 61.

60. See Caroline Arscott, 'Employer, Husband, Spectator: Thomas Fairbairn's Commission of "The Awakening Conscience"', in Janet Wolff and John Seed (eds), *The Culture of Capital: Art, Power and the Nineteenth-century Middle Class* (Manchester, 1988), pp. 159–90.

61. Walker Art Gallery, Liverpool, *William Holman Hunt: An Exhibition Arranged by the Walker Art Gallery* (Liverpool, 1969), p. 36.

62. John Ruskin, letter to *The Times*, 25 May 1854, quoted in Arscott, *op. cit.*, pp. 172–3.

63. As expressed in the parvenu Veneering family in Dickens's *Our Mutual Friend* of 1864–5.

64. For the moral values of Victorian furnishing see especially Halttunen, *op. cit.*

65. Catherine E. Beecher and Harriet Beecher Stowe, *The American Woman's Home* (Boston, 1869), p. 84.

66. *The Building News*, 1874, p. 23, quoted in Mark Turner and William Ruddick, *A London Design Studio 1880–1963: The Silver Studio Collection* (London, 1980), p. 14.

67. Mrs Orrinsmith, *op. cit.*, p. 8.

68. Andrew Jackson Downing, *The Architecture of Country Houses* (1850; New York, 1969), p. 43.

69. From Hall Thorpe, 'On Colour in the Cottage', *Studio Year Book*, 1919, pp. 65–70, quoted in Turner and Ruddick, *op. cit.*, p. 31.

70. Le Corbusier, *The Decorative Art of Today*, trans. James Dunnett (Cambridge, Mass., 1987), p. 192 (First published as *L'Art décoratif d'aujourd'hui*, Paris, 1925.

5. Ornament in Public and Popular Culture

1. Margaret Lambert and Enid Marx, *English Popular Art* (2nd edn, London, 1989); A.J. Lewery, *Popular Art Past and Present* (Newton Abbot, 1991), pp. 94–5; Roy Christian, *Well-Dressing in Derbyshire* (Derby, 1991), *passim.*

2. David Cannadine, 'The Context, Performance and Meaning of Ritual: The British Monarchy and the Invention of Tradition *c.*1820–1977', in E. Hobsbawm and T. Ranger (eds), *The Invention of Tradition* (Cambridge, 1983) pp. 101–64; on George IV's coronation, see Valerie Cumming 'Pantomime and Pageantry: The Coronation of George IV', in Celina Fox (ed.), *London – World City 1800–1840* (New Haven and London, 1992), pp. 39–50.

3. Rodney Dennys, *The Heraldic Imagination* (New York, 1975); Anthony Wagner, *Pedigree and Progress. Essays in the Genealogical Interpretation of History* (London, 1975).

4. T. Woodcock and J.M. Robinson, *The Oxford Guide to Heraldry* (Oxford, 1988), p. 172.

5. On European heraldry see Ottfried Neubecher, *Heraldry. Sources, Symbols, Meaning* (London, 1979). On British heraldry, see Richard Marks and Ann Payne, *British Heraldry from its Origins to c.1800* (London, 1978), chapter 5.

6. On the decoration of buildings in England, see Maurice Howard, *The Early Tudor Country House. Architecture and Politics 1490–1550* (London, 1987), p. 29.

7. Woodcock and Robinson *op. cit.*, pp. 183–6.

8. Wagner, *op. cit.*, pp. 42–4; D.C. Galbreath, 'Continental Heraldry', in *Chambers Encyclopaedia* (1949 edition).

9. Woodcock and Robinson, *op. cit.*, pp. 21–2.

10. On corporate heraldry, see Marks and Payne, *op. cit.*, chapter 4; C.W. Scott-Giles, *Civic Heraldry of England and Wales* (London, 1953); Arnold Whittick, *Symbols, Signs and Meaning* (London, 1960), chapter 5.

11. Scott-Giles, *op. cit.*, pp. 22, 26, 63.

12. Whittick, *op. cit.*, pp. 31–9.

13. George Dow, *Railway Heraldry and Other Insignia* (London, 1973); Brian Haresnape, *Railway Liveries 1923–1947* (Shepperton, 1989).

14. Gordon Honeycombe, *Selfridges. Seventy-Five Years. The Story of the Store 1909–84* (London, 1984), p. 158.

15. Paul Corballis, *Pub Signs* (Luton, 1988), p. 11.

16. For perceptive comments on signs and literacy, C. Phythian-Adams, 'Milk and Soot. The Changing Vocabulary of Popular Ritual in Stuart and Hanoverian London', in D. Fraser and A. Sutcliffe (eds), *The Pursuit of Urban History* (London, 1983), p. 84.

17. Corballis, *op. cit.*, pp. 14, 34–5, 38; Whittick, *op. cit.*, chapter 9.

18. Early descriptions of Scole are found in Francis Blomefield, *Topographical History of the County of Norfolk* (London, 1805 edn), p. 130 and Christobel M. Hood, 'An East Anglian Contemporary of Pepys. Philip Skippon of Foulsham 1641–1692', *Norfolk Archaeology*, 22 (1926), p. 161.

19. Cited by Whittick, *op. cit.*, p. 109.

20. *Ibid.*, pp. 113–14.

21. See David Bergeron, *English Civic Pageantry 1558–1642* (London, 1971); Sheila Williams, 'The Lord Mayor's Show in Tudor and Stuart Times', *Guildhall Miscellany*, 10 (1959), pp. 3–18; Tessa Murdoch, 'The Lord Mayor's Procession of 1680: The Chariot of the Virgin Queen', *Transactions of the London and Middlesex Archaeological Society*, 34 (1983), pp. 207–12.

22. Meg Twycross, 'The Flemish "Ommegang" and its Pageant Cars', *Medieval English Theatre*, Vols 2:1, pp. 15–41 and 2:2, pp. 80–89; Geoffrey Ashton, *Catalogue of Paintings in the Theatre Museum* (London, 1992). On the theme of festivals and their architecture more generally, see William Alexander McClung, 'A Place for a Time: The Architecture of Festivals and Theatres', in Eve Blau and Edward Kaufman (eds), *Architecture and its Image. Four Centuries of Architectural Representation* (Canadian Centre for Architecture, Montreal, 1989), pp. 86–108.

23. See Ronald Hutton, *The Rise and Fall of Merry England. The Ritual Year 1400–1700* (Oxford, 1994), p. 39.

24. C. Phythian Adams, 'Ceremony and the Citizen: The Communal Year at Coventry', in P. Clark and P. Slack (eds), *Crisis and Order in English Towns 1500–1700* (London, 1972), pp. 57–85; Hutton, *op. cit.*, chapter 3.

25. Anthony Munday, *Chrysanaleia: or the Golden Fishing 1616*, ed. J. G. Nichols (London, 1844).

26. Lewery, *op. cit.*, pp. 138–41.

27. Honeycombe, *op. cit.*, p. 41.

28. Ben Rosen, *The Corporate Search for Visual Identity* (New York, 1970). p. 191 ff.

29. Wolfgang Schmittel, *Corporate Design International. Definition and Benefit of a Consistent Corporate Appearance* (Zurich, 1984), pp. 161–8.

30. Arthur Reid, *Airline. The Inside Story of British Airways* (London, 1990). On an earlier phase, see Frank Jackson, 'The New Air Age: BOAC and Design Policy 1945–60', *Journal of Design History*, 7, 3 (1991). pp. 167–85.

31. Rosen, *op. cit.*, pp. 25–30.

32. Reid, *op. cit.*, p. 81.

33. Haresnape, *op. cit.*, pp. 101–2.

34. *Ibid.*, p. 153.

35. Rosen, *op. cit.*, p. 25.

36. Reid, *op. cit.*, pp. 77–8.

37. Lewery, *op. cit.*, pp. 25–7; David Braithwaite *Fairground Architecture* (London, 1968), *passim*; Ian Starsmore, *English Fairs* (London, 1975), chapter 5.

38. William Manus, *Painted Ponies. American Carrousel Art* (Millward, New York, 1986), p. 39.

39. Lewery, *op. cit.*, p. 20.

40. *Ibid.*, pp. 133–5; John Gorman, *Banner Bright* (Harmondsworth, 1973).

41. Paul Bouissac, *Circus and Culture. A Semiotic Approach* (Birmingham and London, 1976), pp. 176–9.

42. Vitruvius, *The Ten Books on Architecture*, trans. Morris Hickey Morgan (New York, 1960), p. 211.

6. Looking Out: the Uses and Meanings of Exoticism in Western Ornament

1. Eroticism, up to then often in the background, became an important part of exoticism in the nineteenth century.

2. On the Western construction of the East see especially Edward Said, *Orientalism* (London and Henley, 1978).

3. James Stevens Curl, *Egyptomania: The Egyptian Revival as a Recurring Theme in the History of Taste* (Manchester, 1994); Patrick Conner (ed.), *The Inspiration of Egypt, Its Influence on British Artists, Travellers and Designers, 1700–1900*, (Brighton, 1983); Gereon Sievernich and Hendrik Budde (eds), *Europa und der Orient, 800–1900* (Berlin, 1989); Jean Marcel Humbert, Michael Pantazzi and Christiane Ziegler, *Egyptomania, L'Egypte dans l'art occidental, 1730–1930* (Paris, 1994).

4. For Europe and the Near East see John Sweetman, *The Oriental Obsession: Islamic Inspiration in British and American Art and Architecture, 1500–1920* (Cambridge, 1988) and Sievernich and Budde, *op. cit.*

5. Sievernich and Budde, *op. cit.*, pp. 641–2.

6. See Jessica Rawson, *Chinese Ornament: The Lotus and the Dragon* (London, 1984), chapter 5, 'Chinese Motifs in Iranian and Turkish Art'.

7. See Sievernich and Budde, *op. cit.*, pp.171–81, 557–70; Jennifer Harris (ed.), *5000 Years of Textiles* (London, 1993).

8. See Donald King and David Sylvester (eds), *The Eastern Carpet in the Western World from the Fifteenth to the Seventeenth Century* (London, 1983); C.E.C. Tattersall and Stanley Read, *A History of British Carpets from the Introduction of the Craft until the Present Day* (revised edn, Leigh-on-Sea, 1966), chapter 2.

9. See B. Klesse, *Seidenstoffe in der Italienischen Malerei des 14. Jahrhunderts* (Berne , 1967); A. Wardwell, 'The Stylistic Development of Fourteenth-century and Fifteenth-century Italian Silk Design', *Aachener Kunstblätter*, 47, pp.177–226; Harris, *op. cit.*

10. Klesse, *op. cit.*, p. 37.

11. *Ibid.*, p.114.

12. Harris, *op. cit.*, p. 79 (ill.).

13. See John Cornforth, 'A Georgian Patchwork', in Gervase Jackson-Stops, Gordon J. Schochet, Lena Cowen Orlin and Elisabeth Blair MacDougall (eds), *The Fashioning and Functioning of the British Country House* (Hanover and London, 1989), pp. 155–74.

14. *The Journal of Design*, 1, March 1849, p. 7. Clive Wainwright, *The Romantic Interior: The British Collector at Home* (New Haven and London, 1989), p. 45.

15. See Alois Riegl, *Problems of Style: Foundations for a History of Ornament*, trans. Evelyn Kain (Princeton, 1992) (originally published as *Stilfragen*, 1893); Rawson, *op. cit.*, pp. 173–93.

16. See John Irwin and Katharine B. Brett, *Origins of Chintz* (London, 1970); Elbetje Hartkamp-Jonxis, *Sits: Oost-West relaties in textilie* (Zwolle, 1987); Josette Bredif, *Toiles de Jouy: Classic Printed Textiles from France 1760–1843* (London, 1989).

17. See John Guy, 'Indian Textiles for the Thai Market – A Royal Prerogative', *The Textile Museum Journal*, 1992, pp. 82–96.

18. Irwin and Brett, *op. cit.*, p. 4.

19. See Santina Levey and Donald King, *The Victoria and Albert Museum's Textile Collection: Embroidery in Britain from 1200–1750* (London, 1993).

20. See John Irwin, *Kashmir Shawls* (London, 1973); M. Levi-Strauss, *The Romance of the Cashmere Shawl* (Milan, 1986; English transl. Ahmedabad, 1987); Frank Ames, *The Kashmir Shawl and its Indo-French Influence* (Woodbridge, 1986).

21. Ames, *op. cit.*, p. 94.

22. *Ibid.*, p. 97.

23. Sievernich and Budde, *op. cit.*, pp. 597–611; G. Curatola (ed.), *Eredità dell' Islam: Arte Islamica in Italia* (Milan, 1993).

24. See e.g. Sylvia Auld, 'Kuficising Inscriptions in the Work of Gentile', *Oriental Art*, 32, pp. 246–65.

25. See Alain Gruber, 'Entrelacs' and 'Mauresques' in Alain Gruber (ed.), *L'Art décoratif en Europe; Renaissance et Maniérisme* (Paris, 1993), pp. 21–112 and 277–345.

26. Riegl, *op. cit.*, chapter 4.

27. See Anthony Hobson, *Humanists and Bookbinders: The Origins and Diffusion of Humanistic Bookbinding 1459–1559, with a Census of Historiated Plaquette and Medallion Bindings of the Renaissance* (Cambridge, 1989).

28. For Leonardo's knots and their link with the *impresa* of Isabella and Beatrice d'Este see Martin Kemp, *Leonardo da Vinci: The Marvellous Works of Nature and Man* (London, Melbourne and Toronto, 1918), p. 187.

29. See Gruber *L'Art décoratif, op. cit.*, pp. 70–71.

30. Nicole Dacos, *La Découverte de la Domus Aurea et la formation des grotesques à la Renaissance* (London and Leiden, 1969), pp. 62–9, figs 85, 94; Timothy Wilson, *Ceramic Art of the Italian Renaissance* (London, 1987), pp. 87–8.

31. Janet Byrne, *Renaissance Ornament Prints and Drawings* (New York, 1981), p. 32.

32. *Ibid.*

33. John F. Hayward, *Virtuoso Goldsmiths and the Triumph of Mannerism* (London, 1976); Yvonne Hackenbroch, *Renaissance Jewellery* (London, 1980); Victoria and Albert Museum, *Princely Magnificence: Court Jewels of the Renaissance, 1500–1630* (London, 1980).

34. Cipriano Piccolpasso, *The Three Books of the Potter's Art*, ed. Ronald Lightbown and A. Caiger-Smith (London, 1980).

35. For example a Caffagiolo jug of *c.*1500–1515 in Wilson, *op. cit.*, pp. 86–7.

36. See Peter Ward-Jackson, 'Some Main Streams and Tributaries of European Ornament', *Victoria and Albert Museum Bulletin*, 3, (1967), p. 58ff., 90ff., 121ff.; Bruno Pons, 'Arabesques, ou nouvelles grotesques', in Alain Gruber (ed.), *L'art décoratif en Europe: classique et baroque* (Paris, 1992), pp.159–225.

37. See Patrick Conner, *Oriental Architecture in the West* (London, 1979); Michael Darby, *The Islamic Perspective: An Aspect of British Architecture and Design in the 19th Century* (London, 1983).

38. Darby, *op. cit.*, pp.108–9.

39. *Journal of Design and Manufactures*, June 1851, p. 91.

40. See Barbara Morris, *Inspiration for Design: The Influence of the Victoria and Albert Museum* (London, 1986), pp. 94–104; Sweetman, *op. cit.*, pp. 178–80, 183–86; William Gaunt and M.D.E. Clayton-Stamm, *William De Morgan* (London, 1971); Martin Greenwood *The Designs of William De Morgan* (Shepton Beauchamp, 1989).

41. Sweetman, *op. cit.*, chapter 5; Darby, *op. cit.*, section 3.

42. See Stuart Durant, *Ornament: A Survey of Decoration since 1830* (London, 1986).

43. Owen Jones, *The Grammar of Ornament* (London, 1856), p. 5.

44. *Ibid.*, propositions 11, 12, 8, pp. 5, 6.

45. See Paul Atterbury and Clive Wainwright (eds), *Pugin: A Gothic Passion* (New Haven and London, 1994).

46. Jones, *op. cit.*, p. 87. He changed his mind in *Examples of Chinese Ornament* (London , 1867).

47. See Hugh Honour, *Chinoiserie: The Vision of Cathay* (London, 1961); Oliver Impey, *Chinoiserie: The Impact of Oriental Styles on Western Art and Decoration* (London, 1977).

48. See Honour, *op. cit.*; Impey, *op. cit.*; Alain Gruber, 'Chinoiseries', in Gruber, *L'art décoratif en Europe: classique et baroque*, pp. 225–324.

49. Rawson, *op. cit.*, p. 11.

50. See Robert Copland, *Spode's Willow Pattern and Other Designs after the Chinese* (London, 1980).

51. Wilson, *op. cit.*, pp. 157–9.

52. See T. Volker, *Porcelain and the Dutch East India Company* (Leiden, 1971); Christian J.A. Jörg, *Porcelain and the Dutch China Trade* (The Hague, 1982); Colin Shaef and Richard Kilburn, *The Hatcher Porcelain Cargoes: The Complete Record* (Oxford, 1988); Maura Rinaldi, *Kraak Porcelain: A Moment in the History of Trade* (London, 1989).

53. See Hendrik Budde, Christoph Müller-Hofstede and Gereon Sievernich (eds), *Europa und der Kaiser von China, 1240–1816* (Frankfurt am Main, 1985), p. 223.

54. From Sir William Temple, *Upon the Gardens of Epicurus; or, of Gardening in the Year 1685*, in Sir William Temple, *Miscellanea*, Vol.II (London, 1697), p. 132.

55. Michael McCarthy, *The Origins of the Gothic Revival* (New Haven and London, 1987), p. 63.

56. See Natalie Rothstein, *Silk Designs of the Eighteenth Century* (London, 1990).

57. Cardinal Mazarin, writing in 1659; see Peter Burke, *The Fabrication of Louis XIV* (New Haven and London, 1992), p.158.

58. Budde *et al.*, *op. cit.*, pp.66–8, 302–5.

59. Robert Fortune, quoted in Honour, *op.cit.*, p. 199.

60. John Stalker and George Parker, *A Treatise of Japanning and Varnishing* (Oxford, 1688).

61. From *The World*, 1754, quoted in Honour, *op. cit.*, p. 154.

62. See Eileen Harris, '*Designs for Chinese Buildings* and the *Dissertation in Oriental Gardening*', in John Harris, *Sir William Chambers: Knight of the Polar Star* (London, 1970), pp.144–62.

63. Honour, *op. cit.*, p.81.

64. See above, p. 123.

65. See Craig Clunas, 'Chinese Furniture and Western Designers', *Journal of the Classical Chinese Furniture Society*, 3, 1 (Winter 1992), pp. 63–5.

66. See John Ayers, Oliver Impey and J.V.G Mallet, *Porcelain for Palaces: The Fashion for Japan in Europe, 1650–1750* (London, 1990).

67. See Phyllis Anne Floyd, *Japonisme in Context: Documentation, Criticism, Aesthetic Reaction* (Ann Arbor, 1983); Paris, Grand Palais, *Le Japonisme* (Paris, 1988); Toshio Watanabe, *High Victorian Japonisme* (Berne, 1991); Tomoko Sato and Toshio Watanabe, *Japan and Britain: An Aesthetic Dialogue 1850–1930* (London 1991); Anna Jackson, 'Imagining Japan: The Victorian Perception and Acquisition of Japanese Culture', *Journal of Design History*, 5, 4 (1992), pp. 245–56.

68. William Burges, 'The International Exhibition', *Gentleman's Magazine*, July 1862, p. 11.

69. Durant, *op. cit.*, p. 163.

70. See Wainwright, *op. cit.*, pp. 90–91; Clive Wainwright, 'Only the True Black Blood', *Furniture History*, 21 (1985), pp. 250–55.

71. Durant, *op. cit.*, p.164.

72. Paris, Grand Palais, *op. cit.*, p. 106.

73. See Paul Greenhalgh, *Ephemeral Vistas: The Expositions, Great Exhibitions and World Fairs 1851–1939* (Manchester, 1988).

74. See Durant, *op. cit.*, chapter 8.

75. See Jonathan M. Woodham, *Twentieth-Century Ornament* (London, 1990).

76. Dinah Hall, *Ethnic by Design* (London, 1992).

77. Anokhi label, 1994.

Critical Bibliography

This bibliography covers some of the basic materials for the purposes of study which may not immediately arise from the notes to the text. Many useful books are in foreign languages. Where translations exist, these are included in the first four sections below; a separate section covers those that are at present only available in the original language. The sections obviously overlap to some extent in content.

The Encyclopaedic Tradition.
The following are chosen from the great nineteenth-century tradition because of their fame, wide circulation or, in some cases, their authors' position at the head of an important museum or in a government post with responsibility for art education. Many are available in reprints or facsimiles: Ludwig (or Lewis) Grüner, *Specimens of Ornamental Art* (London, 1850); Owen Jones, *The Grammar of Ornament* (London, 1856) (repr. Studio Editions, London, 1986); F.S. Meyer, *Handbook of Ornament* (London, 1888; the 1892 edition was reproduced by Dover, New York in 1957, with later editions); H. Dolmetsch, *The Treasury of Ornament* (English edn, London, 1883); R. Glazier, *A Manual of Historic Ornament* (London, 1899). For the best modern summary of these texts and much else on ornament since 1830 see Stuart Durant, *Ornament: A Survey of Decoration since 1830* (London and Sydney, 1986).

The Theory of Ornament
Among the profound, or simply highly influential, writings of the nineteenth century are John Ruskin, *Seven Lamps of Architecture* (London, 1849) and *The Stones of Venice* (London, 1851), especially the chapter on 'The Nature of Gothic'; the standard edition of Ruskin is that edited by E. Cook and A. Wedderburn (London 1903–10); R.N. Wornum, *Analysis of Ornament* (London, 1856); Christopher Dresser, *Development of Ornamental Art* (London, 1862); F. Edward Hulme, *Principles of Ornamental Art* (London, 1875); Alois Riegl, *Problems of Style: Foundations for a History of Ornament* (originally published in German in 1893, trans. Evelyn Kain, Princeton, 1992). E.H. Gombrich, *The Sense of Order. A Study in the Psychology of Decorative Art* (London, 1979) is a fundamental modern study of the subject, with key critiques of Ruskin, Riegl and Loos. Oleg Grabar, *The Mediation of Ornament* (Princeton, 1992) discusses Islamic art but in terms of the universal quality of its motifs. Equally, Jessica Rawson, *Chinese Ornament: The Lotus and the Dragon* (London, 1984) reveals much about the transmission of motifs in general through a study of the East. Recent books on theory include Brent C. Brolin, *Flight of Fancy: the Banishment and Return of Ornament* (New York, 1985) and David Brett, *On Decoration* (Cambridge, 1992). A recent collection of selections from primary texts is Paul Greenhalgh, *Quotations and Sources on Design and the Decorative Arts* (Manchester, 1993).

Histories of Ornament
Books which chart long spans of time are Joan Evans, *Pattern. A Study of Ornament in Western Europe from 1180 to 1900* (Oxford, 1931) and Susan Lambert (ed.), *Pattern and Design. Designs for the Decorative Arts 1480–1980* (London, 1983), which was the catalogue of an exhibition at the Victoria and Albert Museum. Useful works which raise issues about particular periods from the fifteenth century to the present include Janet S. Byrne, *Renaissance Ornament Prints and Drawings* (New York, 1981); Peter Ward-Jackson, 'Some Mainstreams and Tributaries in European Ornament from 1500 to 1750', *Victoria and Albert Museum Bulletin*, 3 (1967), p. 58 ff. 90 ff. 121 ff.; Michael Snodin (ed.), *Rococo: Art and Design in Hogarth's England* (London, 1984; the catalogue of an exhibition at the Victoria and Albert Museum); Paul Atterbury and Clive Wainwright, *Pugin. A Gothic Passion* (London, 1994); Tim and Charlotte Benton, *Form and Function. A Sourcebook for the History of Architecture and Design 1890–1939* (London, 1975); Jonathan M. Woodham, *Twentieth-Century Ornament* (London, 1990). Some books concerned with the history of style have points to make about ornament, particularly the recent series from Phaidon Press: Timothy Mowl, *Elizabethan and Jacobean Style* (London, 1994); Steven Parissien, *Palladian Style* (London, 1994) and the same author's *Regency Style* (London, 1992). A history of ornament based on motifs of which one volume has so far been translated into English is Alain Gruber (ed.), *A History of the Decorative Arts: The Renaissance and Mannerism in Europe* (New York, 1994).

Dictionaries and Other Works of Reference
H. Osborne (ed.), *The Oxford Companion to the Decorative Arts* (Oxford, 1975); J. Fleming and H. Honour, *The Penguin Dictionary of the Decorative Arts* (Harmondsworth, 1977); Simon Jervis, *The Penguin Dictionary of Design and Designers* (Harmondsworth, 1984, with a useful short preface); Philippa Lewis and Gillian Darley, *Dictionary of Ornament* (London, 1985); Eva Wilson, *8000 Years of Ornament. An Illustrated Handbook of Motifs* (London, 1994).

Books in Foreign Languages
For a survey of ornament prints, Rudolf Berliner and Gerhart Egger, *Ornamentale Vorgeblätter des 15. bis 19. Jahrhunderts* (Munich, 1981). The main catalogues of ornament prints are D. Guilmard, *Les Maîtres ornemanistes* (Paris, 1880) and Staatliche Museen zu Berlin, *Katalog der Ornamentstichsammlung der Staatlichen Kunstbibliothek Berlin* (Berlin, 1939). Well-illustrated histories of ornament heavily based on prints include Carsten-Pieter Warncke, *Die ornamentale Groteske in Deutschland* (Berlin, 1979) and Gunter Irmscher, *Kleine Kunstgeschichte des Europäischen Ornament seit der frühen Neuzeit (1400–1900)* (Darmstadt, 1984). The series produced under the direction of Alain Gruber under the title *L'art décoratif en Europe* is a history of ornament based on motifs. The three volumes are subtitled *Renaissance et maniérisme* (Paris, 1993), *Classique et baroque* (Paris, 1992) and *Du Néoclassicisme à l'art deco* (Paris, 1994). The first of these is translated into English (see section on 'Histories' above).

Index

'Queen Anne' style, 127, 212
Quicchelberg, Samuel, 44

railway companies *see* transport
Raimondi, Marcantonio, 30, 31, *53*
Ramsay, Allan, 99, *100*
Raphael, *4*, 36, 39, 52
religious practices and ornament *see*
 ornament
Rembrandt, 117, *125*
Renaissance style and ornament, 12, 13, 16,
 23, 24, 26, 28, 30, 31, 35–41, 42, 70–72, 74,
 80, 82, 84, 87, 112, 116, 119, 123, 125, 132,
 140, 182, 192, 195–8, 207
Reutimann, Johann Conrad, 45
Revett, Nicholas, 68
Reynolds, Sir Joshua, 35
Riario, Cardinal Raffaello, *211*
Richardson, Samuel, 98
Rivière, Madame, *209*
Roberts and Co., Samuel, *88*
rocaille see motifs
rococo style and ornament, 35, *40*, 42, 46, 49,
 56, 165, 207
Rohe, Mies van der, *150*
Roman, ancient, style and ornament, 11,
 31–2, *66*, 67–8, 70, *70*, 71, 78, 94, 160
Romano, Giulio, 82, *82*, 134
Romantic interior, the, 140, 143, 145, 151
Rosselli, Francesco, 23
Roumier, François, 46
Rubens, Sir Peter Paul, *2*
Ruskin, John, 12, 88, 90, 147, 149
Ryff, Walther Hermann, 30

Sadeler, Aegidius, 35
Saint, Gideon, *42*, 46–7
Salamanca, Antonio, *32*, *33*, 42
salon or saloon *see* architecture and interiors:
 rooms
Sandrart, Joachim von, *26*, 32, 34
Santo Bartoli, Pietro, *27*, 34
Sanvito, Bartolomeo, *211*
Savage, Frederick, 174
Savorelli, G., *4*
scagliola, 147
Scève, Maurice, *69*
Schinkel, Karl Friedrich, 58
Schongauer, Martin, *16*, 23, 52
Schönsperger, Johann, *20*, 27, 28
Schweiger, family, of Basel, 23
Scott, Henry, *61*
sculpture as ornament, 133, *144*
Selfridge, Gordon, 167
Sellier, Louis, *59*
Serlio, Sebastiano, 24, 30, 44, 68, 76
Seusenhofer, Konrad, *120*
Shaftesbury, Earl of, 209
Shakers, the 151, *164*
'Sharawaggi' (lack of symmetry), 206
Shaw, Henry, *60*
shell motif *see* motifs

shoes *see* footwear
shopfronts and signs, 62–5, *64–6*, 159, 167,
 176, *177*, *188*
Shute, John, 71
Sibmacher, Johann, 40
signs, commercial and inn, 159, 160, 162, *176*,
 178–82
silk, 98, 183, 185–6, 228
silver, *48*, 50, 54, *55*, 56, *74*, *88*, 134, 137, 157,
 170
Simyan, Victor, *2*
Sinatra, Frank, 106
Solis, Virgil, *39*, 42
Sorolla y Bastida, Joaquin, *113*
Spagnolo Design, *240*
Spain, and ornament, 185, 192
 Barcelona, International Exhibition of
 1929, *150*
 Salamanca, University of, 37
Speight, Alexanna, *118*
Steuco, Agostino, *217*
strapwork *see* motifs
Stuart, James, 68
Stefano della Bella *see* Bella
studio see architecture and interiors: rooms
Stukeley, William, 140
Sullivan, Louis, 12, 63, *64*, 88–9, *90*
sumptuary laws, 98
Sweden, and ornament, 24, 44, 147, *158*
 Stockholm, Royal Library, 44
 Thureholm, chair from, *158*
Switzerland:
 Basel, *41*
Syria: Palmyra, Roman theatre, 66; model of
 temple at, 75

Tabram, Nicolette, *239*
Tagliente, Giovanni Antonio, 28, 195–7, *214*
tattoos and tattooing, 94, 96–7, *96*, *97*
Taylor, John R.J., *137*
Temple, Sir William, 206
Terborch, Gerard, 116
terracotta, 63–4, *61*
Tesco Ltd, supermarkets, *92*
Tessin, Gustave and Nicodemus, 44
textiles and ornament, *20*, 27–8, *95*, 98, 125,
 134, 182, 184–91, 197, *235*
Thomas, Clara Fargo, *188*
tombs and monuments, 44, 80, *81*, 83, 111,
 154, *168*
 see also death and ornament; funerals
trade cards, 46, 56
trade catalogues, *53*, 54, 60
trades union banners, 176, *198*
transport and ornament, 105, 158, 170–73,
 190, *191*, *192*
treatises *see* architecture and interiors
triglyph *see* architecture and interiors
triumphal arches, *69*, 71, 162, 166–7, *187*
triumphal entries, 44, 71, 165, 167, *185*
trophies *see* motifs
'tulipomania', 116, *126*

Turkish and 'Turquerie', 144, 183, 184, 197,
 202, *203*
Tuscan order *see* architecture and interiors:
 orders
Tutill, George, 176, *198*

Udine, Giovanni da, 36, *39*
Udone, Andrea, 133, 140, *144*
United States *see* America

Vardy, John, *44*, 49
Vasari, Giorgio, 34, 80
vases *see* motifs
Vavassore, Giovanni Antonio, 28, *217*
Velde, Henry van de, 90
Veneziano, Agostino, *23*, *26*, 30, 31, 32, 34, 39
Vendramin, Doge Andrea, of Venice, *81*
Vico, Enea, *24*, *26*, 31, 32, 34, *35*, 40
Victoria, Queen, of Great Britain, *1*, 111
Vitruvius, 12, 30, 37, 67, 68, 70, 72, 74, 78, 90,
 122, 125, 132, 147, 179
Vogtherr, Heinrich, the Elder, *21*, 28, 30, 47, 60
Vries, Hans Vredeman de, *38*, 41, 42

Wagner, Otto, 74
Wainwright, Clive, 140
Wakelin, Edward, *170*
Waldegrave, Lady Frances, 127
wall decoration, 37, 71–2, 122, 123, 125, 127, *135*,
 136, *136*, 147, 205, *225*
wallpaper, 79, 127, 129, 131, 140, 143, 147, 148, 149,
 151, *153*, *160*
Walpole, Horace, 66, 124–5, 127, 140, 206
Walt Disney Ltd, 173, *193*
Warham, William, Archbishop of Canterbury, *204*
Watt, William, *234*
well-dressing, 153, *165*
Wild, Charles, *166*
Willow Pattern *see* motifs
Wolfe, Elise de, 143
women *see* ornament: gender
woodcuts, 21, *21*, *22*, 24, 26, 30, 42
woodwork, 22, *22*, 24, 30
Wotton, Sir Henry, 133, 147
Wren, Sir Christopher, 123, 133, 209
Wright, Frank Lloyd, 130, 131, 138, *141*

Yenn, John, 125, 136, *136*

Zündt, Mathis, *129*

Illustration Acknowledgements

Plates not listed below have been made from the authors' own photographs.

The Conway Library, Courtauld Institute of Art 9, 80, 81, 84, 102; The American Museum, Claverton Manor, Bath 10, 79, 176; Trustees of the British Museum 14, 16, 213; © Photo Réunion des Musées Nationaux 15, 209; Pierpont Morgan Library, New York (PML 18699) 17; Metropolitan Museum of Art, New York 20, 42 (Harris Brisbane Dick Fund, 1934 [34.90.1, p. 15]), 109 (50.145.24), 214; Swiss National Museum, Zürich (neg. nr 127549) 41; British Architectural Library, RIBA, London 44, 145; Glasgow School of Art 57; Richard and Claire Gapper 82; The British Library 97; The Witt Library, Courtauld Institute of Art 100; St Andrews University Library 101; Public Information (Army) HQ 103; Maidstone Museum and Art Gallery 104; Archives, University of Colorado at Boulder 106; Royal Pavilion, Museum and Art Gallery, Brighton 108; The National Library, Vienna 112; The Marquess of Salisbury 115; The Wallace Collection 116; The National Gallery, London 125, 231; English Heritage 127; © National Trust Photographic Library 133, 134 (photo Bill Batten); Royal Academy of Arts, London 136; University of Middlesex Library, London 139, 140; Photograph by Thomas A. Heinz © 1995 141; Trustees of the Geffrye Museum, London 142; The Royal Collection © Her Majesty Queen Elizabeth II 144; Sotheby's, London 145; Camera Press 150; Lewis Walpole Library, Yale University 152; private collections 155, 221, 239, 240; Nairn Floors Ltd 156; Peter Fraser 157; Nordic Museum, Stockholm (photo Peter Segermark) 158; Tate Gallery, London 160; Divertimenti (Mail Order) Ltd 162; John Murray Publishers 163; The Shaker Shop 164; Gallagher Ltd 167; The London Borough of Hounslow 172; High Wycombe Central Library 187; Selfridges Archive 188; the National Museum of Labour History, Manchester 198; 20th Century Fox 200 (courtesy the Kobal Collection); Kupferstichkabinett, Staatliche Museen zu Berlin PK 202; National Portrait Gallery, London 204; Fundacion Collecion Thyssen Bornemisza, Madrid 215; Christie's, New York 236, 237; Reed International Books Ltd (photo James Merrell) 238.

The following plates, listed here with museum accession numbers, have been provided by the Board of Trustees of the Victoria and Albert Museum.

1: 3340-1856, 2: 1047-1871, 3: 49 G 54, 4: E335-1887, 5: C150-159-1982, 8: 49 G. 54, 10: 547-1884, 11: E.4737-1906, 12: 171-1866, 13: E.354-1976.23, 18: E.2214-1920, 19: 25984, 21: E.3423-1907, 22: 87 E 31, 23: 16844, 24: E.2023-1899, 25: E.4302-1910, 26: 13630.2, 27: 17239, 28: A.32-1917, 29: 27736.2, 30: Schr. I 369, 31: 656-1884, 32: E.181-1885, 33: E.1384-1897, 34: 16770, 35: 20306.41, 36: 16784, 37: 23089.5, 38: E.361-1926, 39: E.1234-1926, 40: E.1005-1991, 43: E.653-1906, 45: E.240-1967, 46: M.329-g-1977, 47: E.1663-1977, 48: M.77-1947. 49: 28190.9, 50: G30. M. 7, 52: C.2232-1910, 53: Dyce 1032, 54: E.44-1929, 55: E.2628-1901, 56: E.1297c.-188, 58: 58 C 7, 59: 49 G 10, 60: 95 A 58. E.2094-1952, 72: III. RC. N.10, 73: M379-1927, 74: W19-1982, 75: Circ. 217-1916, 77: 22-1882, 79: 1884-718, 83: 604-1883, W.61c-1929, 3416-1901, 86: W43-1949, 87: 33 F. 119, 88: 843b-1905, 93: M135-G-1951, 94: E581-1940, 95: T281-1983, 98: 832-1904, 99: 484-1865, 107: 898-1904, 117: 956-1888, 118: 20 Q, 120: M.195-1921, 121: T282-1987, 122: T769-1919, 123: AP38-1860, 124: E214-1994, 128: E1765-1929, 129: E1814-1927, 131: 632, 632A, 638-1834, 137: E.32-1990, 138: 47 D 38, 143: E.825-1979, 146: E.5914-1905, 147: D.1593-1898, 149: II RC GG 2, 153: E.263-1929, 154: 57 Q 1, 159: 86 MM 29, 161: 230-1926, 166: 59-1878, 170: M32-1961, 171: 342, 342a-1901, 184: HRB 112-6, 185: 5928-1859, 193: T179-1991 (Courtesy The Walt Disney Company Ltd), 199: Antony Hippisley Coxe Collection, 205: 95 EE 29, 206: 329-1898, 207: I.S. 156-1953, 208: W.70-1916, 210: E.4410-1911, 211: L.1609-1954, 212: E.189-1885, 217: L.3395-1938, 218: E.5936-1908, 220: 7262-1861, 222: C.247-1991, 223: C.807 & a-1910, 224: C.3-1969, C.2-1995, 226: 1138-1886, 227: 423-1870, 228: 711-1864, 229: 29067.D, 230: W.143-1921, 232: PP 10, 233: E.1908-1990, 234: Circ.38-1953, 235: E.1028-1977.